Readings in Primary Art Education

To Carla

Readings in Primary Art Education

Edited by Steve Herne, Sue Cox and Robert Watts

intellect Bristol, UK / Chicago, USA

First published in the UK in 2009 by
Intellect Books, The Mill, Parnall Road, Fishponds, Bristol, BS16 3JG, UK

First published in the USA in 2009 by
Intellect Books, The University of Chicago Press, 1427 E. 60th Street, Chicago,
IL 60637, USA

Series: Readings in Art and Design Education
Series editor: John Steers

A catalogue record for this book is available from the British Library.

Cover designer: Holly Rose
Copy-editor: Heather Owen
Typesetting: Mac Style, Beverley, E. Yorkshire

ISBN 978-1-84150-242-7

Printed and bound by Gutenberg Press, Malta.

CONTENTS

ACKNOWLEDGEMENTS

The editors are very grateful to Black Dog Publishing, Anna Harding and Room 13 for permission to republish the essay: 'Room 13: One artist, 11 years, one school', from the book (2005): *Magic Moments, Collaboration between Artists and Young People*, London: Black Dog Publishing, edited by Anna Harding as the final chapter.

The editors are also very grateful to Hannah Hutchings, Art Coordinator, Thomas Buxton Infant School, Tower Hamlets, London E1. for permission to use artwork made by children at the school in the cover design.

PREFACE

This book is the eighth in a planned series of anthologies dealing with a range of issues in art and design education. Titles published to date are:

Critical Studies in Art & Design Education (2005)
Histories of Art and Design Education (2005)
Art Education in a Postmodern World (2006)
The Problem of Assessment in Art & Design (2007)
Research in Art & Design Education (2008)
Writing on Drawing: Essays on Drawing Practice and Research (2008)
Art, Community and Environment: Educational Perspectives (2008)

The principal, but not exclusive source of chapters is papers previously published in the *International Journal of Art & Design Education* and, where appropriate, these have been updated. It should be noted that any reference to the English National Curriculum statutory Orders, the Scottish National Guidelines, etc., are to the versions of curriculum content current at the time of original publication.

The National Society for Education in Art and Design is the leading national authority in the United Kingdom, combining professional association and trade union functions, which represent every facet of art, craft and design in education. Its authority is based partly on a century-long concern for the subject, established contacts within government and local authority departments, and a breadth of membership drawn from every sector of education from the primary school to university.

More information is available at www.nsead.org or from NSEAD, The Gatehouse, Corsham Court, Corsham, Wiltshire, SN13 OBZ (Tel: +44 (0) 1249 714825).

INTRODUCTION: RESEARCH IN PRIMARY ART EDUCATION

Steve Herne, Sue Cox and Robert Watts

This book brings together a selection of the most significant and informative papers on primary art education from over 25 years of the International Journal of Art and Design Education. As a collection it captures key moments in the development and practice of the subject and will inform readers who wish to reflect on and evaluate art and design education for children aged 3–11. The authors explore paradigms and metaphors that have conceptualized primary art education as well as theorizing practice. They record the achievements of the field and point towards the challenges currently faced by teachers of art and design, in the primary and early years phases (ages 3–11), in the twenty-first century.

The selection includes material written from a contemporary perspective as well as from earlier years of the journal and includes one chapter from an outside source. Reflecting the character of the journal itself, the authors discuss important movements and influential thinkers and debates, and the collection includes the work of both practitioners and researchers. Postscripts are added to some of the chapters which identify further readings and, in some cases, contain new commentaries from the original authors or further research findings.

In this introduction the editors present a brief overview of developments in the field of primary art and design education, considering six broad themes that are reflected in the chapters in the collection: research investigations; histories and overviews; curriculum change; drawing; critical studies and children's voices. We hope that this adds value to the collection by providing insights into the contexts and development of primary art and design education, as well as introducing the reader to the content of each chapter.

We believe that the collection will be of relevance to reflective practitioners who wish to develop their art and design teaching or subject leadership. Students embarking on teacher education courses will find this a valuable and readable resource which will support the development of their pedagogical thinking and evaluation of classroom practice. Beginning, developing and experienced researchers in the field will find this collection and its new material essential reading and an ongoing source of reference.

Research investigations

The intended readership of this collection includes teachers in primary schools with a particular interest in art and design. Few would consider themselves specialist teachers of art and design and most are required to teach across the whole of the primary curriculum. Yet many teachers are involved in some kind of research into their practice as a teacher of art and design, which entails reflection on the outcomes in their classrooms as well as challenges to their pre-conceptions and assumptions.

The decisions that teachers make, whether based upon established strategies for teaching and learning, for observing pupils, or for behavioural management, are arguably often informed by research, however informal, into their own or colleagues' practice. And while the concept of research may sometimes seem remote from the pressing and practical problems faced by teachers on a daily basis, informal research essentially underpins the practice of teaching and forms the foundation for change and evolution across the education system. The vast majority of this research may go unrecorded and unnoticed by all but the handful of people directly affected by it. Experiences that could potentially be shared and discussed with colleagues pass quickly in the classroom and opportunities to pause and reflect may be rare. Rarer still may be those occasions on which teachers are able locate these experiences within the broader context of educational research and debate.

Engaging with research offers teachers opportunities to link theory and practice in art education. As Gillian Figg observes in Chapter 5 of this collection, 'To be a practising teacher who is simultaneously involved in research is a chastening and enlightening experience and injects a strong sense of realism into curriculum theory.' Whether carried out recently or decades ago, whether located in a similar context to the teacher's own experience or in a contrasting environment, research can enable teachers to make connections between their own practice and that of other educators, to raise questions about situations they encounter in the classroom and to illuminate key aspects of their own practice.

Conversations with primary teachers with a specialism in art, craft or design reveal that they often invest more energy in developing their teaching in areas of the curriculum other than their specialist subject. Many talk of a slow shifting of identity from being an artist, to an artist who teaches, to a teacher who makes – or used to make – art. One response to this issue has been the emergence of the Artist Teacher Scheme in the UK, which is an expanding professional development programme for teachers and lecturers in art and design and gallery educators. 'The scheme works on the premise that teachers' personal development as artists improves their

effectiveness as teachers and, as a result, their students' learning and creativity' (Arts Council England 2008; NSEAD 2008). Reflecting on personal art production in relation to pedagogic issues is one approach to research; engaging in classroom-based action research is another.

The motivation that has driven many of the authors in this collection to initiate, write and publish their research frequently stems from their own experiences in the classroom, either as an observer or as a practitioner of teaching and learning in art and design. 'As a newly qualified teacher', writes Anthony Dyson in one of the earliest articles in the collection (Chapter 13) 'I was vaguely aware of a dilemma ... I could at that time scarcely analyse my difficulty: now I think I see what it was.' Similarly, Dennis Atkinson recalls in Chapter 9 how 'as a teacher I remember being worried by theories of drawing development in children which appeared to suggest that this process was a hierarchical progression, evolving through predictable stages', highlighting the origins of a number of reflective research pieces exploring children's drawings, including the paper presented in this collection. Angela Martin was a primary teacher at the time of the publication of the paper included here (Chapter 18), which reports on one of three action research projects in which she worked alongside colleagues with the aim of broadening teachers' perspectives on approaches to teaching art. 'I knew from looking at the results of short-timed art lessons that there was a lot of talent bubbling below the surface,' she writes, 'I was sure that given the right workshop atmosphere, exciting media and enough time to develop ideas and a creative response they would surprise everyone.'

Whatever the origins of the research, its publication can, in turn, enable other practitioners to raise questions about situations they encounter in their own classrooms and can illuminate key aspects of their own teaching. Through analysing and documenting their own experiences through research, such practitioners can themselves contribute to the body of work in the field.

Histories and overviews

In the introductory paper in this collection (Chapter 1), originally published in the first volume of the Journal of Art and Design Education in 1982, Geoffrey Southworth sets out to establish 'first principles' for art in the primary school. Growing out of developments in the 1970s, the paper presents us with a conception of the subject that will seem familiar to many readers. The continued debates, analysis and curriculum development in the UK eventually led to the first English National Curriculum for Art, published in 1992 (DES 1992) which reflected many of the ideas explored as well as introducing newer approaches and emphases. The changes in the subject over these years demonstrate close parallels in the curricula of other countries that make up the UK, Scotland, Wales and Northern Ireland, as well as broader parallels with developed and developing countries around the world. Recognition of the wider international debate was reflected in 2000 when the journal changed its title to the International Journal of Art and Design Education (iJADE). More recently, the complete back catalogue of iJADE has become freely available on the Internet to members of the National Society for Art and Design Education (NSEAD) and to readers in subscribing academic libraries around the world.

Those looking for a concise overview of the historical development of art as a subject in the primary phase will find Hallam, Lee and Gupta's account a useful starting point (Chapter 4). This identifies three dominant rationales for art education from the nineteenth century to the present day, starting with the Victorian conception of art as a skills-based subject taught by expert teachers, involving publicly-recognized standards regarded as useful in the development of a skilled workforce and well-designed saleable products. The authors proceed to identify a second rationale in the early twentieth century with the recognition of 'child art' and a paradigm shift towards a child-centred approach based on the principles of Rousseau. In this conception, the teacher assumes the role of facilitator for the competent child's developmental and expressive journey of self-realization. The prominent Austrian artist and educator Franz Cizek is identified as the prime mover and advocate of this approach; however, the British art educator, Marion Richardson, also has a strong and equal claim as an original thinker and innovator in Britain, as Bruce Holdsworth (Chapter 3) argues convincingly. Indeed, those looking for a heroine and inspiration for art in the primary phase would do well to study Marion Richardson's theories and practice, as she prefigures many important approaches and ideas with which we are familiar today. Her work has a depth and breadth that is far from some of the shallow caricatures of child-art that have often been used to justify curriculum change. In recent correspondence with the editors, Holdsworth writes:

> I stated in my research that she was misunderstood and her influence on art education has been underestimated. I believe that her findings were fundamentally original and related to Art in a way that much art teaching has not been. Her definition of art education was based on the idea that all real art, including art by children, is produced when the idea in the artist's mind is so strong that there is a compulsion to express it, whether this is a thought, feeling, memory, description derived, observed or whatever. Surely this is right and, if her ideas are properly understood, then must be relevant today.

The emergence of Child Art and The New Art Teaching in the early Twentieth Century (Macdonald, [1970]2004) is now relatively easy to identify and conceptualize as we are distanced from it by time; however, the more recent past is less clear. Hallam, Lee and Gupta focus on the role of the teacher in their account of three rationales, while another valuable approach is to look at how the identity of the child or learner is conceived in different pedagogical theories and practices. Sheila Paine (Chapter 8) explores this in relation to the teaching of drawing, and readers will find further discussion of the emergence of child art and consequent approaches. Although she limits the identification of conceptions of the child to one source, she provides a valuable starting point for further research.

A distinct period of activity, debate and curriculum development between the late 1960s and early 1980s can be identified under the banner of 'Visual Education'. At secondary level and in art schools a strong influence was the Basic Design Movement, itself strongly influenced by the developments of the Bauhaus in Germany between the wars (Macdonald [1970]2004; Sausmarez [1964]2007). This led to the development of integrated design departments and

the birth of the new subject 'Craft, Design and Technology' in British schools. However, in the primary phase, the principles outlined by Southworth were more representative and the programme described by Gillian Figg in Chapter 5 gives a good example of the approach in practice, with its emphasis on drawing, direct experience, visual resources and working in depth with materials and techniques. 'Close observation' became a common focus in UK primary schools, reflecting the era of primary education that had been influenced by the Plowden Report (CACE 1967). At this time, working from the child's first hand experience was a key principle of primary practice for many teachers.

In the same period, drawing on the expressive conception of art education associated with the child art revolution, writers and educators such as Robert Witkin and Malcolm Ross were interested in putting education in the affective domain – the education of feeling – on a sounder theoretical basis. Frank Dobson and David Jackson (Chapter 2) give an account of Witkin's ideas and approach and argue for a more systematic approach to planning, continuity and progression. They analyse some of Witkin's concepts and illustrate his theoretical stance with an interesting sequence – a scheme of work carried out with some success with small groups of primary school children. The chapter describes the process of translating experience and feelings through media into symbolic form through a series of approximations to develop 'affective schema'. Witkin's concepts were influential and stimulated further debate. The strong feelings engendered can be felt in a critical review written by Alan Simpson and published in a later edition of the journal (Simpson 1984). The ideas, however, find an echo with a more contemporary concern with the development of 'emotional intelligence' (Goleman 1995). Dobson and Jackson also illustrate how an educational theory, a pedagogy, can be translated into experimental practice or a case study and, as such, can be grouped together with a number of other chapters, (5, 6, 10, 13, 17, 18), which contain experimental schemes of work constructed from a theoretical perspective to explore the translation of theory into practice.

Gillian Figg's chapter demonstrates another feature of the period: the motivation to analyse the essential elements, or domains of the discipline of art education. This can be seen as part of the Modernist project to refine disciplines and reveal their essence. In another paper not included in this collection (Figg 1989), she researches the variety of curriculum models derived from the literature, taking as her starting point Herbert Read's model from his iconic book 'Education through Art' (Read 1943).

Prefigured by Read's ideas, the period from the early 1980s through to the 1990s saw the development and then mainstreaming of art appreciation / art historical / critical and contextual studies as a partner to the existing emphasis on practical, expressive art making, experimentation and visual enquiry that had characterized the subject. Influential art and design educators such as Rod Taylor (1986, 1991) helped to foreground the ways in which the inter-relationship of these two aspects might be achieved and the Drumcroon Education Art Centre set up by Taylor became a flagship for such developments in the UK. This additional focus was enforced by legislation or adoption of national or official state curricula in countries around the world and we can conveniently refer to it as the Critical Studies movement. Just

as the Visual Education approach had been spread in the UK by reports from the Schools Council and a cadre of Art Advisors in the late 1970s and early 1980s, existing and newly appointed advisors spread the Critical Studies approach from the mid 1980s through to the introduction of the National Curriculum in 1992 and beyond. This focus on the broader knowledge-base of art and design was seen at the time, by some writers, as a new opportunity to engage primary teachers with the seriousness of the subject. Barnes (1989), for example, recognized the potential for promoting quality teaching with real educational value that would replace superficial conceptions of art and design in the classroom. Although not included in this collection, Barnes' argument may still be relevant today for those who have seen primary art and design once again becoming marginalized, in England at least, by the 'core subjects' of Literacy and Numeracy.

It is arguable that primary art and design educators are beginning to engage with a further paradigm shift and metamorphosis of the subject as the effects of new media, globalization and post-modernism influence theory and practice in the twenty-first century. In this collection, the theme of new media is taken up by John Matthews and Peter Seow in their chapter 'Electronic Paint: Understanding children's representation through their interactions with digital paint' (Chapter 19). These authors discuss their observations of children's use of an electronic paintbox and interactive devices, and show how children's development is influenced by the medium of representation itself.

The current primary curriculum review in the UK (Rose 2009) has revealed a move away from the strong subject boundaries that were re-established in primary schools in the 1990s, following the publication of what became known as the 'three wise men' report (Alexander, Rose and Woodhead 1992). A new model, favouring creativity, integration, cross-curricular approaches, and curriculum design based on areas of learning is emerging. Breaking down traditional subject divisions allows for a conception of thinking and learning across the arts as whole, but in different 'modes' of representation, reflecting the recent emphasis on 'multimodal literacies' (Kress 1997). In the field of art education there is a growing recognition of the socially-situated context of learning, identity and knowledge construction, drawing on the legacy of Lev Vygotsky, social constructivism and discourse theory (e.g. 'communities of practice', see Lave and Wenger 1991, Wenger 1998). Two publications stand out in the art education field that help to define the current paradigm – what we might call, for want of a better name, 'postmodern art education'. These are, Postmodern Art Education: An Approach to Curriculum (Efland et al. 1996) and 'Directions' (iJADE 1999).

Hallam, Lee and Gupta offer a particularly useful 'Foucauldian' approach to the analysis of educational movements or documentation, through close attention to the associated 'discourse', the surrounding writings, artefacts, ideas, characteristic arguments, rationales, approaches, pedagogy, power relations and practices of particular movements. They show how, once these have been identified, it is possible to deconstruct the strands of differing influences, the 'archaeology' of ideas, that inform a document like the English National Curriculum. This could be an approach the reader may bring to many of the chapters in this collection, containing as

they do both a flavour of the dominant ideas and pedagogical approaches of their time as well as potentially important messages relevant to today.

Curriculum change

The International Journal of Art and Design Education has often published papers which advocate, question or chronicle curriculum change and which respond to the competing influence of changing pedagogy and official curriculum initiatives. Margaret Payne (Chapter 6) explores the principles of Friedrich Froebel, who established the foundations of the modern early years curriculum, and from whom comes the term 'kindergarten'. Writing in 1993, the year after the introduction of the English National Curriculum, Payne explores the possibilities of developing a project which reflects Froebelian philosophy while interpreting the requirements of the new programmes of study. Moving on to a later period in the UK, in a scenario familiar from an international perspective, further curriculum change was brought about by a pendulum swing back to a utilitarian focus on Literacy and Numeracy from a more liberal concept of a broad and balanced curriculum that included a shared focus on a rich range of subjects. This moment is explored in Steve Herne's (2000) paper (Chapter 7), chronicling both the achievements of curriculum development in the preceding years and some of the damaging effects of the consequent change in emphasis. Perhaps more optimistically, in Chapter 16, Mary Fawcett and Penny Hay document a carefully crafted curriculum development project, inspired by the approach to education and the creative arts in early years settings in Reggio Emilia, Northern Italy. The approach in Reggio continues to have international impact for curriculum change through international conferences, touring exhibitions, invitations to visit schools in the area and has become an iconic paradigm for the potential of art and design to permeate and enrich children's learning and experience across the whole curriculum.

Drawing

There are several chapters in this collection that focus specifically on children's drawing, and others that make reference to it. Children's early mark making is of particular significance to art educators in the primary phase. It signals the beginnings of the child's representational activity in one of its many forms. In giving meaning to marks made with any medium on any surface, the child begins to engage with the representational potential of the visual and the tactile. Several authors in this collection treat the relationship between children's early drawing and the field of human endeavour that we call 'art and design' as problematic. Shelia Paine (Chapter 8), Dennis Atkinson (Chapter 9), Angela Anning (Chapter 11) and Sue Cox (Chapter 12) analyse children's mark making in ways that disrupt some long-held assumptions about drawing as an activity. These arise from predominant, culturally specific, conceptions within art and design. Each of these authors see children's mark making in terms of children's wider concerns. In particular, this brings into question some conventional ideas about drawing, derived from the perspectival tradition, that have had a very strong influence on the interpretation of young children's drawing activity. These authors challenge the narrow conception that drawing is 'a means of depicting objects in the world, prioritising what is presented to the eye of the viewer situated in a fixed position at a particular moment in time.' (Cox, S. p. 186) As Atkinson suggests, 'The notion of depicting the world from a fixed viewpoint, assumed by linear perspective, is an abstract idea which imposes

a severe reduction upon experiential orientations to our world, despite its usefulness in certain circumstances.' (Atkinson p. 145). In locating drawing in the alternative context of children's own concerns and intentions as they begin to make sense of the world, all four authors provide a critical perspective, in different ways, on established theories of drawing, learning, and learning to draw.

Both Sue Cox and Dennis Atkinson explore the challenges to those theories that characterize children's drawing development in a series of stages. These stage theories are shaped by the assumption that visual representation is synonymous with perspectival representation or an unproblematized notion of 'visual realism', and that 'development' can be neutrally described as the path towards this end point. In looking at drawing from the point of view of the child – as a process that the child undertakes for his or her own purposes – both authors draw on the influential work of John Matthews (1984, 1986, 1988, 1999, 2003). Dennis Atkinson explores the early eclectic use of drawing and the inhibiting effect of the traditional paradigm on this functional variety. Sue Cox similarly analyses the range of representational purposes in children's drawings and goes on to illustrate their recognition of both the power of drawing and their own power to control it. In the context of the interactive and communicative practices through which children's thinking develops, she argues that it plays a crucial role, amongst other modes of representation, for children in their making of meaning. Drawing, for children, is an intentional and constructive process: thinking in action in a socio-cultural context. There are implications for teachers and educators in both these authors' accounts. Atkinson discusses the significance of his argument for assessment – the traditional view that 'assumes a hierarchical progression from simple to more complex stages' becomes inadequate in the face of the variety of functional significance that drawing can have for the child. He argues for sensitivity to the uses to which children put their drawings. Cox's account implies that teachers' responses need to take account of children's purposes and intentions in the context of 'multi-modal' (Kress 1997) communicative practices, rather than attending to drawings as end products.

Angela Anning focuses more directly on the role of teachers, looking at the influence of 'more experienced others' (including significant adults) in the drawing process. She, similarly, sees drawing as a mode of meaning-making that takes place in specific socio-cultural contexts, and explores the 'communities of practice' (Lave and Wenger 1991) in which children draw. She focuses specifically on the contexts of home and school, discussing a longitudinal research project that investigated young children's emergent drawing in these settings. In adopting a theoretical perspective, she acknowledges that children's drawing practices are shaped by interactions with others. Anning shows how these were distinctive in the two settings and how the children tried to make sense of the continuities and discontinuities between the contrasting cultures of home and school. She also demonstrates how teacher interactions and interventions reflected a restricted and restrictive agenda, with children having 'increasingly limited opportunities to choose the content and style of drawing', (Anning, p. 182) whilst, at home, they were 'persisting with trying to make sense of the world and their place within it through self-initiated drawings' (op.cit. p. 181). The discussion resonates with Dennis Atkinson's and Sue Cox's concerns that conventional views of drawing can have a narrowing effect.

Maureen Cox, Grant Cooke and Deirdre Griffin (Chapter 10) start from a position that is echoed by Anning – that drawing activity has a low status in school settings and suffers from lack of appropriate adult intervention. They are critical of notions of art as self-expression that result in children being given no support beyond the provision of materials and some sort of stimulus. In this, their position is in some ways similar to that of the other authors in that they too look much further than 'self-expression' in exploring the significance of children's drawing and the implications for the practice of educators. Similarly, they too argue that drawing in a realistic way is not necessarily '"the correct way" to draw or indeed the only way to draw.' (Cox, Cooke and Griffin p. 154) On the basis, however, that it is one way to draw, and, arguably, enables practising artists to explore alternatives, they argue for tuition in this kind of drawing. In this respect, perhaps in contrast to the other authors, they are engaging more directly with drawing within the traditions and conventions of 'art and design'. They discuss a teaching approach that models the process of drawing, in which the way a drawing is approached is 'negotiated' between the child and the teacher and shows the improvements made in the children's ability to depict objects in a life-like way.

Critical Studies
'Critical Studies' is shorthand for the approach to the Art and Design curriculum which balances the practical, expressive and meaning making art production of learners with a complementary study of art history, art criticism and aesthetics (Dobbs 1992) or as others have put it, art appreciation (Robinson 1989). This means that children are engaged in looking at, and responding to, art, design, craft or, more generally, visual culture, alongside their practical creative activity. In the early stages of the introduction of this approach in England, Wales and elsewhere, a number of issues were thrown up, such as access to the real artefacts as opposed to reproductions; issues of integration of critical study into the productive creative process; and issues of choice, cultural perspective and power and the agency of the learner in relation to interpretation.

Anthony Dyson's chapter (Chapter 13) challenges head on the child-centred notion that children need freedom from adult influence and proposes 'copying', including replicating, emulating, reproducing, interpreting, as a most fruitful form of note taking. He goes on to explore the qualities of originals and reproductions, chronology, comparative study and the 'gallery visit'. Norman Freeman (Chapter 14) explores art learning from a developmental perspective and theorizes the pictorial reasoning of children and their concerns about truth and fact, artefact, beauty and significance. In a contemporary postscript, he identifies the further work that has been done in this field and includes signposts to further reading.

Tara Page and colleagues (Chapter 15) document a cross-phase research project that explored teachers' use of, and children's learning through, contemporary art practices. Representing a triangular relationship between school, gallery and researchers, these authors introduce the theme of museum and gallery education to this collection, alongside the notion of the teacher as an active curriculum developer and researcher. The project responded to the findings of earlier research in the UK (Downing and Watson 2004) that the range of artists and types of

work studied in schools is limited in terms of chronology, cultural context, ethnicity and gender, focusing mainly on early twentieth century Western painting and sculpture, and proposed new understandings of the learner, the teacher, process and product. If access to real artefacts is important, then alongside museum and gallery education, the notion of Artists in Schools (Sharp and Dust 1997) is also gaining ground. Fawcett and Hay's chapter (Chapter 16) represents this theme in the collection through their presentation of the principle and practice employed in Reggio Emilia of employing an artist-in-residence (*Atelierista*) in every preschool.

Children's voices

Children's voices provide a valuable source of data for several of the chapters included in this collection. The tendency for children to express themselves directly enables several of the authors to inject into their texts a freshness of language that can sometimes become lost beneath the surface of academic writing. 'I don't think it's a good idea to be told what to do,' says Kirsty, one of sixteen 10-year-olds surveyed by Gillian Robinson in Chapter 17, 'because when I start to draw I have a faint idea of what I'm drawing but then I just start building it up.' (Robinson, p. 256) Children's refusal to filter or moderate their responses for a specific audience means that their observations often carry a clear conviction. They also offer adults opportunities to reconnect with a state of mind that is increasingly elusive to grasp as we grow older, one in which, as another of Robinson's interviewees highlights, we focus without distraction on our own thoughts and ideas: 'being left alone and then closing my eyes and picturing something in my mind and then drawing it.' (op. cit, p. 256) Robinson's chapter explores the relevance of Roger Fry's theories on the value of modern art, children's art and on approaches to teaching art. 'In my mind's eye', observes one child, 'I think my art is good, even though other people don't think so' – a comment, suggests Robinson, that 'could appropriately have been made by Fry as he watched people's reactions to his first Post-Impressionist exhibition' (op. cit, p. 257).

There are other instances in which the juxtaposition of children's voices with those of art educators provides a glimpse of continuity and of shared ideals. Robert Watts carried out an initial small-scale survey of children's attitudes to making art while he was still teaching in a primary school, before expanding the research project with the help of a number of trainee teachers. The central feature of the resulting chapter (Chapter 20) is the analysis of the breadth of the range of children's responses to questions of why children and adults make art, providing evidence 'that young children are able to think reflectively about the value of art...and that teachers should have high expectations of their pupils' capacity for generating and sharing challenging concepts' (Watts, p. 298). Watts concludes with two quotations. The first is from Elliot Eisner: 'The arts celebrate multiple conceptions of virtue. They teach that there are many ways to see and interpret the world and that people can look through more than one window' – (op. cit, p. 297), while the second is from 7-year-old Immanuela: 'Art sometimes shows things from another way' (op.cit, p. 298). Immanuela may not be familiar with Eisner's work (Eisner 1972) but, should they ever meet, it's clear that they will share some common theoretical ground.

In the late 1990s, artist Rob Fairley took up temporary residence in Room 13, a classroom in Caol Primary School in Fort William, Scotland. As the residency came to an end, pupils

wanted to know what they could do to encourage Mr. Fairley to stay. 'Pay me' was the reply, and the result was one of the most innovative primary art education projects of recent years. Pupils were permitted to abandon lessons in other subjects in order to work in Room 13, run along similar lines to a Fine Art course or artists' studios. Funding followed, and the project has since been extended across other primary schools in Scotland and beyond. 'Our approach is rooted in some very traditional ideas', explain the pupils on their website, '[t]he outcomes are simply a result of adult and younger artists working together in an environment of mutual respect, open communication and creative equality' (Room 13 2008). The project offers a unique and distinctive outlet for children's voices to contribute to debates around the philosophies of art education. An interview with pupils from Caol Primary School forms the final chapter (Chapter 21) of this book.

Finally, children's voices also emerge from this book through the range of illustrations included alongside the published papers. The International Journal of Art and Design Education has recently introduced colour images to its pages, with John Matthews and Peter Seow's investigation into children's use of ICT in art and design (Chapter 19) being one of several recent papers that have benefitted from this development. While the quality of some of the images that illustrate earlier papers in the collection may be a little inconsistent, this serves as a reminder of how new technologies have recently offered opportunities to develop a more thorough and representative record of children's artworks. These images present us with a vivid glimpse of art in primary schools, prompting us to reflect not only upon the practice of colleagues over the past 25 years but also on what further creative lines of enquiry those children went on to pursue.

Conclusion
The articles gathered for this collection will not only provide readers with an overview of issues and debates in primary art education over the past 25 years but also raise questions concerning how these issues will continue to be addressed in years to come. Each of the chapters raises issues for further enquiry that readers may wish to pursue. Maintaining a level of curiosity about one's practice as an artist, art educator or researcher is important, and the process of recording and sharing the results of investigations into that practice is something that the authors of the chapters in this collection have engaged with over the past 25 years. These chapters are representative of an evolving body of work that reflects the culture of primary art and design education during this time; the responsibility for maintaining and developing that culture in the future now rests with the current generation of readers, researchers and art educators.

References
Alexander, R., Rose, J., and Woodhead, C. (1992) *Curriculum Organisation and Classroom Practice in Primary Schools: A Discussion Paper,* London: DES.

Arts Council England (2008) http://www.artscouncil.org.uk/aboutus/project_detail.php?sid=9&id=284 accessed 08.11.08.

Barnes, R. (1989) 'Current Issues in Art and Design Education', *International Journal of Art and Design Education* Vol 8: 3.

CACE (1967) *Children and their primary schools: a report of the Central Advisory Council for Education* (England), London: HMSO.

DES (1992) *Art in the National Curriculum* (England), London: DES/HMSO.

Dobbs, S. (1992) *The DBAE Handbook: An Overview of Discipline-Based Art Education*, Santa Monica: The J. Paul Getty Trust.

Downing, D. and Watson, R. (2004) *School Art: What's in it? Exploring Visual Arts in Secondary Schools*, London: National Foundation for Educational Research/Arts Council for England/Tate.

Efland, A., Freedman, K. and Stuhr, P. (1996) *Postmodern Art Education: an Approach to Curriculum*, Reston, Virginia: NAEA.

Figg, G. (1989). 'Towards a Curriculum Model for Primary Art', in A. Dyson, (ed.) *Looking, Making and Learning: Art and Design in the Primary School*, Bedford Way Papers 36, Institute of Education. University of London.

Eisner, E. (1972) *Educating Artistic Vision*. New York: Macmillan.

Goleman, D. (1995) *Emotional Intelligence: Why It Can Matter More Than IQ*, New York: Bantam Books.

IJADE (1999) 'Directions', *International Journal of Art and Design Education*. Volume 18.1.

Kress, G. (1997) *Before Writing: Rethinking the Paths to Literacy*, London: Routledge.

Lave, J. and Wenger, E. (1991) *Situated Learning*, Cambridge: Cambridge University Press.

Macdonald, S. ([1970]2004) *The History and Philosophy of Art Education*, Cambridge: Lutterworth Press.

Matthews, J. (1984) 'Children Drawing: Are young children really scribbling?' *Early Childhood Development and Care* 18, pp. 1–39.

Matthews, J. (1986) 'Children's Early Representation: the construction of meaning' *Inscape* 2, pp. 12–17.

Matthews, J. (1988) 'The Young Child's Early Representation and Drawing', in G.M. Blenkin, and A.V. Kelly (eds.) *Early Childhood Education: A Developmental Curriculum*, London: Paul Chapman, pp. 163–83.

Matthews, J. (1999) *The Art of Childhood and Adolescence: the construction of meaning*, London, Philadelphia: Falmer Press.

Matthews, J. (2003) *Drawing and Painting – children and visual Representation*, London: Paul Chapman.

NSEAD (2008) http://www.nsead.org/cpd/ats.aspx accessed 08.11.08.

Read, H. (1943) *Education Through Art*, New York: Macmillan.

Robinson, K. (1989) *The Arts in Schools: Principles, Practice and Provision*, London: Calouste Gulbenkian Foundation.

Room 13 (2008) http://www.room13scotland.com/about.html accessed 05.12.08.

Rose, J. (2009) *The Independent Review of the Primary Curriculum: Final report*. London, DfCSF http://publications.teachernet.gov.uk, accessed 28.06.2009.

Sausmarez ([1964]2007) *Basic design: the dynamics of visual form*, London: Studio Vista.

Sharp, C. and Dust, K. (1997) *Artists in Schools: a Handbook for Teachers and Artists*, Slough: NFER.

Simpson, A. (1984) '"But the Emperor has no clothes on": Witkin's theories and a research based upon them,' *International Journal of Art and Design Education* Vol 3.1 pp. 59–70.

Taylor, R. (1986) *Educating for Art*, London: Longman.

Taylor, R. (1991) *The Visual Arts in Education*, London: Falmer Press.

Vygotsky, L. (1986) *Thought and Language*, Cambridge, MA: MIT Press.

Wenger, E. (1998) *Communities of Practice: Learning, Meaning and Identity*, Cambridge: Cambridge University Press.

1

Art in the Primary School: Towards First Principles

Geoffrey W. Southworth

Vol 1, No 2, 1982

Art in the curriculum

The English primary school curriculum is made up of a variety of subjects and activities. The range of the curriculum is diverse, but not all the subjects are equal since the tradition of the three Rs creates an elite core of the so-called 'basic subjects' – reading, writing and number. One can appreciate the reasons for emphasizing these skills but one has less enthusiasm for the damage which this hierarchy tends to inflict on the other activities. Maths and English, generally speaking, have become the titans of the primary curriculum, towering over all other subjects. Moreover, they dominate the attitudes and assumptions of primary curriculum development.

Art is usually one of the activities associated with primary schooling. In one sense it is true to say that it is no longer necessary to fight for art's inclusion in the curriculum. In another sense, though, this is not true. Because of the pre-eminence of maths and basic language skills, art, along with certain other subjects, has tended to suffer. For one thing it is the misfortune of primary art to be considered as simply a decorative frill to the other so-called more important areas of the curriculum. Art is regarded as an occupation which interests children, keeps them busy and is sometimes mildly therapeutic. However, compared to the main purpose of primary schooling, which is the transmission of basic skills, art is 'non serious'. Art, it is thought, has nothing whatsoever to do with mathematical and linguistic understanding. Indeed, art is often considered to have only one main function, namely, to provide opportunities for children to express themselves. Thus, once art is pigeonholed as 'expression' it becomes typical of such compartmentalizing to regard art as having no intellectual function at all. Art may be 'in' the

curriculum but primary art is not given much respect when placed alongside certain 'more important' activities. Art is under-emphasized and it is under-estimated.

The 1978 HMI primary survey said that the general progress of children and their competence in the basic skills appear to benefit where they are involved in a programme of activities that include art, crafts, music, P.E., science, history and geography as well as language, mathematics and religious and moral education (DES 1978: 114, para. 8.29). Insofar as art is concerned we still have to demonstrate the validity of this claim. Primary art specialists need to challenge the attitudes of many of our colleagues in order to reverse the prevailing prejudices which result in art's low standing and diminish and restrict its purpose. Those concerned about primary art need to become more active and convince more teachers of art's real contribution to the child's development. To do this we need to have a fairly clear conception as to the nature of the activity we call art. Only then can we begin to justify the role and scope of art education.

Art's contribution to the child's development

In attempting to identify the nature of the activity we call art it is necessary to ask: what is art's unique contribution to the education of children? Eisner's response is to say that:

> The prime value of the arts in education lies in the unique contributions it makes to the individual's experience with and understanding of the world. The visual arts deal with an aspect of human consciousness that no other field touches on; the aesthetic contemplation of visual form. (Eisner 1972: 9)

Eisner demonstrates that the fundamental nature of the activity is concerned with visual form and this is widely accepted by the common use of art's alternative title, namely visual education. However, Eisner's statement also suggests certain other aspects of art education. For one thing it is noted that art involves the individual's experience with the world. Art education is implicitly concerned with individuals and a regard for individuality. Another thing which is embodied in Eisner's thinking is the notion that the visual arts deal with an aspect of human consciousness. This suggests that consciousness is comprised of a number of aspects that consciousness is not singular or monolithic but, rather, that it is broad and made up of a variety of areas of awareness. Such a view is supported by Hirst's idea of forms of knowledge (Hirst 1974).

It is therefore possible to say that Eisner raises three areas of attention: (1) the visual aspect of art education; (2) individuality; (3) human consciousness. Each makes significant contributions to the nature and role of art education and each needs to be examined.

The visual aspect

As human beings we have a variety of symbol systems at our disposal and in some way or another each of these systems is a mode of understanding. Art is primarily a visual mode, although this is not to deny that there are tactile elements as well. As a visual mode, art can be thought of as a visual 'language' and in order that children can come to know this visual language, they need to know the syntax of it. They need to know the syntax of line, colour,

shape, space, texture, and so on. This is achieved through looking, which is part of the process of seeing. Teachers need to teach children to see. As teachers our task is similar to that identified by the novelist Joseph Conrad, who once said that through his writing he was hoping to make the reader hear and to feel and, before all else, to see. That and nothing else was his task and, as he so pertinently added, it was everything (Conrad *The Nigger and the Narcissus* [1897] 1989: 13). The only difference for art educators is to achieve seeing and feeling through the spoken word and via the power of the visual image rather than the written word. It is in this sense that we are all visual educators.

Children need to be taught to observe and investigate the visual world and record and express their 'findings' in visual terms. This is why drawing is so important. Drawing is the process that leads the eyes to see, since for the artist drawing is discovery. It is a platitude in the teaching of drawing that the heart of the matter lies in the specific process of looking. A line is not only important because it records what you have seen but because of what it will lead you on to see (Berger 1960: 23). As the painter Bridget Riley has said, we work from what we know towards what we do not know.

Yet to speak about teaching children to look fails to convey the dynamics of the process. Looking can and should, at various times, involve interest, curiosity, awe, wonder, analysis, discussion, recording, sharing, tactile experience, expression and so on. These are but a few of the many words appropriate to looking and seeing. As such, these words suggest that looking and seeing are closely connected with (i) observation, (ii) investigation, (iii) communication; three activities which surely are the cornerstones of education. That in itself ought to be sufficient justification for art education. Through the process of seeing and the learning of a visual language, art makes significant contributions to the child's ability to observe, investigate and communicate. However, there are certain other issues which should be highlighted.

Firstly, despite the fact that visual perception plays a significant part in the learning process, the majority of schools, usually once the children attain the age of seven, ignore visual perception and in fact most other sensory modes of learning. Children are not allowed 'to see'; they are told or shown in ways which are so neutralizing that they bear little relation to true sensory experiences. Those schools which are so lobotomized by the clamour to teach 'the basics' are guilty of forgetting the self evident truth that 'seeing comes before words, the baby looks before it speaks' (Berger 1972; 7). Seeing is not a frill, it is not peripheral, it is CENTRAL. To ignore the visual world and the language of vision is to disregard an important area of knowledge.

It is, of course, quite true that seeing in this sense is not the sole preserve of art education. Certain other subjects draw upon the world as a resource – notably the natural sciences. What art does is utilize the visual world and the senses, particularly, visual perception, for the education of artistic vision and this is the second issue. In teaching the language of vision it is our specific task to provide the child with a vision of art. We are not just dealing with perception; we are trying to teach visual aesthetic perception. Art education should try to keep the way open for the child to develop his own powers of representing reality but at the same time teach him the

Figures 1 and 2: Visual analysis: drawings in 4B pencil by fourth-year Juniors.

Figures 3 and 4: Visual analysis: drawings in pen and ink by fourth-year Juniors.

language well enough to be able to communicate intelligently and imaginatively with it. We should aim to teach visual art as a quality of response to visual ideas and this involves the development of visual intelligence and imagination. Our first aim should be to teach the child to look, which is to observe; to see which is to understand; and to make, which is to transform (Landor 1973).

The visual arts deal with an aspect of human life that no other area does: the aesthetic contemplation of visual form. This must be the central point for art education and, in order to teach children about this aspect of life, art education must initiate children into what it feels like to move over and about in a painting; to travel around and in between the masses of a sculpture; what it is like and what it means to produce a set of drawings, or a collage, or a piece of pottery, or an embroidered motif. Aesthetic insight, feeling from the inside what art really is, must be the central starting and expanding point for everything else (Reid 1969: 302).

A third issue to be emphasized from this consideration of the visual component is that the inclusion of visual perception provides a set of credentials which legitimate art as an intellectual activity. There are enough philosophical treatises on the place of perception and its relationship to knowledge to support this view. Equally, the psychology of perception provides further evidence to bolster this claim.[1] In the long term, aesthetic perception challenges us to set aside our preferences. Attitudes and prejudices need to be set aside or suspended in order to appreciate a painting. Such attitudinal suspension is far from being easy; it is difficult and it involves thought and reason. Aesthetic vision is an active concern of the mind. Art, either as making or as appreciation, IS an intellectual activity in its own special way.

Individuality and identity

Earlier it was said that art education is concerned with individuals and a regard for individuality. As Gombrich has said; 'there really is no such thing as art. There are only artists' (Gombrich 1978: 4). Put into an educational context, this statement means that art should ensure opportunities for the child to be himself whilst learning about others and other things. If the child is not being himself then what he is doing may not be art, since the essence of the artist is his uniqueness and

Figure 5: Third-year Juniors modelling.

Figure 6: Plasticine heads by third-year Juniors.

no two children are alike (DES 1959: 221). Art should attempt to embrace the individual's contribution since that is the special feature of all expressive work whereby the teacher is presented, from time to time, with work which the pupil has produced and which the teacher recognizes that he himself could neither have visualised nor executed (Cross 1976: 36).

Individuality is focused upon for three reasons. First, because individuality is intrinsic to the artistic process. The above remarks go some way to illustrating this. Second, because individuality needs to be clarified because in practice, some schools appear to misunderstand the concept. Schools interpret individuality as to do with development and maturation; that is, schools make allowance only for individual RATES of progress. Reading schemes, maths schemes such as SMP and materials such as SRA are materialistic expressions of this emphasis. However, individuality is not just concerned with rate, it is to do with IDENTITY, with each person's personality traits and qualities, with experiential understanding, social realities, forms of expression, and so on. Or, stated another way, visual art (along with the other arts) helps to foster a sense of one's own identity and the identities of others. This introduces the third reason: art is personal. Individuality logically involves personal expression.

Figure 7: Observation and investigation: fourth-year girl drawing insects and spiders.

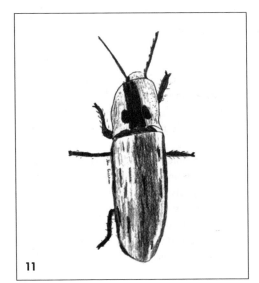

Figures 8–11: Observation and investigation: drawings of insects in 4B pencil by second-year Juniors.

Some years ago, I asked a group of 7-year-olds to paint pictures of themselves playing out. They painted themselves skipping, playing tag, football, rounders, playing on swings or climbing trees. One small boy, called Alex, painted a large detached house with a red door. By the side of the house was a silhouetted figure, intended to be Alex, also painted in red. When I asked what the game was, Alex replied, 'Knock-a-door, run!' He then went on to describe how he

crept up to the front doors of local houses, rang the doorbell and ran away to hide and watch the irate householder answer the door to find no one there. Alex spoke with an energy and a vitality which the painting not only captured but symbolized. Indeed, the picture remains with me for many reasons. It is an embodiment of why children create and what they learn from the activity. It also encompasses how individuality locates within this learning process.

It is possible to discern nine points which children learn when they paint.[2] Alex did not learn all these nine points from his one painting, yet, clearly, Alex's painting contains vestiges of nearly all these learning elements. Undoubtedly, Alex came closer to knowing, if he did not know already, that the images he created functioned as symbols. Later, partly through Alex's verbal description of his images as well as through the picture itself, it was possible to detect how Alex's symbolic understanding is derived from two aspects of artistic knowledge.

Firstly, since the symbols represent an idea or range of ideas the child comes to realize that visual concepts can be transformed into a public form. In one sense this is evidence of the idea that art is a visual language and, as a mode of language, the primary function is communication. In other words, through making images and using symbols, children learn the power of art as a form of communication. The activity of art allows children access to another language and increases the child's scope to communicate. However, this rather obvious and simple notion implies a more sophisticated conception of what is actually going on when children engage in the artistic process. When children make images and symbols, these symbols do not suddenly appear on paper. The marks on paper are the final products of a process whereby the symbols are first conceptually formed before they are ever made public. The symbols articulate thought and only then are the thoughts symbolically communicated (Eisner 1978). This is another demonstration of the cognitive content of art. It also suggests that because art is a communication system it involves personal and public elements.

This leads onto the second aspect. The picture Alex created was full of Alex and his identity. The images and symbols which children create and use are in a crude sense 'bridges'. They are constructs spanning the private and public realms of each individual's life. Individuals need to know about the objective, public world and art helps them to understand the visual world, and the visual aesthetic world in particular. At the same time, though, we need to keep in mind the truth that the child also needs to know about his own world of private space. The child needs to be able to manage the feelings wrought within him by his encounters with the public world. The child, like us all, needs to learn to adapt but, 'if the price of finding oneself in the world is that of losing the world in oneself, then the price is more than anyone can afford' (Witkin 1974: 1).

These two aspects of artistic knowledge begin to depict how artistic action allows the individual to be himself in art's special way. It is difficult to describe because individuality is intrinsic to the artistic process and thus once one begins to focus on one particular feature, you leave behind so many other features which impinge upon and add meaning to whichever one is in view. Alex's painting can be likened to autobiography since his reliving of the game,

'Knock-a-door, run!' provided insights, sensations, feelings and imaginings about himself and the game and in ways so closely bound to the thread of rational, intelligent thought that all became inextricably intertwined so that it is not always possible to separate feeling from intelligence.[3]

Art is a process of learning which does not utilize public forms of knowledge and experience to the detriment of private understanding and meaning, Art is a process of learning which builds on both of these since both are resources. The individual's subjective sensations are properly included in the nature of the activity we call art. Art is an activity which challenges the individual to be his or her self. It is an activity during which feelings and ideas become forms of consciousness which can be transformed into images that can then communicate to others, as well as help the individual child understand visual art. At the same time this transformation of consciousness into images can provide the child with specific, highly personalized opportunities to utilize and come to terms with his or her inner world and the objective world and all the myriad ways in which the two are connected.

Art can make unique contributions to the individual's experience with and understanding of the world. It did for Alex, it should for all children.

Consciousness: knowledge and understanding

The main concern here is how art as a form of consciousness has as much a part to play in education as other subjects. Perhaps the first point to make concerning visual art's role in the curriculum is one of balance. Although I am convinced of the need for art in schools, I am not asking for primary or secondary schools to become miniature art schools, nor am I suggesting that teachers attempt to produce artists. What I am appealing for is a balanced educational diet. A diet which provides the child with opportunities to develop rather more of his faculties and senses than some contemporary curricular schemes appear to achieve. My claim is that art is under-emphasized.

The Schools Council cites Hirst's forms of knowledge to suggest a similar kind of balance and scope as I am appealing for (Schools Council 1981: 19). Hirst originally had doubts as to the validity of the arts as a form of knowledge although, subsequently, he has acknowledged that the arts should be admitted along with the other forms. If we are to adopt Hirst's view of knowledge as a means of legitimating what should constitute education, as the Schools Council clearly do, then it seems somewhat blinkered to quote Hirst in support of one's favourite area of knowledge only, thereafter, to ignore all the other forms. Such a narrow focus is contrary to Hirst's original intention. Hirst sought to argue the case for a liberal education which he saw as 'being determined in scope and content by knowledge itself' and is 'thereby concerned with the development of mind' (Hirst 1974: 41). It is precisely this development of mind and consciousness which is of concern here. Given that there is an identifiable set of forms of knowledge which constitute what it is to be educated and which foster the development of mind, it follows that it is the task of teachers to initiate children into ALL of the constituent forms. We cannot afford to emphasize some and reduce others.

This is true for two reasons. Firstly, each form of knowledge has unique qualities and capabilities. To exclude children from knowing and understanding these attributes is to deny them access to whole areas of learning. This is well known and is a popular battle cry. Secondly, to omit any one form of knowledge is to reduce the range of understanding of other, if not all other, forms of knowledge. The forms of knowledge are not discrete, rather there is a symbiotic relationship between them all. The world we live in is a multi-dimensional reality and we can only come to know that world if we are aware of all the various ways of comprehending reality. These ways of comprehending reality are the forms of knowledge. We need a curriculum which does justice to the scope of children's minds (Eisner 1980) and to all the various means of interpreting and understanding the world.

Of course, in using Hirst's conception of knowledge we must be careful not to confuse his forms of knowledge with school subjects. School subjects are SELECTIONS from the forms of knowledge. However, it seems to me that if Hirst's way of ensuring a liberal education is to provide an education which embodies all the forms of knowledge, then there ought to be a corresponding effort to ensure that the school subjects that are selected reflect a similar scope of knowledge.

Surely we need to put away redundant notions of the 'basics' and the three Rs. We should also try to discard the false dichotomy between 'practical' and 'academic' subjects. The child's mind is of a piece; it is an integrated unit which needs to utilize all the aspects of knowledge and consciousness that it can. As Bronowski said;

> Man is distinguished from other animals by his imaginative gifts. He makes plans, inventions, new discoveries, by putting different talents together; and his discoveries become more subtle and penetrating as he learns to combine his talents in more complex and intimate ways. So the great discoveries of different ages and different cultures in technique, in science, in the arts, express in their progression a richer and more intricate conjunction of human faculties, an ascending trellis of his gifts. (Bronowski 1973: 20)

Schools are concerned with the ascent of children. As Bronowski's statement so eloquently demonstrates, this ascent requires the intricate conjunction of human faculties. Therefore we need to provide a balanced diet which allows the child access to the range and scope of each and all faculties. To under-emphasize the visual arts, or worse to exclude them, is to limit the altitude to which children can ascend.

Conclusions

This chapter has been selective in its coverage. There is much more to consider and that which I have said itself requires further consideration. It has been my intention to outline some of the key areas.

If art is under-estimated we need to make a stand in order to prevent any further deterioration in art's role in the curriculum. In an industrialized society which demands specific skills, and at a time when high technologies require ever more narrow specialisms in science and maths, it is easy to

see why art is being nudged aside. Conrad once wrote, art's 'appeal is less loud, more profound, less distinct, more stirring – and sooner forgotten. Yet its effect endures forever. The artist speaks to our capacity for delight and wonder, to the sense of mystery surrounding our lives; to our sense of pity and beauty and pain. All art appeals primarily to the senses' (Conrad [1897] 1989). The silicon chip cannot replace our senses. In the rush to provide citizens for the twenty-first century let us not ignore the lessons learned in all previous centuries. Man learns via his senses and *art,* which has been practised throughout all these centuries; articulates the senses.

Art is, with music, drama and literature, a form of knowledge. As such it has a role to play in developing consciousness. If we overlook art's contribution in order to provide greater accommodation for the 'more important subjects' we begin to restrict consciousness and sensibility. I always thought that education was intended to increase, not restrict, knowledge. Let those who share this belief resist the present downward trend in the quality and purpose of education in the visual arts; but let them also attempt to demonstrate the validity of art's role by seeking to operationalize the first principles which have been suggested.

It seems to me that in the primary sector we need to have clearer ideas about visual art's purpose; we need to consider the visual aesthetic function of art, the nature of individuality and to seek a truer balance amongst subjects.

Notes

1. See Vernon, M.D. (1962) *The Psychology of Perception.* London: Penguin; whilst the work of Liam Hudson and R. L. Gregory provides other useful allies to the notion that perception is such a close attribute of intelligence that the two are frequently indistinguishable in the developing child.
2. These nine are:

 1. Children learn that they can create images from material and that this activity is satisfying the making of judgements.
 2. They learn that the images they create can function as symbols.
 3. They learn that image making develops skills.
 4. Children learn that the image-making process requires the making of judgements.
 5. Children learn to relate images to one another to form a whole.
 6. They develop skills which make it possible to create illusion and to form visually persuasive images.
 7. Children learn that ideas and emotions that are not physically present can be symbolized by the images they create.
 8. Children can also go on to learn that when making visual images there are ideas and feelings that can ONLY be expressed through visual form.
 9. Children learn that when they paint the world itself can be regarded as a source of aesthetic experience.

 from Eisner, E .W. (1978) 'What Do Children Learn When They Paint?', in *Art Education.* Vol. 31, pp. 6-10.
3. Abbs, P. (1981) 'It's autobiography…but is it a legitimate form of study?', in *The Times Higher Educational Supplement.* 13/11/81, pp. 10-11.

References

Berger, J. (1960) *Permanent Red,* London: Writers and Readers.

Berger, J. (1972) *Ways of Seeing,* London: Penguin.

Bronowski, J. (1973) *The Ascent of Man,* London: BBC.

Conrad, J. ([1897]1989) *The Nigger of the Narcissus,* London: Penguin.

Cross, J. (1976) 'Design Issues; Part Two, Art Education', *Open University Course E203, Units 14–15,* Bletchley: Open University Press.

DES, (1959) *Primary Education.* London: HMSO.

DES, (1978) *Primary Education in England, A Survey by H.M. Inspectors of Schools.* London: HMSO.

Eisner, E. W. (1972) *Educating Artistic Vision,* London: Collier-Macmillan.

Eisner, E .W. (1978) 'What Do Children Learn When They Paint?' *Art Education.* Vol. 31, pp. 6–10.

Eisner, E. W. (1980) 'The Impoverished Mind', *Curriculum.* Vol. 1, No. 2, pp. 11–17.

Gombrich, E. (1978) *The Story of Art,* London: Phaidon.

Hirst, P. (1974) *Knowledge and the Curriculum.* London: RKP.

Landor, R. (1973) 'The Language of Vision and the Vision of Art', *Art Education.* Vol. 26, No. 7 pp. 14–17.

Reid, L.A. (1969) *Meaning In the Arts.* London: Allen and Unwin.

Schools Council (1981) 'The Practical Curriculum', *Schools Council Working Paper 70,* London: Methuen.

Witkin, R. (1974) *The Intelligence of Feeling.* London: Heinemann.

2

Art and the Pre-adolescent Child – Applying Robert Witkin's Theory of Subject-Reflexive Action to the Primary School

Frank Dobson and David Jackson

Vol 1, No 2, 1982

The Plowden Report (1967) made an emphatic stand on the value of art education for primary children:

> Art is both a form of communication and a means of expression of feeling which ought to permeate the whole curriculum and the whole life of the school. A society which neglects or despises it is dangerously sick. (The Plowden Report 1967: para. 676)

Unquestionably primary schools have come a long way in terms of providing their children with a variety of experiences across the wide spectrum of the arts, and this in a context including a great many non-specialist teachers. What is in question here is the coherence and continuity of those experiences, with regard to the notion that art activity constitutes a mode of knowing. While too much imposition and interference from the teacher is undesirable and indeed unnecessary, the lack of structured guidance has meant that the arts are often witnessed as one-off affairs – with little or no growth of understanding between experiences. The child's awareness of feeling may well manifest itself in a number of cathartic or reactive expressions, but he may learn little of self and may well not be encouraged to reflect upon his own feeling-responses. The subjective, or the 'feeling life' of the child, is allowed to sail on a

random course. If the arts are not to be treated, as they so often are, as self-indulgent, mildly therapeutic hobby-type activities, then qualitative experiences need to be taken seriously. As Goodman (1976) argues, the arts are concerned with feelings not only 'too deep for tears', in Wordsworth's phrase, but too deep for words.

The structuring and organization of feeling is the concern of Robert Witkin's book *The Intelligence of Feeling* (1974). Although not fully examined in this context, Witkin proposes a structured framework around which feelings may be expressed and 'known', a developmental model parallel to Piaget's sequencing of cognitive development. The stages of development put forward provide us with a key to thinking about continuity and sequence in the child's arts experiences and offer the teacher a basis for long term planning.

Witkin's analysis of the creative act

Two concepts are presented by Witkin (1974) to form the main thrust of his conceptual framework. These are: *subjective-reflexive* action and *subject-knowing*. They are seen as complementary in so far as the former indicates the process of creative action, while the latter refers to the outcome or result of this process. To attain subject-knowing is the aim of the creative arts in education, and as seen by Witkin, it is characterized by what he calls 'knowledge of Being'. 'Being', in this context, appears to be closely related to Maslow's (1968) concept of self – the existential core of the individual. A vital part of knowing, according to Witkin, is the degree to which it involves awareness of one's Being in the world – the simultaneous knowing of one's sensing and feeling activities. At the beginning of his book Witkin emphasizes for us the distinction between the objective, real world in which we all live, and the more personal world, or phenomenal field, of the individual: 'a world that exists only because the individual exists... the world of his own sensations and feelings' (Witkin 1974: 1). The individual responds in his own particular way to objects and events in the real world and the concept 'subject-knowing' includes the organization of emotional, feeling responses which can be expressed in media in form symbolic of these responses. The creative arts are thus seen as ideal vehicles for the manifestation of Being.

Ross (1978) amplifies this theme in Chapter 3 of his book, as follows:

> We go in for subjective symboling – we make and seek images of our feeling life in order to represent our Being. To find ourselves for ourselves. To make our feelings about how we feel intelligible. (Ross 1978: 37)

And again:

> The major hypothesis of this book, following Witkin, is that *we sort out our feelings through our acts of creative self expression*. Subject-reflexive action builds mature affective schemas, builds our intelligence of feeling. (ibid: 53)

Subject-reflexive action has as its aim the production of an image – a sensuous form (painterly, poetic, dramatic, etc.). This form will have the power to evoke or recall the initial stimulus experience (and feeling responses) that gave rise to it. Ross (1978) continues: 'The image we seek through the projective act is one that will both contain and recall the "mood of the moment"' (ibid: 53).

The sensuous form embodies the initial experience, expressing the essence or structural characteristics of it. The expression of essence in symbolic form recalls the initial experience, enabling feeling responses (and knowledge of them) to come out of the shadow of non-awareness. Thus, within the process of subjective-reflexive action, the person organizes his feelings and becomes aware of them in his Being; he also becomes aware of the internal movement of feeling. Expressing feeling in symbolic form is important to the process of subject-reflexive action and to the attainment of subject-knowing. In Witkin's words, '[u]sing symbols permits one to bring about a great separation between acts of impression and acts of expression' (p. 24).

Bruner (1974) refers to the use of symbolic forms as standing 'in the place of actuality' and freeing the child's representational behaviour from dominance by the object. Symbols can thus be said to represent the subjective world and to carry or evoke feeling. Ross (1978) sums up the position most clearly:

> This sensuous form will have if it is successful, the power of evoking or recalling the sensate impulse (i.e. feeling response) [our brackets] that gave rise to it – it will be able to do so because it "embodies" that impulse. That is to say, there will be something about its sensuous structure that matches the affective structure of the impulse – it will be an outward and visible symbol of an inward, emotional state. (Ross 1978: 96)

Witkin holds (1974: 177–8) that feeling responses to sensate experience can be categorized – a proposition based on the notion that sensuous and qualitative experiences have an inherent structure or logic. That is, feelings belong in a particular gestalt or whole – a group or category in which they become crystallized. For pre-adolescent children he lists the following: contrast, harmony, discord, and semblance (ibid: 178), as 'a very tentative outline of a system for classifying sensate experience' (ibid: 180). These experiential categories are generalizations of subjective experience and, consequently, abstractions from reality, subsuming the totality of the pre-adolescent child's subjective life. They are seen by Witkin as the logic inherent in the structure of sensuous form – the logic of sensate experience itself. Feelings and emotions 'come to rest' within a category which contains the structural characteristics or 'essence' of them. The particular *gestalt* of each category is understood by its relationship or standing to another. The principle applies, for example, when we consider the concept 'cool'; it is only by placing it in relation to its counterpart 'warm' that we can be said to know it. Feelings and ideas also need to be explored in relation to their counterparts in order for there to be greater understanding of the original sensate experience and its inherent logic.

If it is a reflective process, the nature of the creative act is also an unfolding one. Starting with an initial stimulus experience, a person sets about producing a sensuous form and in doing so makes an exploratory journey in which he unfolds and discovers the centre or core meaning of the initial experience. Feeling responses are likewise discovered in relation to that experience. This journey takes a somewhat roundabout form, described by Witkin as 'successive approximations' (1974: 184) which involve the person, through the use of media, in getting closer to a centre or core. A feeling or idea is explored in form until it will satisfactorily approximate to the perceived structural characteristics of the subject in hand. Painting, printmaking, drama, poetry, and so on, are seen as devices for achieving satisfactory approximations within the process in symbolic form. Each approximation is likened to a stage, structuring the process and being structured by it. At each stage, significant aspects are explored and expressed, related to the previous stage and developed in the following one until finally the problem is resolved in a satisfactory form.

The process is one of increasingly abstracting away from the initial experience or source, until a concluding form emerges as a 'generalization' of the source – a crystallization of essence. Whether or not contrast, harmony, discord and semblance are realized in form is not debated here. What is important is the principle and structure of the process of making such generalizations. Pickard (1980) points out that any creative process demands that the person be capable of reflecting upon knowledge and the process of knowing. In this way control is kept over the process, making for awareness of it and allowing for decisions to be made in respect of its content.

In other words he must be Piaget's formal operations knower. (Pickard, 1980: 16)

Where the preadolescent is concerned, the capacity to reflect being not yet substantially developed, it is suggested in this chapter that each stage of successive approximations be used to develop this capacity. Guiding concepts are seen as the means for achieving this, as well as providing a form of control over the process. The use of container concepts allows for the flow of feelings and ideas to be crystallized at each stage, plotting or mapping the direction of the process overall. This makes more apparent the relationship between stages and highlights the transformation taking place. Each stage of the process will be developed in full, and a satisfactory form achieved if the teacher has some idea of the structural characteristics of the subject. As Witkin points out, the teacher should enter the process from its inception (1974: 169) and only in this way can the child be helped to resolve an expressive problem. The teacher, by either setting the problem, (sensate problem) or allowing the child to choose for himself, is helping him to reflect upon the process of expression, the thinking processes involved and of becoming aware of its structure as it proceeds to a resolution. The use of guiding concepts (see Figure 5) has two functions; to map or plot the development of the affective structure and to know, in conceptual terms, the transition and development of feeling into form. Successive approximations are illustrated in Figure 1.

In order to describe the process of subject-reflexive action, we need first to consider six experiences which Witkin sees as being involved in the production of a sensuous form.

First comes the ENCOUNTER: the initial or source experience from which the person starts. It might be a real event or object, imagined, or an abstract concept such as fear, contrasts,

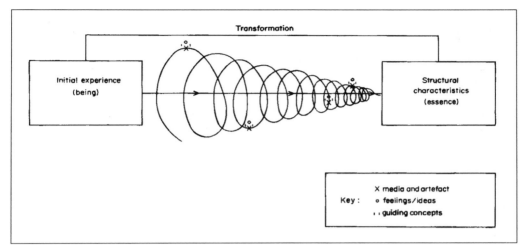

Figure 1: Successive approximations.

etc. In focusing attention on the encounter, the person begins to experience feelings about it. He begins to have ideas about its content and nature – what it involves. This formulation is described as the person's SCHEMA. Encounter and formulation of schema are experienced all the time the person is awake. Where the production of form is concerned (artefact), Witkin describes Art and the process in terms of impulse, hypothesis and medium. MEDIUM is that

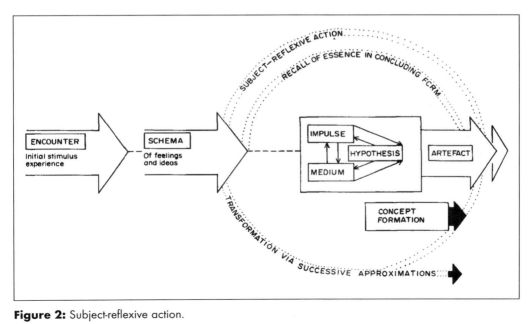

Figure 2: Subject-reflexive action.

from which an artefact is made. IMPULSE is the direction of the person's feelings towards the medium in terms of the schema. The impulses become clarified in terms of a HYPOTHESIS which focuses on the person's perceptions of the essence of the schema in relation to what has been achieved with the medium. ARTEFACT is the result of the process which recalls the encounter and schema in form symbolic of them.

As described above, the production of the artefact is a linear development from the encounter. Such a linear process is not subject-reflexive in Witkin's terms but 'subject-reactive' (emotional release or catharsis) – it is not a learning process in terms of subject-knowing. As interpreted here, subject-reflexive action involves the production of a number of artefacts through successive approximations, each one resulting in a reformulation of the schema with consequently new impulses and hypotheses and new media. The 'sensuous image' is the concluding artefact within the process. Subject-reflexive action is illustrated in Figure 2.

Subject-reflexive action and successive approximations are brought together in this illustration, showing the relationship between them. These are the actual mechanics of the person's involvement in the process of making an artefact and the continuation of the process until a satisfactory approximation is realized.

The Project: Application and investigation of Witkin's theory

The aim of the project was to provide the children with a variety of media so as to promote successive approximations and subsequently, subject-reflexive action. The researcher decided that painting was to be the main vehicle in which the encounter could be recalled, using poetry, story writing and drama as means of support and extension.

Five boys and five girls were selected from one class of second years in a Nottinghamshire school. They met the researcher on eight occasions: 75 minutes once a week for eight weeks. The children were chosen by their class teacher as representing a cross-section of ability. They had had no previous contact with the researcher. Appendix A shows test scores for the National Foundation for Educational Research (NFER) Maths and English test and the Burt Reading Age Test. None of the children were seen to have any particular talent or 'gift' in their art work, which was observed before the researcher met the group. The class teacher showed little propensity towards the arts in terms of structuring the children's experience. The majority of the art work was used as illustrative material for project and topic work. The school was chosen for this project in a random manner, i.e. no previous knowledge was available about the school. In this section the sequence of work through the eight sessions is described. A summary of the work will be found in Figure 3.

Session 1

The researcher introduced himself to the group of ten children and said he would be meeting them once a week for several weeks and that they would be doing some art work based on their own choices. He asked them to think about things that they were interested in and the things that they disliked. After some discussion the children listed on paper their likes and dislikes. They were encouraged to make extensive lists and their thinking was prompted by

questions aimed to recall a variety of experiences: 'How do you spend your weekends?' 'Where have you been on holiday?' 'What games do you play?' Such questions were then focused in terms of specific aspects, e.g. 'What things can you remember about your holiday in Skegness that you liked or disliked?' The listings were mainly of objects and events rather than abstractions. The atmosphere during the discussion was one of an interchange of ideas and not a competition to produce the longest list or to succeed in the taking of a test.

Session 2
After a discussion of the previous session's work the children were asked to organize their lists into categories or sets. The researcher asked the children to think carefully about each category in turn and to choose one as a subject for exploration during the coming weeks. Each child was gently challenged to ensure that he or she had a subject which would sustain interest. ('You don't really like dogs, do you?' 'Stamp collecting is rather boring, isn't it?')

Session 3
Each child was asked to write either a descriptive or imaginative piece about his chosen subject. They were encouraged to focus upon what they saw as the essential features of the subject and on their feelings in relation to it. In this way it was hoped that each child would recall as much as possible about their subject.

Session 4
First, each child read what had been written in the previous session; then, as a preliminary to making a painting, initial sketches were drawn as a visual interpretation of the writing and with an eye to content of the subject and composition in the forthcoming painting. This was followed by a refined sketch which was either a composite of the previous sketches or a selection of the most appropriate. While doing this, the discussion centred on close observation of 'objects' in terms of colour, colour application, content and form. The materials for these sketches were paper, pencils, crayons, felt-tip pens.

Session 5
The 'refined' sketch of the previous week was used as a basis for making paintings. The sketches were on A4 paper and the paintings on A1, which meant that the children had to think carefully about enlargement in terms of content and composition. The researcher gave careful support to each individual, for example in discussing the problems of painting and in encouraging reference back to the sketches.

Session 6
Each child inspected his painting and commented informally about it to the researcher. He or she then prepared a piece of imaginative or descriptive writing based on the subject as seen through the painting. As each child finished he was asked to prepare a list of keywords which could be used to summarize the essence of the painting and the writing. Discussion ensued on symbols as abstractions from reality, which can be used to express reality. Symbols were seen as a reduction and simplification of visual form: motifs. Emphasis was made on the use of

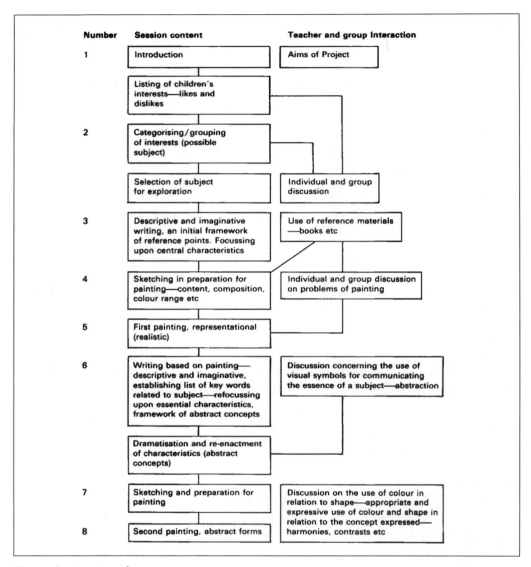

Figure 3: Summary of sessions.

abstract form to express and communicate essence of a subject. Each child dramatized his perception of the essence of his subject, with the guidance of the researcher. For example, one girl dramatized the movement of a bird in flight in calm and stormy weather conditions. Immediately afterwards she drew that flight in chalk on the blackboard. In this way she produced a symbolic form as an abstraction of a flying bird. In this work, as throughout the eight sessions, the children took the task seriously and enthusiastically.

Session 7

The pieces of writing of Session 6 and the lists of keywords were considered by each child and the drama activities recalled. This led to a further exploration of the essence of the subject in the form of sketches. Afterwards the group discussed the use of colour in relation to shape for the purpose of portraying the essence of the subject in the most appropriate and expressive way. Part of the discussion centred on the question 'What colours and shapes produce harmony?' 'What colours and shapes produce contrast?' 'What colours and shapes are most appropriate for expressing "X" (a particular concept)?'

Session 8

The discussion of the previous session was continued. Then the children produced their second paintings. These were attempts by them to express the essence of their chosen subject in abstract form as visual metaphors. These second paintings were symbolic representations of the essence of their subject. Finally they wrote a short descriptive piece about their second paintings. Continuity throughout the eight sessions was achieved, in part, by reflecting and looking back to previous sessions. In this way the children were made aware of the direction of the work from session to session. The researcher in the fourth session drew a diagram about the project up to that time, asking the children to complete it. In other words the children were constantly being referred to the content of their work; keeping it under review and estimating where it might go.

The children's work

The difficulty in showing what the children have done is that they have produced so much. We have chosen to reproduce Edward's papers in full and parts of Gordon's, Judith's, Amanda's and Annette's work. Edward's work was chosen to represent the process because he is considered to be 'average' in terms of the test scores in relation to the group. Each child's painting is titled and listed below (Figure 4). The purpose of disclosing the titles is to give some insight into the transformation taking place between the first and second painting.

Children	Subject	First painting	Second painting
Judith	The theatre and dancing	'Two Ballet Dancers on Stage'	'The Pirouette'
Annette	Nature	'Birds'	'Flight'
Penny	Nature	'Fish'	'Swimming'
Amanda	Dogs	'Performing Circus Dogs'	'Running, Jumping Rolling'
Melanie	Flowers	'Garden with Flowers'	*Unfinished*
Gordon	Stamp Collecting	'Stamps'	'Calmness'
Edward	Sport	'Rugby Match'	'The Tackle'
Darren	Adventure	'Pirates'	'Boat on a Rough Sea'
Richard	Nature	'Butterflies in Parkland'	'Butterflies in Flight with Figure'
Robert	Houses	'House'	'Balloons'

Figure 4

art ✓ School
Sports ✓ ghosts
Rugby ✓ Spraind
Xmas ✓ ancle
Cycling ✓ netball
records ✓ punk
Holidays ✓ records
places ✓ teethout
Bridlington ✓ figting
Hobiys
bits
Swiming ✓
gardening ✓
bow and arrow ✓
lego
red roses
Drawing ✓
animals ✓
dogs ✓
radio ✓
top60 ✓
Green ✓
gold fish ✓✓
tropiclefish ✓
Reading
School ✓
tv
Mr Jackson ✓
Mr Boston ✓

EDWARD: *Session 1 Listing of likes (left) and dislikes (right).*

art - modeling
Sports - Rugby Sports presents
Xmas - present
Cycling - Scrambleing dirtybike
records - Mod Mod records
places - Bridlington Land/Sea
Holiday - Places Sea
Swiming - Running Sports
gardening - digging holes
red - purple Colours
drawing - writing paper
names - Mr Boston - Mr Jackson Names
animals - dogs - cats - mice - hamsters - birds animals
radio - top 60 music
fish - goldfish tropicle fish fish
tv - fantastic four probrams
Hobiys - bits and bobs bits and bobs
School - English work
target - bow and arrow Shuting

EDWARD: *Session 2 Categorizing of interests.*

Rugby
The players are coming on the allblacks v
wites the captains have just come on the pith
I support the all blacks because I want to play
for them when I'm older I like rugby because
it is a sport where you have to be strong the
ref has blown the whistle the whites have the
ball the blacks are trying to get the ball
they've got it and there half way up the pitch but they
lost it the whites are going to score it's a goal
the half time whistle gos. After half time a player
from the allblacks team was shot from the
roof of the stadium Someboby was up there
with a gun it must have been a vage rifle
because nothing else could have reched that point
but the game went on So the blacks were one
player short but when the game ended Somebody
else was killed the police went out looking for
him.

EDWARD: *Session 3 Descriptive and imaginative writing.*

EDWARD: *Session 4 Sketch for painting.*

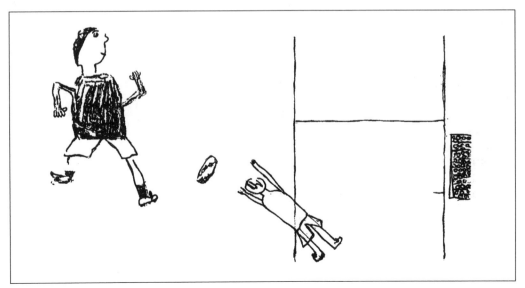

EDWARD: *Session 4 Preliminary sketches.*

EDWARD: *Session 5* First painting: representational.

Rugby

The players are comming on to the pitch the players have bean lead onto the pitch by their Coaches the teams are all blacks and whites have got the ball and are going for a try but the blks are not going leb them Score and go after the whites but the whites have Scored the whites. are going to Score again but the blacks are determined to stop them and they have and now the all blacks have the ball the Sky is dark and it is cold the all blacks have Scored and are after another try and they have Scored and it is 21 the all blacks are winning

but the whites are detorined and cunning and wont let the all blacks win and run as fast as they can and play as fast as theycan and they get the ball and Score the Score is now 2 all but the blacks now the whites and now the plan so they make a plan too and now the whites are going for a try but the blacks now the plan and tackled the whites and go for a try and get a goal the Score is 32 the blacks are winning the blacks have the ball but the whites got the the blacks are trying to get the ball and Sucseaded but the whites have got it back and have Scored and got three ball but the backs have got it and Scored the

whistle is jused about to go but blacks have got the ball scored again the whistle has gone the score is now 63 the blacks have won Ed word Monday 2 Dec

EDWARD: *Session 6* Writing based on the subject as seen through his painting.

hurt.
~~~~~~~
whistle
Score
whistle,
Kick
kicking
dived
dive

run
running
Sky
dark
cold
very
end
~~~~~~~
comming

EDWARD: *Session 6* List of key words from the writing.

EDWARD: *Session 7 Sketches in preparation for painting.*

EDWARD: *Session 8 Second painting: abstraction.*

EDWARD

In my picture their are a lot of pretty colour and some lines that describe what rugby players look like if you couldn't see them. Also in my picture it shows you it is rough. I was glad I was not playing players were cliding time after time. In my picture the players kept scoring. For the pattern of cliding I put lines in the shape of a star and for the scoring pattern I put curved lines. Some of my colours are rough and some are calm. I used all sorts of colours. It's colours are red, orange and purple and a lots more. There are a lot of squiggly lines all different colours are around them.

JUDITH – Danceing

Danceing is very nice,
I've done it more than twice.
It's a long time to sit,
But people enjoy it every bit.
We have music called Cavatina,
There was a dancer called Tina,
There are brown and green trees,
And little humming bees.

You could see a red curtain,
The scenery was nice,
But the tickets were a price,
The curtains were red,
There was a bow in Tina's head
There was a coloured rainbow,
We had a dumpling made from sago.

JUDITH

The pattern on my picture is squiggly. Most of the colours are bright. These are the colours I used:

Blue	Bage
Red	Orange
Brown	Green
Purple	White
Yellow	

It is the simble of a ballet dancer spinning round. There are some small spaces and some large spaces.

ANNETTE

Birds fly in the sky ever so high up and up they fly birds
I like sparows and trushes I like bird
I watch the birds fly past me

I like to watch the ducks on the pond I like to watch their feet paddle along
the top of the water I like the colours of them I like the pigens in london they
come on your sholder bird like the ostrich can't fly but it gets away from its
enirnies by running very fast the movement is very fast but heres a few movements
some birds like the egle move with there wind upwards.

ANNETTE

In my picture there are all diffrent colours pretty colours bright colours like blue,
green, red, orange, purpul, evil colours evil colour are black, brown, green, red.

GORDON

In my picture the countries that the stamps are from are Guernsey, Isle of Man, Lundy Island and Zambia. Stamps were invented by Sir Rowland Hill in Queen Victoria's reign in the 1800s.

They were first used in England they were established in Brazil They are usually very colourful and come in shapes such as triangles, diamond and normal shape like squares and rectangles. Usually there are either a kings head or a queens head on it.

In some countries they have sets of stamps that have all got different animals on them. Britain sends out a special sets of Christmas Stamps for Christmas. And they sometimes send them out on important peoples birthdays like the Queen Mether's 80th birthday.

The first stamps were the penny black and the twopenny blue. People say that the most valuable stamp is the New Giauna 1 cent which was sold for $180,000 but it is in very bad condition because it has been signed and its corners clipped off.

Albums are easy to get and cost about 25p. You can get about 75 mixed stamps from all over the world for about 85p.

GORDON

In my picture there are lots of light colours. It is a picture showing the movement of running water which is a symbol of peace. It has lots of curvy lines and hardly any straight ones. The stream is running and the wiggly lines show it going over stones. The main colours are purple, blue, yellow and green. The are no common shapes such as squares and circles.

AMANDA - At the Circus

One day I went to the circus. It was noisey it was a Saturday when I went. In the background you could hear the dogs and lions and the horses and they were false flowers put on the stage the dogs have to practice to balance on the string.

In my picture their are colourfull colour and it has a yellow background. It is a lovely drawing. It was a fast movement.

Taking the five children's work reproduced in this section, we can trace in more detail the conceptual and 'artistic' development occurring between the two paintings. Figure 5 shows this.

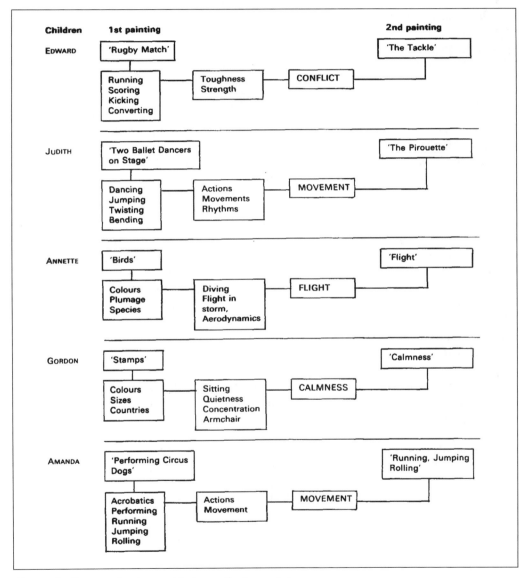

Figure 5: Concept development between the two paintings.

Evaluation and discussion

We have been able to present only the barest outline of Witkin's analysis. For example, discussion of 'holding form' (Witkin, 1974: 180) and other aspects has been omitted for the sake of brevity, but such apparent omissions have been considered and are taken into account in the general scope of this investigation.

From the examples given, it is evident that a change has occurred in the process of the children's thinking. This is witnessed in the development and transformation of ideas about each subject (conceptual structure) and in the nature of expression (compare first and second paintings). This change appears to have been enhanced by the use of successive approximations. Transformations have been effected; from real events in experience, each child has focused on significant aspects of the subject, recalling in form(s) those things which are meaningful to the child. Edward, for example, on being asked why he had decided to choose 'sport' and subsequently 'rugby', replied, 'because it's tough, sir'. The physicality of the sport (which they don't play in his school) appealed to him. The process he entered into was one of arriving at the realization of 'physicality' through exploration of the subject's content, the acknowledgement of what he personally felt about it and the expression in media of what he considered to be particularly meaningful to him. In terms of subject-knowing this is an important requirement if the organization of feeling responses and their expression is to be successful. Increasingly, each child moved away from the initial encounter or immediacy of experience towards abstract thought, using visual metaphor as the 'sensuous image' to embody essence (cf Bruner 1962: 59–74). Drama or poetry could have been used as the main vehicles of expression, with painting, story-writing and music as means of extension and support – as written forms and drama have served in this situation. The relationship between media forms and guiding concepts is a complementary one, in so far as each conceptual understanding of the subject-in-process was complemented and developed by the use of a particular media form. In other words, there is reciprocal understanding at each approximation of the subject's essence. The development of abstract thinking and symbolic representation in thought and images was the result of the transformation of an original schema, leading to new impulses and new hypotheses, with consequently new artefacts.

Knowledge, according to Pickard (1980) is the construction of reality. Creativity, she argues, is its reconstruction. Creating something in a medium, which is a way of knowing, demands that reality be transformed in some way – through the organization, reformulation and expression of cognitive and affective domains. What has occurred is not a purely expressive or logical/ rational 'statement', but rather a synthesis or combination of mental faculties. If the interpretation of Witkin is accepted, then we may suggest that what has taken place results from the intelligent use of feeling.

The relationship between 'affective' and 'cognitive' growth has been a subject of research in recent years. Parsons (1976) for example, looked at the interaction between cognition and affect and, as tentatively suggested in this chapter, found that a synthesis occurs in the process of expression, rather than one or the other having precedence. Witkin's four categories of contrast,

harmony, semblance and discord clearly need further examination if one is to accept them on a parallel level to Piaget's main cognitive categories. It has not been within the scope of this investigation to do this; we have simply adopted the general principles of Witkin's conceptual framework.

To what extent we have provided teachers with a working model, in which continuity of experience and progression in the arts is the aim, the best judgement must come from those teachers who read the chapter and decide there is something to learn. For this reason the opinion of the class teacher of the children studied is being quoted:

> Despite the importance placed on art in the Primary School in recent years this art has often been subservient to other aspects of the curriculum, i.e. usually as a means for illustrating various topics and projects. This is a legitimate use of art but too often art qua art is neglected. Its unique contribution to educational development being submerged in an all embracing inter-disciplinary concept of primary education. Primary school art becomes merely a means of producing pleasing displays of work currently being tackled in other areas of the curriculum. More seriously still, most teachers lack an adequate philosophy of art education.

> Now this research may help to provide a remedy for some of these problems and deficiencies. It doesn't abandon the inter-disciplinary or child-centred approaches but it does attempt to create a structured framework into which these approaches might fit, a framework which could embody a relevant theory of art education and give that education more direction and purpose. The chief purpose of this project, it seems to me, is to encourage and foster a genuinely child-centred approach to art education.

> In the average primary school with classes of 30+ the problem will remain a perennial one – how to promote the artistic development of a group of children with widely differing interests and abilities. Working with a small group, the researcher, armed with his specialist expertise, should be able to test this theory on a very individual basis. The class teacher, however, may have to compromise. Instead of beginning with each child's personal, even idiosyncratic interest, they may have to choose the starting point for the whole class, although he will of course choose a subject which has wide appeal, e.g. 'holidays' – as suggested by the project researcher. A handbook of such 'starting points' or ideas and the ways in which they might be developed would be very helpful to the primary school teacher, particularly the non-art specialist. Armed with such knowledge the teacher would, of course, have to be careful that their suggestions do not become impositions, thereby destroying spontaneity and forcing the child to follow some preconceived pattern of artistic development.

Clearly, the success of such an approach in the primary school would depend upon the specific objectives the teacher adopts, in terms of the media the children are to use, and the nature of the encounter – whether or not the teacher decides or the child has a say in the subject. In

this project, any skills learnt during the process have been subservient to the process itself (see Sessions 4 and 7). Decisions as to what media are to be used (and subsequent skills developed) will determine the structure of the process in terms of the concluding and supporting forms. Thus the teacher would need to have in mind where the emphasis is to lie over the year; whether poetry is to be the main feature in one half-term (or longer) and painting the next; and so on. The choice of encounter likewise needs to be looked at closely. Decisions need to be taken in respect of existing or planned projects and their adaptability and appropriateness to this approach. As the class teacher suggests in his evaluation of the project, a handbook of starting points would benefit the teacher, beginning with topic titles that are to be found in the repertoire of many primary schools, showing their possible development and direction with regard to guiding concepts and the media of expression. Such a handbook is being developed at present and will, we hope, be available in the near future. Flexibility within the process is an important factor if the child is not to be tied to the teacher's thinking. In other words, the process is one of mutual sharing as to the direction to be taken.

The authors would like to record their thanks to Dr Michael Bassey of the Centre for Educational Research, Trent Polytechnic, for making this investigation possible.

Appendix
The table below gives ages and test scores of the children studied. In attempting to acquire a cross section of ability, we used the school's own test scores. A standard IQ test is not used by the school.

Children	Age	Burt reading test	NFER English test (English progress B2)	NFER maths test (Attainment B)
Judith	9 yrs	+ 37	127	112
Annette	8½ yrs	+ 27	107	105
Penny	9 yrs	+ 3	114	113
Amanda	8½ yrs	− 5	105	112
Melanie	8½ yrs	− 13	97	99
Gordon	9 yrs	+ 40	126	140
Edward	8½ yrs	+ 26	121	113
Darren	8½ yrs	+ 11	113	118
Richard	9 yrs	− 9	95	97
Robert	8½ yrs	− 22	85	87

References
Bruner, J.S. (1962) On Knowing – Essays for the Left Hand, Harvard: Harvard University Press.
Bruner, J.S. (1974) Beyond the Information Given, London: George Allen and Unwin.
Goodman, E. (1976) 'The place of art in the curriculum', Athene, Vol. 64.
Maslow, A. H. (1968) Toward a Psychology of Being, New York: Van Nostrand Reinhold.
Parsons, M. J. (1976) 'A suggestion concerning the development of aesthetic experience in children', Journal of Aesthetics and Art Criticism, Vol. XXXIV, No. 3.
Pickard, E. (1980) The Development of Creative Ability, NFER.
Plowden Report (1967) 'Children and Their Primary Schools', Vol. I. HMSO
Ross, M. (1978) The Creative Arts, London: Heinemann Educational Books Ltd.
Witkin, R.W. (1974) The Intelligence of Feeling, London: Heinemann Educational Books Ltd.

3

Marion Richardson (1892–1946)

Bruce Holdsworth

Vol 7, No 2, 1988

Marion Richardson's name figures prominently and frequently in the literature of the history of art education. She is credited with having been one of the pioneers of the child art movement (though until recently this had not been substantiated with systematic research).[1] She is also well known as the inventor of the Marion Richardson *Writing and Writing Patterns*, to which her name is perhaps more readily attached than to her achievements in art education (Richardson 1935). This ought not to diminish the importance of her contribution to education in art, which has been largely misunderstood until recent years, and has been in danger of being neglected altogether through lack of objective information of the circumstances surrounding her rise to fame. Some distortion of her relative importance has occurred, due mainly to the fact that her findings were not published in book form until after her death, but long before this she influenced a generation of teachers and significantly affected the New Art Teaching Movement. Her colleague at the Inspectorate of the London County Council, R. R. Tomlinson, contributed to this confusion by publishing the first accounts of the new movement, to which he had not otherwise contributed, but which would probably not have occurred without the pioneering work carried out by Marion Richardson (Tomlinson 1934).

Early life and education (1892–1912)
Marion Richardson was born on the 9th October 1892 in Ashford, Kent, the second daughter in five children of Walter Marshall Richardson, a master brewer, and Ellen Dyer. According to her mother, Marion Richardson showed great powers of imagination and was fond of making up stories and inventing exciting games,and was interested in literature and the arts. Her early education took place in a family schoolroom at home, followed by a small private day school; Winchester High School; Uplands School (boarding); and Milham Ford School in Oxford. She

Figure 1: Marion Richardson: The Mill; 1904. Royal Drawing Society examination piece, Winchester High School. Reproduced by courtesy of the City of Birmingham Polytechnic, Marion Richardson Archive

Figure 2: Marion Richardson: Bottle and Glass; drawing; aged 11. Reproduced by courtesy of the City of Birmingham Polytechnic, Marion Richardson Archive.

showed early promise in drawing and passed Royal Drawing Society examinations with relative ease (Figure 1). In her later life she illustrated her lectures with an 'object drawing' of a beer bottle and glass, which she had drawn when she was eleven, as an example of the type of drawing lesson which she was against (Figure 2).

Milham Ford School, Oxford, was a girls' high school, established to meet the growing demand for middle-class secondary education for girls at the turn of the century. In 1906, the year Marion Richardson started, a new school building was opened simultaneously with a teacher-training college. Catherine Dodd was appointed joint Principal of the College and Headmistress of the School. She was well known as one of the foremost experts on practical work in education and had written books on Herbartian principles applied to teaching. This means that Marion Richardson came into contact with progressive ideas in education when she was still at school and, as training for women teachers was far in advance of that for men at this time, this must have had some effect on the readiness with which she was later able to put her own advanced theories into practice.

The art mistress at Milham Ford, Gladys Williams, prompted Marion Richardson to sit for a teacher-training scholarship at the Birmingham Municipal School of Arts and Crafts in 1908, when she was sixteen. She passed the Oxford Senior Local Examination 'Associate of Arts' and was successful with the scholarship and reluctantly went to Birmingham. She had hoped to stay on at Milham Ford but her father had died and the change in the family's economic circumstances meant that she could not afford to overlook this opportunity.

She attended the teacher-training course at Birmingham between 1908 and 1912. It was here that she came into contact with two people who were to influence the course of her life and career: Robert Catterson-Smith and Margery Fry. At the end of her first year she was awarded an 'Elementary Art Certificate' by the School of Art and then went on to pass the Board of Education examinations in conventional subjects, such as 'drawing in light and shade from a cast', 'freehand drawing', 'perspective', and 'geometric drawing'; all legacies of the South Kensington system. At that time, Birmingham School of Art was the top art school in the country, winning more national awards and prizes than any other. Birmingham was the centre, too, of a late flowering of the Arts and Crafts movement and staff and students at the School of Art were very much involved in it. Examples of Marion Richardson's student work in jewellery, illumination and embroidery have survived and indicate high levels of craftsmanship.

Catterson-Smith, Headmaster at Birmingham, had worked with William Morris, Burne-Jones and William Lethaby and, as Headmaster, he was also responsible for the junior art schools, branch art schools and drawing in all the elementary and higher grade schools in Birmingham. It was this wider responsibility which led him to become interested in many different aspects of art education and to introduce a particular type of memory drawing known as 'shut-eye' drawing to teacher-training students at Birmingham.[2] His memory drawing methods were similar to, and in some respects derived from, those of Thomas Ablett. They were well known, but not widely taken up by art teachers and Marion Richardson appears to have been his principal convert,

taking one of his methods and adapting it to her own circumstances. Catterson-Smith used to show lantern slides of historic ornament and objects, which the students were asked to memorize and then draw from memory with their eyes shut before completing a finished drawing with eyes open. Marion Richardson had no access to slides or a lantern when she started teaching and so relied on descriptions or pupils' memories of things previously seen. The important point is that she began to realize that it was the strength of the pupil's mental image which seemed to give rise to the most interesting and successful art. This idea became the centre of her philosophy and eventually governed all her teaching methods.

Between April 1910 and December 1911, Marion Richardson was registered as a pupil-teacher at Moseley Art School. She was taken on to the staff as a Junior Assistant Teacher in December 1911 and left in June 1912. In her final year at Birmingham she lived at University House, Edgbaston, where Margery Fry was the Warden. University House had a policy of taking women from a variety of colleges and also from the professions: a policy which derived from the University Settlement ideas of Canon Barnett. Margery Fry was active on many committees connected with education and penal reform. She provided Marion Richardson with an almost perfect model of the unmarried, professional woman at a time when female emancipation was in its formative stages. Marion Richardson never married but devoted herself completely to her work in art education. She and Margery Fry shared many interests including art, embroidery, drama and music, but it was later when Marion Richardson met Margery Fry's brother, the artist, writer and critic, Roger Fry, that their friendship developed. In the meantime Margery Fry, who was on the Staffordshire Education Committee, helped Marion Richardson secure her first teaching post as Art Mistress at Dudley Girls' High School.

Dudley Girls' High School (1912–1923)
Marion Richardson took up this appointment on the 4 June 1912, having passed the Art Class Teacher's Certificate, but she left before sitting the Art Master's Certificate. Her special subjects were listed in the school staff records as 'Drawing, Embroidery, Lettering' and she worked there full-time until the summer of 1923 and then part-time as Senior Art Mistress until 1930.[3]

Dudley Girls' High School enjoyed a reputation in the Midlands for providing a good academic education but not at the expense of culture or the development of social skills. The high academic standards achieved there were due to two very good headmistresses, Miss Burke (1891–1914) and Miss Frood (1914–1941). Miss Frood found Marion Richardson particularly supportive of her own ideas, such as those for self-government, and it is significant that the 'school court', introduced by Miss Frood in 1919, was traditionally held in the art studio. It appears that after Marion Richardson came to public attention in 1917, many other educational 'experiments' were carried out, resulting in a constant stream of visitors from Great Britain and abroad including the Ministers of Education for Romania, China and Austria.

Marion Richardson appears to have led the way at Dudley Girls' High School by being particularly interested in modern methods and by developing her own system of teaching 'art' to replace the traditional subject of 'drawing'. Sometime between 1914 and 1916 she

attended a course of Dalcroze Eurhythmics, which indicates her interest in modern methods, and during the same period she largely abandoned the traditional drawing syllabus, mainly object drawing, replacing it with water-colour painting which relied on the girls' own mental visualizations. She developed various methods of stimulating her pupils to ensure that they had a good mental image or 'picture' from which they could work, including a variation of Catterson-Smith's 'shut-eye' technique (Figure 3). The earliest surviving Dudley paintings are very small, in some cases only a few inches square, and typically represented various aspects of Dudley or illustrated a poem. The subject matter was either described by Marion Richardson or generated by the pupil, but it is important to realize that senior pupils worked directly from objects or from life for Oxford Local Examinations and there is evidence that she tried a very wide variety of techniques, media and subject matter with her pupils. The term 'generated' is used here to take account of the particularly large number of paintings known as 'Mind Pictures', many of which are entirely abstract and intended to be truthful representations of what the pupils could 'see' when they closed their eyes and concentrated on capturing a mental image.[4]

The Dudley work which has survived is remarkable in comparison with contemporary secondary school art. There is no evidence of any other secondary school in Britain producing work like this between 1912 and 1924. Although Ablett's Royal Drawing Society examinations encouraged picture making and working from memory, the results were largely imitative of adult work and do not compare with the abstracts, pattern-making, mind pictures and bright, colourful, childish

Figure 3: Marion Richardson: 'Shut-Eye' drawing and watercolour. Reproduced by courtesy of the City of Birmingham Polytechnic, Marion Richardson Archive.

Figure 4: Dudley Girls' High School; 'Abstract Design'; watercolour. Reproduced by courtesy of the City of Birmingham Polytechnic, Marion Richardson Archive

conceptions of the Dudley work (Figs. 4, 5, 6). Franz Cizek exhibited at an art education congress in London in 1908, but his work was not really known or imitated in Britain until it was circulated in the 1920s (see Hancock 1984). British artists and critics, such as Clutton Brock, one of the organizers of the Cizek exhibitions, had long been familiar with Marion Richardson's theory and practice and, as Cizek's ideas received little recognition in his own country at the

Figure 5: Dudley Girls' High School; 'Abstract Design'; watercolour; by Dorothy Baker. Reproduced by courtesy of the City of Birmingham Polytechnic, Marion Richardson Archive

Figure 6: Dudley Girls' High School; Sleeping Beauty; watercolour. Reproduced by courtesy of the City of Birmingham Polytechnic, Marion Richardson Archive

time, there is good reason to believe that Marion Richardson prepared the way for the support which Cizek received in this country. Marion Richardson worked out her ideas independently of Cizek and as the leading advocate of child art in Great Britain, she was called upon to open one of the first exhibitions of his pupils' work in Cambridge in 1920. Although their ideas were essentially sympathetic, she recognized the difference in results obtained and thought that his pupils produced work which was too stylized. She visited his class in Vienna in 1923 but by then she had finished working full-time at Dudley and had worked out her own fairly complete philosophy of art education based on eleven years' classroom experience.

The most important thing to happen to Marion Richardson in this period was her meeting with Roger Fry at the Exhibition of Children's Drawings held at his Omega Workshops in London in February and March 1917. She was in London being interviewed for a post, for which she was unsuccessful, and took the opportunity to visit Omega. Roger Fry was astonished by the Dudley work that she showed him and so he included it in the exhibition and brought it to the attention of the Minister of Education, H.A.L. Fisher, who also recognized its importance. It attracted the attention of critics and received over one hundred mentions in national and international newspapers. The Omega exhibition was a milestone in art education, being the first time in Britain that children's art was exhibited in its own right and for its own qualities. Roger Fry was interested in child art for the primitive qualities it displayed and he compared it to the 'primitive' art of other periods and cultures, including the art of the early Renaissance. He did not directly compare it with the work shown in his two famous exhibitions of Post-Impressionist paintings (1910–1913), but there is no doubt that he and Marion Richardson both considered child art to be of a similar type to Post-Impressionism.

Roger Fry helped Marion Richardson in many ways and, apart from proposing that she should be put in charge of a children's art school immediately, he introduced her to the art and artists of Bloomsbury and changed the course of her career through the influence of his ideas and

Figures 7 and 8: Dudley Girls' High School; Ballet Russes; watercolours. Reproduced by courtesy of the City of Birmingham Polytechnic, Marion Richardson Archive

contacts. He arranged for her to go backstage at Diaghilev's Ballet Russes to see Picasso designing for *Parade* and she followed this through by giving vivid descriptions of the Ballet Russes to her pupils, who produced some remarkable images (Figs. 7, 8).

The immediate result of her contact with Roger Fry can be seen in the extraordinary written statement she produced to accompany an exhibition of pupils' work held at Dudley Girls' High School in December 1917. It is reproduced here in full:

> The drawings in this exhibition are all the work of children who receive no help but the encouragement to draw. They are taught that drawing is a language, which exists to speak about things that cannot be expressed in words – emotional ideas about the beauty of the world that come to us. It is these ideas and not literal and photographic representation of appearances that the artist seeks to express, and as the children are working with this motive – the same motive that has inspired all art – their drawing must be considered as tiny works of Art. There is no fixed syllabus for the work. As far as possible each child decides what she will draw and comes to the studio with her ideas ready, using the lesson simply as a convenient opportunity for working out some idea that has come to her. There is no emphasis laid upon mere skill and no direct training of technical methods. It is felt that the force of an idea is of itself sufficient to find means of expression, and that if any such help is needed, it is better given individually when the child is ready to ask for it. The point most insisted upon is clear thinking. The children never begin to draw until they feel they have grasped the idea, until they know what they want to do and feel impelled to do it. The greatest factor in attaining this clearness is the visual power. It is towards a greater realisation of this

Figure 9: Painted Cupboard from Dudley Girls' High School. Reproduced by courtesy of Dudley School and the National Arts Education Archive, Bretton Hall

power that teachers of drawing are working, but to attempt to teach visual drawing and at the same time to reject any genuine visual effort is both contradictory and dangerous. That some of these drawings are not just as we would have done them is perhaps their greatest virtue. Remembering that all art must reveal to us something of which we were not aware, we must not reject them for what seems to us queerness – queerness, which we mostly accept in primitive or foreign art – but look at them and try to receive the message they seek to convey, often simply an idea of space, colour, volume, contrast etc.[5]

Figure 10: Dudley Girls' High School; Block printed paper-covered boxes. Reproduced by courtesy of the City of Birmingham Polytechnic, Marion Richardson Archive

All subsequent writing by Marion Richardson was essentially an elaboration of this basic philosophy, indicating that by 1917 she had arrived at a coherent and original theory of art education based on sound practice.

The Omega Workshops, although short lived, had a profound influence on Marion Richardson. She did not follow the breakaway 'rebel' artists who became Vorticists, but extended her class work into the decorative arts in similar fashion to Omega, producing painted furniture, trays, lampshades and block-printed fabrics and papers applied to boxes etc. (Figure 9, 10). Roger Fry arranged for her to have an exhibition of Dudley work at Omega in 1919, in conjunction with some drawings and marionettes by Larionov. This was the very last exhibition held at Omega, because it went into liquidation in 1920, but it was the beginning of a long list of exhibitions of Dudley work held all over Great Britain and abroad. Her confidence at this time was such that she wrote an article on 'How to Teach Drawing' which was published in the *Cambridge Magazine* in August 1919.

Her interest in developing an effective handwriting scheme also dates from this period at Dudley. In 1914 she was given the additional responsibility for teaching writing to the lower school and lower fourth forms and in her usual thorough way devised a system which led to the publication of *The Dudley Writing Cards* in 1928 (Richardson 1928) and *Writing and Writing Patterns* in 1935. She had studied calligraphy and illumination at Birmingham School of Art and shared an interest in handwriting with Roger Fry. Her system was partly based on Graily Hewitt's copy books but she also consulted Edward Johnston who wrote an appreciation of *The Dudley Writing Cards* in the note to teachers which accompanied the sets.

By 1922 she was sufficiently well known to be invited by the Consultative Committee of the Board of Education to report on the possibility of developing Art Teaching in connection with History and Literature. In the same year she was on the Examination Committee of the Teachers' Registration Council, helping to determine the standards of attainment to be required of Registered Art Teachers.

Middle years (1923–1930)

Within weeks of their first meeting Roger Fry had promised to help Marion Richardson secure a post as a teacher-training lecturer by using his influence with the Minister for Education. As this began to seem unlikely, she had a prospectus printed in order to take private pupils. She then began to hold private classes, while also lecturing part-time on the new graduate training course at the London Day Training College, where the Principal, Percy Nunn, was sympathetic to her views.

On Mondays she taught at Benenden, the girls' public school in Kent. On Tuesdays she supervised students on teaching practice. On Wednesday mornings she taught at Hayes Court private school in Oxford, and on Wednesday afternoons she brought in classes of elementary school children to work with her students at the LDTC. On Thursdays and Fridays she returned to Dudley Girls' High School, where she carried out her duties as Senior Art Mistress, and on

Saturdays she held a private class at a country house in Northamptonshire. Work by pupils other than from Dudley is often more sophisticated, larger and painted with opaque colour (Figure 11). In addition, she started a class for elementary school children at an LCC school on two evenings a week. She also had other private pupils and started to build up a punishing programme of lectures all over the country and these increased in frequency until in 1939 she became too ill to continue. The following list of lectures delivered in 1929 indicates the range and type of venues:

April: Ambleside Old Students' Association; Wiltshire Arts and Crafts Association
July: Two short courses for the Board of Education in Oxford
October: Birmingham Education Study Society.
November: Hull Froebel Society; Conference on *New Ideals in Education* Worcestershire; Lecture to Child Study Society.

In the spring of 1925 she delivered the first of many lectures to London County Council (LCC) teachers on 'The Teaching of Drawing'. It was these lectures and her contact with teachers-in-training at the LDTC which first helped to spread her methods. Within a relatively short time she convinced a number of students, including Nan Youngman, Clarence Whaite and Clifford Ellis, of the validity of her ideas, which were now more readily understood in the light of modern art movements and the recognition afforded to Cizek. One of her students, R. J. Puttick, taught so successfully along her lines at Westminster City School that he was invited to exhibit his pupils' work with hers at the Whitworth Art Gallery in Manchester in the spring of 1928. At this exhibition Marion Richardson summed up her approach in the following way:

Figure 11: Mother and Baby; watercolour. Reproduced by courtesy of the City of Birmingham Polytechnic, Marion Richardson Archive

The essence of my method is to encourage the girls to concentrate upon and give expression to mental images formed upon their own observations. I try to avoid giving them any ready-made formula for translating these visions into pictures. The most positive part of my work is to present suitable objects to the child's mind, though often the children succeed in inventing their own subjects. The study (through reproductions) of the works of great artists helps them to realise for themselves the essentials of formal design. I direct the criticisms of their own and each other's work. In this the value of an honest attempt at expression as compared with the production of an accomplished rendering is emphasised. By their working together, a common tradition and style has grown up among the girls, of a kind quite unforeseen by me.[6]

It was at this exhibition that a number of the children's block designs were sold to manufacturers and eventually put into production. The Calico Printers' Association chose twenty-three designs and they were printed on 'Rossvale Rayon Crepe' and marketed as the 'Maid Marian Range'.

In the summer of 1925, her professional standing was such that she represented the Association of Assistant Mistresses in Paris at a meeting of the International Federation of Art Teachers. She was often invited to speak at national conferences and this provides important evidence about her status within the New Education Movement.[7] The essential features of this movement have been identified as: taking account of the personality of the child and aiming for a better society, a better world, a new era. This is a gross simplification of a movement which grew and developed over many years, but the consequence of accepting New Education principles was that the teacher was required to watch and help the growth of the child's abilities and not impose strict learning regimes. Marion Richardson's theory and practice fit easily into this concept. Her approach stands up to the criticism normally levelled against child-centred approaches, that they merely confirm the child's immaturity, because it was essentially learner-centred. The results of her methods indicate that her pupils produced carefully considered work which did not conform to normal educational requirements but went beyond them to take account of new ideas in art. Spontaneity, to her, was an element of art rather than education and she was at pains to point out that her concern was for the recognition of sincerely produced individual forms of art rather than the training of competent copyists. She took the school subject of 'drawing' away from practical training and scientific observation and linked it more firmly with new ideas about art. There is a similarity here between her idea that drawing should be linked to real art and the contemporary notion that 'drill' in the school curriculum should give way to real games.

To associate Marion Richardson with the New Art Teaching of the 1930s and 40s is correct because this is when her influence was most directly felt, but she also belongs firmly within the New Education Movement of the previous two decades, having developed her ideas and methods at the same time as many notable pioneers of progressive education and in advance of most. Her true contemporaries, then, were Maria Montessori, Margaret Macmillan, Homer Lane, Norman Macmunn, Caldwell Cook, John Dewey and Franz Cizek. This puts her in advance of Susan Isaacs, the Russells, the Elmhirsts at Dartington, and New Art Teachers such as Robin Tanner.

Marion Richardson was directly involved in the Conferences on New Ideals in Education and in particular the 1919 Cambridge Conference, the 1929 Worcestershire Conference, and the 1930 Oxford Conference. She was also involved in the New Education Fellowship and spoke at the 1935 St Andrews Conference, and the Seventh World Congress held at Cheltenham in 1936. This level of involvement, at the forefront of new educational theory and practice, marks her out as a distinguished teacher within the New Education Movement and there is a noticeable and serious omission of her name in the standard history of education texts, which may be accounted for, but hardly justified, by the subject-based nature of her activities.

London County Council (1930–1946)

By April 1930, Marion Richardson's reputation in education was such that Cyril Burt asked her to read a rough draft of a report he was preparing for the Hadow Committee. In September they became colleagues when she was appointed Inspector of Art to the LCC where she had a profound influence on the teaching of art, craft, pattern-making and handwriting, particularly in infant and junior schools, Her influence was spread in many ways including 'surgeries' for teachers, held in her office at County Hall, visits to schools, and lectures. She also ran courses for teachers, which were always oversubscribed. Applications for the 1934–5 course, 'Art in Infant Schools', held on Wednesday evenings in January at a fee of four shillings, were refused after the number had risen to one thousand because only forty could be accommodated. She organized a number of small exhibitions and contributed to others between 1930–1938, but it was the large exhibition of children's art held at County Hall in July 1938 which attracted the most attention and is widely regarded as the point at which her work culminated and finally convinced even the most sceptical of the value of art in education. Her initiative in organizing exhibitions of this type was later taken up by the British Council, through the influence of Herbert Read, and British Child Art was later toured all over the world, particularly in North and South America.

She extended the idea of handwriting and pattern making down to primary school level. The introduction of sugar paper, large brushes and powder colour for the purpose of producing writing patterns, led eventually to these materials being adopted as standard in the teaching of art in primary schools. Within a few years at the LCC she had made a dramatic difference to the type of art being produced in many London Schools. In international terms, Marion Richardson was to London what Cizek was to Vienna and Arthur Lismer was to Toronto.

An important aspect of the inter-war years was the interest shown in design or 'art and industry' and the relationships between them. The effect of this movement on art education has not been properly charted but as the propaganda began to take effect, it swept many educationalists on board. Marion Richardson, whose interest was in decorative design rather than product design, was involved in various ways and corresponded with some of the principal figures of the movement, including Frank Pick, Harry H. Peach, Anne Carter and Herbert Read. As early as 1928, Paul Nash sent someone from the Curwen Press along to see some of her pupils' decorative papers with a view to putting them into production. In 1930 she received a request for a memorandum from the Gorrell Committee and she was subsequently mentioned in their

report (Gorrell 1932). She was involved with the famous Exhibition of British Industrial Art in Relation to the Home held at the Dorland Hall in 1933, where the Edinburgh Weavers saw some of her pupils' designs that they were anxious to purchase. In 1934 she was requested by the Council for Art and Industry to give evidence on art education in London and produced a report for them on 'The Development of Artistic Sensibility in School Children', the content of which helped towards their report Education for the Consumer (HMSO 1935).

It is not generally realized that she also played an important part in the Council for Art and Industry sponsored exhibition, Design in Education, held at County Hall in 1937. This was arranged as an exhibition of material for use in elementary schools, and she organized a section on 'Writing as a Form of Art' (Figure 12), in company with Walter Gropius, whose 'Mathematics' section was a display of geometrical models. The same year she delivered a lecture to the Royal Society of Arts which won her its silver medal. The following year, 1938, she gave a lecture to the Design and Industries Association on the teaching of art and design to children.

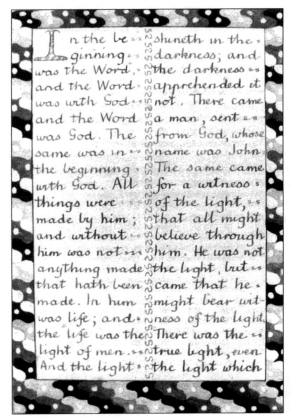

Figure 12: Handwriting and Letter Patterns. Reproduced by courtesy of the City of Birmingham Polytechnic, Marion Richardson Archive

This was also the year of the hugely successful exhibition at County Hall and, unfortunately, the year in which she started to show signs of illness. When the Second World War started she was evacuated with school children to Oxford and her illness got progressively worse. She was declared unfit for duty and finished working in January 1942. She moved to Dudley in 1945 and, although seriously ill by this time, she sewed and embroidered little articles for friends and relations and wrote her book *Art and the Child*, which she finished on 11 November 1946, the day before she died (Richardson 1948).[8]

Conclusion

Marion Richardson was an early pioneer of the New Education Movement, and the theory and practice she evolved at Dudley Girls' High School between 1912 and 1923 subsequently influenced teachers of art, craft, design and handwriting. There were many factors involved in the development of the New Art Teaching (as identified by Tomlinson in 1934), but we can be sure that the work of Marion Richardson was one of the most important, and that she did more than any other teacher in Britain to promulgate the idea that children were capable of producing original works of art.

Her ideas are still relevant (see Cieslik 1985; Hart 1984; Keene 1986; Kinch 1985). This is especially true when classroom practice is informed by a thorough study and understanding of her theory and practice. Art and Design education is always capable of being enriched by the work of enlightened and influential school teachers, and we do well to study and test those that have existed in the past. Marion Richardson offers a supreme example of how we are in danger of neglecting and negating the work of our finest practising teachers, the careful study of which can help us to avoid re-inventing the wheel.

Notes

1. This became apparent when I was researching the period of English art education between the two world wars and decided that there was a need for clarification of this issue (see Holdsworth, Bruce 'English Art Education Between the Wars' *Journal of Art and Design Education* 3, 2, 1984). I have looked closely into the claims made about Marion Richardson, by researching in the Marion Richardson Archive at the City of Birmingham Polytechnic (see Swift, J. *The Marion Richardson Archive* School of Art Education, City of Birmingham Polytechnic, 1985). It is the presence of this archive and the opportunity and stimulus it offers which has led to the recent progress in research on Marion Richardson. The first substantial research to use this primary source material was conducted by D. Campbell, who carried out the initial cataloguing with the aid of a Social Science Research Grant (see Campbell, D. 'Marion Richardson: A Misunderstood Figure in Art Education'; Unpublished M. Phi1. CNAA thesis, City of Birmingham Polytechnic)
2. See Swift, J. (1978). 'Robert Catterson-Smith's Concept of Memory Drawing 1911–1920' Unpublished MA CNAA thesis, City of Birmingham Polytechnic ; See also Swift, J. (1983). 'The Role of Drawing and Memory Drawing in English Art Education (1800–1980)' Unpublished PhD CNAA thesis, City of Birmingham Polytechnic,
3. Dudley Girls' High School records, Dudley Public Library.
4. A detailed account of the 'mind pictures' is given by Swift, J. (1986) 'Marion Richardson and the "Mind Picture"', *Canadian Review of Art Education Research 13*.

5. Handwritten statement; Marion Richardson Archive, City of Birmingham Polytechnic.
6. Introduction to catalogue Exhibition of Drawings and Designs by Children, Whitworth Art Gallery, Manchester, Spring 1928.
7. This movement has been identified by Selleck and others as a late nineteenth century and early twentieth century reaction against the rigid educational methods which had set in following the 'payment by results' system and the Revised Code (see Selleck, J.W. (1968) *The New Education* London: Pitman). The New Education started with the abolition of the Standards in the 1890s and was helped along by the reorganisation of local educational administration and the establishment of the LEAS in 1902.
8. Death Certificate records death as: (a) Myocardial Failure; (b) Rheumatoid Arthritis; (c) Anaemia.

References

Campbell, D. 'Marion Richardson: A Misunderstood Figure in Art Education' Unpublished M.Phil.

Cieslik, K. D. (1985) 'Marion Richardson: A Curriculum Study'. (The effectiveness of the teaching techniques of Marion Richardson on pupils with learning difficulties). DES/Manchester Education Committee/City of Birmingham Polytechnic Teacher Fellowship, CNAA thesis, City of Birmingham Polytechnic).

Hancock, J. C. (1984) 'Franz Cizek: A Consideration of his Philosophy, Methods and Results' MA CNAA thesis, City of Birmingham Polytechnic.

Hart, E. V. (1984) 'Marion Richardson: A New Curriculum Study', DES/Manchester Education Committee/City of Birmingham Polytechnic Teacher Fellowship.

HMSO (1932) 'Art and Industry', (The Gorrell Report).

HMSO (1935) 'Education for the Consumer', (Art in Elementary and Secondary School Education).

Holdsworth, B. (1984) 'English Art Education Between the Wars', *Journal of Art and Design Education* 3:2.

Keene, J. (1986) 'Marion Richardson: Her Approach to Handwriting', DES/Hertfordshire Education Authority/City of Birmingham Polytechnic Teacher Fellowship.

Kinch, B. (1985) 'Curriculum Project on the Work of Marion Richardson', DES/City of Birmingham Polytechnic Teacher Fellowship.

Richardson, M. (1928) *The Dudley Writing Cards*, London: G.Bell and Sons.

Richardson, M. (1935) *Writing and Writing Patterns*, London: University of London Press.

Richardson, M. (1948) *Art and the Child*, London: University of London Press.

Selleck, J.W. (1968) *The New Education*, London: Pitman.

Swift, J. (1978) 'Robert Catterson-Smith's Concept of Memory Drawing 1911–1920' Unpublished MA CNAA thesis, City of Birmingham Polytechnic.

Swift, J. (1983) 'The Role of Drawing and Memory Drawing in English Art Education (1800–1980)' Unpublished PhD CNAA thesis, City of Birmingham Polytechnic.

Swift, J. (1985) *The Marion Richardson Archive* School of Art Education, City of Birmingham Polytechnic.

Swift, J. (1986) 'Marion Richardson and the "Mind Picture"', *Canadian Review of Art Education Research* 13.

Tomlinson, R.R. (1934) *Picture Making by Children*, London: The Studio Ltd.

Tomlinson, R.R. (1935) *Crafts for Children*, London: The Studio Ltd.

A condensed Marion Richardson chronology

1892: Born, Marion Elaine Richardson, 9 October, Ashford, Kent

1904: Winchester High (Junior) School

1906: Uplands School

1906: Milham Ford School, Oxford

1908: Birmingham School of Arts and Crafts

1910: Pupil-teacher at Moseley School of Art

1911: Met Margery Fry at University House. Junior Assistant Teacher at Moseley School of Art

1912: Dudley Girls' High School

1917: Met Roger Fry at Omega Workshops, Exhibition of Children's Art

1919: Exhibition at Omega Workshops. Saw Russian Ballet. Article in Cambridge Magazine. New Ideals in Education Conference, Cambridge

1920: Opened Cizek Exhibition in Cambridge

1922: On Sub-Committee of Board of Education Consultative Committee. On Examining Committee of Teachers' Registration Council. Article in Woman's Leader

1923: Visited Russia and Cizek in Vienna. Finished full-time work at Dudley and moved to London to stay with Roger Fry and Margery Fry. Started private classes and part-time teaching

1924: Started lecturing at the London Day Training College. Exhibition at the Independent Galleries

1925: Delegate of Association of Assistant Mistresses, Paris

1927: Exhibitions at Independent Galleries and LDTC

1928: Dudley Writing Cards published. Exhibitions at the Whitworth Art Gallery, Manchester; Claridge Gallery, London; Heals, London. New Ideals in Education Conference, Worcestershire

1930: New Ideals in Education Conference, Oxford. Appointed Inspector of Art for the LCC. Memorandum for the Gorrell Committee

1933: Exhibitions; British industrial Art in Relation to the Home, Dorland Hall; County Hall

1934: Evidence to Council for Art and Industry. Visited Canada and USA

1935: Writing and Writing Patterns published. New Education Fellowship Conference, St Andrews. Silver Jubilee Exhibition, County Hall

1936: New Education Fellowship Seventh World Congress, Cheltenham

1937: Design in Education Exhibition. RSA lecture and silver medal

1938: Lecture to DIA. Exhibition of Children's Art, County Hall

1939: Jubilee Exhibition at County Hall. Evacuated to Oxford

1941: British Council Exhibitions

1942: Finished work at the LCC

1946: Marion Richardson died, aged 54

1948: Art and the Child published. Marion Richardson Memorial Exhibition

All photographs kindly produced by Frank Power.

4

An Analysis of The Presentation of Art in the National Primary School Curriculum and its Implications for Teaching

Jenny Hallam, Helen Lee and Mani Das Gupta

Vol 26, No 2, 2007

Introduction

In recent years, the National Curriculum for art has been criticized by academics who argue that the curriculum's inadequate theoretical base has led to unsatisfactory school-based art courses (Rayment 2000). The current chapter builds on this criticism by adopting an historical approach – informed by a Foucauldian style analysis – to explore how art has been conceptualized in Britain. It examines different understandings about child art and art education as well as tracing the evolution of the current curriculum.

Art education – a brief history

Art was officially recognized and incorporated into the British school curriculum during the 1830s and 1840s because it produced a useful workforce – a generation of designers (Robinson 1989). At this time the Central Society for Education (1836) conceptualized art as 'affording great aid in defining, expressing and retaining certain ideas...and must assist in the formation of habits of attention from the circumstances of its requiring so much care and accuracy' (cited in MacDonald 1970). In an environment where accuracy and neatness were valued, art was presented to pupils as a topic in which they were expected to develop their technical drawing skills (ibid.). Consequently the popular nineteenth century conceptualization of the child as a 'blank slate' – who had to be filled with knowledge and trained in 'useful' forms of drawing by the teacher – dominated the way art was taught. Children were expected to develop their artistic skills by copying images such

as geometric shapes, figures, birds, animals, machinery or maps following the teacher's example or an instructional book (Tomlinson 1947 cited in Anning and Ring 2004). Children were positioned in the role of passive students, receptacles of knowledge who were expected to gain the skills which the adult population considered to be important (Paley 1993).

The pragmatic conceptualization of art education shifted during the beginning of the twentieth century as Franz Cizek (an Austrian artist and prominent art educator based in Vienna) argued that child art should be valued in its own right. This perspective construed child art as 'the first and purest source of artistic creation' (MacDonald 1970: 343). This change in the way children's artwork was conceptualized coincided with the art world's discovery of child art. During this time artists such as Kandinsky, Miro, Klee and Klimt championed child art and considered it to be an important form of self-expression, a creative and natural process for the child during which their unique ideas flowed onto the page (Fineberg 1997, 1998). For these artists, child art embodied the nature of humanity and captured the inner essence of the depicted objects. This is because children's work was considered to be free from the influence of culture and taught art conventions. In order to support and promote this conceptualization Cizek organized a travelling art exhibition that showcased child art (Anning and Ring 2004). In addition he set up art academies to encourage children between the ages of 5 and 16 to develop their own artistic style, free from any adult influence. These academies worked on a radical Rousseauan conceptualization of child development in which children were seen as having their own rules such that nature rather than adult influence was deemed as guiding children's creative development (MacDonald 1970). Following this line, teachers were advised to encourage their pupils to follow their creative impulses. Consequently, the teacher's role was to offer children the opportunity to explore different art materials and create what they wanted to (Arnheim 1989). In all, this approach signified a shift away from the dominant nineteenth century view of art educator as someone who takes an active role in developing the technical skills children need to be successful artists.

Current approaches to art education

The approach to child art and art education advocated by Cizek dominated the way art was taught during the 1950s and 1960s (Barnes 2002). After all, Cizek's conceptualization of child art fitted in well with Western ideologies surrounding uniqueness (Lindstom and Darras 2000). This led to a child-centred approach to education being utilized in art lessons. The child-centred approach to education advocates that 'education should be oriented towards children's interest, needs and developmental growth and informed by an idea of child development' (Burman 1994: 164). Following this line of argument, art education has been viewed as the external realization of inner potential and the teacher's role simply to create a stimulating learning environment for the child (Saarnivarra 2000).

However, the rise of Thatcher's government in the 1980s saw a move away from this child-centred view of art education, instead placing emphasis on design and technology (Barnes 2002). This move signified a return to a skills-based focus and traditional educational approaches of the nineteenth century (Burman 1994). Children were conceptualized as 'not simply creatures expressing their essence through drawing, but also novices who are learning how to draw'

(Freeman cited in Cooke et al. 1998: 2). The focus on developing skills was consistent with the theory of drawing development outlined by Luquet in which children's' drawings progress through four age-related stages: (1) the scribbling stage – characterized by the child making experimental and non-representational marks on the page; (2) the synthetic incapability stage – characterized by the child's first unsuccessful attempts to make representational drawings; (3) the intellectual realism stage – characterized by the child creating representational drawings but drawing what they know to be there instead of what they observe, e.g. when drawing a pregnant woman the baby is included in the drawing; (4) the visual realism stage – characterized by the child successfully producing representational drawings (Luquet 1927).

When placed in the broader context of child development, Luquet's theory has close links with the way Piaget conceptualized cognitive development. Following Luquet, Piaget viewed development as a process in which children progress through distinct, quantitatively different stages at specific ages as their thought processes become more sophisticated. However Piaget – unlike Luquet – offered an explanation as to how these cognitive shifts occurred through the processes of accommodation and assimilation. Put simply, children have schemas – ways of understanding the world – in which they assimilate knowledge through their active experience with their surrounding environment. There comes a point where the child acquires knowledge which does not fit into their existing schema – this creates a state of cognitive disequilibrium and the child has to change their schema to accommodate this new knowledge.

Following this understanding of development, when the child first picks up a pencil they have a very limited drawing schema and motor control so their first attempt at drawing takes the form of marking and scribbles. As the child gains more experience with different coloured pencils and media, all this information is assimilated into their 'art schema' until they reach the point where something does not fit. At this point the child has reached the limit of what they can do naturally. They have to learn new skills and techniques in order to develop further. The accommodation of these new skills into the 'art schema' results in the child moving on to the next stage of their drawing development. In line with this conceptualization of artistic development, the teacher's role is twofold. Primarily they have to ensure the child has the opportunity to explore different art materials and engage in the process of assimilation. Once the child has assimilated all they can through experimentation, the teacher should then intervene and transfer the skills the child needs to take their schema for art to the next stage. This suggests that to teach art successfully teachers must strike a balance between two extreme positions – one which focuses on taking an active role to transfer skills to children and one which focuses on allowing children freedom to create the kind of artwork they want to.

The current study

The aim of the current analysis is to explore how different historical approaches to child art and art education have shaped the presentation of art in the National Curriculum. This is achieved by identifying the different discourses that are utilized in the curriculum; how these discourses work to create different presentations of art; and the consequences these different understandings of art have for the way art is taught.

For Michel Foucault discourses are 'practices that systematically form the objects for which we speak' (Foucault 1969: 69). So discourses represent the kinds of language available to construct knowledge in a given historical period. This means that discourses have the power to shape our understanding about a phenomenon such as art by 'ruling in' and defining acceptable conceptualizations and 'ruling out' undesirable ways of constructing knowledge. Following this argument, discourses work to present certain ways of *seeing* the world through the construction of knowledge, and *being* in the world through the production of subject positions (Parker 1992, cited in Willig 2001).

In institutional settings, such as the school system, discourses work to 'organise' and 'regulate' institutional practices (Willig 2001: 107). As outlined in the introduction, the need to create a generation of designers in the nineteenth century led to the dominance of a skills-based discourse. Consequently, teachers focused on the technical aspects of art in their lessons, thus creating the required workforce.

In modern day Britain the National Curriculum embodies the 'official' educational discourses about art, supplied by the government. It can be viewed as a document which contains dominant discourses promoting the 'right' way to teach children, and it is used as a tool to regulate teaching practices. In line with the Foucauldian framework in this chapter, we examine how the National Curriculum works to shape teachers' understanding of art and their teaching practices.

The presentation of art in the National Curriculum

The following extract is taken from p. 116 of the National Curriculum. It is presented as an introduction to art in the curriculum and outlines what the government considers to be 'the importance of art and design' before the aims of each key stage are covered. Line numbers have been added to aid discussion.

Extract 1

The importance of art and design*

1. Art and design stimulates creativity and imagination. It provides visual, tactile and
2. sensory experiences and a unique way of understanding and responding to the
3. world. Pupils use colour, form, texture, pattern and different materials to
4. communicate what they see, feel and think. Through art and design activities, they
5. learn to make informed value judgements and aesthetic and practical decisions,
6. becoming actively involved in shaping environments. They explore ideas and
7. meanings in the work of artists, craftspeople and designers. They learn about the
8. diverse roles and functions of art, craft and design in contemporary life, and in
9. different times and cultures. Understanding, appreciation and enjoyment of the
10. visuals art have the power to enrich our personal and public lives.

* art and design includes craft.

In this extract the initial presentation of art as a subject which stimulates 'creativity' and 'imagination' (line 1) draws heavily on an understanding of art popularized by Cizek – focusing on the innate creative potential of the child. This understanding of art is elaborated upon in lines 3 and 4 as art is construed as a topic in which children use 'different materials' to 'communicate what they see, feel and think'. Hence artwork produced by children is construed as personal expression. Creativity and imagination are located within the child and reach the outside world through the manipulation of different art materials. The provision of lots of 'visual, tactile and sensory experiences' (line 2) is important in constructing this concept of art as these provide children the freedom they need to express their inner imagination and meet their creative potential.

It is important to stress that this understanding of art, in focusing on freedom and creativity, construes art as a subject where children do not 'learn' formally. Instead, learning is construed as being experimental – a by-product of providing the materials children need to express themselves. The failure to pay attention to the skill it takes to manipulate art materials construes child art as a natural expression, something in which children do not require formal training. Furthermore 'creativity' and artistic flair are positioned as talents which cannot be learnt.

This understanding of art echoes Rousseau's conceptualization of development as supported by Cizek. Hence, teachers are expected to take a child-centred approach to education and provide an environment in which children are given artistic freedom along with adequate art materials to create expressions of personal art.

Conversely, in line 5 of the extract a different conceptualization of art is presented as the focus shifts to child learning. Art lessons are construed as a vehicle through which children can make 'value judgements' and 'aesthetic and practical decisions'. The suggestion that children develop their understanding and appreciation of art 'through' taking part in practical art activities shifts away from the notion of inner expression but still locates any change in understanding as coming from within the child. Art is construed as a practical subject where children's aesthetic sensibilities develop through engaging with the art experience and creating their own artwork. Consequently teachers are given a more active role as they are expected to draw on their own values to facilitate the learning process through teacher guided art activities.

In lines 6–8 the teacher position shifts again as they are offered a more traditional role in shaping and informing child understanding of 'meanings in the work of artists' and the 'diverse roles and functions of art'. This focus on wider understanding of art from 'different times and cultures' signifies a shift away from the child and their development through practical art activities to art history. Following this understanding, art becomes a topic in its own right and works of art, their function and art history, the focus of study. The presentation of art in this way offers teachers an alternative position which places them in a traditional teaching role as someone who passes on their knowledge about art to the class, and facilitates the development of child knowledge about art.

To sum up, extract 1 illustrates how the curriculum dissects art into a subject made up of two components - the creative component (lines 1–4), which comes from within the child, and a taught

component (lines 5–8), where children are expected to develop their knowledge in specified areas. The final two lines of the extract place equal emphasis on 'understanding, appreciation and enjoyment', construing these as elements of visual art that 'enrich' our lives. Following this, in order to teach art successfully teachers must be able to achieve a balance between the taught elements of art to enable children to develop their 'understanding' and 'appreciation' and the child-centred approach to art which focuses on 'enjoyment' of the art experience.

The presentation of art at each of the key stages

After this introduction the National Curriculum for Art goes on to outline what children are expected to achieve at each of the government-defined key stages – Key Stage 1 (ages 5–7) and Key Stage 2 (ages 7–11). This section of the analysis examines the way the discourses outlined above are produced in relation to each of these key stages.

Key Stage 1

The following extract is taken from the National Curriculum (p. 118). It gives an overview of what pupils are expected to cover in Key Stage 1 art and design.

Extract 2

The presentation of art at Key Stage 1.

1. During key stage 1 pupils develop their creativity and imagination by
2. exploring the visual, tactile and sensory qualities of materials and
3. processes. They learn about the role of art, craft and design in their
4. environment. They begin to understand colour, shape and space and
5. pattern and texture and use them to represent their ideas and feelings.

Three discourses are used in this extract. At the beginning of this extract an expressive discourse dominates. As outlined in relation to extract 1, likewise in extract 2 (lines 1–3) art is construed as a subject in which children develop their 'creativity' and 'imagination' through 'exploring' different art materials. This focus on experimental learning is aligned with Piaget's theory of cognitive development as learning starts with the child exploring art materials and therefore assimilating knowledge about these materials. However, in line 3, the emphasis shifts away from exploration and promotion of creativity to the child's learning experience. The learning focus centres on developing the children's understanding of the 'role of art'. Correspondingly, this positions teachers as art philosophers and historians – they are expected to pass on their knowledge about what art 'is' to their class. However, in line 4 the learning focus shifts again – away from art history to children's understanding of the formal properties present in their own art such as 'colour, shape and space'. Consequently, the teachers' position also changes as they are required to work with the child to develop this understanding and the skills required to create appropriate forms and textures.

Key Stage 2

The following extract is taken from p. 120 of the Curriculum. It gives an overview of what pupils are expected to cover in Key Stage 2 art and design.

Extract 3
The presentation of art at Key Stage 2

1. During key stage 2 pupils develop their creativity and imagination
2. through more complex activities. These help to build on their skills and
3. improve their control of materials, tools and techniques. They increase
4. their critical awareness of the roles and purposes of art, craft and design
5. in different times and cultures. They become more confident in using
6. visual and tactile elements and materials and processes to communicate
7. what they see, feel and think.

This extract signifies a shift away from the expressive conceptualization of art presented in Key Stage 1 as instead, art is construed a skills-based subject. At Key Stage 2 (extract 3) more emphasis is placed on 'complex activities' which allow children an opportunity to develop the skills they need to be successful artists. This contrasts with 'creativity' and 'imagination' that are mentioned briefly in the first line. Therefore, the focus in this extract is on improving a child's 'control of materials, tools and techniques' (line 3) and developing their confidence in 'using visual and tactile elements...and processes' (line 6). This presents a skills-based discourse of art and in so doing extends beyond the conceptualization of art education outlined in the introduction to art in the curriculum (extract 1). Teachers are positioned as experts who teach children the skills required to create technically sound pieces of artwork. From a Piagetian perspective, this shift from exploration to a focus on technical skills echoes children's developmental shift from assimilation to accommodation. It follows that the child has learnt all they can through experimentation and more formal teaching methods should be employed.

In addition to the position of expert, the roles outlined in Key Stage 2 (extract 2) are also present. Teachers are expected to adopt a role of philosopher – someone who develops the children's 'critical awareness of the roles...of art' (line 4) and facilitator – someone who gives the children the space to 'communicate what they see, feel and think' (lines 6 and 7).

Discussion
In this analysis three distinct art discourses were presented – (1) art as an expressive subject (2) art as a skills based subject and (3) the history of art and art appreciation. Correspondingly, three teaching roles/positions offered by these discourses were outlined – (a) facilitator (b) expert (c) philosopher. The wider implications of these discourses in terms of roles and approaches available to teaching professionals will now be discussed in turn.

Art as an expressive subject and the role of the facilitator
In the curriculum, initially art is seen as a subject that provides children with an opportunity to express themselves – a place for creativity and imagination. Historically, this presentation of art can be traced back to Cizek's conceptualization of child art as an expression of the 'inner child' and artistic development as a natural process that should not be interfered with by adults. In line with this conceptualization of development, there should be 'no standards of correctness or excellence to be met and no rules to be obeyed', instead children should be free to create artwork in the way they want without adult influence (Arnheim 1989: 52).

This expressive discourse positions the teacher in a facilitating role where they simply provide the materials and the creative environment the child needs to express themselves and do not get involved in shaping the way the child approaches art. Indeed, adult intervention is construed as being undesirable because it prevents the child from expressing themselves in their own way. This resembles Lowenfeld's argument that teachers should not 'impose their own image on a child' and 'never let a child copy anything' because the teacher's input interferes with the child's creativity (Lowenfeld 1957: 14).

Art as a skills-based subject and the role of the expert teacher
The skills-based understanding of art presented at Key Stage 2 focused on the skills children need to 'control materials and tools' through mastering certain techniques. This approach to art education can be traced back to a nineteenth-century conceptualization of art that focused on developing the skills needed to create a useful workforce. The focus on skills and the expectation that children should develop their artistic ability to meet key stage targets echoes the understanding of artistic development put forward by Luquet, in which children overcome their drawing 'deficiencies' to produce more sophisticated, realistic pieces of artwork. Following this approach, the goal of art education is for children to develop the artistic skills necessary to move from 'scribbling' towards confidently using art materials and techniques such as shading and perspective as a means of creating visually realistic and accurate pieces of artwork.

As an expert, the teacher transfers artistic skills to the child. To teach young children techniques, Cooke, Cox and Griffin advocate the use of 'negotiated drawing' tasks with teachers playing an active role in helping children create visually realistic and technically sound pieces of work (Cooke et al. 1957). This teaching approach is reminiscent of the teaching methods advocated in the nineteenth century as teachers are advised that the best way to teach children to draw is to allow them to copy their own drawing technique.

Art appreciation and art history and the role of philosopher
Beyond the discourses presented in the curriculum which centre on the teacher's role in art education, art was also presented as a topic in its own right. Accordingly, teachers are expected to teach children about art history, the philosophy of art and provide them with the vocabulary they need to successfully and sensitively discuss works of art (Arnheim 1989). This philosophical discourse places teachers firmly in a traditional role as someone who passes knowledge to their class. This involves developing the child's awareness of different historical periods and artists associated with each historical style and introducing children to the cultural significance of art such as religious pieces or tribal art. In the role of philosopher, teachers are expected to grapple with issues such as exploring the message behind the artwork, the functions of art; and developing pupils' understandings of the aesthetic qualities of artwork.

Wider implications of the positions presented in the curriculum
As outlined in this analysis, the curriculum presents a number of different roles to teachers. When discussing the 'importance of art and design' the curriculum offers teachers three teaching approaches – the facilitator, the expert and the philosopher –and places equal emphasis on

each. When we examine the presentation of art at each of the key stages, we find that the differing teaching approaches are still present but the importance of adopting each role changes. The representation of art in Key Stage 1, for example, stresses the importance of expression and experimental learning. Therefore, teachers are expected to focus on their role of facilitator whilst the roles of philosopher and expert take a back seat. Conversely, the role of expert is highlighted in the representation of art at Key Stage 2. Consequently, teaching professionals are expected to concentrate on this role whilst still finding a place for the role of facilitator and philosopher.

The multiple understandings of art and the positions made available to teachers present a complex representation of art which could be construed as confusing. This situation is exacerbated by conflicting messages put forward by prominent researchers and art educators. When considering the role teachers have in aiding children to create their own pieces of artwork, two 'camps' have emerged – each with their own agenda. When addressing the question of how to teach art to children, Barnes is critical of 'free expression' and the Rousseauon philosophy that underpins this approach (Barnes 2002). For Barnes, this approach is somewhat *laissez-faire* and creates an environment where only the most creative pupils can survive. In order to remedy this he suggests that art should be taught like other curriculum topics such as Mathematics, because if children are just left to 'get on with things' they quickly become bored and frustrated as they cannot create the kind of work they would like to. Arnheim, on the other hand, is a strong supporter of 'free expression' (Arnheim 1989: 2). He is critical of the use of formal teaching methods which focus on skills such as those advocated by Cooke, Cox and Griffin. These methods, he argues, promote the 'mechanical correctness of producing images' and encourage 'mindless reproduction'. Therefore, a teaching approach focused on developing children's skills from a young age is problematic because it stifles creativity by passing on the message that 'good' art is a photographic copy of reality (Arnheim 1989: 33).

So where does this leave teaching professionals? They are faced with three very different teaching roles dictated in the curriculum and critiques centring on two of these roles – that of the 'facilitator' and 'expert'. If teachers choose to follow the advice offered by Barnes and teach art formally, how can the role of facilitator successfully be incorporated into this approach? If this is not done successfully, teachers might be accused of stifling the child's creativity by not offering them the freedom to express themselves. Similarly, if teachers choose to leave their class to express themselves in any way they see fit, will the absence of the 'expert' teacher allow children to develop as artists? Moreover, on a philosophical level, what message does each of these approaches send to the children about the purpose of art? These questions are not currently addressed in the National Curriculum. While teachers work to balance these roles, some consideration and discussion of these concerns would be beneficial for developing teaching practice.

When working in the classroom, teachers are left with little guidance to put the theoretical principles presented in the curriculum into practice. This means walking the fine line between allowing children the freedom to express themselves, training them in the technical skills they need to be successful artists, and passing on knowledge about the history of art. Teaching professionals are left in a difficult situation of knowing when to step in and take an active

role in helping the child create their artwork, and what kinds of help and task boundaries are appropriate. For primary school teaching professionals who do not have formal training in art, this is particularly problematic as they are faced with making choices of how best to approach the teaching of a topic that they are not familiar with – which can lead to unclear objectives in the classroom (Barnes 2002). Teachers are left to draw on their own values and experience to decide which approach to take, resulting in a lack of consistency in the type of art education children receive. Perhaps one solution to this problem would be to open up the debate surrounding art within the teaching profession. Through the discussion of teaching techniques and approaches to art education, individual teachers would be able to reach an understanding of what 'works' for them whilst fulfilling the stipulations of the National Curriculum.

References

Anning, A. and Ring, K. (2004) *Making Sense of Children's Drawings*, Maidenhead: Open University Press.

Arnheim, R. (1989) *Thoughts on Art Education*, Los Angeles: Getty Center for Education in the Arts.

Barnes, R. (2002) *Teaching Art to Children 4–9*, London: Routledge Falmer.

Burman, E. (1994) *Deconstructing Developmental Psychology*, London: Routledge.

Cooke, G., Griffin, D. and Cox, M. (1998) *Teaching Young Children to Draw: Imaginative Approaches to Representational Drawings*, London: Falmer Press.

Fineberg, J. (1997) *The Innocent Eye*, Princeton NJ: Princeton University Press.

Fineberg, J. (1998) *Discovering Child Art*, Princeton NJ: Princeton University Press.

Foucault, M. (1969) *The Archaeology of Knowledge*, London: Tavistock.

Lindstrom, L. and Darras, B. (Eds) (2000) *The Cultural Context: Comparative Studies of Art Education and Children's Drawings*, Stockholm: Stockholm University Press.

Lowenfeld, V. (1957) *Creative and Mental Growth*, New York: Macmillan.

Luquet, G. ([1927] 2001) *Children's Drawings/ Les Dessin Enfantin* (trans. with Introduction and Notes by Alan Costall), London: Free Association Books.

MacDonald, S. (1970) *The History and Philosophy of Art Education*. London: University of London Press.

Paley, N. (1995) *Finding Art's Place: Experiments in Contemporary Education and Culture*, London: Routledge.

Parker, I. (1992) *Discourse and Dynamics: Critical Analysis for Social and Individual Psychology*, Buckingham: Open University Press.

Rayment, T. (2000) 'Art Teachers' View of National Curriculum Art: A Repertory Grid Analysis', *Educational Studies* Vol. 24, No. 2, p. 165.

Robinson, G. (1989) 'Stimulus for Art in the Primary School: Historical Perspective', in A. Dyson (Ed) *Looking, Making and Learning: Art and Design in the Primary School*, New York: Kogan Page.

Saarnivarra, M. (2000) 'Art Education and the Place of Children. A Methodological Comment', in L. Lindstrom and B. Darras (Eds) *The Cultural Context: Comparative Studies of Art Education and Children's Drawings*. Stockholm: Stockholm University Press.

Tomlinson, R. (1947) *Children as Artists*, London: Penguin.

Willig, C. (2001) *Introducing Qualitative Research in Psychology: Adventures in Theory and Method*. Maidenhead: Open University Press.

5

IN SEARCH OF A CURRICULUM MODEL FOR THE PRIMARY SCHOOLS

Gillian Figg

Vol 4, No 1, 1985

At a time of deep concern about the state of art, craft and design education in our primary schools it seems very necessary to produce a framework of principles for teaching in this area, with the non-specialist primary school teacher in mind, also to provide practical examples of how the principles might be applied in the classroom. Being aware of these needs, I undertook a study, funded by the NSAE/Berol Curriculum Development Bursary, which stretched over a period of four terms, from one autumn to the next. During this time my objectives were:

1. To review some of the available material on art education at primary level that could provide a context for the research.
2. To draw up a series of teaching units that could be used to construct a programme of work.
3. To provide a range of supplementary references that non-specialist teachers might find useful.
4. To introduce the teaching units as a school-focused in-service education scheme with a pilot group of primary school teachers.
5. To monitor the interpretation and take-up of the teaching units when used by the group of teachers in their own schools.
6. To evaluate the results of the work in primary schools, leading to a review and modification of the materials produced for the project.

Providing a context for the research

In order to provide a context for the research it was necessary, first of all, to identify the problems in art education facing primary school teachers. From a number of surveys (DES, 1978; Eisner 1972; Denham 1980) it was possible to conclude that the difficulties I had encountered in primary art teaching at a local level were matched on a national and, indeed, international level.

The criticisms made by these surveys may be broadly summarized by fixing upon the following four important elements lacking in the art education of some primary school children.

1. The opportunity to work from direct experience and to be provided with stimulating visual resources.

Figure 1: The calendar (e.g. St David's Day) used as a stimulus for study of pattern: Drawing girls in Welsh costume from life, felt pen – Steven Godsall and Alison Sandford.

The 1978 Primary Survey (DES 1978) states that 'drawing or modelling from direct observation was rarely encouraged, although some interesting work arose in this way' (Para. 5.87) and that 'there is a need for children to be taught to observe more carefully and to record faithfully what they see and know' (Para. 5.94).

This is a reaction to the swing away from the use of direct experience as visual source material which has taken place over the last ten years, according to the Schools Council Bulletin *Art 7–17* (1978). It is associated with the following contributory factors:

■ The expansion of the art and craft industry and the consequent promotion of the new 'gimmicky' techniques by television presenters etc.
■ The growth of project work in schools, where children are encouraged to illustrate their work by copying drawings from books etc.
■ The ready supply of images from comics and colour supplements as secondary source material (p. 38)

2. The opportunity for a depth of experience with materials and techniques.

Eisner (1972) criticizes teachers because 'they frequently work on the assumption that the more material (they use) the better and often tend to equate a rich art programme with one that provides the widest array of art material.' He points out that this can result in children being deprived of the 'competencies that breed confidence in their own work', adding that 'Few of us like to participate in fields in which we feel inadequate' (1972: 24). Paragraph 5.94 of the Primary Survey supports this argument, pointing out that

the emphasis which has been placed on children using a wider variety of materials has in some cases resulted in children working in a superficial way. A more carefully selected range of art and craft activities worked at more thoroughly would enable children in the execution of their work to obtain more satisfaction from it. (DES 1978: para 5.94)

In the light of these comments, recent advice from the Schools Council *Working Paper 75* (1983) is misleading. It recommends that:

Children should quickly begin to work in different media, including paints, crayon, ink, paper, cane, cloth and clay. They experiment with different techniques, brushwork, collage, printing, fabric, brass-rubbing and modelling. They may start working with other materials, wood, metal, stone and plastic. (Schools Council 1983: 78)

Yet, in the next paragraph, it emphasizes the children's need for 'help in developing control over their materials and acquiring higher levels of skill and co-ordination'. It is questionable that any degree of skill may be developed by offering the wide range of materials listed. In the opinion of the Schools Council Art Committee , this leads only 'to the worst kind of superficial tasting' (1983: 36). A more realistic view of the general class teacher's task is indicated by the advice

Figure 2: Studies of friends (see Unit B: OTHER PEOPLE 1 'how your friend is feeling'): 'David feeling sad' (left), 'Owen feeling fed-up' (right) – Barry Bourne and Owen Gibbins.

that perhaps painting, drawing, plus one related material area is enough for any non-specialist teacher to handle with any confidence (1983: 36).

3. The opportunity to explore the historical and cultural aspects of art.

The tendency to over-emphasize the making of art at the expense of the more reflective and critical aspects of art education is a view put forward by Eisner (1972: 26) and supported by the Gulbenkian Report, *Arts in Schools* (Robinson 1982). The report argues that participation and appreciation are complementary aspects of art teaching, a tenet that had already been put forward by Read in 1942. He defined the activity of appreciation as 'the response of the individual to the modes of expression which other people address or have addressed to him and generally the individual's response to values in the world of facts' (Read 1942: 205).

4. Confident teaching.

One further major contributory factor in the 'decline in the quality and purpose of work in the 7–11 range' (School's Council 1978: 7) would appear to be a lack of confidence amongst

teachers. The Gulbenkian Report (1982) places the blame for this on teachers' initial training, pointing out that it does not include any compulsory arts element at all, or alternatively that students only practise the arts at their own level (Robinson 1982: 57). In the classroom, teachers are left with the problem of selecting content and are often left in a quandary about what to teach (Eisner, 1972: 25). For the primary school teacher who is often responsible for all subject areas, the task of deciding what should be taught can be extremely difficult. It would seem to require some kind of supporting agency to ensure that children are being given a balanced education. The Local Education Authority, as one kind of supporting agency, may provide guidelines for primary school art teaching although such provision opposes the tradition in this country of preserving the autonomy of teachers to develop their own individual responses to teaching the curriculum. Furthermore, it is apparent from the documents relating to primary art education that I received as part of my research that LEA provision is uneven. Some LEAs have not produced any material, while others provide guidelines of a high quality, both from the point of view of preparation and content.

Most of these guidelines reflect the ideas of four modestly produced but very influential publications: the two Schools Council Bulletins *Art 7–11* (1978) and *Resources for Visual Education* (1981), the HMI book *Art in Junior Education* (DES 1978) and a booklet called *Learning through Drawing* (Art Advisors Association 1978) published to accompany a travelling exhibition of children's drawing in the same year.

Designing the teaching units
The design of my own teaching units was heavily influenced by these sources, supported by the work of Eisner (1972, 1979), Barrett (1979), the Gulbenkian Foundation publication (Robinson 1982) and the earlier Schools Council project, *Children's Growth through Creative Experience* (Schools Council 1974). I was also able to capitalize on valuable practical experience gained as a member of the Schools Council Art and the Built Environment Working

Figure 3: A sequence: 'How to score a goal' – Steven Godsall.

Figure 4: A sequence: 'A day in my life' (see Unit A: WHO AM I? 4) – Owen Gibbins.

Party Project (1980–82) in West Glamorgan. This provided opportunities to work together with the project officers, other teachers, architects and planners to develop and then implement study methods, designed to foster in children an awareness of the built environment.

Because of the constraint of working within a time limit for the research study, the background reading and review of source material had to be highly selective. In my examination of the curriculum models which exist in art education, the main types include those based on techniques, psychological conceptions of art, elements of creative design and anthropological and historical approaches (Feldman 1982: 2–45). In addition to these, Eisner (1979) has proposed a model structured upon three domains (the productive, the critical and the historical) and Allison (1982: 59) presents a model based upon four domains: the expressive/productive; the analytical/ critical; the historical, and the cultural. While many of these models may offer

Figure 5: A sequence: drama theme '... change your friend into a horrible monster' (see Unit B: OTHER PEOPLE 2) – Steven Godsall.

Figure 6: 'My foot' by Penny Williams, 11 years (see Unit A: WHO AM I? 3.

Figure 7: 'My foot' by Vicky Stock, 10 years.

Figure 8: Pencil drawings to serve as a basis for a printed design by Liane Woodward, 11 years (see Unit C: THE ENVIRONMENT 5).

the secondary school art and design specialist a useful framework within which to evaluate and develop an appropriate curriculum, the complexity of some of the models and the highly specialized language used to describe their features render them inaccessible to the primary school non-specialist. Indeed, certain models, in particular that described in the recently published Assessment of Performance Unit Document, *Aesthetic Development* (1983), seem so complex that they are likely to confuse rather than help the classroom teacher.

While the specialist art teacher may be able to select the appropriate model or models and operate from his/her strengths, according to training and inclination, non-specialists are not often in a position to do this. They usually require help so that they may clarify the issues. A clear, direct and unambiguous curriculum model is needed, in order to determine the balance of content for the work programme.

A curriculum model

The model shown in the diagram represents the relationship between the child and his/her environment as the foundation for the curriculum, described by Lowenfeld (Lowenfeld and Lambert Brittain 1975) as a 'basic ingredient of a creative art experience'. The child exists in the context of her/his own culture, both historical and living.

The three separate sections:

- Visual Elements
- Techniques, Media and
- Materials

Functions of a Visual Education depict WHAT occurs when a child makes art, and HOW it occurs. For example, if a child has found a sea shell on the beach, she/he has probably experienced some kind of initial sensory response from looking at it and holding it. She/he may want to record that visual aspect of the shell which appeals most. It may be that the shell has a pleasing feel to it, and fits happily into his/her cupped hand, in which case a plastic material such as clay will best lend itself to the child's expression. The cycle of the art activity begins and ends with appraisal: in the first place with an aesthetic appraisal of the sea shell, then with an appraisal of the activity or process, and finally of the product itself.

In this activity, something from all five of the different elements included in the diagram has been touched upon:

(i) the child's relationship with the environment
(ii) the aesthetic appreciation of the shell (i.e. the cultural element)
(iii) the sensory and tactile perception of its visual properties (e.g. form, pattern, texture)
(iv) the choice of clay as the material/medium; and modelling as the technique
(v) the desire to record, express and communicate what she/he sees and feels about the shell, and the appraisal of his/her response.

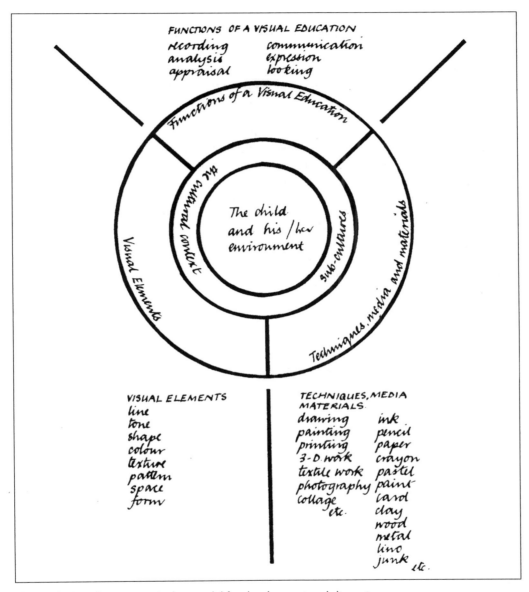

Figure 9: A preliminary curriculum model for development and discussion.

Within the child-centred thematic framework of the teaching units, it was hoped to furnish children with a balance of those different elements, and so provide opportunities to:

1. Develop in children a more sensitive visual perception, mainly through direct experiences.
2. Encourage a thorough understanding of the properties of certain specified materials and media.
3. Practise certain skills (related to, e.g. drawing, painting, etc.).
4. Encounter a balance of two-and three-dimensional work.
5. Experience a balance of the six stated functions of a visual education, i.e. looking, recording, analysis, communication, expression, and appraisal.
6. Study all of the visual elements (tone, line, pattern, texture etc.).
7. Introduce an aesthetic awareness of cultural and historical aspects of art.
8. Encourage self-evaluation and the foundations for development of a critical vocabulary.

It was strongly felt that although the teaching units should provide a clear and unambiguous guide for the teacher, they should also actively encourage personal and individual response, both from the point of view of child and teacher.

In an evaluation of his curriculum development project for primary schools, Eisner (1979) had observed:

> We erred in attempting to develop materials that needed little or no in-service education, that over-emphasised instructional objectives, that paid too much attention to the development of technical skills and provided too little opportunity for the exercise of imagination, that were too prescriptive regarding sequence. (Eisner 1979)

In the condensed version of excerpts from the teaching units present here it may be noted that, while the activities are child centred, they also provide a depth of experience in certain media, in order to promote competence in specific skills.

An area that perhaps invited a more structured approach than the three child-centred units allowed for was colour. Teaching children about colour through the use of paint can be problematical in the junior school. Pupils who, as infants, used paint with panache seem to become inhibited as they get older, often because they are not given sufficient scope to develop the skills necessary for improvement. Too often, paintings are nothing more than coloured-in drawings and children frequently choose not to use paint lest it 'spoil' their drawings.

A separate unit of work was developed dealing with colour, although teachers would be advised to integrate it with the child-centred units, rather than consider it as a completely independent unit. This decision was made in the light of actually putting the first draft of the colour unit into practice in my own classroom. Originally it was planned to span at least half a term, but it soon became apparent that a great deal of learning could be absorbed in two or three lessons. Children seemed to need a period of reflection in order to assimilate the

experience gained. In Eisner's (1979) evaluation of his own curriculum development project, he observed that in future he would not attempt to provide a sequence longer than three lessons. In fact, his programmes had been designed in sequences of seven to ten lessons.

The discrepancy between what is anticipated by the researcher and what actually happens in the classroom is worth noting. To be a practising teacher who is simultaneously involved in research is a chastening and enlightening experience and injects a strong sense of realism into curriculum theory.

The first draft of the teaching units was now complete and required testing by a wider audience of teachers and children. For this purpose, an in-service course of nine weeks was organized with the support of an enthusiastic local Teachers' Centre Warden.

The in-service course and evaluation of the teaching units

The main purpose of this course was to present the units of work and discuss them with non-specialist teachers who would then test them in their schools. However, during the first two introductory meetings it became obvious that the teachers would need some instruction in basic art theory and experience with materials and techniques at their own level. It was stressed that this experience was provided so that the teachers would themselves appreciate the difficulties that children would encounter rather than to demonstrate to the child how he/she might respond. It is difficult to prescribe a specific pedagogy for the art lesson, although it would seem that the kind of stimulus offered for a good creative writing lesson might be similarly applied to the art activity, e.g. direct, sensory experiences and plenty of opportunity for carefully structured discussion.

One of the most significant aspects in the cycle of an art activity is assessment and evaluation, and more often than not, this is simply not considered by many primary teachers. Giving children the opportunity to ponder and reflect on their own work and that of their peers shows them that it is valued. It also helps them to see how they might improve, through discussion with the rest of the class.

In-service course members were specifically asked to spend some time after each completed art project in promoting this session of self-assessment by the children. In the case of older Juniors, the responses might also, for example, be written:

1. 'Whose work do you like best? Why?'
2. 'What do you feel about your own work?'
3. 'Compare it with the piece of work you like best, and decide what you would need to do to improve your own next time.'
4. 'What did you think of the medium you were using?'

Being specific about how a piece of work might be improved gives children something concrete to relate to. It also elevates the standing of the art activity in their eyes and develops positive attitudes for future art lessons.

UNIT A: WHO AM I?

Activity	Techniques, Media & Materials	Visual Elements	Art Functions	Curricular links	Purpose of the Activity
1. Mark-making with a variety of pencils	Pencils - as many grades as possible.	Line Rhythm Tone	Expression	Language - vocabulary: thin, thick; long, short; straight, curvy, strong, weak; etc.	To familiarise children with the properties of the various grades of pencil
2. Self portraits using mirrors	Pencils various grades. Children may use more than one grade in their drawing if they wish	Line Texture Pattern	Recording Analysis Expression	Begin a biographical notebook - both visual and verbal: an "IDENTIKIT" - photographs, letters, cuttings, drawings, writing etc.	To extend knowledge of properties of the pencil. To encourage careful observation.
3. Drawing hands and feet - tensed, relaxed, contorted.	Pencils - variety of grades.	Line Tone Shape	Recording Analysis	Careful written descriptions of hands and feet. A companion - what hands do that feet can't, etc.	To encourage careful looking. To give further opportunities for using pencils of different grades
4. A day in my life - drawing time sequences.	Black felt markers	Line Texture Pattern	Communication Expression	Initial drama session to introduce theme. Also a written account of "A day in my life"	To introduce a new medium - & encourage direct mark-making. Also to allow for an ordering of thoughts, first through drama, then drawing
5. A drawing or painting of you wearing what you have on at the moment.	Choice of coloured drawing materials (pencils, crayons, pastels) or paint or mixed media	Line Texture Pattern Colour Tone Shape	Recording Analysis	Science: children can find out what each garment is made from - experiments with different fabrics. Language: favourite clothes; clothes you hate wearing, etc.	To introduce coloured media. To encourage sensitivity to texture and pattern.
6. A drawing of the thing you like playing with best - from observation if possible.	Choice of media - pencils, charcoal, black felt marker, coloured drawing materials.	Line Texture Pattern Colour Tone Shape	Recording Expression	Language: why have you chosen this article in particular? Describe an incident to illustrate your answer.	To provide the opportunity for personal autonomy in the choice of materials to be used.
7. Paint a big plate on a patterned cloth. On it paint your favourite meal. Look at some appropriate paintings e.g. Matisse, Cezanne	Paints or Mixed media (colour)	Colour Pattern Shape	Communication Expression Appraisal	Language: descriptions of food (Tolkien, H.E. Bates etc.) Science - tasting experiments.	To provide further opportunities to use colour and paint. To introduce an appreciation of the work of others

Figure 10: UNIT A - WHO AM I?

UNIT B: OTHER PEOPLE

Activity	Techniques/Media & Materials	Visual Elements	Art Functions	Curricular Links	Purpose of the Activity
1. Make a study of a friend – find out as much as you can about him/her. Make a visual study, recording as faithfully as possible, including how your friend is feeling (e.g. sad, happy, worried, etc.)	Black felt marker – to encourage direct and spontaneous mark-making	Line Texture Pattern Shape	Recording Analysis Expression Communication	Drama – perform any work – children can pretend to be blind & feel friends hair, head, features, etc. Describe WITHOUT looking. Mime whatever your friend does – imagine s/he is looking at his/her reflection in the mirror – YOU are the reflection.	To build on experiences of looking and drawing
2. Fold a sheet of A4 into 6. In the top L-hand square draw your friend. Now EITHER a) change your friend into a horrible monster OR b) make your friend grow older.	Black marker – coloured markers may be used if wished. (cf comic strip)	Line Texture Pattern Shape	Recording Expression Communication	Drama – theme of metamorphosis e.g. Jekyll & Hyde, Snow White, Frog Prince etc. Collect comic strips of horror pictures, monsters etc.	To encourage children to use drawing to order their thinking for the logical organisation of the sequence
3. Following on from dramatic aspects of previous activity make a mask. Look at photographs, slides/real masks in museums.	Various materials – fabric, feathers, sequins, papier maché, paper bags, cardboard tubes, cardboard boxes, paper strips, etc.	Form Pattern Colour Texture	Expression Communication	Extension of previous drama lesson. Children may like to work in groups and write a "horror" story or play.	To give children experience with three dimensional materials. Problem solving i.e. must fit well & allow wearer to see
4. Develop the face in a different medium e.g. clay (relief) weaving appliqué print	Materials as indicated; class may be divided into groups and work in all four media.	Form Texture Pattern Colour etc.	Expression Communication		Experience of a different medium – learning to adapt an idea in another material area
5. Model of a group of people, e.g. a bus queue, a rugby scrum, children playing. Think of the model as being one whole unit, not a number of individual figures	Clay	Form Texture Rhythm	Expression Communication	Movement work in groups – figures linked in a common activity.	Further experiences in 3 dimensions
6. Make a scrapbook or "storyboard" about your friend using any means of documentation drawing, writing etc.	Drawing materials Writing Cameras/film Tape-recorders etc.		Recording Expression Communication Analysis Appraisal	Discussion work – children to interview partners, then write a comprehensive description.	To develop a variety of means of communication and documentation. To develop both sensory and cognitive perception.

Figure 11: UNIT B – OTHER PEOPLE.

UNIT C: THE ENVIRONMENT

Activity	Techniques, Media & Materials	Visual Elements	Art Functions	Curricular Links	Purpose of the Activity
1. Memory map. Describe your journey to school visually. There may be places you pass that you like/dislike etc. OR a plan of your own house OR a plan of your school	Black markers - coloured markers, inks, etc.	Line Texture Pattern Shape Colour	Recording Expression Communication Appraisal	Drama - re-enact journey to school. Whom do you meet on the way? Are there places you are afraid of, etc. Dialogue as you meet your friends on the way	Memory maps - to see how much the children know and how much they don't know. Drama activity - to stimulate memory and feelings.
2. Outside, make a trail around the school (or further afield) imagine that a stranger has to follow your plan using any clues you can provide.	Pencils or felt markers - allow children to choose. (no colour) Chip boards	Line Texture Pattern Shape	Recording Analysis Expression Communication Appraisal	Language - a verbal or written description of your trail.	To encourage careful looking and more acute awareness of the environment.
3. Sensory experience of the trail: a) TOUCH: make rubbings of all the interesting textures you encounter b) record with drawings and/or words what you smell and hear on your trail	a) wax crayons kitchen paper b) markers or pencils A4 duplicating paper Clip boards	Texture Pattern	Recording Analysis Expression Communication Appraisal	Language work: poems, discussion, writing about the senses. Science: the senses Drama: imagine life without one of your senses.	To gain a sensory experience of the environment - to heighten sensory awareness
4. Using a viewfinder as a focussing device, make a careful, analytical drawing of a feature you have noticed on your trail that is of particular interest to you	Felt marker or pencil A4 paper Chip board Viewfinder (e.g. inside of toilet roll; matchbox cover; rectangle of card with cut out 'window'.	Line Texture Pattern	Analysis Appraisal	Language - description of feature chosen; recording of responses to, and feelings about, the feature.	To begin to investigate certain elements of the trail in greater depth. To encourage a feeling response to the environment.
5. Make a print using the drawing made in the previous activity as a point of departure	Polystyrene printing tile (e.g. Berol "Pressprint") OR monoprint technique	Line Texture Pattern	Expression Recording		Introduction to a simple form of printing which can subsequently be developed into more complex techniques.
6. Make a presentation of all your work — e.g. slide/tape sequence; hire presentation; exhibition etc.	Appropriate materials		Communication Appraisal	Prepare a script; story board; shooting script etc.	To communicate responses/feelings to others. To reflect on own & other's experiences.

Figure 12: UNIT C – THE ENVIRONMENT.

UNIT D: COLOUR

Activity	Techniques, Media & Materials	Visual Elements	Art Functions	Curricular Links	Purpose of the Activity
1. Using coloured cellophane on classroom windows invite children to talk about their responses when looking out through the different colours	Red, blue, yellow cellophane	Colour	Expression Communication Appraisal	Language - oral description of feelings evoked by the different colours	Introduction to colour and its effect on the emotions.
2. Children can be given pieces of different-coloured cellophane & asked to see how many different colour combinations can be achieved.	Red, blue, yellow cellophane. May also like to use overhead projector to show admixtures of colour.	Colour	Recording Analysis	Science - children may record or chart the colours made. Further work is suggested in Schools Council Science 5-13 unit on colour.	Introduction to colour mixing
3. Choose one of the primary colours and collect objects in this colour for a display (e.g. red) Groups of children may like to take it in turns to arrange the displays	All kinds of visual resources- natural & man-made - from palest pink to reddish-brown	Colour Texture Form Pattern etc.	Expression Analysis Appraisal	Discussion - children may like to decide how to organise the display; e.g. "warm" reds and "cool" reds; a dark reds & light reds a reds you like reds you don't like	Developing a more discriminating perception of colour - an appreciation of the various tones and shades that exist under the umbrella name of a given colour.
4. EITHER: a) draw an irregular grid on your paper (e.g. pretend you are drawing a wall) OR: b) fold your paper into about 16 compartments. Mix reds to match those in the display and fill each compartment	Cartridge paper paints brushes	Colour	Analysis Appraisal	Appraisal - discuss the colours that result. What names can you give them? e.g. tomato ketchup red, bubblegum pink, etc. Children might like to make a chart to record how they mixed the colours.	To give experience and confidence in colour mixing. To develop colour perception.
5. Make a RED picture: EITHER: a) from direct observation of some of the things in the display OR: b) from imagination e.g. The Fiery Furnace The Red Planet The Firebird	Cartridge paper paints brushes (of various sizes)	Colour Shape Form Pattern Texture etc.	Expression Communication Recording	Drama, music and language work stemming from the colour red and all its implications: e.g. heat anger danger	To give children the opportunity to use some of the skills they have developed in an expressive way

Figure 13: UNIT D – COLOUR.

The teacher's formal assessment of the child is more problematic. It is pointed out in the Gulbenkian Report, *The Arts in Schools* (Robinson, 1982) that grades, percentages, or rank positions do not constitute assessment and are not essential to it. Assessments are not statements of absolute ability, but about achievement. Best (1982) maintains that 'assessment in the arts, as in so many spheres of education, is necessarily a matter of judgement... sensitive high quality judgement, which again emphasises that there can never be a substitute for sensitive, high quality teachers.' Finding a satisfactory model for a framework within which the teacher can express his/her judgements is extremely difficult for the non-specialist primary teacher. In order for it to be meaningful to all teachers within a given primary school, it would need to be discussed by all members of staff. A whole school policy is essential, with a common vocabulary that is agreed and understood by the whole staff. The Gulbenkian Report (Robinson 1982) advocates greater opportunities for in-service training in this 'critical area' of developing effective patterns of assessment.

Assessment in art education was discussed during the in-service course, but it was felt that the scope of the project was too limited to deal adequately with such a complex area. A further course or school-based, in-service work would be required. In the meantime, the Summer Term was given to testing the teaching units in schools. I had originally planned to monitor the 'interpretation and take-up' of the units in the schools concerned, but unfortunately it was not possible to fulfil this satisfactorily, due to my own teaching commitments. However, I did have the opportunity to visit six of the course members in their own classrooms, to photograph some of the work and to talk informally with the children. A date was set for a final meeting in the autumn, when teachers were asked to bring along all the work they had done relating to the teaching units, so that it could be discussed and experiences shared.

Course members were generally supportive of the work units and all said they felt more confident in teaching art. Ambiguities in the writing of the lessons were pointed out although, on the whole, teachers felt that the ideas were clearly stated. One teacher thought that, 'if anything, they were over-simplified'. What the course members appreciated most were the opportunities for making links with other curriculum areas, e.g. the Schools Council *Science 5–13 Project* (Colour, Myself, etc.), drama and language work and also environmental studies.

The period of the Bursary was now coming to an end, yet the curriculum development project was poised for a second phase which would benefit considerably from the experiences gained during the course of the study.

By the following Spring Term it was necessary to present the findings of my research study to the NSAE/Berol Bursary Panel, and this took the form of a 170 page Research Notebook. Although I am now aware of personal shortcomings in many parts of the report, the work appears to have attracted considerable interest and the hundred copies, which the Bursary enabled me to publish, were soon disposed of.

Since publication of the Bursary Report, there have been several new developments in my research study. A second draft of the teaching units was written and put together in booklet

Figure 14: The entrance to my school: Berol press print (see Unit C: THE ENVIRONMENT 5).

form ready for a further in-service course the following Autumn Term. The focus of this course differed from the previous one and consisted of three integral components: a basic philosophy and theory, opportunities for teachers to practise with materials and techniques at their own level, and some group discussions.

The teachers' evaluation of this second course generated some interesting points: the interface of philosophy with practical experience was appreciated, and the opportunity for discussion found to be both stimulating and valuable for all concerned. Generally, the course members felt that further follow-up courses were needed in specific areas of art education, for example, evaluation and assessment, display, work in textiles, clay, problem-solving and design and more experiences with colour and paint. Future plans include a third in-service course to follow up some of the points raised.

Since completing my initial research study, I have been granted a two-year secondment by my LEA to develop the work further within an Institute of Higher Education. This includes lecturing to BEd students concerning art and design education in the primary school. It has given me greater independence than I had as a general class teacher and offers far more scope to experiment further with both school and college based curriculum development projects.

In considering the outcome of my research study, it would seem that the stated aims of the NSAE/Berol Bursary have been most appropriately achieved:

1. 'To promote school and college based curriculum development and evaluation in the teaching of art and design.'
2. 'To encourage the professional development of art and design teachers and lecturers.'

This chapter is a brief survey of the research carried out by the author for the NSAE/Berol Bursary of 1980.

References

Allison, B. (1982) 'Identifying the core in art and design' *Journal of Art and Design Education*, Vol 1, No. 1, pp. 59–66.

Art Advisors Association (1978) *Learning through Drawing*, Bradford.

Assessment Of Performance Unit (1983) Discussion Document on the Assessment of the Aesthetic Development through Engagement in the Creative and Performing Arts.

Barrett, M. (1979) *Art Education: a Strategy for Course Design*, London: Heinemann Educational Books.

Best, D. (1982) 'Accountability: Objective Assessment in Arts Education', Paper: Department of Philosophy, University College of Swansea.

Davies, I.K. (1982) 'Evaluation of Bursary Project: Progress Report', London: Department of Education and Science.

Department of Education and Science (1978) *Art in Junior Education*, London: H.M.S.O.

Department of Education and Science (1978) *Primary Education in England*, London: H.M.S.O.

Denhamp, (1980) 'Primary Art and Craft: a Framework for Development', *Service Children's Education Authority Bulletin No. 19.* Autumn 1980.

Eisner, E.W. (1972) *Educating Artistic Vision*, New York: Macmillan.

Eisner, E.W. (1979) *The Educational Imagination*, New York: Macmillan.

Feldman, E.B. (1982) 'Varieties of Art Curriculum', *Journal of Art and Design Education* Vol 1, No. 1, pp. 21–45.

Lowenfeld, V. and Lambert Brittain, W. (1975) *Creative and Mental Growth*, New York: Macmillan.

North Eastern Region of the Art Adviser Association (1978) *Learning through Drawing*. Bradford: Art Advisers Association.

Read, H. (1942) *Education through Art*, London: Faber and Faber.

Robinson, K. (ed.) (1982) *The Arts in Schools*. London: Calouste Gulbenkian Foundation.

Schools Council (1978) 'Art 7–11'. Occasional Bulletin from the Subjects Committee.

Schools Council 'Art and the Built Environment Project 1976–82', Project Directors 1980–82, Eileen Adams, Ken Baynes: Project Officers: Roger Standen, Gill Streater.

Schools Council (1974) 'Children's Growth through Creative Experience: Research and Curriculum Development Project in Art and Craft Education 8–13', London: Van Nostrand Reinhold Company.

Schools Council (1983) 'Working Paper 75: Primary Practice', London: Methuen.

Schools Council (1981) 'Visual Resources in Art Education', Occasional Bulletin from the Subjects Committee.

Local Education Authority Documents Received

City of Birmingham Education Department (1980) *Further Developments in the Primary Curriculum: Art and Craft.*

County of South Glamorgan (1981) *Guidelines for Art and Craft 2–11.*

Inner London Education Authority (1981) *Learning to Look.*

Inner London Education Authority (1981) *Looking.*

Inner London Education Authority (1981) *Starting.*

Hereford And Worcester County Council *Art for Starters.*

Michael Moore: *Primary Art.* Hertfordshire Art Advisory Service.

Staffordshire Education Committee *Guidelines for Art and Craft 5–13.*

Suffolk County Council *Art in the Middle Years of Schooling.*

In Search of a Curriculum Model for Primary Schools, JADE Vol 4.1 (p. 35–52): A response

Reading through this paper again, over 20 years after I wrote it, I blush at how certain I was that I could produce a 'clear, direct and unambiguous curriculum model for primary art education.' What seemed to me at the time to be obvious and simple now seems far more complex.

However, it is important from the perspective of today to understand the context within which I did the research. At the time, support for primary school art teaching was very patchy across the country. HMI had not succeeded in producing a subject document in art, although there was one for every other subject in the school curriculum. Not surprisingly, they had failed to agree on a final draft. Some LEAs had produced helpful guidelines for primary schools, many of them founded on work carried out by the Schools Council. A name that stands out as being most influential and most tuned in to the needs of the primary school teacher was Bob Clement, then Art Advisor for Devon. His contribution to primary art education (and to me personally) has been colossal.

At the time, though trained initially as a secondary school art specialist, I found myself, for various domestic reasons, teaching in the local primary school. There was no scheme of work for art, either in the school or in the LEA. My teaching colleagues would ask me for advice, often in the staff room at lunchtime: 'What can I do with my class this afternoon?'

I knew that I should do something about the situation, and began to look into it seriously. Then winning the NSEAD/Berol Bursary concentrated my thoughts considerably and I eventually produced a hefty tome, of which I made a hundred copies. These were requested by teachers across the country who attended the NSEAD-run conferences where I presented the research.

Subsequently, I was seconded to Swansea Institute of Higher Education to work with BEd students and also with teachers on in-service courses, both at BEd and MEd level. Here I continued with my research into art education, working towards an MPhil.

In 1990, I was invited to be a member of the National Curriculum Art Working Party, a unique experience which added considerably to my own professional development and understanding of art education.

Latterly, I have been working as an independent inspector of schools, both in the primary and secondary sector, and have had the privilege of seeing some superb teachers as well as some at quite the other end of the scale.

All of these experiences have contributed to making me realize that, notwithstanding all the published guidance and National Curriculum documents in the world, the crucial factor in the end is the quality of the teaching: how well does the teacher understand the subject and how well does the teacher understand the child? How can primary school teachers best be nurtured to develop this insight? After a career in art education at all its various levels, I still don't know the answer.

As a post-script, most recently I have been helping to look after my six little grandchildren and watching them as they make their own art. They approach their work with such assurance, needing no intervention

on my part except as a provider of materials. I hope that this confidence will not be destroyed in future by heavy-handed teaching.

I wonder now whether I imposed too much on my own pupils in the past and maybe the art education I gave them was too much based on objective observation and not enough on more subjective aspects. The words of a teacher who attended one of the NSEAD conferences at which I spoke in those early days often come back to me. She was a primary school teacher from the north of England and said to me, very gently, in her quiet voice: 'Do you not give your children some enchantment, Gillian?' It cut me to the quick.

Did I, I wonder? I hope so. Somewhere in that search for a 'Curriculum Model for Primary Schools', I hope I also managed to give them some enchantment. It's certainly what I would want for my grandchildren.

Gillian Figg, 29 September, 2008

6

Compatibility; Incompatibility? Froebelian Principles and the Art National Curriculum

Margaret Payne

Vol 12, No 2, 1993

Note: This chapter refers to the first version of the National Curriculum: *Art in the National Curriculum*. England, DES / HMSO published in 1992.

In an article in The Guardian 19th May 1992, Jonathan Croal suggested that Froebel's educational ideas have been so persuasive that they have been quite simply absorbed into the system. The implication of this statement with regard to schools of the 1990s begs consideration, notwithstanding the evident truth that generations of primary school children throughout the UK have been taught by Froebel-trained teachers. Thus many children will have experienced in varying degrees – and their approach to learning influenced by some of the aspects associated with – a Froebelian education. The *Hadow Report* in 1931 reflected the extent to which Froebelian practice had become acceptable at that time in acknowledging that 'the curriculum ... is to be thought of in terms of activity and experience, rather than knowledge to be acquired and facts to be stored' (Croal 1992).

Phrases such as 'child-centred education', 'investigatory approach' and 'integrated learning' are associated with primary school practice and betray Froebel's influence in schools. Froebel's educational principles were formulated and revised in various writings in the last century. Froebel put forward a holistic view of needs, as he envisaged them, to be considered in planning an educational provision for a child, and the process to achieving it. Courthope Bowen

identified and summarized that at the heart of Froebel's system is 'the practical application of the principles of self-activity...together with the doctrines of continuity and connectedness' (Courthope Bowen 1907: 54) These principles and doctrines pervade all aspects of the provision – content, method, atmosphere – and are intended to be the means whereby the opportunity is offered to 'lead and guide man to clearness concerning himself and in himself, to peace with nature, and to unity with God (Froebel 1885).

Although the mode of writing reflects a bygone age, and some of Froebel's reasoning, for example in trying to make law and unity apparent in everything, show in Courthope Bowen's words 'artificiality and mere fancy' (Courthope Bowen 1907: 50), much of what is central to Froebel's argument has withstood the test of time. Appraisal and modification have updated the ideas to make them relevant to current needs. For instance, Tina Bruce is one of a line of educationalists to put forward revisions. By analysing the meaning behind selected statements by Froebel she made a case for the educational process as an 'interaction between the child and the environment...and knowledge itself' (Bruce 1987: 172) – the implication being that knowledge needs to play a greater role within a child-centred education than had been the norm in the 1960s and 1970s.

With the advent of the National Curriculum the question arises as to whether the teaching of young children in the public sector can continue to be underpinned in the Froebelian tradition. As many Froebel-trained teachers work in schools, and indeed students continue to be trained in the tradition, it is important to consider if the National Curriculum can be delivered, as all teachers in state schools are bound to do by law, without the teacher compromising his or her integrity with regard to educational beliefs. Froebel's ideas may have been absorbed into the system (as writers such as Croal (1992) claim) and presumably, if this is so, will be evident in the core and foundation subjects. If this factor can be recognized in the content and approach of the programmes of study there will be compatibility between the two systems – this will be good news for Froebel trained teachers currently working in UK primary schools. This chapter, then, considers the extent to which one can recognize the assimilation of Froebel's thinking in the Art National Curriculum.

The Art National Curriculum

The Art National Curriculum for England is designed to cover schooling from 5 to 14 years and the Programmes of Study (PoS) are detailed under two headings, 'Attainment Target 1 (AT1): Investigating and Making', AT2: Knowledge and Understanding. Learning to be tackled is banded under strands, viz. for AT1 (1) recording, (2) using resources, (3) using different materials and techniques, (4) reviewing and modifying, and, for AT2, (5) knowledge of different kinds of art, (6) knowledge of different periods, cultures, traditions, influential artists, (7) applying knowledge of the work of artists to own work (NCC 1992; 83). These strands stretch through each Key Stage (KS) offering continuity in learning but differentiality in approach. For example, the emphasis for AT1 at KS1 is for teachers to plan work that allows children to be engaged in exploring, ref. PoS (4)–(8) (DES 1992; 4), whereas at KS2 planning should allow for experimenting and applying this knowledge, ref. PoS (4)–(9) (DES 1992; 6), Appropriately,

work in the latter stage is more advanced as children must use their experimentation and put it to purposeful use. Similarly with regard to AT2 the stress in the PoS at KS2 is about understanding, discussing, comparing (ibid: 7) and replaces the simpler notion of looking at and talking about that predominates at KS1 (ibid: 5). Thus there is a sense of sequencing and of promoting learning to build onto previous learning.

Froebel (1885), in discussing the subjects of instruction he proposes, indicates the value of a sequenced curriculum. He clarifies how the sequenced curriculum relates to the child's growth, gives reasons why subjects are included and sets this thinking within the context of his beliefs about education. Contrary to this, the rationale of the National Curriculum has never been fully explained or its overall values highlighted. Admittedly, each AT in each of the core and foundation subjects has what might be called an aim, but it is specific to that bit of the curriculum. For instance, With regard to AT 1 of the Art Order the following heads the text: 'the development of visual perception and the skills associated with investigating and making in art, craft and design' (DES 1992: 2), and, for AT2, a similar brief statement is given:

> The development of visual literacy and knowledge and understanding of art, craft and design including the history of art, our diverse artistic heritage and a variety of other artistic traditions, together with the ability to make practical connections between this and pupils' own work. (DES 1992: 2)

John White argues that the National Curriculum (NC) intentionally prevents 'thought about fundamental values' (White 1988: 122) to the ultimate advantage of the power-holding minority body. Political discussions apart, the lack of aims does leave an unresolved question that a thoughtful teacher will search to answer. It is unclear if this leeway allows for personal interpretation, in tune with whatever educational beliefs one might hold, or if teachers would be out of step to question it. I will leave this point with the recollection that Froebel said 'only thoughtful persons ought to teach' (DES 1992: 2)

By the manner of its inclusion in the National Curriculum, one supposes art is recognized to be of value in the capacity of a foundation subject rather than of the core. In contrast, Froebel details how, in observing the child, one will be shown the 'nature and requirements of human development at the stage of boyhood' and have the answer to what should be on the curriculum (Froebel 1885: 263). The importance of art is spelt out in a somewhat complex and overworked argument showing the artist, as a creator, to have attributes similar to God the creator of nature (ibid: 137). Relating this to classroom level he concedes that:

> ... art and appreciation of art constitute a general capacity or talent of man ... A universal and comprehensive plan of human education must ... consider at an early period ... drawing, painting and modelling; it will not leave them to an arbitrary, frivolous, whimsicalness, but treat them as serious objects of the school. (Froebel 1885: 227–8)

These being areas of study that should be treated seriously, Froebel plans a sequenced curriculum for art which is neither arbitrary nor frivolous but almost prescriptive by twentieth century standards of art education. It seems a far cry from Froebel's dictum, and from Froebelian-trained teachers observing children and planning a curriculum in response to their needs. It would suggest he may have meant that one needed to observe children in order to gauge and then to respond to stage characteristics, rather than planning a curriculum in response to observing each individual child, as has been attempted by Froebelian teachers.

In planning a course of instruction in drawing, Froebel (pp. 288–295) offers a curriculum for all to follow that progresses from exercises to representation. The pupils begin by drawing vertical and horizontal lines of different lengths and of different distances apart as a prelude to 'a new stage of development in the pupil – the stage of invention, of the spontaneous representation of linear wholes...' (p. 293). The text follows this up by clarifying that 'a course of study for the invention of figures is reserved for the next scholastic stage' (p. 294).

Similarly, in discussing colour, Froebel suggests a fairly rigid framework structured with an inbuilt notion of progression (pp. 295–303). He advocates that in studying colours, 'we do not pass from one colour to the next until the pupil has attained some proficiency in the use of the former' (p. 300). Froebel details a series of exercises (pp. 301–2) and concludes his discussion by saying that '[t]he next stage would comprise – as in the case of the invention of figures in drawing – the free invention of colour groups, the study of colours in their various degrees of intensity and tint, and the study and representation of natural forms' (p. 303).

Interestingly, this has parallels with the National Curriculum Art Order. Under PoS for KS2 it states at (7) 'apply the principles of colour mixing in making various kinds of images' (DES 1992: 6) which is a direct extension from K S PoS (6) 'explore colour mixing from primary colours' (ibid: 4). Explicitly, the National Curriculum states that pupils should 'undertake a balanced programme of...activities which clearly builds on previous work...' (ibid: 3).

Froebel advocates his curriculum being followed 'step by step' and suggests its value is such that it would be worthy enough to use widely saying The use of this instruction would supply one of the greatest wants of our schools in town and country and should be introduced to them all (Froebel 1885: 294).

Both Froebel and the National Curriculum writers seem to assume that it is a viable proposition to supply a learning package to suit all children. Although one needs to bear in mind the total message of Froebel's text, nevertheless his paragraphs on drawing and the study of colour reflect little that child-centred Froebelian educators have held in high esteem, but rather puts forward a prescriptive plan for progression in art. Whether Froebel would have justified his programme 'because it teaches the clear living thought' – one of the grounds he says is acceptable for offering a 'prescriptive, interfering education' – is not revealed.

For the very young children at kindergarten level, Froebel implicitly introduces learning about colour, shape, texture and movement via the 'gifts' and the child will develop skills in clay, paper cutting painting, weaving and drawing through the 'occupations' (1885: 285–8). The elements and materials mentioned by Froebel feature also in the Key Stage (KS) 1 programme for art: they are seen as helping a child to learn about art whereas in Froebel's terms their value lies in making the 'external internal, the internal external' (ibid: 227). The gifts lead to discovery, the occupations to invention.

In turning to consider Attainment Target (AT) 2 'Knowledge and Understanding', one notes this is an area that Froebel would argue was of value and like art: 'art appreciation...should be cared for early at the latest in boyhood' (p. 227). He clarifies that art education is not tackled with the intention that the child should 'become an artist; but that he should be enabled to understand and appreciate works of art' (p. 228). With regard to appreciating works of art and learning about influential artists Froebel's text has some parallels with the National Curriculum in rooting itself in the European tradition. Froebel's bias is perhaps understandable for a man of his generation and upbringing, and he specifically mentions that because Christian art deals with the representation of man and through this the representation of the divine, 'Christian art is the highest' (p. 228). The National Curriculum overtly favours Mediterranean/ European styles, advising in the Programmes of Study (PoS) for KS2, AT2, that pupils should 'look at and discuss art from early Renaissance and later periods in order to start to understand the way art has developed' (DES 1992: 7).

In looking at the non-statutory examples that relate to this KS, one notes the names of artists that are suggested for study. Out of the thirteen named artists all but one are European, and of the periods, only one (Assyrian reliefs) is of the non-Mediterranean tradition. The same applies at KS1, where nine European artists are listed by name but there is just one non-European example – African tribal art (1992: 5). In short, the text of the Art National Curriculum pays little more than lip service to the art forms from the ethnic cultures that make up a large percentage of the British school population today. Both the National Curriculum and Froebel see art and art appreciation as interlinking factors; Froebel furthermore links art to other curriculum areas showing how 'there is in art, a side where it touches Mathematics...language...nature...religion' (Froebel 1885: 226). The subject documents of the National Curriculum give varying degrees of support to cross curriculum linkage. The writers are keen to stress that where links are introduced they should be 'genuine rather than tenuous and contrived' (NCC 1991: C15). Generally, links are only shown if they offer learning particular to that subject, although some reciprocal learning is acknowledged in the non-statutory guidance for history as it is suggested that pictures and artefacts can be used as historical sources and that 'History in turn can help art...through studying artists...in their historical context' (NCC 1991: C9). In the technology document it is recognized that in primary schools design and technology capability 'has its roots in...art, craft' (NCC 1990: C9), and that 'teachers of art and design have an important role...in teaching pupils...to apply aesthetic judgments' (ibid: C10).

Figure 1: Children painting in the garden of Grove House, Roehampton, London.

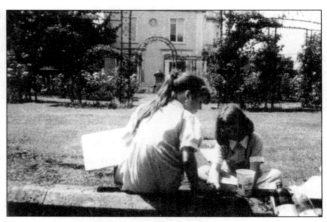

In the non-statutory guidance for art, attention is drawn to links between art and technology (NCC 1992 D12–D13). Although links between other subject areas are not specifically mentioned, the examples given show there is an expectation of interlinking. For example, a series of sessions on clay included looking at Roman and Viking pots (ibid: D11) which cross-refers to the National Curriculum for history's non-statutory examples (NCC 1991: 3). Similarly, a KS2 teacher using poetry and story in a discussion about landscape painting (NCC 1992: 11) relates to the English National Curriculum (DES 1990). Thus it could be argued that the writers of the Art Order tacitly are in agreement with inter-curriculum links. Bearing this in mind, an example of children working on an art project with reference to other curriculum areas is described in the

Figure 2: Observational drawing in the garden of Grove House.

Figures 3 and 4: Lizzie, 9-years-old, at work on her charcoal drawing of Grove House. The finished drawing was selected as the advertising poster (lettering added) for the exhibition A Celebration of Children 's Art.

next section. A discussion will be set up to consider to what extent the provision (planned to fulfil National Curriculum requirements) could be said to be compatible with Froebel's philosophy.

The project
Setting the context of the art activity.

Flexibility in responding to children's learning needs and to educational opportunities is a hallmark of good primary practice. An opportunity was offered to a class of 9-year-olds at a primary school in Roehampton to work on-site in the grounds of Froebel Institute College, Roehampton, London (Figs 1–4). The invitation was offered in connection with the centenary of Froebel College (June 1992) and a proposal to stage events to celebrate children's art making – both process and end product. The latter would be part of a small exhibition. For this reason the sessions were planned to be largely concerned with learning in art but were set up in conjunction with the children's then current topic work – a study of the local environment with particular reference to the history of Roehampton. Using Froebel College premises was appropriate in this instance since the main building, Grove House, is a neo-Classical mansion designed by Wyatt in 1792 and now a grade 2 listed building of historic interest. Although planned at a later date, the grounds complement the architecture with balustraded steps,

terraces, niched sculptures and ornamental structures. Lying away from the house lawns, a lake and a grotto are flanked by large trees and bushes – an attractive and picturesque environment for art work.

Setting up the sessions

In consultation with the class teacher of the 9-year-olds at the Sacred Heart Primary School Roehampton, I planned the project to occupy six sessions. Four initial sessions were to be information-gathering through observational work in various media. These would offer learning in themselves but would also provide the source material for a more substantial piece of work. Thus, in building onto the work of the previous sessions there was a sense of continuity and sequencing. The work was designed to relate to the programme of study for KS2 but also acknowledged that learning would not just be confined to art. The intention was that in studying the historic, and making observations expressed in spoken and visual terms, art would be a vehicle to gain historical understanding and to make this learning one's own.

In tune with the National Curriculum (NC) recommendations, AT1 and AT2 were interrelated. 'Knowledge and understanding' (AT 2) played a supportive role within the context of practical work (AT 1). For instance, reproductions of landscape drawings by well-known artists, as well as original water colours, were shown as a means of stimulation and clarification in the sessions dealing with these media. Features of the architecture were talked about continuously with individual children as they worked, as well as being highlighted for specific consideration in a discussion session.

In an attempt to be realistic about possible achievements, the same strands of learning (detailed in the programmes of study and related to end of key stage statements) were repeated in several sessions – thus aiming to consolidate the children's learning and allow them to become familiar with the aspect and be confident about them. Each session lasted approximately one and a half hours; each followed a similar pattern – the children congregated in a classroom at college, chose and collected materials, and had time to try out the media available for the session. The children were individually responsible for collecting their own materials (equipment was laid out or easily accessible for collection) and for carrying drawing boards, bottles of water, brushes, paints, etc. Helping them to grow in independence and to act as 'artists' was seen as part of their being responsible for their own learning.

It should be noted that although there was a skeletal plan for the series (Table I), detailed planning for each session was done as the work developed and in response to the children's progress and interests. The children visited the exhibition to see their work and, although some selection was made for this, all the children had work included in a continuous display that was built up over the weeks, as a result of all work being put up after each session. This allowed for discussion and review.

Table 1: Outline plan of the sessions.*

Session 1
Relates to AT1 PoS (I), (6), (7)
Observational work choice of black and white media eg. charcoal, chalk, 2B, 4B, 6B pencils. Choice of paper size. Learning focus on line and tone.

Relates to AT2 PoS (3), (4)
Reproductions of landscape drawings were used to introduce the session. This aimed to reinforce the notion that an investigation of techniques, materials and media was important (more so than a bland, neatly finished result) and that conveying the mood and how one felt about the subject matter was of consequence. Drawings shown included Leonardo, *Deluge* 1513 (black chalk); Pasmore, *Linear Development* 1963 (charcoal); Picasso, *Tree* 1944, (ink, pen, wash); Rembrandt, *Houses among Trees on Bank of River* 1650 (pen, wash); Riley, *Tonal Landscape* 1959; Seurat, *Study for La Grand Jatte* 1884; Van Gogh, *Reapers, Village Behind* 1888 (pen, ink) Yusho, *Landscape with Pavilion* seventeenth century.

Session 2
Relates to AT 1 PoS (I), (a), (7)
Observational work: drawing with colour. Choice of oil pastels wax crayons, coloured chalks, pastels. Choice of paper, colour, type, size – sugar, cartridge, etc. Learning focus on colour mixing and matching.

Session 3
Relates to AT 1 PoS (I), (6)
Observational work: graffito on scraper paper and board. Choice of type and size. Learning focus on line.

Relates to AT1 PoS (12)
Review of previous week's work, discussion.

Session 4
Relates to ATI PoS (I), (a), (7)
Observational work: watercolour drawing, paper (cartridge) stretched by children; choice of size of paper and brushes. Learning focus on tone and colour.

Relates to AT2 PoS (5)
Examples of watercolours by adult students shown to introduce the session and define some possibilities and limitations of technique.

Session 5
Relates to AT1 PoS (5), (7)
Printmaking: classroom-based session. Children based their print on work done in one of the previous sessions and it was translated into a mono-print and/or polystyrene print.

Session 6

Relates to AT2 PoS (1), (2)

Architecture appreciation: classroom-based learning of terms, styles in Greek, Roman and neo-Classical buildings, followed by on-site observing, commenting and discussing the external architectural features of Grove House, Roehampton. Discussion of columns, capitals, entablature of arcades and portico, stressing relationship of decoration to natural forms, plants, leaves on Corinthian capitals. Looked for leaves in garden to match them

* All sessions were held outside unless otherwise stated.

Having related the sessions to NC Programmes of Study, the next consideration is the extent to which this scheme of work can be seen to reflect aspects that are in sympathy with Froebel's philosophy. Froebel would recognize in this work certain aspects that he recommended should be the concern of an educational provision. The art activities reflected his belief that learning should start from the known and concrete rather than abstract or second hand stimuli. Froebel, in explaining the value of the observation of nature and surroundings, said that it is from a study of the 'nearest surroundings ... the sitting room ... the garden ... the village ... the pupil will get the clearest insight into the character of things, of nature and surroundings if he sees and studies them in their natural connection' (Froebel 1885: 251).

The 9-year-olds who took part in the activities were familiar with the environment of Grove House, as many live in Roehampton village and walk past the entrance gates on their daily journeys to and from school; furthermore they occasionally visit the college to work with students. Froebel advocates that a study of the particular is the basis for a more abstract study of a subject area at a later stage in scholastic work (1885: 254). In this instance, the sessions laid foundations for more in-depth work in colour, drawing and printmaking and for historic period study on wider issues. Architecture appreciation bridged both areas of learning.

Although Grove House was a focus of attention in much of the work during the sessions, the views the children selected were framed by trees and natural forms. The children were in close contact with nature in its urban setting and experienced it in a way they might not have done if they had not been sitting among it for an extended time. Froebel would have been sympathetic with the children having the time to be absorbed in the study of nature and to understand something of how 'Nature and life, in their phenomena, speak to man'. Froebel details how the seasons affect mankind – e.g. with 'gladness and new life' in spring, with 'longing and hope' in autumn (ibid: 265). Although he omits to mention the attributes associated with summer, the children's enjoyment and contentment during the sessions may well have been a reflection of being in a garden displaying itself in full bloom and fulfilment. In converse, Froebel also points out that 'not only do nature and life speak to man, but man too, would express the thoughts and feelings that are awakened in him, and for which he can not find words' (ibid: 267).

The sessions gave the children the opportunity to work in a non-verbal mode, and to work from direct experience to fulfil KS2 PoS (1) select and record images from first-hand observation

(DES 1992: 6). It is hoped that the experience will also have aroused the children to a more important human endeavour – a 'keenness of observation' (Froebel 1885: 264) as well as confidence to 'express the thoughts and feelings awakened' by the experience. It would seem that the children experienced the gardens with more senses than just the visual, and that the art activity was not merely physical 'activity alone' but involved the mind and senses, thus becoming an 'all-sided activity of the whole being the whole self – in brief, what is defined as 'self activity' (Hailmann, translated note in Froebel 1885: 11).

Connectedness – a key work in Froebel's philosophy – is recognizable in the format of the provision in the sense that the art learning related to other areas of the curriculum, notably history. Speaking and listening skills (AT 1 of the English NC) were incorporated into discussion informally – and more formally in the architecture appreciation session. The children were immersed in nature. Through developing skills such as a 'keenness of observation' the children will have a transferable facility to bring to learning in other curriculum areas. Although some latter day Froebelians would not acknowledge these aspects as connectedness, but rather as a correlation of subjects and an imposed unity of content (Priestman 1969: 147), I would suggest that whether children make their own 'inner connection' through their own devices or through being involved in selective and multi-faceted learning is not such a wide differential. Indeed the latter is more akin to Froebel's own philosophy.

Linking subject areas through art may be a way of retaining a sense of an integrated learning approach that promotes connectedness. This is beneficial to learning at primary level for the wholeness it offers and lack of compartmentalization – reflecting the way young children perceive their world. With careful planning, teachers could form a provision that fulfilled Art NC requirements and was a genuinely useful inter-curricular link. Commonly it is said that children will gain a fuller understanding of academic work and internalize it via observational art work (see Newland and Rubens 1983; Barnes 1989). Observational work is a worthwhile activity to support learning in other curriculum areas. However, if art learning is to be achieved, teachers must be aware that activities should not degenerate into memory work (remembered from observations) to illustrate writing. The activities undertaken with the Roehampton primary school children attempt to show how it is possible to plan a provision that covers specific learning in art but also offers learning through art – in this instance in history and English. There is no reason to suppose that it is possible or fruitful to try to cover too many curriculum areas simultaneously; it would seem more valuable to offer quality learning authentic to the subjects.

The sessions planned for the 9-year-olds offered learning authentic to the subject areas and, it is hoped, the discussion has shown how this related both to the Art NC and to those principles most essential to Froebel's argument. I believe most NC art activities could well be 'phrased' to fit this pattern of learning, viz one that is in accordance with the NC yet inbuilds the major aspects of Froebel's philosophy – self-activity, continuity, connectedness. Both curriculums share certain common denominators, e.g. the term 'investigating and making' heading AT1 reflects the type of thinking Froebel was sympathetic to. Nevertheless, despite the similarities, there are

differences – notably the expectation that children will have achieved learning according to end of key stage statements in specific subject areas and will be assessed.

This chapter has considered whether Froebel trained teachers might experience a dilemma, and their principles be compromised, in delivering the Art NC, or if Froebel's ideas have been absorbed into the system as it is claimed and are reflected in the Art Order. Of some significance to this discussion is the fact that Froebel's philosophy has been freely interpreted by his followers, and even its key issues are spelt out with different emphasis. For example, self-activity is explained very differently by Hailmann (in Froebel 1885) and by Priestman (1969). Thus few Froebel-trained teachers may actually be in tune with the original Froebel philosophy but with the Froebelian developed version in one of its many guises. Each generation of Froebelian educators presents a different interpretation. These range from a fairly formal approach in 1906,[1] to correlating subjects in 1910 (Priestman 1969), to a 'change to the newer and free methods of interpretation' (Woodman Smith 1969), to the belief that the child, 'left free ... grows and by his own activities forms and educates himself' (Isaacs 1969) and latterly to the 'knowledge input' approach (Bruce 1987).

Froebel-trained teachers, holding a commitment to a 1950s and 1960s type of Froebelian view, may feel their thinking is at odds with the NC unless, through InSET, they have grown towards an acceptance of more recent versions of Froebelian theory, and find delivering the NC to be at least a workable proposition. By necessity, teachers must recognize the NC as the benchmark, and it is the responsibility of individuals and bodies who wish to work within the system to consider how their views can be dovetailed into concordance with it. In this chapter I have chosen to look back to the roots of Froebelian tradition – Froebel's own writings – believing that if such texts have withstood the test of time, in whatever varied forms, they hold intrinsic points of value for children's learning. In conclusion, I would suggest that the 300 PGCE and the 160 BA (QTS) students graduating in 1993 from Roehampton Institute, London (of which Froebel Institute College is a constituent), as well as Froebel-trained teachers in employment, will not need to compromise their principles with regard to delivering the statutory requirements of the Art NC, as self-activity, continuity and connectedness, as the discussion above may have shown, can be built into the loosely worded framework of the Art Order.

Acknowledgements

This is an extended version of a paper entitled 'Working out of doors: observational work in the local environment', Education 3–13, Vol. 21, No. 2, June 1993, pp. 32–36. I wish to thank members of the Sacred Heart Primary School, Roehampton, London, for their assistance – the children for participating, the Headmistress and class teachers for their cooperation. I am grateful to S. Waterman for printing my photographs.

Note
1. See photograph in Lawrence 1969: 7.

References

Barnes, R. (1989) *Art, Design and Topic Work 8–13*, London: Unwin Hyman.

Bruce, T. (1987) *Early Childhood and Education*, London: Hodder and Stoughton.

Courthope Bowen, H. (1907) *Froebel and Education by Self-Activity*, London: Heinemann.

Croal, J. (1992) *The Guardian*, May 19, p. 22.

Department of Education and Science (DES) (1992) *Art in the National Curriculum*, London: HMSO.

Department of Education and Science (DES) (1990) *English in the National Curriculum*, London: HMSO.

Froebel, F. (1885) *The Education of Man*, London: D Appleton-Century Company.

Isaacs, N. (1969) 'Froebel's Educational Philosophy in 1952', in E. Lawrence (ed) *Friedrich Froebel and English Education*, London: Routledge and Kegan Paul.

National Curriculum Council (NCC) (1991) *Geography Non-Statutory Guidance*, York: NCC.

NCC (1991) *History Non-Statutory Guidance*, York: NCC.

NCC (1990) *Technology Non-Statutory Guidance*, York: NCC.

NCC (1992) *Art Non-Statutory Guidance*, York: NCC.

Newland, M and Rubens, M. (1983) *Some Functions of Art in the Primary School*, London: ILEA.

Priestman, O.B. (1969) 'The influence of Froebel on the independent preparatory schools of today', in E. Lawrence (ed.) *Friedrich Froebel and English Education*, London: Routledge and Kegan Paul.

White, J. (1988) 'The Unconstitutional National Curriculum', in D. Lawton, and C. Chitty, (eds) *The National Curriculum*. London: University of London Institute of Education.

Woodman Smith, P. (1969) 'History of the Froebel movement in England', in E. Lawrence (ed) *Friedrich Froebel and English Education*, London: Routledge and Kegan Paul.

7

Breadth and Balance? The Impact of the National Literacy and Numeracy Strategies on Art in the Primary School

Steve Herne

Vol 19, No 2, 2000

Introduction

The (New) Labour government swept to power in Britain in May 1997. Teachers had been promised a five year moratorium on curriculum change by the outgoing Conservative administration. On the 13th January 1998 it was announced that in order to 'give a clear priority to the teaching of literacy and numeracy and to meeting the Government's literacy and numeracy targets…' more flexible arrangements for the curriculum in primary schools would be introduced from September 1998 until the development of a revised national curriculum for introduction to all schools in September 2000.[1] The requirements of the statutory Orders in history, geography, design and technology, art, music and physical education were modified so that schools were not required to follow the programmes of study in those six subjects at Key Stages 1 and 2. However, schools still had a statutory duty to provide a broad and balanced curriculum.

A year later there was growing anecdotal, and some documented, evidence of 'shrinkage' in these foundation subjects (Cassidy 1999) as well as within teacher education curricula (Royal Society of Arts 1998). To investigate this further I conducted a small-scale research project to obtain evidence of the impact of this policy change on art in the primary phase (Glaser and

Strauss 1967). My research design required me to interview a small sample of curriculum coordinators for the subject, or their nearest equivalent, as people who would have been likely to reflect on the development of the subject in the school, note and evaluate change.

The data was comparatively analysed and an initially tentative grouping of categories led towards firmer coding, which in turn made possible the development of substantive theory about what was happening (Hitchcock and Hughes 1989). The interviewees were asked to characterize the development of the art curriculum in their school from the introduction of the Orders in 1992 to their 'relaxation' in 1998, identifying gradual changes in emphasis or particular phases over the six year period. For some, the introduction had offered new job opportunities. One interviewee had been appointed as an art and display curriculum coordinator on a 'B' scale to lead the new subject, another had been appointed as a part-time specialist art teacher to raise standards in the school and train other nonspecialist staff, while a third had been appointed by the Local Education Authority to lead an artist-in-residency scheme to develop the art curriculum in local primary schools.

The art national curriculum years 1992–1998

Art has long held a special place in British primary education. One head teacher had told me that, before the introduction of the National Curriculum, many primary educators had regarded the 'core' subjects as English, maths, nature study and art. However, art would often play a lower-status role, chiefly through supporting learning in other subjects, illustrating topic work or as therapeutic play. Interviewees backed up the findings of Caroline Sharp (Sharp 1990), which identified confidence as a key factor in whether teachers chose to teach art regularly before the introduction of the National Curriculum, and afterwards, in its quality and challenge. Besides the focus of resources evident in the new posts of responsibility, those interviewees who had been in-post at the introduction of the art National Curriculum spoke of a new status and seriousness attached to the subject. One curriculum coordinator was able to organize a comprehensive in-service training (InSET) programme;

> I was here for one year and then we had an art focus... thirteen staff meetings in all devoted to art. We had some InSET at the Tate Gallery, the Whitechapel... At the Tower of London we had a whole staff InSET including primary helpers. We had art-focused displays, especially observational work... I think that we were particularly thinking about why we did art, why we taught art and what was good art teaching.

Another spoke of the higher profile of the subject, the more 'academic' approach taken in local authority InSET, its equal status with other subjects and the way it became more of a subject 'in its own right':

> Before the 'feel' was more 'art and craft' and then it became much more refined, became more about art as a subject in its own right. I suppose it became purer.

> Access to InSET became easier, there was more money for resources. Time was available in staff meetings and curriculum coordination working groups could be set up.

The coordinators interviewed drew on the resources of museum and gallery education departments, artists' residencies and local authority working parties, training and publications, to support both their own development and that of the subject in school. One coordinator, and the specialist art teacher possessed an art education background, while another had attended a ten day government (GEST) funded training course at a local university. Others had developed expertise through a variety of InSET opportunities, and enthusiasm for teaching or project management.

Unfortunately, space does not allow for detailed data to be quoted from the transcripts to support the following summary; however, early on in the subject's development after the introduction of the art National Curriculum, the key processes in developing higher standards of work and a systematic, unified approach were variously reported as: timetabling a weekly slot and a reasonable amount of time to the subject; seeing art as a subject in its own right in addition to its cross-curricular role; giving more time to planning; forming a school policy writing group to develop an art policy; the art coordinator's membership of a borough-wide subject working group sometimes focused on the production of a publication; providing school-based InSET and practical workshops to develop teachers' skills and understanding; coordination strategies, releasing the curriculum coordinator for team teaching as a form of in-service training; children and staff working with a specialist art teacher or artist-in-residence, to undertake more ambitious techniques or develop models of good art teaching; using art to make an impact on the school environment through high quality display or more permanent environmental work such as murals, ceramic tiles, blinds, outdoor sculpture etc., often involving the children in design and production and sometimes with the help of artists in residence or members of the wider school community; purchase of reproductions of work by well known artists or representations of cultural traditions; efforts to balance these resources with work by non-Western, bicultural and female artists; purchase of artefacts; policies to encourage regular visits to galleries and museums; and organzing 'Art Weeks' or whole-school thematic focuses lasting half a term.

Later the focus shifted to developing Schemes of Work (SoW). These are medium- and long-term plans across each year of the primary phase to promote continuity and progression, breadth and balance, and avoid unintentional repetition. In some cases this was accompanied by the development of a portfolio of examples of children's work which could be used for a variety of monitoring and assessment purposes but primarily to inspire colleagues. One interviewee commented that, while there was an expectation for art coordinators to develop a scheme of work, unfairly there were no examples to work from. National Curriculum Schemes of Work for Key Stages 1 and 2 are now published (art and design in early 2000), but officially-sanctioned publications clearly have their own pitfalls in arts subjects where creativity and variety are important elements for teachers and pupils.

Changes
Curriculum time
The most significant area of change brought about by the introduction of the National Literacy and Numeracy Strategies was in curriculum time available to foundation subjects and, specifically,

art. Previously, the majority of schools would timetable a weekly art activity close to or above the recommendations of the Dearing Report (Dearing 1994) of between an hour and an hour and a quarter a week (or 36 hours in Key Stage 1, and 45 hours in Key Stage 2 per year, as it appears in the report). In one school, art now alternated with Design and Technology (D&T) in each term, and in another with music on a termly basis; a cut in half of curriculum time. In the latter school, the Key Stage 1 teachers had managed to retain much of the time previously devoted to art, but at Key Stage 2 art 'had gone on a back burner'. Not a lot of distinction was made between art and design and technology (D&T), and art was often linked to display when the Coordinator was working with other's classes.

One interviewee reported that there was 'more pressure to be academic in Key Stage 1' and therefore 'less time for creativity'. In two schools, while there was no direct policy on reduction of curriculum time, it was reported that the current conditions encouraged those teachers who were 'less creative' to feel it was 'alright' to do little art with their own classes. In these two schools there was a lot of pressure on the art coordinator to carry the subject, working with others' classes, and maintain art display almost single-handed. Another interviewee reported that in her school, where art had been a high profile subject, 'most of us are lucky if we can do an hour'. Finally, one interviewee reported that it was now often difficult to find groups of children to work with an artist-in-residence. Teachers considered they were 'sacrificing' children, taking them away from important work.

Mornings and afternoons

It is characteristic of the new strategies that they now tend to take up most of the mornings in primary schools, leaving the afternoons to the foundation subjects or 'topic work'. There are ten subjects in the National Curriculum, plus RE, with Information Communications Technology as a cross-curricular element. The Literacy and Numeracy Strategies do not make up the whole of English and maths teaching. There are therefore many subjects which jostle for time and space in the remaining curriculum time, in the afternoon. Some schools have moved to new timetabling arrangements to allow two working sessions in the afternoon while others retain one major activity period. One interviewee saw the location of art always in the afternoon as 'disrespect to the subject':

> You actually now only teach art when they are at their most tired … you could begin the day with art. There's a fresh thing with children who are awake and alert. When you get to the afternoon the kids are 'clapped out', they're not at their peak, their best. So art becomes a relaxation, they are never at their best when doing it.

Cross-curricular planning

The Literacy and Numeracy Strategies were clearly designed to support or reintroduce whole class interactive teaching for at least part of each session, perhaps, in opposition to the 'integrated day' approach, with its focus on group work. There is scope for cross-curricular links in both strategies but also a resistance to integrated planning through 'topic work'. In one school, a 'topic-based approach' was seen as a way of preserving the foundation subjects with the whole school following different subject-focused themes each term:

We have taken a conscious decision to take a topic-based approach. This time last year we were talking about management policy with the staff and there was serious concern that we were going to lose the foundation subjects. We now have termly focuses. Last year was music so we had lots of outside musicians and whole school assemblies weekly ... It's a rolling programme ... We then had an art focus ... this term we are doing dance, next term the humanities.

The strength of the school was felt to be its 'cross-curricular and multi-cultural nature'. Another interviewee felt that 'topic' seemed to have become 'a dirty word' in educational debates during InSET sessions, despite feeling that her best work came out of topic work. In another case the interviewee felt that discrete focuses on art from non-Western cultures were going to disappear as there was only time to plan art within existing topic themes.

Language
In two of the schools, where a majority of the children were bilingual and were learning English as an additional language, there was a strong connection between art and language development. In one school the coordinator believed strongly in the power of art activity to promote talk:

The most important thing for our children is that they have to talk while they do it ... they have to ask questions. I often make them work together so they have to talk to each other. It's important for you to interact with them as well, you know: 'Hold your picture up. What do you think? What do you want to do with it? Are you pleased with it? How can you change it?' They have to look. They have to be critical about their work ... it becomes very, very important to them.

In the second case there was a strong tradition of book-making in the school where images, children's drawings and paintings, were a powerful way of developing narratives which led into writing, mutually enriching each other:

... we had just had a big language focus with a very experienced language coordinator. The teachers were very much behind her. We'd spent a year of really focused work, [making] really good links [across the curriculum]. We use core books so we'd take a book and [develop] all this fabulous work you could do around it ... then the literacy strategy!

In both cases there was a certain irony seen in the way the 'daily literacy hour' was squeezing a subject that they felt had such a strong input into developing literacy.

Links between standards, training and support
The impact of the 'squeeze' on curriculum time has had other effects. A number of the interviewees talked of trying to 'cram' the planned schemes of work in art into less time.

We tried to do art on a weekly basis, it was more part of the curriculum. With the introduction of the Strategies you could only do music for a term and for another term do art.

Teachers are still trying to teach the whole curriculum, trying to cram it all in. It's been stressful. It's been successful because people are dedicated to trying to fit all this mass of work in.

In some schools the quality of the work was the same but less was done, while in others standards had deteriorated. However, the main reason for this seemed to be staff turnover and the lack of opportunity to train new staff, particularly some from overseas who had received little input in this subject in their teacher training. In only one of the five schools had there been any focus in staff meetings or InSET for the previous two years. In some inner city schools where staff turnover could approach as much as 50 per cent per annum, this lack of opportunity to train, explore methods and review aims and policies could rapidly lead to a situation where 'teachers don't know about paint mixing...using printing ink for painting!' The focus on the two strategies had also led in a number of schools to the diversion of primary helpers, in some cases with the aid of specialised training, being moved away from preparation and assisting with practical and creative work and display.

Extension and reflection
One interviewee described a way of working in primary education, in which a visit is used as a starting point for further work extending across the curriculum, perhaps starting with artwork followed by writing and so on. She felt that this sort of approach, where the direction taken in the project would often draw on the pupils' responses and developing interests, was not possible any more. It was also difficult to find the time to finish work satisfactorily 'because young children can spend a day...on one piece of work. It's not difficult for them, and that's part of the extension.' Another felt the 'pace was hotting up' – if work was missed for any reason there was little chance of catching up.

One thing about it, they don't get bored! I think they get frustrated...keeping up with the pace...It's a balance...children need time to reflect on things, on what they can do, and their designs and how they can improve...

Conclusion
This enquiry suggests that the introduction of the National Literacy and Numeracy Strategies has had an impact on the amount of curriculum time available for art. In some cases the curriculum available has been cut by half. Most art is now taught in the afternoons when the children are not as 'fresh'. There has been little InSET in art for the last two years in primary schools. This is particularly damaging for schools with a high staff-turnover. Teachers can become deskilled and a shared vision for the subject gradually disintegrates. The status of the subject has been reduced by lack of attention and diversion of resources. Progress and development in the subject in the primary phase has been largely suspended. At a time when many primary schools had achieved balanced schemes of work and were beginning to centre on progression, differentiation and assessment in art, the strong focus on the strategies has disrupted the balance.

The study has highlighted the vital role of the art specialist curriculum coordinator in keeping alive the subject when there is little central support or attention. The Key Stage 3 art curriculum remains unaffected, but it must be borne in mind, as Clement and Jones (1996) point out, that two thirds of the entitlement curriculum for art is delivered within the primary sector. Therefore these, perhaps unintended, outcomes of government policy are a serious issue for art education as a whole. Certainly, they suggest that unless a further 'steer' similar to the non-statutory advice given by the Dearing Report (1994) in relation to curriculum time is given for art in the National Curriculum 2000, together with a refocusing of InSET time and resources, art education in this country will have suffered a serious setback.

The author wishes to acknowledge those interviewed in giving their time and thoughts so generously.

Notes

1. QCA Letter to Head teachers of Key Stage 1 and Key Stage 2 schools in England. 13th January 1998.

References

Cassidy, S. (1999) 'Science sacrificed on the altar of literacy', *Times Educational Supplement*, 25th June.

Clement, R. and Jones, H. (1996) *Edge to Edge. Continuity in Teaching Art and Design from Key Stage 2 to Key Stage 3*, Plymouth: University of Plymouth.

Dearing, R. (1994) 'The National Curriculum and its assessment: Final Report', London: SCAA.

Glaser, B. and Strauss, A. (1967) *The Discovery of Grounded Theory*, Chicago: Aldine Publishing Company.

Hitchcock, G. and Hughes, D. (1989) *Research and the Teacher. A Qualitative Introduction to School-based Research*, London: Routledge.

Royal Society of Arts (1998) *The Disappearing Arts? The current state of the arts in initial teacher training and professional development*, London; Royal Society for the Encouragement of Arts, Manufactures and Commerce.

Sharp, C. (1990) *Developing the Arts in Primary School. Good Practice in Teacher Education*, Slough: National Foundation for Educational Research.

Postscript

Returning to this paper approximately eight years later, I found it interesting to reflect on how much the situation presented by the original research has changed. With this in mind I re-interviewed two of the original interviewees and additionally another subject-leader who had started teaching soon after the Strategies had been introduced. By developing open-ended semi-structured interview questions, then using coding analysis on the transcripts, I hoped to identify a sample of the current discourse surrounding the practice of art and design education in the English primary school.

These findings make no claims to generalized truths. All three interviewees were committed, enthusiastic art specialists whose own situations had optimistic and positive elements. They are also all London-based.

However, they do have contacts with other schools in their area and access to further networks through school clusters, arts organizations, museums and galleries, occasional conferences, local authorities etc., so their views can carry local significance. These findings could provide a platform for further localized research or larger scale enquiry.

Perhaps three key areas of change stood out. The first was a process of policy change leading to greater diversity. For instance, Creative Partnerships, the Government's flagship creative learning programme initiated in 2002 (Creative Partnerships 2008) which was the main policy initiative of the Labour government in the arts, was only ever designed to reach a selection of schools in selected of regions in England, unlike the national scope of the literacy and numeracy strategies which initiated the original paper. Of my interviewees, one had benefited greatly from the networking opportunities, funding and professional development brought about by her involvement in a creative partnerships school, while another had felt the cascading effects from the programme in the borough and a neighbouring secondary school.

A second area of change was development in new technology in the classroom and access to online resources and information. Interactive whiteboards are now to be found in most primary school classrooms in the UK with access to interactive software and the internet. One interviewee explored curriculum ideas, sourced artists to work in school, collated visual resources for other teachers in her school, and researched museums and galleries for visits online. However, she observed that besides finding pictures of artists' work there were fewer designed curriculum resources for the subject than other subjects such as maths and science that had a wealth of dedicated material and interactive games.

The third area of change has been the growth of the museum and gallery education sector and provision of in-service training (InSET) in this context. While InSET has almost disappeared from local authority provision and little has been provided by teacher training establishments and universities, museum and gallery education departments continue to expand their offer.

Interviewees confirmed that key elements in the success of art and design education in the primary school were the roles of the head teacher and curriculum coordinator/subject leader. It was evident that processes of successful curriculum leadership involved social entrepreneurialism by a committed and strategic coordinator and the creation of effective communities of practice amongst the staff and broader networks of support.

Interviewees demonstrated beliefs in the value of art and design and creativity and the entitlement of children to be creative.

Since the original research, curriculum and policy changes have displayed a gradual loosening of centralized prescription, with themes like 'excellence and enjoyment' (DFES 2003) and a policy focus on creativity, albeit without a relaxation of inspection and league-table judgements which rely heavily on SATs results in literacy and numeracy. There was agreement that teacher education courses are doing little to prepare the generalist primary teacher to teach art and design effectively.

Finally interviewees observed that neglect of the subject does not just mean that it continues at the same level but that staff turnover leads to a loss of knowledge and understanding and impacts on incrementally

on practice, although this may not be so marked in areas of low staff turn-over. What is also clear is that a committed individual taking the initiative can make a real difference to a local school community and in so doing change the lives of staff, and generations of children and parents.

Steve Herne 2008

Acknowledgements

Many thanks are due to interviewees: Dee Bleach, Acting Head Teacher, Mayflower Primary School, Tower Hamlets, London E14., Hannah Hutchings, Art Coordinator, Thomas Buxton Infant School, Tower Hamlets, London E1., and Rebecca Benjamins, Creativity Coordinator, Bessemer Grange Primary School, Southwark, London SE5.

References

Creative Partnerships (2008) Accessed 18.11.08: http://www.creative-partnerships.com/
DFES (2003) Excellence and enjoyment: A strategy for primary schools. Accessed 17/05/08 http://www.standards.dfes.gov.uk/primary/publications/literacy/63553/

8

Changing Views of Childhood and their Effects on Continuity in the Teaching of Drawing

Sheila Paine

Vol 3, No 1, 1984

Children's progress in drawing is most commonly judged by ability to record faithfully perceptions of objects in space, especially of the human figure. Those who seem to be representing other more idiosyncratic things in their own unique ways are often thought to be poor at drawing, and if attempts are made to teach them, these are usually attempts to instil the more easily definable drawing conventions like perspective, chiaroscuro, or a rationale for colour. But in preadolescence, art teaching is not a clear issue; the talented, it is assumed, will emerge anyway; others need encouragement but not direct intervention. What children actually need – some positive help from teachers with what they want to do (as opposed to what schools tend to expect) – is a need that frequently passes unfulfilled. We have hitherto found it difficult to develop an adequate approach to the teaching of drawing for the young, primarily because of a failure to reappraise our understanding of the state of childhood as it reflects upon the activity of drawing.

The devising of teaching programmes and techniques for teaching drawing at any age level initially requires a clear understanding of the ways in which individuals structure, evolve, sequence, and employ drawings at earlier and later stages of their development. Only then can a teacher analyse current difficulties in drawing which pupils encounter as well as the significances of individual drawings. No amount of attention to notional averages of attainment can be as illuminating, nor can the application of any relevant psychological theory be truly useful unless considered in relation to the evidence of actual drawing sequences.

No such evidence can be properly considered other than in the context of those influences which help to determine it. Children in their drawing make individual and often tacit responses to an impinging social world as well as to other images – visual, emotional and symbolic – which make up their early experiences. Although there is general similarity between the development in drawing of most individuals, there is consequently nothing inevitable about it; there are also numerous differences.

A second influence, and one at the heart of the educational context of drawing, concerns our understanding of it as a process of development. How we perceive that process and how we interpret perceptions of the activity of drawing is a consequence of our own social conditioning – the beliefs which we have formed about art, drawing, education and especially childhood which mould our understanding as well as the decisions we make as teachers.

I intend to show here how changing views of childhood over the past six centuries continue to be reflected in the attitudes of teachers, parents and educators to the drawing activities of children. Such attitudes do, of course, change art teaching approaches and have their consequences in what children do in drawing. At key moments in the history of art education, educators have sometimes been too ready to allow their understanding of art to be distorted by current theory,

Figure 1: Case study: Nicholas B., 6 years, 'Daddy'.

in ways which have been detrimental to the cause of art teaching. A reappraisal of the concept of childhood at the present time might however help us to evolve a more positive practice for the teaching of drawing in the early years and achieve greater continuity of teaching in drawing between primary and secondary phases than as yet exists.

In *Centuries of Childhood* (1973), Philippe Aries presented an analysis of historical changes in the notion of childhood, using the evidence of images in art to support his theories. He noted that in the mediaeval world there was no place for childhood; it was 'seen as a period of transition which passed quickly and was just as quickly forgotten' (ibid: 32). We know that in art in the eleventh and twelfth centuries, children were commonly depicted with adult bodies, distinguishable only by their small size in relation to adult figures. Artists now might assume this artistic phenomenon to be only a consequence of a dominance in the mind of the mediaeval artist of human-figure concept over child percept. Aries sees it, as perhaps it also was, as a significant reflection of contemporary attitudes towards the insignificance of childhood.

By the thirteenth century in Gothic art, adolescent or preadolescent child figures had begun to appear as angels, often shown naked and to represent or to accompany the dead. In the next two centuries, this idea of holy childhood gave way to what Aries calls 'an allegorical iconography of childhood': children were featured in family, school or work settings, not perhaps as important beings in themselves but simply showing their presence, mingling with adults in everyday life. They appear as graceful and picturesque rather than naturalistic. Yet because their child lives, physical characteristics and personalities were regarded as transitory and unmemorable (too many died anyway), they were not even portrayed, as adults often were, on their own tombs.

Aries identifies the sixteenth century as the significant one for a change in attitudes to childhood. Although the term 'puerile' equated (as it still does) child behaviour with feebleness and inconsequentiality, and even though the arrangements for the burial of children continued to be casual, to say the least, the emergence in that century of a fashion for child portraiture seems to suggest a new interest in children as personalities. It extended to the desire to record even the expended lives of deceased children as well as, and frequently alongside, the living children of a family group. 'By the 17th century it had become customary to preserve by means of the painter's art the ephemeral appearance of childhood' (Aries 1973: 40) because the child's soul was by then considered immortal too and his personality in consequence of some importance. The concept of childhood had been 'discovered' and this discovery was reflected in the increasing portrayal of children in art throughout the sixteenth and seventeenth centuries as well as in the emergence of clothing specially designed for children (of the wealthy).

Not one but two opposing concepts of childhood in fact emerged, as Aries notes, and these two concepts were to have a long and ambiguous influence (it seems to me) in education as well as in the art of Western Europe. The fundamental differences in the views of childhood which they present may well stem from inherently female and male differences in contemporary perceptions of life, although this is not a point which Aries makes.

The first of these two concepts, referred to by Aries as the 'coddling' concept, arises certainly from a more family-oriented and possibly a more maternal perception of children: 'the child, on account of his sweetness, simplicity and drollery, became a source of amusement and relaxation for the adult' (1973: 126). But in this view childhood was short-lived and the child expected to forsake childish ways and be absorbed into adulthood by the age of about seven. Until that time adults were tolerant and took pleasure in a child's games and 'infantile nonsense'.

The second concept of childhood seems to have arisen in the seventeenth century as an exasperated reaction to the behaviour generated and permitted by the first, eventually being reinforced as a moral attitude and a prescription for ideal behaviour. It assumed childhood to be a state of unreadiness for life and requiring time and training to enable children to emerge from that unreadiness. This view had two important consequences. Firstly it lead to the development of the school as 'an agent of the extension of childhood' (1973: 320), keeping children (male children at least) away from adult society for a longer period. Secondly, it ultimately emphasized social distinctions between classes; particularly in the period of the industrial revolution in Britain, the children of poorer families continued to be pitchforked into adulthood as soon as they were considered old enough (physically) to be employed, while wealthier families kept their children isolated at school for periods of ten to twelve years.

Echoes of both concepts of childhood seem evident in contemporary education, manifested in the contrasting motivations of primary and secondary schools in the British system. In some ways the primary school promotes a kind of education for being a child rather than

Figure 2: Case Study: Nicholas B., 9 years, 'Landscape with giraffes'.

Figure 3: Case study: Nicholas B., 10 years, 'Mexican cartoon'.

for growing up, not without resemblances to the 'coddling' concept: primary education is centred on learning through play to delight in the world as seen through the eyes of childhood. Although the activities undertaken normally have a serious purpose, the artefacts created by the children are considered as instrumentally, rather than intrinsically, valuable. Secondary education, however, looks more like the prolonged initiation into adulthood which characterizes the second concept. The shift of objectives which every child has to accommodate in changing from the primary to the secondary phase might be described as a shift from the idea of the discovery of one's self as a child to the idea of learning and aspiring to become an adult. To be 'successful' at the secondary stage, the individual must learn to emulate adult techniques; failure lies in the inability to attain them. Between these two phases of schooling the notion of continuous development cannot easily flourish nor can the integrity and value of childhood achievement. The effect of this discontinuity upon the practice of drawing in education has been severe.

Until the nineteenth century the visual art of children was the subject of as much indifference as was mediaeval childhood. Although, according to Aries, the concepts of childhood were formed between the thirteenth and sixteenth centuries, one may note that it was not until the nineteenth century that a corresponding concept of child art was recognized, one that acknowledged that the art of children existed in its own right, having its own methods and meanings and not merely as a preliminary to later achievement. Until then children's drawing could only be thought of as amusing or embryonic and always as trivial.

Figure 4: Case study: Nicholas B., 15 years, 'Shops'.

The three intellectual events which modified society's perception of child art in the nineteenth century are well documented by Stuart Macdonald (1970, Chapter 18) – the emergence in psychology and in philosophy of new theories of the mind, associated with new value given to

Figure 5: Case study: Nicholas B., 18 years, 'Flying machine'.

the child's natural preferences, capacity for pleasure, emotion and imagination; secondly the anthropologists' assertion of a parallel between human development and the development of civilisations from primitivism to sophistication; thirdly the emergence of the Modern Movement in art which made some less conventional imagery much more acceptable.

Recognition of child art was nevertheless slow; Macdonald notes that it was not until 1857 that the art of children was thought worthy to be the subject of a published book, and it was three years after that before anyone chose to present an exhibition of children's art. One may argue, too, that these developments were not necessarily all helpful to the cause of art education. The anthropologists' recapitulation theory may have increased interest in children's art through comparing it with the art of primitive peoples, but it also tended to reinforce the association between ineptitude and children's work. The title of the first exhibition (Children's Royal Academy) does seem to suggest that it may have contained only work which successfully emulated adult styles and techniques rather than that which might be more natural to children. And the 'discovery' of child art, having first imbued the work of children with some credibility, ultimately caused it to be seen as quite separate in nature from the art of adults, as though at some magic moment in late adolescence an individual passed through the graduation gates of life, leaving childhood and child art on the other side.

How have these changes of thinking come to fruition in the present century? Writing within a year or two of its commencement, James Sully was clearly influenced by some of the new ideas of the nineteenth century in describing contemporary discernment of 'the subtle charm and the deeper significance of infancy' (Sully 1895: 1). But he also tacitly acknowledged the earlier 'coddling' concept – the very instinct of childhood to be glad in its self-created world' (ibid: 3). Interestingly, he advocated the study of individual children on the grounds that 'although collective and statistical enquiry is seen as valuable – it is no substitute for the careful methodical study of the individual child' (ibid: 23–24). He agreed that there were 'interesting points of analogy between child art and primitive race art' but we must not 'expect a perfect parallelism' because, he argued, of superior art skills even in the primitive individual (ibid: 299). He was obviously perplexed about the 'general crudity of taste' which he felt that children displayed (ibid: 320). He suggested that children's art-like play is not fully art, because their play is too self-centred, providing them with new environments but not produced with objective value: a state of 'contented privacy' as he saw it (ibid: 326). Made at the beginning of the century these views would have been more tenable then, before the advent of twentieth century artists delighting in subjectivity and exploiting imagery which Sully would have probably found crude and tasteless. But he was already contributing to the growing idea of a conceptual split between child art and adult art which was to last through the next eighty years.

It was inevitable that the 'discovery' of child art should generate a succession of unique teachers to advance that discovery. None is better known than the Austrian Franz Cizek. As an exponent of the 'coddling' concept, he idealized the minds and the alleged innocence of the very young:

> There can be hardly any doubt which is stronger, more genuine, more beautiful, in one word more artistic, the work of the four or five year old (Cizek would say the two or three year old) or the fifteen year old – but what Cizek fought for – was to make people – see the immense beauty in the so-called clumsy stupid works of small children. There is nothing stronger on earth he said repeatedly. (Viola, 1942: 76)

Although he envisaged this early period as accessible to teaching, Cizek saw the young child as naturally creative, able to draw upon inner riches and with help able to 'acquire as possible everything for himself' (ibid: 80). Cizek's attitude to development seems to have been a strangely defensive one. If Viola's picture of him is correct, he was a surprisingly dominant teacher, convinced that the inner world of the child's mind should be actively defended for as long as possible from the polluting influences of society, even though it might ultimately (and perhaps inevitably in his view) destroy innocence and natural creative powers. 'There is so much of Summer and Autumn but the Spring never comes again' he is quoted as saying (Macdonald 1970: 347). How might he have understood Picasso, an artist deeply conscious of the quality of childhood perceptions, who managed to re-visit his own 'Spring' but paradoxically with the eyes and intellect of the mature (even the autumnal) artist?

In the first decade of the new century, and while Cizek and others 'coddled' the young child 'artist', European schools generally concentrated on the intention to prepare children for a future life in an adult world which was supposed to be more real than the one they were in. 'The idea of childhood as a valuable stage in its own right, not just as a kind of apprenticeship for adulthood, was not yet a powerful influence.' (Lawton, 1973: 98)

Indeed it rarely seems to have been envisaged as a possible alternative to either of the other two historical views of childhood. To gather sufficient credibility it had to await some of the longer-term effervescent effects of the study of psychology and of the remarkable changes of thinking of some artists in the new century.

In the first thirty years of that century many psychologists attempted to construct, from their observations of children and adolescents, descriptions of alleged stages through which children passed. These operated on the somewhat revised assumption that all childhood (including its earliest years) is a state of adulthood-seeking, which in part it is. The young child was no longer merely idealized, and a more meaningful continuum was being perceived for the whole of the first eighteen years of life. Not surprisingly, in looking for significant behaviour to study in order to construct developmental stages, some psychologists turned to the activity of drawing in the belief that this might mirror or illuminate one aspect or another of the developmental process.

The writings of some art educators of this period show a naïve willingness to embrace any new psychological theory which seemed to have a useful bearing upon art. 'The psychologists have made most valuable discoveries', wrote R. R. Tomlinson (an English art Inspector) enthusiastically,

'there are different stages of development common to all children:

1. manipulation, up to 3 years,
2. child-symbolism, to 6th or 8th year,
3. pseudo-realism, 8 to 11 years (transitional),
4. realism and awakening.' (Tomlinson 1934: 10)

Gone at this point, apparently, is the 'coddling' concept, not only so far as childhood is concerned but more specifically as it influenced understanding of children's art. A strong link is being assumed between earlier and later drawing. The earliest work is given importance in this new view as the 'bedrock' of later achievement and as evidence of the development of intelligence (at least). The drawings of children and adolescents could now have transitional meaning and value if not ultimate recognition as art.

The stages of drawing development to which Tomlinson refers have similarity with those proposed by Luquet in 1927. Possibly Tomlinson acquired his version from British psychologists influenced by Luquet. Luquet's four phases are:

fortuitous realism,
failed realism,
intellectual realism,
visual realism (after about 8 or 9 years)

Luquet's topology of drawing development seems to have found favour for many years. Even as late as 1969, Piaget and Inhelder wrote:

> In his celebrated study on children's drawings, Luquet (*Le Dessin Enfantin*, Paris. Alcan. 1927) proposed stages and interpretations which are still valid today. Before him, two contrary opinions were maintained. One group held that the first drawings of children are essentially realistic, since they keep to actual models, and that drawings of the imagination do not appear until rather late. The other group insisted that idealisation was evidenced in early drawings. Luquet seems to have settled the dispute conclusively by showing that until about eight or nine a child's drawing is essentially realistic in intention although the subject begins by drawing what he knows about a person long before he can draw what he sees. (Piaget and Inhelder, 1969: 63–64)

The assumptions which appear to inform this very positive and confident statement are dubious. It is assumed that development in knowing about the world and development in recreating it through drawing are fundamentally linear and parallel processes. This is of course a traditional notion of development with many subscribers and its origins in the work of Rousseau, Froebel and of course Piaget himself, as well as in the writings of many of the art educators such as Lowenfeld in 1947 and Read in 1943, both of whom were obviously influenced by Rousseau and Froebel.

But by the time that Piaget and Inhelder were writing *The Psychology of the Child*, other models of development were being suggested for which there is at least as much evidence in behaviour, as alternative (not exclusive) theories to the traditional one. Freud had drawn attention much earlier to apparent regressive behaviour and there is every reason to suppose that some drawing behaviour is a kind of regression with a purpose; if so, then it is unwise to assume that drawings always reflect the intellectual stage of their maker or that they can be used to determine intelligence levels. Other more radical variations on the linear model have been proposed; development might have multilinear or even cyclical form; it might be through a synthesizing process; it might have some random aspects. There is evidence that drawing development manifests some or all of these patterns in different individual cases (Paine, in Dyson 1983: 46).

A second assumption at the heart of the Luquet model and tacitly accepted by Piaget et al. is that the child is always striving to represent the 'real' or 'adult' world – an idea in parallel with the second concept of childhood which sees this as the prime motivation for the activity of children. Yet the drawings of children frequently tell us of a whole other world of childhood ideas and imagery with their own vivid meanings. (It is this independent but not totally separate world which

Figure 6: Case study: Nicholas B., 19 years, 'Oil-rig with bottle opener'.

the illustrators of children's books try to enter when they hope to interest young readers). Drawings can also be imaginative representations of inner experiences and may employ their own visual symbolic language. It is absurd to conceive of a threshold over which children pass at the moment of moving from preoccupation with the imagined to the real: these two interests coexist from their earliest drawings, each becoming more or less evident at different times.

The two historical concepts of childhood have been jointly responsible for the assumption of discrete phases in the continuum of development and the idea that in art education particularly, earlier work is distinctively inferior as well as distinctively different in intention from later work. But if one can conceive, as Lawton does, of a third concept whereby childhood is itself a stage of inherently valuable activity, then the traditional differences of approach between primary and secondary art teaching can be seen as conventions without justification.

If the earlier work is as important, developmentally and possibly artistically, as the later, then it is not enough for primary children to be given freedom and opportunity for drawing without more positive teaching to help them. But it would be wrong to thrust at them too soon some of the better known artistic conventions for the portrayal of form and space; these are not necessarily appropriate to what they want or need to do. Indeed it has been a common mistake

of the psychological researcher to give such conventions undue prominence in research when other phenomena would have greater significance. The real need in primary teaching is for an attention to some much more fundamental aspects of drawing: how it may express the felt as well as the observed and not just, as it does, the subject-matter of drawings; how one image may symbolize or refer to another; and the qualities of different media differently used. Such things are not beyond the understanding of young children providing that they are approached through the making of art and increasing familiarity with art objects including some of the very best of those. And this intensely analytical process must begin early in schooling before social prejudices have had time to affect sensitivity. Once begun, it is a process which can be continued naturally into the secondary school stage. And it is a process of deeper and deeper insight, nourishing as well as arising from intellectual development, not one of merely learning new pseudo-artistic illusionary tricks, however useful in other contexts those may be.

Bibliography

Aries, P. (1973) *The Concept of Childhood*, Harmondsworth: Penguin Books.

Dyson, A. (Ed) (1983) *Art Education: Heritage and Prospect*. Tinga-Tinga: Heinemann Educational Books.

Lawton, D. (1973) *Social Change, Educational Theory and Curriculum Planning*, Seven Oaks: Hodder and Stoughton.

Macdonald, S. (1970) *The History and Philosophy of Art Education*, London: University of London Press.

Piaget and Inhelder (1969) *The Psychology of the Child*, London: Routledge and Kegan Paul.

Sully, J. (1895) *Studies of Childhood*, London: Longmans Green and Co.

Tomlinson, R. (1934) *Picture Making by Children*, London: The Studio Ltd.

Viola, W. (1942) *Child Art*, London: University of London Press.

9

How Children use Drawing

Dennis Atkinson

Vol 10, No 1, 1991

Introduction

As a teacher I remember being worried by theories of drawing development in children which appeared to suggest that this process was a hierarchical progression, evolving through predictable stages. I suppose the metaphor, 'stages', evoked a picture which suggested that children's drawing developed incrementally from simple to complex forms. My concern stemmed from the fact that I did not find this kind of model helpful for informing my practice, where I was confronted daily with a need to respond to the diversity of form emerging from children's drawing experiences.

Maurice Barrett, for instance, presents a sequence of diagrams which indicate a series of 'developmental differentiations' (Barrett 1979: 88) in the attempts of children (5-17 years) to represent space in their drawings of houses. Such differentiations are analogous to developmental stages and I think it fair to suggest that they imply a hierarchical model of the development of drawing ability. Psychological enquiry into the development of drawing abilities has naturally tended to invoke a hierarchical picture of this process. At the end of the last century, James Sully's *Studies in Childhood* (1895) contained the first comprehensive analysis and classification of stages of development in children's drawings. These stages were investigated and interpreted more rigidly in Cyril Burt's *Mental and Scholastic Tests* (1922). Lowenfeld and Brittain's five editions of *Creative and Mental Growth* (1947-70) provide a series of stages describing the 'gestural/physical' and 'expressive/representational' development of children's drawing. Lowenfeld's stages model of development has recently been reappraised by Barrett and it also forms the theoretical source for Hampshire Education Authority's *Guidelines for Art*

Education (1985). The latter provides teachers with a route-map of the development of drawing ability and a description of the typical features of each stage along the way.

Fundamental to Lowenfeld's theory of development is a view which sees this process as a predictable incremental progression from one stage to the next. 'Children draw in predictable ways, going through fairly definite stages, starting with the first marks on paper and progressing through adolescence' (Lowenfeld and Brittain 1970: 25–6). He also correlates drawing ability with 'intellectual level' (ibid: 36). Those who 'can draw' are generally perceived to evolve through predictable stages of development that exhibit an ability to handle increasing levels of graphic complexity, which indicate increasing degrees of mental awareness.

In Barrett's differentiation model (Barrett 1979: 89–90), each stage is depicted by diagrams which act as pictorial indices to locate where a child's drawing ability lies on the developmental route map. The pictorial terminus of this route is that stage in which a person demonstrates an ability to use linear perspective. Not all children will attain this level of development and it must be emphasized that Barrett and others are not encouraging teachers to guide children relentlessly towards formal perspective but to work sympathetically with and alongside the particular drawing system a child is using. It seems for them to be a matter of using the predictable hierarchical progression as a guideline to assist those who can to respond to its demands.

Can we think of the process of drawing development in a way which does not assume a predictable hierarchical progression, involving related assumptions of an evolution from inferior or primitive to superior levels of ability? One of the aims of this chapter is to consider the development of drawing from a viewpoint which does not assume such a progression. There is a difficulty here in view of the conventional tendency to measure the development of children's drawing abilities by their skill in representing aspects of the three-dimensional world. The depiction of objects in space lends itself to common verifiable assessment of drawing ability, because we are familiar with their visual appearance. The visual order of a drawn configuration can be measured against the visual order of an object seen from a particular viewpoint (see Freeman and Cox 1985).

However, when thinking about the universe of a child's experience, is it the case that children possess an overwhelming interest or desire to represent objects in space from a fixed viewpoint? Such a representation is only concerned with a particular experiential orientation within an entire universe of experience. For other experiential orientations – such as fantasizing, map making (Wolf and Perry 1988), relations between objects (Light 1985), playing games, describing action sequences – to be articulated, they will require appropriate representational forms. Furthermore, the variety of such experiences will invoke different cognitive, affective and connative drives which will inform the drawing process.

I argue that children do use drawing to represent a range of experiential orientations, but I make no claim for originality in doing this. Their drawings necessarily involve the inventive and eclectic use of mark configurations to represent such experiences. The use of mark configurations may

not always be consistent with those configurative schemas used to represent objects from a fixed viewpoint, and which are often used to assess development in drawing. This is because children are functioning in drawing to articulate other experiential orientations. Whereas Lowenfeld's enquiry appears to recognize children's eclectic use of drawing, the developmental model into which this use is assimilated is one assuming a hierarchical and predictable progression of stages. My aim is to show that children's use of drawing acquires a different developmental pattern.

As a consequence of my work with young children, I have formulated a view of development concerned with what I call the 'functional use of drawing'. A major concern of this chapter is to try to present this view, which lies in contrast to a mechanistic stages model of drawing development. My functional orientation for perspective provides a different evolutionary pattern to that of a stages theory, and is one which I have found more useful when teaching children and thinking about initiating drawing activities. The first task, however, is to consider what is assumed by the term 'representation' when applied to drawing development, and how such assumptions may affect our assessment of children's drawing abilities.

Representation in children's drawing

The various 'stages' approaches to the development of children's drawing abilities seem to assume a particular understanding of the term 'representation'. This understanding seems to preclude a real appreciation of mark-making systems not compatible with, or understandable within, the particular formal paradigm. Or, to put this another way, within this particular paradigmatic understanding of representation certain mark-making systems may be taken to be inferior, less skilful, or even incomprehensible.

Essentially, the notion of representation adopted by traditional stages theories appears to assume the accurate representing of the world from a static viewpoint. This attitude has a long history of value in our Western culture, emerging powerfully during the Renaissance. The most effective technology for effecting this form of representation was supplied by the drawing system we generally call 'linear perspective'. In Barrett (1979) there is a description of two pieces of research into children's drawing abilities which appear to assume and use perspectival representation as the criterion which signifies the highest level of drawing development. Both seek to explore how children's (5–17 year-olds) ability to represent three-dimensional space develops. Both tend to correlate the use of particular drawing systems with particular age phases and stages of development. In both enquiries, early representational forms are taken to be simpler and less complex than those produced by older children. Children's early representational forms are characterized by flat images showing the height and width of objects, whilst drawings produced by older children are characterized by a movement towards perspectival form. One researcher sets up a table with objects on it for children to draw from a fixed viewpoint, whilst another chooses to study children's drawings of houses.

There is, I believe, a difficulty here. Is giving children 'a real scene to draw from a fixed viewpoint' (Barrett 1979) already influenced by a perspectival paradigm of representation? For in the research conclusions, perspectival drawings are assumed to be the most complex

and advanced. Indeed, Wolf and Perry in discussing the conception of development in drawing skills suggest that:

> At the heart of this conception is the assumption that the development of drawing skills can – at least within a culture – be adequately understood in terms of a single endpoint, usually the rules for *the* predominant system of visual representation in the setting.(Wolf and Perry1988)

Is the researcher's choice of subject matter – the still-life, the houses – and his positioning of the child before it, already pre-informed by a particular, predominant, paradigm of representation? Does in fact this paradigmatic view inform, subconsciously, the researcher's actual choice of scene to draw, in the quest to discover how children's ability to represent three-dimensional space develops? Does this paradigm infect his expectations of what will be produced by the children?

The historical efficacy of perspectival drawing systems to represent the world from a fixed viewpoint is not in question here, but are the experimental procedures above already infected with a series of representational conditions which are almost beckoning for the use of this graphic system? Is the perspectival paradigm of representation pre-informing the researcher's categorization of children's drawing abilities? Is such a paradigm relevant to children's forms of representation which are used to represent their experiential orientations?

Such questions need to be considered when reflecting upon the notion of representation in children's drawing. It is arguable that the perspectival system has become so naturalized in our western consciousness that we tend to believe that the way we see our world corresponds with the way it is represented in perspectival depictions. Consequently this representational system can be used as the unassailable yardstick by which a person's ability to draw what he sees can be evaluated. Perspective becomes synonymous with visual representation. This graphic system has established a deep stability in our consciousness, vis-à-vis representation. Its naturalization obscures its essentially mythic effect. A close inspection of perspectival projection reveals that it distorts the world in relation to how we actually experience viewing it, and transposes this experience onto a rigid and abstract geometrical matrix.

The implied synonymous relationship between visual representation and perspective can create a constraining effect upon our perception of children's drawings and children's approaches to representation. The difficulty is that if we judge children's representation of space from within this paradigm, we may miss other, quite clever methods of representation that children use. Such methods may be screened from us by the paradigm of representation that is informing our judgement. In other words, the paradigm of (admittedly quite useful) perspective representation adopted by the research invokes a circularity whereby what is actually measured is the child's ability to employ drawing systems commensurate with, or comprehensible within, this paradigm.

Is it possible that not recognizing the circular nature of the enquiry makes us oblivious to any other orientational interests, and their respective drawing systems, which children may be using

to represent space: systems that are not compatible with the researcher's paradigm, but which are effective for the child? Ignoring this circularity invokes and compounds other difficulties as when young children's drawings of three-dimensional space are declared to be less complex than (with the possible implications that they are thus inferior to) drawings produced by older people. A further implication from such claims is that the younger child's *visual awareness* is deemed to be simpler and less complex. The inferiority of young children's drawing ability to that of older children is induced according to Light (1985), by the negative explanations of 'intellectual realism': children draw what they know, not what they see. In such explanations 'the younger child's drawing is best seen as a more or less incompetent attempt at what the older child successfully brings off' (Light 1985: 225–6) .

Is it appropriate, relevant or even commensurable to children's interests in using drawing as a representational action through which they articulate their orientations and concerns, that a perspectival paradigm of presentation be presupposed? Is it reasonable to make conclusions about children's visual awareness from within such a paradigm if it is not commensurate with the child's interest and use of drawing? Which circularity matters? Within a perspectival paradigm, the hierarchical categorizing of children's drawing systems and abilities can be appreciated. But is it reasonable to assume that young children are aiming to represent what their 'seeing orientation' involves from within such a paradigm? If not, why use it to judge and classify their drawings? Would a young child choose to use drawing to represent space from a fixed position consistent with a static perspective projection? Such a graphic paradigm is, I suspect, incommensurable to young children's representational interests. But within it, their drawings can be easily interpreted as being primitive in relation to drawings produced by older children.

It is interesting to consider what Lowenfeld means by representation. For instance, he states that it is during the Pre-Schematic Stage (4–7 years) 'where the child makes his first representational attempts' (Lowenfeld and Brittain: 37: 1970). In other words during the unfortunately-termed Scribble Stage (2–4 years) immediately preceding, children are assumed not to be making any representational responses in their drawing. I find this hard to believe. Again, discussing the Pre-Schematic Stage, Lowenfeld states 'It is possible to think of drawing by children of this age as evolving from an *undefined collection of lines* into a definite representational configuration' (ibid: 37, emphasis added).

This view is confirmed in Hampshire Education Authority's *Guidelines for Art Education* (1984). Quoting Lowenfeld on the representation of the human figure during the Scribble Stage, the *Guidelines* state quite bluntly that 'no attempts are made' (1984: 32).

Although, as far as I am aware, Lowenfeld makes no attempt to say what he means by the term 'representation', I suspect he is using it to characterize children's mark configurations which form visual equivalents of objects or beings in the world, as perceived by adults already compromised by the perspective model. In trying to find a way to distinguish between a child's intentions and an adult's interpretations, I find the terms 'metonymy' and 'metaphor', as used by Leach (1976) helpful. A metonymic association is when some attribute or *part* of what is

being referred to, the referent, is substituted for and represents the *whole* referent, as a crown represents monarchy. There has to be a prior context of association before metonymy can function. The essence of metaphor, however, is to describe and understand something in terms of another, the two things emerging from two unrelated contexts. For instance, in the expression 'the wind combs through the grass' the social context of combing has no intrinsic relationship with the meteorological context of winds.

Hence a useful way of describing Lowenfeld's notion of 'representational configuration' beginning to function is when children's mark making operates *metonymically* for adults in relation to the way we visually perceive our world. I suspect the metonymic attribute of children's drawing which Lowenfeld describes as 'a definite representational configuration' will be that which appears to depict the shape or form of objects or beings in our compromised adult world. If this is the case, then the representational context of a particular child's drawing can only be determined when his or her mark-making configurations become *re-cognizable* within our paradigm of representation – when we are able to 'recognize' metonymically the representational configuration with its referent in the world.

For children, however, such metonymic configurations – being essentially partial – are almost certainly incommensurable with their drawing actions (I use the term 'drawing action' to denote mark making that contains an implicit metaphoric power). They are likely to be creating *metaphoric* associations between their drawing forms and their referents. That is, in asserting a similarity between marks and their referents, the child ensures that his or her marks take on representational significance for himself or herself, no matter how they appear to others – whether sympathetically metonymic or totally incomprehensible.

This raises difficulties of interpretation. How do we know that during the Scribble Stage young children are not attempting to represent the human figure (as Lowenfeld maintains) or other aspects of their experiences? For them, their mark making may possess representational qualities, as they invoke an asserted similarity (metaphor) between their so-called scribbles and their referents. As adults, we often find it difficult to interpret and appreciate any representational qualities in such early mark making systems as we scan them metonymically (sympathetically), searching for attributes of objects or beings we can recognize. It is probable that we can only appreciate that which we recognize – the circularity is built-in by the prefix 're'.

Recent research (Mathews 1984, 1986, 1988; Smith 1983; Willats 1985) suggests that it is indeed the case that drawings produced by young children at the Scribble Stage age do possess quite complicated systems of ordering and powerful representational qualities. Such insights, however, need to be qualified with a question – 'who recognizes?' I want to emphasize the important point of trying to understand what children are attempting to *use* drawing for in representing particular orientations to their experience. Simply scanning their drawings for recognizable attributes and features is inadequate to such understanding.[1] We may then begin to appreciate that so-called 'scribbles' and pre-schematic drawings are far more complex and ordered than such pejorative descriptions imply.

I am becoming increasingly aware of children's eclectic use of drawing to represent aspects of their experience. They appear to possess an ingenious capacity for doing this. For them drawing appears to be a powerful tool which they can use in a variety of ways to represent and be articulate about their world. This eclecticism must in turn involve quite complicated modes of thinking and reasoning which inform and create order in the drawing. The fact that the visual form of many early drawings is difficult to recognize within our adult paradigms of representation probably has little relevance to a child's use of drawing. His or her marks are likely to possess a coherent form-meaning circularity embedded within the child's contextual use of drawing. Thus if we base our assessment of children's drawings within irrelevant paradigms of representation and particular models of development, we are likely to miss the functioning significance the drawing has for the child, and misconstrue the way in which drawing ability develops.

In the above, the word 'space' appears sometimes qualified by 'three-dimensional', and at others alone and unqualified. When investigations into how children 'represent three-dimensional space' are made, I want to ask what is meant by this term. Does what is meant correspond with the way in which a child is actually experiencing space and therefore how he or she is interested in representing whatever he or she is asked to draw? I wonder if the term 'three-dimensional space' is not itself a metaphor for hinting at the child's representation of the 'world out there'. A metaphor which helps reduce the complexity of experiencing and representing and which has long been accepted but unexamined.

Duthie (1985) argues that although linear perspective – the drawing system often used as a yardstick to gauge drawing development – provides a solution for depth representation, children may not be interested in using it. He reminds us that our experience of perceiving the world involves 'seeing in space' as well as 'in depth', and that this

> implies encoding many alternative orientations of one scene rather than a unique viewpoint of a succession of scenes. The encoding of alternative orientations introduces one more aspect of the perception of form that is hardly ever discussed in relation to how a child depicts form, and that is eye movement. (Duthie 1985: 106)

Traditionally, perspective drawing is a model for adding a third dimension, 'depth', to the two dimensions geometrically recognized on the drawing board.

The notion of depicting the world from a fixed viewpoint, assumed by linear perspective, is an abstract idea which imposes a severe reduction upon experiential orientations to our world, despite its usefulness in certain circumstances. Duthie's reference to eye movement is a reminder that experiencing the world is a dynamic flow in which our relations to objects and space possess implicit relativity. As I sit and look out into the room before me, the spatial relations I perceive between furniture, books, chairs, doors, windows, carpet, ceiling, walls, etc, will change as I shift my focus. However, as Duthie maintains, the practical difficulties of representing objects in space – as we experience and perceive them in this flow – are complex because such experience cannot be articulated according to a single set of graphic rules. Such representation

is far too difficult for children, even though they may wish to 'depict objects in related space'. However, what they can do in order to hint at their experiential orientations is to try to represent objects *and* space. Thus, in furthering our understanding and assessment of children's drawing abilities, we may need to consider whether a single paradigm of representation is redundant. In reality, several paradigms may be functioning, dissociated in time.

Drawing systems; drawing discourses

Following my discussion of some underlying assumptions behind the use of the term 'representation', I want to lay stress upon the word 'use' when considering children's developing drawing abilities. Matthews (1984, 1986, 1988) and Willats (1985) have shown that early drawings from the age of two years possess a variety of representational uses. In my own work, considering drawings produced by children from the age of five years, I have been impressed by their ability to use drawing as a flexible and powerful tool to perform a variety of representational tasks, depicting for instance, actions, events, time-sequences, people, objects and narrative. I will now offer an interpretation of some children's drawings, bearing in mind that such interpretation is informed by my functional interest in how children use drawing. I am thus declaring from the beginning my partial interpreter's position in relation to the drawings.

Consider the use of lines in Figure 1. Captain America, the horizontal flying figure right of centre, is placed at the end of a spiralling line, deliberately constructed to represent his acrobatic flight path. Alternatively, Spiderman, the vertical figure left of centre, is depicted with lines projecting from both hands to the left and right top corners of the drawing. Noticeably, at these positions, both lines curl round in a loop. Here the lines signify Spiderman's anchor ropes shooting out and finding anchorage points, so that he can escape the clutches of the monster, to the left.

Figure 1

The drawn lines seem to capture the characteristic action of their referents. The lines emerging from the hands of the small figure, bottom right, depict some form of missile or laser trajectory, whose characteristic properties are suggested by the ends of both lines 'exploding'. Similarly the line from the monster's mouth indicates that it is a line of flame by the form of its ending. Such lines are mainly being used to represent action sequences.

When considering the figures, lines are used differently to represent aspects of the same forms. For instance, Captain America's outstretched arms are each depicted by a single line with a blob on the end. This line could be said to represent the linear extension of an arm in space. However, both legs are drawn with two lines and those of the monster by a continuous looping line describing leg and foot. Here the lines appear to suggest the volume of a leg and its long extension in space. These lines represent particular formal aspects of solids extended in space (see Willats 1985). The drawing is a representational compendium of narrative, action and description, in the context of the boy's drawing action.

In Figure 2, produced at the same age (six years) the boy is providing a specific emphasis to represent a time sequence. When he is drawing he tells me that the diver is 'running out of air'. The focus is not upon describing the diver as such, but the imminent tragedy.

Figures 3 and 4 were produced at nine years, within a few weeks of each other. They contain different representational orientations equivalent to the boy's interest in soccer. In Figure 3 a carefully orchestrated time and action sequence is articulated, as the boy plots how a goal is scored. There appears to be a major concern for representing the interaction of players and the dynamic sequence in which they are involved. Lines depict players and the looping path of the ball passing from head to foot, eventually bursting through the goalposts. The drawing also includes different viewpoints of similar events, involving the use of orthographic and oblique projections to depict the goalposts.

Figure 2

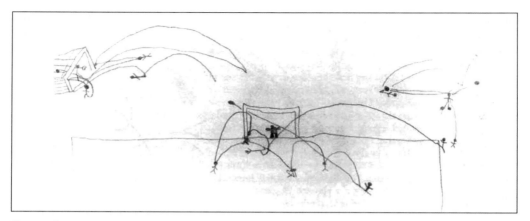

Figure 3

In Figure 4 there is an obvious fascination with the 'soccer player', who is drawn in great detail. The drawing still involves the act of shooting for goal but there is not the concern shown in Figure 3 to represent a continuous sequence of play through time. Thus a different soccer interest evokes the use of a relevant representational form. Players are depicted from front, rear and side viewpoints. There is an attempt to cope with foreshortening and the problem of occluded shape in the drawing of player 10's boots.

Figure 4

Such drawings are, I believe, manifestations of an eclectic use of drawing to represent a variety of orientations to experience. I want to develop this claim by creating an analogy with the way we use language. I have found Wittgenstein's aphorism '[t]he meaning of a word is its use in the language' (Wittgenstein 1978) helpful when thinking about how children use drawing. I will try to show how. In its functioning flow, when people are using language, it consists of a plurality of discourses. By this I mean that although language is a medium with common currency, the meanings we give words emanate from our experiences and interests inherent to the local contexts in which we use them. Although in argument or discussion people may be using the same common word, its meaning may be ambiguous due to the speaker's interest stemming from his context of functioning. I often feel the presence of such ambiguity when people from contrasting contexts – employers and union leaders, for instance – use words like accountability, responsibility or justification to support their opposing views.

From the static forms of language we are able to generate an infinity of local discourses as we supply words with our local meanings. Wittgenstein gave us the notion of 'language games' to remind us that when words are being used, when language is functioning, there is always the possibility of ambiguity of meaning because we speak or write from a variety of contexts. A context of use will include a person's biographical circumstances, interests and desires, in relation to the present place-time in which he or she is using a particular configuration of words. All these things will inform, and so constitute, the person's discourse, and of course signify different localities of meaning depending on its context.

Analogously, when we are thinking about the meaning children give to their drawings, perhaps we can say 'the meaning of a mark, or mark configuration, is its use in the drawing system'. As in my reference to the functioning of language, I maintain that in the functional flow of drawing a particular drawing system can be used by children to elicit a plurality of drawing discourses. A drawing system, I suggest, can consist of a way of marking marks (and their respective configurational arrangements) in which a child has developed a confidence in handling and is able to use it for particular representational purposes. The morphogenetic evolution of different drawing systems – which are sometimes referred to as flat, oblique or perspectival – may occur as a consequence of the struggle to find new mark making forms to represent new insights or concerns which the child's previously assimilated drawing systems fail to do.

A drawing discourse represents an actual functioning of a child's drawing system within a particular context of use. In different drawing contexts the 'same' system may be used quite differently and thus form a variety of drawing discourses. A context of use may involve actions other than drawing which contribute to the discourse: such actions are intrinsic to the child's purpose of drawing. This is quite common to observe in young children, who often accompany their drawing with noises and gestures which relate to the subject matter of the drawing. Hence, here in the functioning flow of drawing, a child's assimilated drawing systems are given meaning through their use in particular drawing discourses. A child can use almost identical lines and configurations in different drawing discourses and thus they will acquire different meaning. I have already suggested that different drawing discourses may be used in the same drawing, when almost identical lines are used for a variety of representational purposes.

Ascribing any meaning to drawings produced by children of two or three years is difficult. The use of their range of mark configurations is not easy to interpret and the mark configurations can be extremely ambiguous, especially when we only consider the finished drawing, detached from its context of production. Matthews has produced some significant insights into a child's ability to use similar marks in different drawing discourses so that in each discourse the drawing will acquire a particular representational purpose. Observing a 2-year-old boy drawing, he notices that the boy uses the almost identical mark configuration in two drawings, firstly to represent an aeroplane, as object, and then in the second drawing, to represent the aeroplane flying. The different discourses were differentiated by carefully noticing the child's approach to what ostensibly appeared to be the same drawing, done twice. After the first drawing the child stands back and states 'this is an aeroplane' (object discourse) During the second drawing, whilst making vigorous marks, he makes the same statement, but now the drawing represents the action of the aeroplane flying (action discourse).

Thus the context of use indicates what a child's mark making means for the child. Here in the functioning flow of drawing, the child's assimilated drawing systems (which possess no meaning outside of their use) evoke meaning through their use in drawing discourses. Although young children may appear to possess a limited range of drawing systems (and this is arguable) they do command enormous ingenuity for using them differently and evoking different meanings, in a variety of drawing discourses. They are perhaps far more versatile in their eclectic use of drawing than we adults in our culturally inhibited states.

It seems crucial, then, that if we wish to discover the meaning a child is giving to a drawing, we need to be aware of how the marks are being used in the particular context of the drawing action. This point relates to my earlier concern for considering the functional use of drawing. A sensitivity to the use of drawing allows some insight into the meaning a child gives to it. This sensitivity is also pertinent when we are considering the meaning of drawings produced by older children in secondary school. In the latter context, when assessing drawings, I often failed to consider how a pupil was using his or her mark configurations; therefore I must have been unaware of their meaning for the pupil. My experience of examining tells me that assessment is made frequently from detached paradigms of representation and technique which are insensitive towards a pupil's drawing discourse.

Acculturation: functioning and form

Could it be the case that as children become acclimatized to our culture, the process sometimes called 'acculturation' gradually invokes inhibitors upon their early eclectic use of drawing? In trying to face this question I want to readdress the notion of development from a functional viewpoint and offer some speculations as to the form of its evolutionary pattern. Do cultural inhibitors effect a particular perception of the use of drawing, so reducing the interest in its functional capacities to the objective representation of the world as we see it? If this is so it would account for the valuing of perspectival systems which are so adept when used for this function.

My belief is that when we consider the use of drawing in relation to the process of acculturation, both use, and hence value, have a tendency to narrow. There appears to be a deep channelling

of a particular use. The earlier eclecticism of drawing systems to create a high variety of drawing discourses permits the articulation of a whole range of experiences. Later drawing systems, which perhaps possess greater degrees of elaboration, lack this eclectic use and their function gravitates towards an interest in an objective re-presenting of the visual world. Hence there is a tendency towards object drawing discourses. This is observable of course only in those who 'draw'. Others may keep their eclecticism, but our acculturation prevents them from being recognized.

Is it the case that in a functioning sense of drawing development, the later elaboration of a particular drawing system, such as perspectival projection, permits a range of drawing discourses with a restricted, but highly efficacious use? If this is the case, and I suspect it is, it seems remarkable: the more elaborate the drawing system the more restricted becomes its function, as it tends to be valued for effecting particular ends. Perhaps we need to recognize that the gravitation to an interest in valuing drawing for a singular purpose, means that the once useful range of drawing discourses are no longer valued.

The developmental evolution being suggested indicates both a narrowing of use (drawing discourses) and an attraction towards valuing a particular drawing system which can be used for a particular purpose. I am therefore offering a different picture of the development of children's drawing to that view which suggests an evolution from less complex to more complex stages, from inferior to superior systems of representation. Such a view implies that for those who are recognized as being able to 'draw', their drawing ability will improve incrementally as they grow. My concern is to describe a functional interpretation of drawing development. The ingenuity to create a high variety of drawing discourses suggests that, *in functioning,* children's use of drawing is more complex than imagined. When functioning in drawing, children display a complicated use of this activity, which tends to dissipate during the process called acculturation. This implies that as children grow, generally their use of drawing narrows.

The form of a child's drawing may appear simple, primitive or deficient in some way, to those whose judgement is affected by a particular attitude towards representation – intellectual realism, for example. But in simply considering the form we are likely to miss the crucial factor, that is, how the drawing is functioning for a child in his or her particular drawing discourse. This has implications for assessment procedures in teaching, which neglect the functional significance a drawing has for a child. The essential point is that when considered from a functional context, the development of children's drawing abilities could be said to graduate from a high to a low variety of use. I believe that a traditional view of the development of children's drawing abilities, which assumes a hierarchical progression from simple to more advanced stages, becomes inadequate, and perhaps redundant, when the functioning use of drawing is considered.

The tendency to value and elaborate certain drawing systems creates in many youngsters a restriction in their use of drawing. Many feel they can no longer draw. This is often expressed by late primary and early secondary pupils. From being highly versatile inventors of drawing discourses, many become worriers over form. They are often, directly and indirectly, 'educated' into perceiving that the purpose of drawing is to achieve a particular form of representation which accurately depicts the three dimensional world.

Note

1. In one classroom I visited I noticed a drawing of a local pond produced by a 5-year-old boy. When I first saw the drawing, I found it incomprehensible, apart from concentric, ring-like marks I guessed were something to do with ripples on the pond's surface. However, when I talked with the boy about his drawing, he revealed a system of order and representation. He had been throwing stones into the pond, and he had used jagged lines to represent their impact. His concentric lines represented what happened when the stones were sinking; and he had used dots to represent what happened when the lines had 'gone away'. In other words, here was a drawing representing a time sequence in an order and representational format which was full of meaning and significance for the boy – but this was not immediately accessible and significant to me.

References

Barrett, M. (1979) *Art Education: a Strategy for Course Design,* London: Heinemann Educational.

Burt, C. (1922, 1947) *Mental and Scholastic Tests* London: Staples Press.

Duthie, R. K. (1985) 'The adolescent's point of view: studies of forms in conflict', in: N.H. Freeman and M.V.

Freeman, N. H. and Cox, M.V. (Eds) (1985) *Visual Order: the Nature and Development of Pictorial Representation,* Cambridge: Cambridge University Press.

Hampshire Education Authority (1985) *Guidelines for Art Education*

Light, P. (1985) 'The development of view-specific representation considered from a socio-cognitive standpoint', in: N.H. Freeman and M.V. Cox (eds.) *Visual Order: the Nature and Development of Pictorial Representation,* Cambridge: Cambridge University Press, pp. 214–30.

Leach, E . (1976) *Culture and Communication,* Cambridge: Cambridge University Press.

Lowenfeld, V. and Brittain, W .L. (1970) *Creative and Mental Growth,* London: Macmillan.

Matthews, J. (1984) 'Children drawing: are young children really scribbling?' *Early Child Development and Care* 18, pp. 1–39.

Matthews, J. (1986) 'Children's early representation: the construction of meaning', *Inscape* 2, pp. 12–17.

Matthews, J. (1988) 'The young child's early representation and drawing', in G.M. Blenkin, and A.V. Kelly, (Eds) *Early Childhood Education: a Developmental Curriculum,* London: Paul Chapman, pp. 163–83.

Smith, N.R. (1983) *Experience and Art: Teaching Children to Paint,* New York: Columbia University Teachers' College Press.

Sully, J. (1895) *Studies in Childhood,* London: Longmans Green.

Willats, J.A. (1985) 'Drawing systems revisited: the role of denotational systems in children's figure drawings', in: N.H. Freeman and M.V. Cox (Eds) *Visual Order: the Nature and Development of Pictorial Representation,* Cambridge: Cambridge University Press.

Wittgenstein, L. (1978) *Philosophical Investigations,* Oxford: Blackwell.

Wolf, D. and Perry, M.D. (1988) 'From endpoints to repertoires: some new conclusions about drawing development', *Journal of Aesthetic Education* 22, 1, pp. 15–34.

10

TEACHING CHILDREN TO DRAW IN THE INFANTS SCHOOL

Maureen Cox, Grant Cooke and Deirdre Griffin

Vol 14, No 2, 1995

The role of art in the primary school

A number of studies (e.g. ORACLE study, Mortimer et al. 1987; Tizard et al. 1988) have shown that teachers in primary school classrooms tend to concentrate their efforts on helping children with the 'basic skills' of reading, writing and number, believing that these skills need to be taught, whereas they tend to leave children to draw and paint on their own without any assistance. More recently, Hargreaves and Galton (1992) have found that teachers tend to use drawing and other artwork as 'fillers' for some pupils while they supervise other activities in other parts of the classroom.

Beliefs and attitudes

This practice of relegating art to a 'filler' activity results from a number of beliefs and attitudes. One is that art is not a basic skill and therefore does not matter very much. Children have not had to achieve certain standards and the teachers themselves have not developed their own artistic skills, and often have neither the inclination nor the ability to provide technical help for their pupils. There is also a belief that art is a gift, an innate aptitude rather than an acquired skill; 'born' artists will acquire techniques somehow on their own. Many teachers hold the belief that they should not intervene in the child's artistic productions since the whole point of children's art is that it is concerned with self-expression, a view promulgated by art educators such as Cizek (Viola 1936) and Lowenfeld (1939) earlier in this century. Perhaps because these earlier educators were reacting to an over-formal, technique-led approach to art, they over emphasized the notion of art as uninhibited self-expression, which would be stifled if adults interfered. The

result has been that many teachers are so concerned not to interfere that they treat children's artwork almost as sacred and feel that their pupils will be psychologically damaged if their work is criticized. Many teachers feel that the most they should or can do is to provide the materials and suggest interesting and exciting topics to inspire children's imaginations. Hargreaves and Galton (1992) describe the teacher's role as one of a 'facilitator' rather than an active participant in the child's artistic development.

As a consequence, most children receive little or no tuition in basic drawing technique and as soon as they devise 'schemas' for objects which look recognizable, they may cease to experiment further. Indeed, Brent and Marjorie Wilson (1981, 1984) have shown that the schemas children use are actually rather few, and this finding prompted Brent Wilson to remark, '...the child is the most conventional rather than the most creative producer of art' Wilson (1992: 23). After the age of 9 or 10 years (Edwards, 1979), many children are reluctant to draw, often believing that they 'cannot draw' and are 'not artistic'.

The importance of tuition
It is our view that, as with any other skill, tuition in art is important both for those who show promise and for those who do not. Furthermore, we do not believe that tuition will inevitably result in the stifling of creativity or the production of 'wooden' and uninspired work. Even the great artists of the past were themselves apprenticed to others and spent much time learning the techniques of the day. Artists such as van Gogh, who was largely self-taught, recognized the need to come to grips with basic drawing techniques in order to give expression to his work.

Wanting to be able to draw in a fairly realistic fashion is something which children aspire to by the age of about 9 years of age and they usually give up if they do not acquire this skill (Cox 1992). Of course it is not necessarily the case that this is 'the correct way' to draw, or indeed the only way to draw. But it is one way, and it does not follow that teaching children one technique will prevent them from learning and exploring other ways of drawing. In fact, if they do not learn how to draw realistically then their options have already been narrowed. David Hockney has said that this a trap for artists. As Edwards (1979) has argued, '[t]he sources of creativity have never been blocked by gaining skills in drawing, the basic skill of all art.' Most children do not naturally and inevitably discover how to draw; if they did then most of us would be reasonably skilled artists.

Art in the National Curriculum
Art is now a foundation subject in the National Curriculum, which means that it must be taught as a subject in its own right. But how ready are class teachers in primary schools to take this on? Clement (1994) addressed this issue in a recent questionnaire study and found that over 60 per cent of teachers felt the need for further in-service training if they are to teach the new art curriculum. Whereas teachers have a good idea of the standards expected at each level in most school subjects and know how to teach them, they are much less certain in the case of art.

The process of art

The fact that children do not usually see class teachers and parents draw or paint may lead them to assume that pictures can only be produced by 'proper' artists and that proper artists are born and not made. They may also believe that a skilled artist produces a picture easily and automatically; a view perhaps reinforced by 'painting made easy' television programmes where experts make production appear effortless. 'Real' artists, however, do not usually work like this; they are constantly re-thinking and reworking their pictures. But children can only understand this process if they have the opportunity to see how artists work. Schools which have an 'artist-in-residence' are able to provide this role model, stimulating the children's general interest but perhaps more importantly, giving them more insight into the actual process of creating a picture. Unfortunately many schools may not have the opportunity or the funds to get an artist into the school. But what they can do is to try to incorporate some of the features of the artistic process into their teaching.

The 'negotiated drawing' process

Recently we have evaluated an approach to the teaching of drawing in the infants school developed by Grant Cooke with the help of Deirdre Griffin. The technique of 'negotiated drawing' was devised in order to provide young children with some insight into the decision making processes involved in the production of an image of an observed object, and to put them in touch with an important role model – an adult engaged in the drawing process.

The children are seated so that they all have approximately the same view of the chosen object. The teacher asks the children to help her to draw the mutually-observed object on the board by giving her clear verbal instructions. During the drawing process the teacher makes deliberate errors of judgement involving shape, scale, placement and orientation. As she begins to construct an image the children are encouraged to give the teacher advice, drawing attention to and describing how to correct any errors which she makes. The teacher's drawing is the focus that enables the children to discuss and articulate what they think should be drawn next, and to describe shapes and make judgements about the accuracy of the marks made on the board. Through directing the teacher in this way, the children are helped to formulate a relationship between the object and the marks which the teacher makes on the board. They engage in reflection upon the process of drawing.

The children are also being required to use verbal language in a precise way, and there is scope for this element of 'negotiated drawing' to become progressively more demanding over a series of lessons. Before the children begin their own drawings, the object is placed within a fictitious context or story. This adds an imaginative dimension to the children's drawings and helps motivation.

The drawing on the board is seldom finished, and is always wiped away before the children make their own drawings of the observed object. At no stage in the process of 'negotiated drawing' are the children asked to copy the teacher or allowed to copy the teacher's drawing.

This process was arrived at in an attempt to fill an apparent gap in the art experiences of children in Key Stage 1. Within the local education authority (LEA) in which Cooke and Griffin worked a great deal of imaginative work was undertaken with infants in which they produced colourful paintings, experimented with materials and textures, and made three dimensional art objects. However, little attention seemed to be given to helping young children to understand drawing as a process, whether within the context of art work, or drawing as a mode of enquiry and way of recording in other curriculum areas. Members of the Brycbox Team each had a specific subject specialism but were interested in ways in which expertise from one arts area might colour or motivate work in other areas of arts education. The negotiated drawing process brings together the creation of imaginative contexts associated with drama and storytelling, coupled with a focus on language development and related teacher questioning. It borrows from the drama convention of 'mantle of the expert', empowering children to become decision makers in a process within which it is the teacher who appears to be the 'learner'. The underlying intention is to encourage the development of drawing skills within a context which is fun for the participants and embeds the process within the whole curriculum. It is seen as a way of working which can easily become part of the repertoire of class teachers who may not consider themselves to have well-developed drawing skills. It also offers exciting possibilities for making connections between developing drawing as a visual language and other curriculum areas.

An example of a lesson involving 'Negotiated Drawing'

This lesson involved the children being asked to draw a large inflatable skeleton within the context of a story which had been developed with the class about a skeleton who did not know how to dance. The teacher hangs the inflated skeleton in a prominent position close to the drawing board, and asks the class to sit in a way which, as far as possible, enables all to have a similar view of the front of the skeleton.

Teacher: *Can you help me draw this skeleton? It's going to be my hand which does the drawing, but your eyes and brains which tell my hand what to do. Should I start at the head or body?*

Sometimes the choice is completely open but, as in this case, there is a chance that a child sitting at the front may choose a part of the skeleton which is too small to provide a good example at the start of the exercise. For this reason, the teacher poses a question which limits choice.

Child: *Head!*
Teacher: *What shape is the head?*
Child: *A circle.*

In actual fact it is not a perfect circle, but the teacher takes the child's suggestion and draws a circle near the bottom of the board.

Child: *It's too low!*
Teacher: (Asking all the class) *What's wrong with that?*
Child: *There's no room for the body.*

This obvious mistake made by the teacher shows that even the initial marks have to be thought about.

The teacher now rubs out the original circle and draws a very large circle near the top of the board, erasing this when the children say that it is too big and replacing it with a smaller circle.

Teacher: (Pointing to the head of the skeleton) *Is this a proper circle?*

A short discussion ensues in which different children compare the shape of the skeleton's head with the shape 'oval' and 'an egg'. Following new advice from the children, the teacher now narrows the lower part of the head shape on the board.

Teacher: *I don't want to draw in the eyes and mouth now – when you do your drawings you can add all those things.*

The teacher judges that these printed features are too easy, and wants to move on to other parts of the body. The children now help the teacher to draw the neck of the skeleton. Next the children give the teacher instructions about how to draw the shape of the skeleton's rib cage.

Child: *It's a square.*

The teacher draws a very small square.

Child: *No. It's bigger.*

Teacher erases the first square and draws another which is too big.

Child: *No ... It's sort of in between ...*

Eventually the children decide that it is not a perfect square, and that the corners of the shape are rounded. Quite often the teacher has to insist on moving on as the children can become quite obsessive about small differences. When this happens the teacher stresses that the children will be able to include all the details which they are pointing out in their own drawings.

When the class focus on the complicated pattern of ribs which is printed onto the surface of the inflated chest of the skeleton, the teacher first of all uses analogy.

Teacher: *Look, it is a bit like curving branches on a tree* (pointing to a rib curving away from the breastbone). *Can you hold your arm up and make that shape in the air?*

Asking all the children to make a shape in this way is a useful strategy for involving every child, particularly in situations in which some of the more vocal members of the group are in danger of dominating the proceedings.

At this point the teacher judges that it is time to move on.

The object of the exercise is to create a route towards the children's own drawings, so it is unnecessary to complete the drawing on the board.

The teacher now repositions the skeleton so that it is sitting on a chair in the middle of the room and begins to build a story. 'One day when the children come in from play they hear a sobbing noise and see a skeleton sitting on the chair crying...' The teacher gets one of the children to ask the skeleton why it is so unhappy. They learn that the skeleton used to be a dancing skeleton, but one day it woke up and found that it had forgotten how to dance. After a short discussion, the children decide that they will teach the skeleton how to dance. In turn, they get up and demonstrate to the skeleton some of the ways they can dance.

When this active story session comes to an end, the teacher's drawing is wiped off the board and the children are invited to make their own drawings of how the skeleton was taught to dance. The skeleton is left sitting on the chair and the children are asked to refer to this as they set about making their drawings.

The teacher-child interactions in the course of this session combine a range of different kinds of signals: verbal, visual, and gestural judgements which the children are asked to make become progressively more difficult, and they have opportunities to practise precision in their instructions, using the kind of spatial language which is seldom required in general conversation. The children can learn from each other's use of language, and the teacher brings into play differentiation through the level of demand made of individual children in the questioning process. There is a strong element of humour and sense of enjoyment – it is fun to 'correct' your teacher!

Figure 1: The negotiated drawing.

Table 1: The design of the study.

Condition 1	Condition 2	Condition 3	Condition 4
Cooke giving his drawing programme	Teacher trained in drawing programme	Cooke's normal teaching	Teachers' normal teaching
N = 62	N = 54	N = 58	N = 61
30 boys, 32 girls	27 boys, 32 girls	30 boys, 28 girls	29 boys, 32 girls
Age: average 5:10	Age: average 5:9	Age: average 5:10	Age: average 5:9
range 5:4-6:3	range 5:3-7:0	range 5:4-6:11	range 5:3-6:3

In other lessons, specific communication problems were used to motivate the children's work. For example, the children had to 'teach' their teacher how to fry an egg! Following this process, which took place using a portable cooker in the middle of the classroom, the children made a negotiated drawing of the cooker. They then made their own pictures designed to remind the teacher how to fry an egg, referring to the real object as they worked. We believe that this process of 'negotiated drawing' helps to introduce young children to drawing processes which are culturally important conventions, not just in Western art education, but in drawing as a cross curricular skill. We do not suggest that work of this kind should replace the exciting exploration of materials and multicultural approaches to visual arts which are a feature of good practice in many infant schools. We do, however, feel that this provides a way of focusing on the drawing process which is accessible to young children and enables the development of understandings and skills which are relevant to the needs of children in Key Stage 1.

The design of the study

We developed a course of ten drawing lessons, each with a different topic, for children aged between 5 and 6 years and then evaluated their effectiveness in improving the children's drawings. There were four experimental conditions (see Table I). In condition 1, Cooke himself gave the ten lessons. In condition 2, a supply-teacher was trained in his approach and gave the ten lessons. The aim was to see if the approach would improve children's drawings when adopted by other teachers; indeed, if Cooke's approach is to have any general benefit, it must be capable of being adopted by others. In condition 3, Cooke gave ten 'ordinary' drawing lessons; that is, he covered the same ten topics but did not adopt his 'negotiated drawing' approach. The aim here was to see if Cooke himself giving ordinary lessons would have the same effect compared with his special approach; it may be that any improvement is brought about not by his approach per se but because of the novelty effect or his own charisma. Finally, in condition 4, the children's regular class teachers gave ten ordinary drawing lessons. Unfortunately the class teachers chose not to cover all the same topics as the other three conditions; since there were only two topics common to all four conditions, namely 'the magic bicycle' and 'daffodils', it was only possible to make direct comparisons across all four conditions of the drawings carried out in the lessons with these two topics.

The children

Four schools took part in the study, each one supplying two classes of children. Classes were allocated at random to our four experimental conditions, with the proviso that no school could have both classes in the same condition. Details of the number of children in each condition, number of boys and girls, the average age and age range are given in Table I.

In order to ensure that the children in the four experimental conditions were well-matched in ability, they were all tested for non-verbal reasoning using the Raven's Coloured Matrices (Raven, Court and Raven 1990), before the drawing programme began. In addition, they were asked to draw a person. These figures were then scored according to the Goodenough-Harris scoring system (Harris 1963) and also the Koppitz system (Koppitz 1968); there is evidence that scores on these drawing tests correlate with children's intellectual maturity or developmental level. The children were also asked about their drawing ability and were asked to point to one of a set of four cartoon faces (ranging from glum, indicating very poor at drawing, to smiling broadly, indicating very good at drawing) to indicate their feelings about this. There were no significant differences among the four conditions on these various measures and most children in all conditions thought they were very good at drawing.

Three drawing tasks (the pre- and post-tests)

Although we were able to make direct comparisons among the four sets of children on only two of the topics covered in the lessons, we administered three drawing tasks to all the children before the drawing programme began and then after it had finished. Thus, each child produced three pre- and three post-test drawings. These three tasks were chosen to cover a range of different kinds of drawing activity: the telephone task involved a 'still-life' drawing in that the children drew the object placed before them; the other two tasks involved drawing from imagination ('brushing your teeth' is an everyday event, whereas 'a strange zoo' allows more scope for fantasy).

The judges

Three former art advisers were asked to judge the pictures. The drawings were number-coded and had no other information attached to them. In each pile (bicycle, daffodils, telephone, teeth, zoo) the pictures were randomized so that the judges had no knowledge of the condition a drawing belonged; they were not told that there had been a pre- and post-test for the telephone, teeth and zoo drawings and they treated each picture quite separately. They were told about the instructions that the children had been given for each of the pre- and post-test tasks. They were given no specific criteria on how to judge the pictures, but were asked to rate them on a 5-point scale where 1 is very poor and 5 is excellent. Each judge rated the drawings independently.

The agreement among the three judges was quite high. 82 per cent of the bicycle drawings were given either exactly the same rating by all the judges, or the same rating by two judges with the third judge only one category rating apart. Similarly, the agreements for the other sets of drawings were: 90 per cent for the daffodils, 90 per cent for the telephone, 85 per cent for

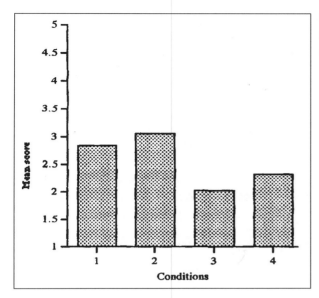

Table 2: 'A magic bicycle'. Average ratings of children's pictures in the four conditions.

the teeth, and 50 per cent for the zoo. Although we did not specify criteria for rating before this exercise the three judges were clearly using similar criteria. We asked them to reflect on their criteria and to write them down. Where real objects were involved (bicycle, daffodils, telephone and teeth), the judges mentioned similar kinds of criteria: a vital sense of the object in question; an amount of detail; shape of different parts; relationship between parts; proportions;

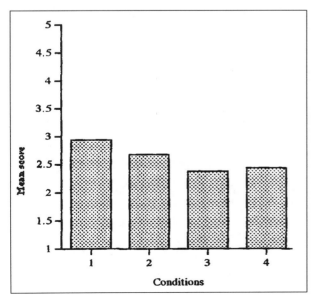

Table 3: 'Daffodils'. Avergae ratings of children's pictures in the four conditions.

composition; representation of occlusion; three dimensionality; and maturity, confidence and originality. Not surprisingly, judges were less in agreement on their ratings and on their criteria for the zoo drawings which involved much more of a dimension of fantasy.

The results

The average rating for each of the four conditions for the 'magic bicycle' and 'daffodils' pictures are shown in Tables 1 and 3. For both these topics, the drawings of children in conditions 1 and 2 (the negotiated drawing conditions) received significantly higher ratings than those in conditions 3 and 4.

Figure 2 shows an example of a condition 3 child's 'magic bicycle' drawing, which received a rating of 1 from the judges, and an example of a condition 2 child's drawing, which received a rating of 4 or 5 from the judges.

Figure 3 compares two 'daffodils' drawings, both drawn by children in condition 4, one receiving a rating of 1, the other a rating of 5.

Figure 2: An example of a 'magic bicycle' drawing rated 1 by a child in condition 3 (upper drawing), and one rated 5 by a child in condition 2 (lower drawing).

Figure 3: An example of 'daffodils' drawing by two children in condition 4 [upper drawing rated 1 and lower drawing rated 5).

Tables 4, 5 and 6 show the average rating of each condition in the three pre- and post-test drawing tasks. There were no significant differences among the four conditions at the pre-test. On average, the children in all conditions improved their ratings from the pre- to the post-test. What we were interested to find out was whether there would be greater improvement for the pictures in the negotiated drawing conditions than for the other two conditions. In fact, we did find that conditions 1 and 2 improved significantly more than conditions 3 and 4 in the 'telephone' and the 'teeth' tasks.

Figure 4 shows a condition 1 child's pre- and post-test pictures of a telephone; the pre-test drawing received ratings of 1 or 2 from the judges and the post-test drawing received ratings of 3 or 4. Improvements in the zoo task were less; although there was a tendency for pictures in condition 1 to improve more than those in conditions 3 and 4, the pictures in condition 2 improved very little.

Table 4: 'Telephone'. Average rating of children's pictures in the four conditions.

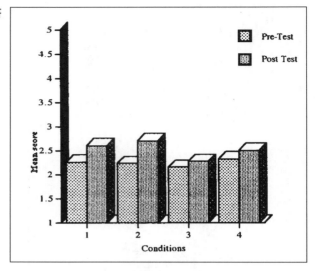

Conclusions

Overall, the study has shown that the negotiated drawing approach leads to an improvement in children's drawings, not only for those drawings completed during the lessons themselves, but also for other drawings. Furthermore, it is an approach which produces results not only when administered by a professional art educator with a vested interest in it, but also when applied by a teacher who is a non-art specialist. The supply teacher in this study was enthusiastic about the approach and willing to try it out but did not consider herself at all good at art. In

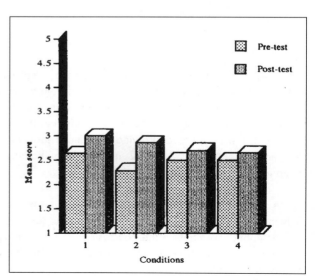

Table 5: 'Brushing your teeth'. Average ratings of children's pictures in the four conditions.

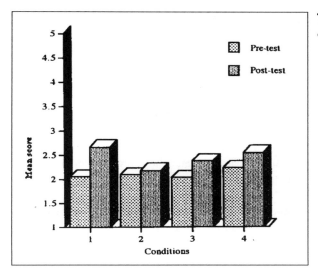

Table 6: 'A strange zoo'. Average ratings of children's pictures in the four conditions.

Figure 4: A condition 1 child's pre-test (upper) and post-test (lower) drawing of a telephone. The pre-test drawing received ratings of 1 and 2, and the post-test drawing ratings of 3 and 4 from the judges.

fact it is likely that most classroom teachers will also feel poorly qualified in this respect (Clement, 1994). So, the finding that the drawings of children in the supply teacher's class improved after the programme is very important; if the 'negotiated drawing' approach is to be widely recommended then it must be shown to be effective when tried by an 'ordinary' primary school teacher.

The improvement can only be said to be 'modest' in the present study but that may be because only ten lessons were given. We would predict that if children were to experience more of such lessons, or were regularly taught with this approach, then the standard of their drawings would improve even further. We should also emphasize that improvement has only been demonstrated in those drawings which include 'real' objects, albeit set in exciting or magical contexts.

When we asked children to draw a fantastic topic (the strange zoo), improvement was less. The reason for this may be, at least in part, that the judges were much less in agreement about the criteria for rating the pictures on this topic.

There are a number of different factors involved in the 'negotiated drawing' approach: objects are produced for observation; they are usually set in an interesting and dramatic story context; children and teacher are engaged in an interactive negotiation about how certain objects are to be drawn; and so on. At this stage we cannot say whether all or only some of these aspects of the approach are necessary for its success. Since the children in conditions 3 and 4 were also given topics which were often presented in a story format, we suspect that the most effective parts of the 'negotiated drawing' approach are likely to be the observation of real objects and the negotiation of the drawing. It will be for further research studies to tease out the relative importance of these different aspects.

It is important to stress that the 'negotiated drawing' approach does not mean that children are taught rigid formulae for drawing objects or are indoctrinated into a particular 'correct' way of drawing; on the contrary, the approach allows discussion of the different ways of drawing things and should encourage a greater flexibility in the representations children employ. This should be advantageous not only in improving children's artwork but also their drawings used for recording and understanding material in other areas of the curriculum.

Note

The research reported here was supported by a grant from the Leverhulme Trust to the first author. The findings were presented at the NSEAD Annual Conference, Cardiff, 18–20 November 1994, and details have been published recently in Cox, M.V., Eames, K. and Cooke, G. (1994) The teaching of drawing in the Infants school: an evaluation of the 'negotiated drawing' approach. *International Journal of Early Years Education*, volume 2, number 3.

References

Clement, R. (1994) 'The readiness of primary schools to teach the National Curriculum in Art', *Journal of Art and Design Education* (13) pp. 3–19.

Cox, M.V. (1992) *Children's Drawings,* London: Penguin Books

Cooke, M., Griffin, G. and Cox, D. (1998) *Teaching Young Children to Draw,* Cambridge: Cambridge University press

Edwards, B. (1979) *Drawing on the Right Side of the Brain,* Los Angeles: Tarcher.

Hargreaves, D.J. and Galton, M.J. (1992) 'Aesthetic learning: psychological theory and educational practice', in B. Reimer and R.A. Smith (eds.) *The Arts, Education and Aesthetic Knowing,* 91st Yearbook of the NSSE. Part 11, Chicago: University of Chicago Press.

Harris, D.B. (1963). *Children's drawings as a measure of intellectual maturity,* New York: Harcourt, Brace and World.

Koppitz, E.M. (1968) *Psychological Evaluation of Children's Human Figure Drawings,* New York: Grune and Stratton, Inc.

Lowenfeld, V. (1939) *The Nature of Creative Activity,* New York: Macmillan.

Mortimer, P., Sammons, P., Stoll, L., Lewis, D. and Ecob, R. (1987) *School Matters: The Junior Years,* Wells: Open Books.

Raven, J.C., Court, J.H. and Raven, J. (1990). *Manual for Raven's Progressive Matrices and Vocabulary Scales: American and International Norms,* Oxford: Oxford Psychological Press.

Tizard, B., Blatchford, P., Burke, J., Farquhar and Plewis, I. (1988) *Young Children at School in the Inner City,* London and Hillsdale (N.J.): Lawrence Erlbaum.

Wilson, B. (1992) 'Primitivism, the avant-garde and the art of little children', in D. Thistlewood, (ed) *Drawing Research and Development.* Harlow, Essex: Longman/NSEAD.

Wilson, B. and Wilson, M. (1981) 'The case of the disappearing two-eyed profile; or how little children influence the drawing of little children', *Review of Research in Visual Arts Education* (15) p. 118.

Wilson, B. and Wilson, M. (1984) 'Children's drawings in Egypt: cultural style acquisition as graphic development', *Visual Arts Research* (10).

Viola, W. (1936) *Child Art and Franz Cizek,* Vienna: Austrian Junior Red Cross.

Postscript

The 'negotiated drawing approach' is a way of engaging children's imaginations by setting real objects in an interesting context and then discussing how they might be drawn. It is an interactive approach and does not involve copying or imposing adult models on the children. We published a full account in *Teaching Young Children to Draw* (Cooke, Griffin and Cox, 1998). There are a number of different factors involved in our approach but one that we suggested might be particularly important is observational drawing. A study by Stephanie Robinson, reported in Maureen Cox's book, *The Pictorial World of the Child* (Cambridge University Press, 2005) has provided evidence that this is the case. Drawing real objects teaches us how to notice their details and also how they are structured. Observational drawing, then, is an important ingredient in the general learning process as well as in children's artistic development.

Maureen Cox, 2008.

11

Conversations Around Young Children's Drawing: The Impact of the Beliefs of Significant Others at Home and School

Angela Anning

Vol 21, No 3, 2002

Theoretical framework

Within the domain of sociocultural theory there is growing interest in the effect of the cultural context in which children learn. Children learn what they think is expected of them by the members of the 'community of practice' in which they are reared and educated (Lave and Wenger 1991; Chaiklin and Lave 1993). For example, at home a young child expects to ask questions of adults. One of the early lessons they learn as they enter educational settings is that quite the reverse is expected. Now it is the adults who ask children questions (Willes 1983).

Such shifts in expectations of 'appropriate' learning behaviours impact on children's developing sense of self – who they are and what they are expected to become – and on what they feel they can do. Their developing sense of themselves as learners, and in school as pupils, affects their motivation, or what has been called their 'disposition', to learn. So, for example, if a parent or sibling models persistence and a range of problem solving strategies when a child is learning to draw, the child is likely to adopt a 'mastery' orientation to drawing when she transfers to the new cultural context of a nursery class. A child who has not had such learning strategies modelled is likely to give up when faced with an unfamiliar task involving drawing at school and adopt a 'helpless' orientation (Dweck 1991). Worse still, an adult in a school

setting may undermine the child's confidence in the efficacy of drawing strategies they have been using routinely at home by, at best, ignoring or, at worst, responding negatively to them. Many children learn in the first years at school that they 'can't draw'; and many adults remain arrested in the drawing capability they assumed at the age of six or seven.

One of the key features of sociocultural theory is that young children learn what is important in making meaning and expressing their understanding through interactions with more experienced others, be they adults, peers or siblings, in the communities of practice at home and school. It is significant adults' beliefs about children and childhood that underpin the nature of their interactions with young children. The quality of these interactions reflect their ability, or not, to tune into children's ways of making sense of the world and into children's favoured modes of representing their growing understanding of phenomena and relationships. These interactions have been characterized as 'joint involvement episodes' by Schaffer (1992). Both participants have to develop strategies to 'tune into' each other (Trevarthen 1995).

However, as well as the quality of language in shaping learning in different cultural contexts, learning also occurs through interactions with and around objects. Verbal and physical interactions around objects such as toys, books, pencils and paper, and construction kits function quite differently in different cultural settings. For example, at home a child may be given a space on the kitchen table and some felt tip pens and paper to sit alongside an older sibling while they both draw cards for Granny's birthday. In school, felt tip pens may be used as a motivating factor in getting the same child to complete a worksheet.

Young children have to try to make sense of the continuities and discontinuities between their experiences of the kinds of tools (such as language or drawing), artefacts (such as colouring books and worksheets) and activities (such as making a birthday card for Mum and being asked to draw an apple from observation) as they learn to be members of the distinct communities of practice of home and school (See Figure 1).

Little research has been funded into young children's emergent drawing. The chapter draws on data from a longitudinal study of seven young children drawing in home and as they moved from pre-school to school contexts over a period of three years.

Research Design
Our research questions were:

- How do young children represent their emergent understanding of their worlds through drawing?
- What informs or influences their representations in the two distinct communities of practice at home and in pre-school and school settings?
- What are the beliefs/views of their significant adults in the two settings and how do their beliefs/views impact on children's drawing behaviours?

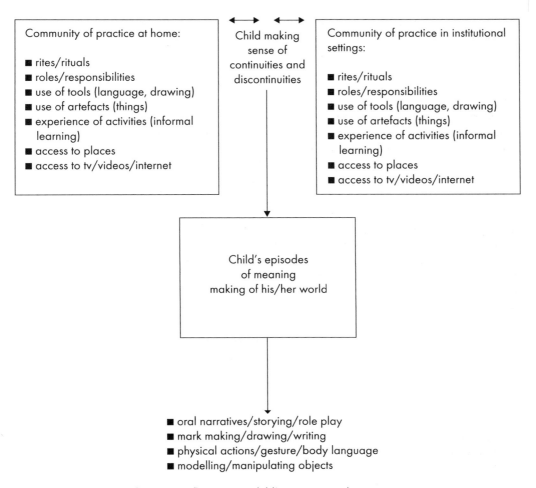

Figure 1: Community of practice influences on child's meaning making.

The sample of children was drawn from a pair of children – a girl and a boy (in one case two boys were nominated and we retained the extra child in case of attrition) – nominated by their key workers in pre-school settings as within families who were likely to cooperate with us over the period of a three-year longitudinal study. We did not ask the practitioners to nominate children who were 'good' at drawing. They were in effect 'ordinary' children. The settings where the children were placed at the start of the project were:

■ A Family (day-care) Centre in an inner city area characterized by multiple levels of deprivation
■ The Reception class of a new purpose built primary school in the inner suburb of a large Northern city characterized by mixed private and public housing and mainly skilled workers with young families

■ The nursery class of a long-established primary school in a 'dormitory' village where the population was a mixture of 'incomers' commuting to a large port town and rural/agricultural workers

We selected the transitional period of entry to a new educational setting for a month of data collection annually over three years as it is at points of transition that similarities and differences in cultural contexts are thrown into the sharpest relief. Parents and key workers were given a large scrapbook and instant camera and asked to record episodes and contextual features of drawing, painting, playing with small objects and role-play over a period of one month. Parents, practitioners, and the children were invited to talk to us about the recorded episodes. The dialogues were tape recorded and transcribed.

Analysis of the data took evidence of the children's activities as the starting point. We were not concerned with coding the children's drawings using developmental (Matthews 1992) or technical (Cox 1992) criteria. We analysed the content and style of the drawings and the contextual features of drawing episodes. We also identified children's personal passions influencing their drawing, (media, hobbies, sibling or parent interests, extended family network activities) and individual styles of drawing. We used interview and field note data to try to explain the similarities and differences of the drawings across children and settings.

We triangulated evidence of contextual information, and parent, practitioner and child transcripts with the visual data of the scrapbooks and photographs. This meant hours of examining and categorizing units of speech and contextual information referring to the children's drawings. We worked backwards and forwards from evidence to theoretical perspectives over the three-year period as the evidence accumulated and was analysed. We refined the analytical framework to the following domains:

■ Observed/recorded child behaviours
■ Distinctive features of the environment
■ Values and beliefs of significant adults at home and school
■ Adult styles of interaction around drawings
■ Adults' perspectives on children's drawing behaviours
■ Children's perspectives on their drawings

For the purposes of this chapter some key incidents of what and how two of the children drew, with contextual and transcript evidence, will be used to illustrate continuities and discontinuities in the cultural contexts of home and school. The focus will be in particular on the nature of 'joint involvement episodes' with significant adults, the beliefs underpinning the episodes and how the children attempted to make sense of them.

Luke drawing at home and in the Family Centre
Luke lived with a younger brother, his mum and dad in the inner city. The drawings he did at home revealed a fertile imagination, a preoccupation with scary things and a strong influence

of television and video imagery. His drawing at the age of three of 'A crocodile with sharp teeth and scary legs' (Figure 2) records a fascination with crocodiles that was reflected in role-play. Figure 3 shows Luke's lively representation of a play episode, reported by his mother: 'He goes fishing in the baby bath. He rows really fast. The coat hangers change from fishing rods to oars.' He put cushions on the floor to represent stepping stones across the water, and again with the crocodile theme in mind: 'The carpet is the water and there's a big crocodile in it.' Significantly this fluent representation of Luke's 'experienced' narrative was drawn with felt tip pens, so compelling for young children in terms of their fluidity and bright colours. Matthews (1992) has pointed out that the meaning making of young children is often a complex interaction between exploring the properties of a medium and exploring the concepts within a narrative or series of episodes with which the child is preoccupied. There is a subtle interplay between the use of line to represent objects and zigzags, dots and dashes to symbolize movements, actions and the passage of time. The child's physical actions in drawing are often accompanied by talk. The drawings are the visual equivalent of dramatic play. In home situations parents were able to tune into these representations. We found that these kinds of fluent drawings representing movement in space and time featured particularly strongly in drawings by boys at home, but were largely ignored (perhaps dismissed as 'scribble') by practitioners in pre-school and school settings.

Luke's young mother was perceived by the staff at the Family Centre as anxious about her role as a parent. At home her relationship with the boys was often exuberant. She had 'silly times' with the two boys when they sang and danced together: 'Unless we're, mainly me, too tired to dance around... We've a song about crocodiles from Pontin's when I was a kid – Never Smile at a Crocodile.' She shared the children's love of television and videos, often sitting with them to watch programmes and tapes. Figure 4 shows Luke's emotional response to an advertisement for fruit pastilles which featured a strawberry eating a small boy. His mother described how he 'backed away' from the television whenever it was shown.

Luke was a meticulous child. When his younger brother was napping he was allowed scissors and glue at the kitchen table where he carefully cut and pasted both abstract and figurative images and annotated the cut outs with felt tips (Figure 5). His mother reported:

> He's forever making squiggles with the pen, then cutting them out and making shapes with the cuttings. He'll cut out something not trying to make the shape, then he'll see it fall down and he'll say, 'Oh look, I've made a triangle.' He'll pretend he meant to make it.

His mother drew for him, but Luke's meticulous approach, even at three, meant he insisted on accuracy! Interestingly, in these joint involvement episodes, Luke held the dominant position. His mother reported their shared experience of trying to draw the Teletubbies. She was not only tuning into shared interests with her son, but sharing with him the exploration of media and techniques:

> They've all got different shapes on their heads and different colours so you have to get the colours right. We've got these paint pens and you can't often get the right shape

with them because they're so fat. I did La La and he said, 'La La's head doesn't go like that.' You've got to get the right colour, the right shade. There could be something really wrong, but it's the little detail he goes for.

In the Family Centre which Luke attended, drawing was perceived to be a relaxing thing for young children to do, always popular with them, and even a way of calming a fractious child by putting them on your knee and drawing pictures for them to distract their attention from crying. Mark-making equipment was set out as a free choice activity on a daily basis.

However, the 'colonisation' of day-care and playgroup settings by education through the requirement to demonstrate their delivery of Desirable Learning Outcomes (DfEE/ SCAA 1996) and subsequently Early Learning Goals (QCA 2000) to 3 and 4 year-olds had shifted staff in the Family Centre to a growing concern with promoting learning in literacy and numeracy (Anning and Edwards 2006). Their relaxed approach to drawing changed. The manager of the Family Centre was aware of the pressure on her staff to focus on emergent literacy:

> When we hear the phrase mark making, it doesn't matter how many times you go through it, you still think writing. It's there in the back of your mind all the time. That's not to say if a child did a row of circles they wouldn't be impressed by that, but only because it's starting to look like letters. They feel that's what they ought to be…they know the benefits, they know the therapy that children get from expressing, from experiencing. But their own vulnerability will always lead them to think in terms of writing, particularly if they're talking to knowledgeable people.

A second cultural imperative was the function of artwork as 'decoration'. A nursery nurse described the afternoon art work sessions as 'when you get time to do your display work; you know, the pictures you want the children to do'. It was also expected that children should take artwork home at the end of each day. One practitioner was disparaging about her past experience of art activities in a private day nursery, where thirty children were hounded daily through two art tasks, strongly directed by the adults, in order to take home evidence of what they had 'achieved'. She described the process as 'like a conveyor belt… "Stick this bit here, do that line there" … not at all the child's choice'.

In the informal learning environment of the Family Centre, staff were aware of the children's passionate interest in cultural icons and images from the world of the media – cartoon characters, pop stars, adventure game heroes – and chatted freely with the children about them. However the 'educational' agenda had displaced the informality of these exchanges in activities set up for key worker groups. Staff now had a checklist to complete for each child, marking their progression from horizontal and vertical marks, through figure drawing and onto early writing. So in Figure 6, Luke's spontaneous, untutored drawing of his 'Mam' was followed by a directed drawing, Figure 7, where the key worker modelled a figure drawing and then showed him on his own attempts where to put the eyes and nose, etc. The child's own exuberant version is in marked contrast to the stolid 'correct' drawing of his mother. His key worker was

Figure 2: Luke's Crocodile.

Figure 3: The river with crocodiles.

Figure 4: The Fruit Pastille advertisement.

ambivalent about coaxing children into drawing figures as a pedagogic strategy: 'I do it, yes, because I'm stumped to know how else I can help them'. Under these constrained conditions for drawing, so different from his home experiences of drawing his mother, Luke rarely chose to draw in the Family Centre, instead electing to spend his time in active physical play, mainly with boys. At home during the parallel period he remained a prolific drawer.

Holly drawing at home and school

At four, Holly was the oldest child in the family with two siblings. The family, living in the 'dormitory village', had strong links with a local church and had a large, extended family. On Sundays, Holly, her siblings and cousins of various ages all met up in their grandma's house and were supplied with generous amounts of drawing paper and materials to keep them occupied while the adults talked. Holly's mother reported:

> When she goes to our Mam's, she's just bought a sketchpad and she says when they've drawn a picture she wants to keep it. I don't want to rip the pages out. They can all draw, but I want to keep it. She did it with us when we were little. She always played with us.

The children were discouraged from watching television and Holly spent much of her time at home in role play with her two favourite dolls representing shared family experiences of picnics, shopping and the routines of eating and sleeping. Holly seemed to use drawing and play with her dolls as a way of removing herself from the clamorous demands of her siblings.

With a baby and toddler to contend with, Holly's mother left her much to her own devices in play and drawing activities. It was her father who drew with her at home.

> When she was first drawing she'd say, 'Draw me a face, Dad' and I'd draw her a face and she'll copy it…and she'll say 'Draw me an elephant, Dad, or a dog', and she'll try and copy. We have a joke and say, 'Dad's not very good at drawing'. The pair of us [mother and father] are hopeless at drawing…I'll say, When Auntie Pauline comes round get her to draw you a dog 'cos she's better at drawing than me.

So Holly was confident that the community of practice of her extended family would support her in learning to draw.

Holly's drawings at home featured two aspects of relationships with which she was preoccupied – representations of spatial relationships of the significant objects and spaces that featured in her life, and of human relationships of the significant people in her life. She had an accurate recall of the salient features of buildings and spaces where she spent time and the ability to represent them in her fluent and joyful drawings, executed at speed. For example, Figure 8 is one of many drawings she did of the church. It shows spaces where the adults and children gathered to worship and talk, Darren playing his guitar for them and the entrances and exits to significant parts of the building. Family relationships were of overwhelming importance to Holly.

Figure 9 is a drawing of her large, extended family, including her pets. Her mother explained that her mother-in-law had had twins: 'Nana with babies in her tummy is from when Holly was talking about when she was younger and was having twins – Holly's dad and his brother'.

Holly attended a nursery class in a well-established primary school. In this pre-school setting, drawing was part of a much more structured set of learning activities based around topics. Each day there would be adult-directed activities which might be art-based – for example observational drawing or experimenting with different media – or might be linked to the knowledge domains of the topic. All the children would be 'invited' to sit and take part in the adult directed activities at some point during the session.

The nursery teacher's discourse was about promoting skills. For her, drawing was about developing fine motor control, grasping new techniques: 'beginning to hold a pencil and realising there are different ways of making marks with different materials, selecting the correct materials for the purpose ... the right paper ... doing a plan in the construction area or the brick corner they might use squared paper'. The agenda was very much about preparing the children for school. The teacher saw the purpose of tasks involving drawing as promoting cognitive gains as well as skills: 'to record pictorially the things that they've learnt, to reinforce new concepts'. A range of art activities was planned. She saw a need for direct adult intervention in the child's learning: 'if you look at a piece of work a child has done on his own and one where an adult has intervened there is a big difference'. Yet she articulated ambivalence about the nature of adult intervention: 'We would never say what's wrong or right, but we would pose the right questions: "What do you think if? Have you thought about?"'

Holly responded obediently and competently but without much enthusiasm to the art activities and topic-based drawing tasks she was asked to do. They showed little of the flair and fluency of her drawings at home. Her preference was to role-play, mainly with girls, in the domestic and small figure play areas of the nursery.

When Holly moved from the nursery class to school, a very different, adult, agenda dominated. The National Curriculum introduced subjects into the traditionally topic-orientated curriculum for 5–7 year-olds (Anning 1995). Art was taught as a subject in its own right. Teachers planned for art activities, but their setting up, supervision and monitoring were mostly deployed to nursery nurses or classroom support assistants. Again, the pressure of getting displays up rather than the educational rationale often drove activities. A teacher reported that '[a]t the moment I am fitting in art as often as possible because I want to get lots done. I am trying to get lots of groups through a printing activity because we have got a display and we have to get things up there'.

The Key Stage 1 and Foundation Stage teachers seemed uncertain about pedagogic strategies for teaching art. So for example, a Reception class teacher, talking about her approach to teaching drawing, told us that

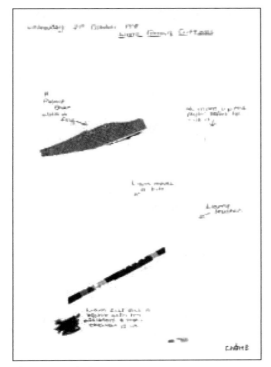

Figure 5: Luke's cut outs. **Figure 6:** Luke's untutored Mam.

[w]hen we did self portraits, I drew my face on the board first and we touched our eyebrows and our nose, but I don't mind if they are less accurate in their drawing than their writing. If a child brought a drawing to me and it was a huge potato head and a small body I wouldn't correct them. I'd say, 'Oh that's lovely. You've got a smiley face – that's great.' But if they brought something to me and they'd written their name and there's a capital letter in the middle … I'd know I didn't want that … I'd use the opportunity to sort it out. I've stopped myself saying, 'Dogs don't have five legs do they?' because if that child's representation of a dog has six legs, that's them expressing themselves. It's artistic licence.

In the National Curriculum Art Order, teachers are instructed to ask children to draw on observation, memory and imagination as the stimuli for representation in line or colour, but the Key Stage 1 teachers tended to focus on observational drawing. Holly found observational drawing difficult. Figure 10 shows, on the left-hand side, her struggle to draw a doll from observation: a 'history' task. She had no strategies for looking at the doll and attempting to represent what she saw and, unlike at home, the teacher did not attempt to model them. In exasperation Holly retreated to what she knew, and the drawings of her own dolls at home, on the right hand side, were from memory.

Figure 7: Luke's tutored mammy.

In the year Holly started school the introduction of the Literacy and Numeracy hours transformed Key Stage 1 classrooms. Young children were given little choice of activity, except perhaps on a Friday afternoon. On the rare occasions when they were allowed to choose what they drew, a newly qualified teacher reported:

> As soon as I say they can choose they are like bees in a workhouse. They know just what they want to do. They love it. If I gave them an hour they'd keep busy the whole hour and they do some really lovely stuff.

Mostly teachers allocated art to timetabled slots in the afternoons, with a whole class introduction, followed by a set activity, often based on Qualification and Curriculum (QCA) schemes of work, and at the end, a recap on what had been achieved. As one teacher put it: 'We do collective art, like collective worship; we do art on a Tuesday afternoon.' The only free choice drawing took place during 'wet playtimes', but these drawings were then stuffed into the children's drawers and lockers under the fierce pressure to tidy up ready for 'proper' work. For Holly, the lack of time for role-play and drawing was difficult to accept. She was seen by the teachers to be a passive child, a listener, who tended to gravitate to older girls for friendship.

Drawing was also used as a seat-based activity to occupy children in 'busy work' or to augment their recording aspects of their understanding across the curriculum. Figure 11 is a typical

Figure 8: Holly's Church Drawing.

Figure 9: Holly's Family.

'school' task. Holly was asked to write a story, but she chose to spend a disproportionate amount of the time on the drawings. She was frustrated at having to colour her detailed pencil drawings with the ungainly, fat crayons set out on the table. Her writing and related drawing was seen by her teachers as 'untidy'. Under the regime of the literacy hour the children were forbidden to illustrate their stories at all. Holly became a reluctant writer and reader. During the

Figure 10: An observational drawing of a doll.

Figure 11: Holly's story.

Figure 12: 'Girlie' drawing. **Figure 13:** A romantic drawing.

equivalent period at home, Holly remained a prolific drawer. Her interest in fashion, particularly elaborate hairstyles, and romance was reflected in her drawings. We found that by aged six the content of the children's drawings was strongly influenced by gender preferences. (Figures 12 and 13) Her mother reported: 'Oh, I think this is just a girlie thing from school. She learnt to draw hearts and that's it, she draws hearts on everything...'

Discussion

Evidence from the research confirmed the key role that significant adults played in the children's drawing. It also raised our awareness of the distinctiveness of 'joint involvement episodes' in the contrasting cultures of home and school.

At home, parents and members of the extended families of the children modelled drawing behaviours on the basis of shared interests and activities. Drawing was a sociocultural activity. Drawings often revolved around media, fashion, music, or sport imagery and reflected gendered patterns. Children developed personal styles and pursued their own preoccupations, persisting with trying to make sense of the world and their place within it through their self-initiated drawings. They mostly gained unconditional support for their drawing from the adults around them.

Practitioners in early childhood settings seemed unsure about the strategies they might use to foster young children's drawing, or how to respond to their spontaneous representations. They were unable or reluctant to tune into the children's home worlds of media, fashion, pop music or sport imagery, and particularly the pre-occupations of boys. Their 'joint involvement episodes' with the children were unfocused and tentative. Their preoccupation was with getting the children to read and write. Drawing was perceived as a 'time filler', a vehicle for decorating the walls, or within art 'lessons' as a one-off directed activity to promote specific skills and techniques. Children had increasingly limited opportunities to choose the content and style of drawing as they progressed from nursery to the end of Key Stage 1 settings.

The restrictions placed upon them within school contexts resulted in these young children withdrawing from drawing unless it was set as a directed activity. They began to lose confidence in their ability to draw. Their sense of self-as-artist appeared to wither in their emergent identity as learners in school contexts. But at home they quietly persisted in learning to draw and drawing to learn.

Acknowlegement
Kathy Ring collected the data for this research. With Angela Anning she co-authored a book entitled *Making Sense of Children's Drawings*, published by Open University Press in 2004.

References
Anning, A. (1995) 'Art', in A. Anning (ed.) *A National Curriculum for the Early Years*, Buckingham: Open University Press, pp. 96–112.

Anning, A. and Edwards, A. (2006) *Promoting Children's Learning from Birth to Five*, Maidenhead: Open University Press/McGraw-Hill Education.

Chaiklin, S. and Lave, J. (eds.) (1993) *Understanding Practice: Perspectives on Activity and Context*, Cambridge: Cambridge University Press.

Cox, M. (1992) *Children's Drawings*, London: Penguin.

DfEE/SCAA (1996) Nursery Education: *Desirable Outcomes for Children's Learning on Entering Compulsory Education*, London: DfEE.

Dweck, C.S. (1991) 'Self theories and goals: their role in motivation, personality and development,' in R. Deinstbeir (ed.) *Nebraska Symposium on Motivation 1990*, Vol. 36, pp. 199–235, Lincoln, NE: University of Nebraska Press.

Lave, J. and Wenger, E. (1991) *Situated Learning: Legitimate Peripheral Participation*, Cambridge: Cambridge University Press.

Matthews, J. (1992) 'The Genesis of Aesthetic Sensibility', in D. Thistlewood (ed.) *Drawing: Research and Development*, Longman in association with NSEAD. pp. 26–39.

QCA (2000) *Early Learning Goals*, London: DfEE/QCA.

Schaffer, H.R. (1992) 'Joint Involvement Episodes as Contexts for Cognitive Development,' in H. McGurk (ed.) *Childhood and Social Development: Contemporary Perspectives*, Hove: Lawrence Erlbaum.

Trevarthen, C. (1995) 'The child's need to learn a culture,' in *Children and Society* Vol. 9 (1).

Willats, J. (1977) *The Child's Representation of the World*, New York: Plenum Press.

Willes, M. J. (1983) *Children into Pupils*, London: Routledge and Kegan Paul.

Postscript

Curriculum changes for young children in England have come thick and fast since this chapter was written. Statutory National Curriculum subjects, including Art and Design, were rolled out from September 1989 to 1992 for all children aged from five to eleven in English and Welsh primary schools (see Anning 1995). However, until 2008 the curriculum for children under five was non-statutory, though *guidelines* for the curriculum (including creative development) for children aged from three to five were introduced for English pre-school settings at the turn of the century (see DfEE/SCAA 1996; QCA 2000). The Welsh curriculum has been legislated for separately since political power was devolved to the Welsh Assembly in 1999. In September 2008, a Statutory Foundation Stage Curriculum (www.teachernet-gov.uk/publications, ref: 00012-2007BKT-EN) was introduced into all English pre-school settings catering for children from birth to 4 years, (including private schools, daycare, pre-school playgroups, child-minding, nursery school and nursery classes in primary schools). Most settings now register to offer free half-day nursery education for 3 and 4 year-olds. The Foundation Stage Curriculum includes a section on Creative Development. Ironically this formalizing of a curriculum for English babies, toddlers and children (unprecedented in the world) is happening whilst pressure is being put on primary schools in England to cast off the constraints of the National Curriculum.

12

Intention and Meaning in Young Children's Drawing

Sue Cox

Vol 24, No 2, 2005

In this chapter I present some ideas, based on my research into young children's drawing, related to the developing discourse on young children's thinking and meaning making (see, for example, Athey 1990; Kress 1997; Pahl 1999a; Matthews 1999, 2003). This takes children's drawing beyond the domain of 'art', but at the same time informs the way in which we might think about art and art education.

The research took place over a period of a year, during which I regularly spent afternoons in a nursery classroom. I observed the children as they engaged in varied activities, focusing particularly on those which involved drawing, painting and construction, but also being aware of the children's other related activities. (Drawing in the sense of marks on a two-dimensional surface is the main focus of this chapter, but the argument problematizes the distinction between drawing and other 'making'). The setting was one in which child-initiated activity predominated and where the teacher and the nursery assistants supported children's ideas and learning through rich provision of resources and constructive conversation. The class teacher, Geoff Chamberlain, was deeply interested in the way in which the children's thinking developed and sensitive to their interests and concerns of the moment.

My observations were made in a naturalistic way. As the children drew and painted, I made detailed notes of individuals' actions across a variety of modes, including their solitary talk, physical action, and their verbal and non-verbal interactions with others, as well as their drawings and paintings as they were made. I tended not to collect the children's work, partly

because the children always expected and wanted to take it with them, and partly because my focus became the child's interaction with the work as it was produced. Whilst end products did sometimes offer new avenues for analysis, the work in progress was the central source of data. This was qualitatively analysed; the analytical memos that were made in the early stages were revisited and reinterpreted in the light of further evidence and emerging ideas, so that theories were well grounded in my observations.

The new discourse around children's drawing activity provides a clear alternative to the previously dominant paradigm, which interpreted children's drawings in terms of a theory of more or less invariant and staged development. The traditional view is based on the idea that there are observable patterns in the structural features of children's drawings. Whilst apparently a neutral theory based on empirical observation, this way of looking at children's drawings inevitably carries with it an underlying set of theoretical assumptions about the way in which drawings 'represent'. It is framed within an understanding of drawing as a means of depicting objects in the world, prioritizing what is presented to the eye of the viewer situated in a fixed position at a particular moment in time. On this model, the purposes of drawing are interpreted in terms of representation of what is seen, using 'seen' in this limited sense; children's development is movement towards verisimilitude in their drawings.

It is not surprising that children's early drawings are often interpreted in this way. The familiar drawings of the human figure, sometimes referred to as 'tadpole' drawings in which there usually appears to be a head but no body, can be seen as evidence of the way in which immature conception *distorts* what is perceived. However, this is a circular kind of argument, since it is the evidence of the child's 'immature' drawing which is taken as the indicator of the immature cognition of the child. In its simplest form, the argument goes, as the child attends to what they see rather than what they know, they move, over time, to a more accurate representation based on perceptual reality. This view presupposes a transparent relationship between the objects in the world to be depicted, the way they are 'seen' and the way they are represented. It creates the familiar, but naïve, distinction that is often made between what is known and what is seen (the one being the object of cognition and the other of perception) – between intellectual realism and visual realism – as if these were unrelated. It has given us the notion of the 'innocent eye' – the assumption that our representations of what we perceive are unmediated by how we think.

This ancient and pervasive belief has been widely called into question across contemporary psychological, visual and cultural theory, as well as in the context of children's drawing. The deconstruction of traditional concepts of representation and the fusion of perception and meaning are central to different strands of current visual theory as, for example, in Burgin's account of the 'end of art theory' (Burgin 1986) and in the hermeneutic account of seeing (see, for example, Davey 1999). Earlier, Gombrich had challenged the notion that perception could be separated from conception, claiming that 'The innocent eye is a myth' (Gombrich 1960). Specifically in relation to children's drawing, Arnheim referred some time ago to the distinction between the conceptual and the perceptual as an 'absurd dichotomy' (Arnheim 1954). Costall (1985, 1995) pursues similar arguments. The assumption that the unmediated, visually accurate

drawing is one that observes linear perspective takes no account of the view that perspective is a conventional construct. Costall shows how Gibson (1973) challenged the possibility of the innocent eye by focusing on 'the fact that visual perception occurs over time and on the move' (Costall 1995: 220) and thus cannot be explained in terms of a picture or image of an object's form but rather, in terms of understanding its invariant, but 'formless', features. In the context of her research into children's drawing, Golomb similarly questioned the assumptions around the traditional idea that what children 'see' is distorted by what they know. She challenged the idea that children's mental immaturity and static mental images govern their drawings, giving rise to their apparent visual inaccuracy. She found in her experiments that children could produce representations at differing levels of accuracy in different types of media and task, which challenged the idea 'that the child's representational model stands in a one-to-one correspondence with his concept of the object' (Golomb 1974).

The origins of the stage theory of children's drawing are usually attributed to Luquet ([1927] 1977) and to Piaget and Inhelder ([1948] 1956). However, Costall (1995) points out that although he coined the terms and drew the distinction between 'intellectual realism' and 'visual realism', Luquet questioned the primacy of the latter over the former. Lange-Kuttner and Reith also show that it's a misrepresentation of the theories of Piaget and Inhelder to see them in terms of the common polarization of knowing and seeing: 'central to Piaget's views is that the very act of perceiving is a dynamic process which becomes intimately related to and largely influenced by the emergence of conceptual thought' (Lange-Kuttner and Reith 1995).

There are, then, a range of objections to the idea that there is a 'given', transparent relationship between 'reality', perception and representation, and there are counter-arguments to the related divergence between 'knowing' and 'seeing'. There are also possible misreadings of Luquet and Piaget. However, in spite of this, assumptions related to stage theory have a persistent influence on the way we look at children's drawing. As Matthews points out, citing Freeman and Cox (1985), '[t]he dichotomy between intellectual and visual realism is accepted by many contemporary psychologists as essentially truthful and development is assumed to be a linear path towards visual realism' (Matthews 1999). He notes that some researchers have substituted 'object-centred' for intellectual realism and 'viewer-centred' for visual realism, but that their research 'still fails to question' the underlying assumptions.

The central assumption of stage theory (that there is an overriding and unquestioned end point, which is the lifelike rendering of the objects in the world on the two-dimensional surface) has the effect of focusing the study of children's drawings on the drawings themselves, which are analysed in terms of what they say about the child's stage of development – on the continuum towards a supposedly 'natural' end point of the 'realistic' depiction. Stage theorists are concerned, then, with the properties of the drawing or the drawing behaviour in isolation as it stands in relation to that continuum. Thomas (1995) suggests that more recent research in developmental psychology has focused on drawing processes. However, others, such as Matthews (1999) and Costall (1995) argue that the distinction between perception and conception and between visual realism and intellectual realism or viewer-centred and object-centred drawing continues to dominate, and the

assumption persists that the former, in each case, is the desired achievement in drawing. They argue for an alternative approach through which, in Costall's words, 'we can begin to evaluate children's drawings on their own terms' (1995: 24).

We can challenge the idea that drawing involves some kind of lifelike depiction or replication of what is in the world by recognizing this criterion as culturally specific, rather than neutral. This has implications both for interpreting graphic 'representation' and for making inferences about children's development. Rather than focusing on the ways in which the drawing as artefact fails to meet the culturally determined goals of perceptual accuracy, thus promulgating a view of children's drawing as deficient, this different view opens up the question of what *purposes* their drawing actually serves. When the purpose of drawing is no longer tied to the assumed intention to depict the world as it is 'neutrally' seen, a new perspective is opened up. We can look at children's drawing, not so much in terms of categorizing the artefacts which are produced, but in terms of looking at the activities which produce them and at the children who are engaging in those activities. It shifts the focus towards what is going on when children draw. This kind of attention to the process of drawing brings to the foreground what the child is trying to do. As Matthews suggests, the process of drawing ceases to be 'object-centred' or 'viewer-centred' but 'drawing-centred' (1999).

Paying attention to children's drawing in progress, during my observations, revealed a far wider variety of intentions than could be imputed to the finished drawings themselves, when the information was restricted to what was available in what the child had produced and interpretations of it were questionable. It also went beyond the graphic strategies and skills which children used when they were drawing. In this chapter I will focus on the implications of seeing the process of drawing in this way – in context.

My observations showed how, in being situated in specific contexts of cultural and personal significance, children's drawing activity is illuminated by the way in which it occurs and the other activities linked to it. The following example illustrates this. 3-year-old Leanne was drawing with felt pen on green paper, on her own, in the writing corner of the nursery classroom. She began by drawing an enclosed oval shape. She then proceeded to fill the shape with dots, some of which, as her arm descended with some force, became more extended marks. As she continued, she began to talk to herself, unaware that I was listening (I was observing some other children at the time). She identified the shape as a duck pond and the marks she was making as ducks. She then made a final dot within the shape, and declared it to be the plug where the water goes out. She moved to the corner of the paper where she made some individual shapes, working from left to right. Reaching the edge of the page, she continued immediately beneath. As she did this, she said, slowly, as she was making the marks, 'to Auntie Bonny'. There were no easily recognizable visual referents which would identify the marks as an aerial view of ducks on a pond, the drawing itself did not suggest any differentiation between marks within the shape and there was no clear indication that the marks in the corner of the paper were words. Significantly, it was Leanne's commentary, apparently spoken only to herself, which provided the clues to how the various marks were distinguished and ascribed meaning – she ascribed

distinctive meanings to similar marks in a way that suggested that particular marks could be flexibly interpreted. It should be clear that reading the drawing in this way became possible, not only by giving attention to the information available in the wider context of the drawing activity (in this case, Leanne's commentary, and perhaps, the fact that she was working in the writing corner) but also by suspending the criterion of 'realistic' depiction of the object.

Seen in context, not only was it apparent that similar marks could be given distinctive meanings by children, such as in the example above, but a single configuration of marks could be given a range of different meanings. During the course of drawing activity the marks made were often reinterpreted many times by children. Sometimes, a child might encode an idea through a mark which they then decoded in a different way. (This was evident in the verbal commentary of the child as they drew). The stimulus could be something extraneous to the drawing itself. For instance, Jake drew several arcs above each other and identified his drawing as a rainbow. At that moment someone near to him sneezed and he decided that the drawing now represented a sneeze. On other occasions, the drawing itself could suggest a new idea, prompting additional mark making or a modification of the original marks. Rory's drawing illustrated this point. He was playing with, and closely observing, a model zebra. Rather than observing the object from a fixed viewpoint (a culturally specific way of looking, which he has yet to learn about), he inspected it from all angles, turning it around in his hands. As he drew, he stated that he needed black and white. Having drawn some vertical black lines, he then declared: 'it's raining – it's all rain coming down.' He then added further short vertical lines over the paper in response to this idea. Matthews makes the following observation about these kinds of variations in denotational meaning which occur in response to the context:

> In these drawings, the link with entities in the external world is only provisional; a useful pivot around which many plays and interplays on structure and meaning, text and context, can be formed.

He also says:

> These are event structures, not just in the conventional sense of a picture story, not simply serialized images tied to a narrative rather, they are an interaction between entwined visual and linguistic commentaries, which enrich and transform each other as they unfold. (Matthews 1999: 101)

Significantly, it is sometimes the drawings, talk or other activity of other children in the vicinity which suggest an alternative reading of the mark. Two children, Hannah and Jade, sitting next to each other, each with their own paper and pencils, were conversing as they drew. The marks they made on their paper stimulated new topics of conversation (for example, about what they did on their holidays) which in turn prompted new readings of the marks. They commented on, and responded to, each other's drawings as well as their own. Sometimes, one of the children made a change to her drawing in response to the marks made by the other child, 'conversing' through the drawing rather than in words. The drawings were continually transformed over

the period of time that the children sustained the drawing activity and the conversation (about twenty minutes), and provided a graphic record of their ideas and concerns as they changed from moment to moment. By way of a further example, a number of children were drawing around a table with their teacher. Each of the children was drawing apparently random shapes on their paper. One had drawn an enclosed shape which he said was a rock ('it's a rock'). In response to this comment a child nearby, who had drawn a tall vertical shape, identified his own drawing as a 'rocket' and a child who had drawn a horizontal, banana-like shape named his own drawing as a 'rocker'. The children seemed to be adapting the first child's 'verbal designation' – to use Golomb's term (1974) – of his drawing to their own marks, using a similar word and an appropriate idea to decode what they had drawn.

Transformations thus occurred on a number of levels. The meanings of marks were progressively transformed through multiple interpretations of similar marks or the same marks (as in the cases of Leanne, Rory and Jake above); through progressive changes to the marks themselves and their meanings (as with Hannah and Jade above); and also within the flow of ideas. This sometimes happened during individual activity and sometimes in the context of interaction with other children.

The above examples help to show that we can gain a different view of children's drawing by observing it as a process, taking place over time in a specific context. Close observation showed that, for the children themselves, the drawing could be seen as an on-going activity, that occurred for a period of time, with no definitive 'end-point' in terms of the drawing as a specific configuration on the drawing surface. The children would draw until they were ready to move on to another activity. In other words, 'finishing' did not seem to be prompted by the drawing they were producing. This approach to children's drawings again echoes that of Matthews. He notes from his observations, that many representations 'were not discernible in the finished drawing, but they could be identified in the drawing actions, as processes of representational thinking unfolding in time' and that a child may be thinking in what he refers to as an 'episodic' way, which he describes as 'using the drawing as an episode in time, as a continuing dialectical relationship between their constantly changing understandings of the world and what is emerging on the drawing surface' (Matthews 1999: 93). The focus on completing a drawing makes more sense when the purpose of drawing is seen only in the limited terms of making a satisfactory, 'realistic' depiction. When, by contrast, the process itself becomes the focus, different kinds of representational purposes become apparent which may not necessarily be evident in the drawing itself. Matthews gives a clear demonstration of this through his observation that 'not only do children use visual media to represent the structure and shape of objects, they also use these to represent the structure and shape of events' (ibid: 31). Athey also noted that 'representation of the figurative did not preclude an "action" component' (Athey 1990: 106). In the example of Rory above, the interpretation of the marks on the paper as a sneeze depend on the contextual clues of the event itself and the child's comment.

A further significant feature of the children's drawing activity that I observed was the economical way in which they made, and used, marks. The limited range of graphic schema, such as

vertical and horizontal lines, the grid, the zigzag, the arc, the enclosure and the 'core and radial' (sun shapes), which children use in their early mark making is well documented (see, for example, Kellogg 1969; Athey 1990). Children combine these different schema in different ways. For the traditional stage theories, these strategies produce deficient drawings, lacking visual verisimilitude in relation to the objects they represent. From the alternative perspective that I am exploring, they can be seen differently: in terms of the way in which they help children to achieve their representational purposes. Ellie designated her drawing as her mummy and daddy in a boat. Reflecting on her drawing she said: 'I better 'tach them together. Because inside the boat it's very rocky.' Rather than redrawing the figures to achieve this, she chose an economical, symbolic solution, drawing some dashes to join them up. The verbal commentary explained both the meaning and necessity of the marks. If this range of purposes is not limited to the realistic depiction of objects, there is no reason to assume that an economical, schematic mark cannot fulfil the child's intentions. We can see the process in Arnheim's terms as the use of structural equivalents not constrained by accuracy (Arnheim 1954). Whilst, in my own observations, the extent to which children spontaneously embellished their drawings with detail varied, what became clear was that lack of detail could not always be associated with an inability to observe and record it when that was their representational intention. It sometimes seemed to be a matter of choice. To illustrate this, when responding to a classroom assistant's focus on detailed close observation, a child in the nursery produced a drawing of a tree with branches and twigs. In other contexts, the economy of a symbolic motif adequately served his purposes. This kind of example raises the possibility that it is varying purposes that determine the way the representation is made rather than perceptual deficiencies or cognitive determinants. An 'inaccurate' drawing may not necessarily suggest that perception has been distorted by immature conception, as theories based on the false dichotomy between perception and conception might suggest; indeed, in the context of the child's own purposes, 'inaccuracy' is a misapplied term.

On the same theme, there were other sorts of examples which also challenged this assumption in different ways. For example, Gemma had drawn a figure with one leg. Whilst the drawing itself may have suggested deficient perceptual abilities, her commentary explained the apparent inaccuracy: she identified her drawing as a person hopping. Similarly, the children made jokes with their drawings, or appeared to deliberately subvert their 'accuracy'. For example, Daniel announced, giggling as he drew, 'a pig with five legs!' and Kylie, as she made an orange patch towards the bottom of her paper, 'I'm doing the sun at the bottom. Ha!' These kinds of playful intentions can provide alternative explanations of the apparently 'deficient' product. They show on the one hand, that children can recognize the power of representation and the power of drawing to represent, and on the other hand, that they, themselves, can be in control of this. The children explore the process through playing with possibilities, not only through representing their idiosyncratic ideas but also in subverting 'reality' and, in effect, creating new realities.

So, when we see children's drawings in this way, in terms of their representational purposes, we cannot presume that their use of visually appropriate elements suggests that 'intellectual realism' has been surpassed in favour of 'visual realism'; that an ability to render detail is developmentally

more advanced. This again presupposes the false dichotomy between so-called 'intellectual realism' and 'visual realism'. Rather, the drawings differ because they reflect different purposes. The fact that children can find more 'visually realistic' solutions when this is appropriate to their purpose, and use a more economical motif when that is appropriate, seems to endorse this. Furthermore, to see the 'immature' drawing in terms of the child's discovery of their ability to be in control of the process of representation may be a more adequate explanation than deficiency of perception or conception. The familiar tendency for children to put into a drawing what they know is there, rather than what they see from a fixed point, can then be seen differently. Being less constrained by the cultural conventions of the viewer-centred approach to drawing, they include, in a drawing, those elements which they want to. For example, when the children in the nursery were watching their teacher do an observational drawing of an iron, he did not include the flex. The children pointed this out. When the teacher protested, saying that he couldn't see it from where he was sitting, they insisted that he should put it in because it was an important part of the iron. This kind of occurrence is very familiar to anyone who takes an interest in children's drawing, and might seem to confirm the staged development theory. But interpreted in relation to the children's representational purposes, it suggests that rather than being developmentally determined, the way they configure the drawing is purposeful; it is related to an intention to show the significant features of the iron.

This intentionality in children's representational activities, even those of the youngest children, underpins the arguments of both Kress (1997) and Matthews (1999). Kress notes that it is contentious: it means that 'we have to look at these childish productions with entirely new eyes, and with the same seriousness which we accord, say, to adults' use of language' (1997: 36). The transformations I observed (described above) show that there was a continual interplay of intention and mark. Inevitably, the child's intention must be deduced from what can be observed. Analysis of my observations suggested that sometimes the drawings followed a declared intention. When James, for instance, was observing a model gorilla, he announced what he was drawing, saying 'eyes' and drawing two dots next to each other, then saying 'boobies' and drawing two more dots beneath the first ones. Sometimes, by contrast, the intention became clear as the drawing took shape and was evident from the contextual talk. Gayle, for instance, painted a swan on a nest that she had seen the day before on a farm visit – she described what she had seen as she drew. Sometimes there was no verbal indication of intention but the intention was evident in the configuration of the drawing. This was apparent where there were clear visual or structural clues that related the drawing to objects in the world. For example, the two vertical lines of crosses in Hayley's drawing were identifiable as plaits from the fact that they were placed on either side of a face.

Clearly, a central part of the contexts for drawing which I have described is the verbal commentary which often accompanies the act of drawing. On the one hand, this provides the observer with clues as to what the drawing means and what its purpose might be. However, I suggest that it can also be seen as further evidence of what is going on when children draw. When we pay attention to children's representational purposes we can see the talk as part of the broader activity that is taking place when children are drawing. Kellogg's (1969) earlier

research into children's drawing explicitly isolated the drawing from its context. The focus was on the form of the drawing rather than its content, so talk which contributed to what the drawing meant was regarded as irrelevant. In Golomb's research, which was carried out at a later date, she took a different line, acknowledging the significance of the children's talk. However, she used the term 'romancing' to refer to the stories which children tell to account for their scribbles and saw the talk that accompanies children's drawing activity as a means of completing the inadequate representation when the child's level of skill is insufficient to achieve, graphically, what they intended:

> What seems to be a 'graphically' incomplete rendition of a figure should not be misconstrued as a simple direct expression of the child's incomplete and therefore immature concept of a man. The extensive narratives accompanying the drawing reveal that the child is not interested in a complete depiction of what he knows about a man. Much is left out because it is difficult to represent, superfluous to the basic structure of the human, and can be accomplished by verbal description. (Golomb 1974: 60)

When a child verbally reinterpreted a drawing, Golomb explained this as a way of adapting a drawing that had not met their intention. Whilst she acknowledged that children do not draw to replicate objects in the world, these explanations implicitly maintain a deficit view of the child's drawing. Similarly, Gardner (1980) also referred to the child's remarks as 'romancing', on the grounds that their drawing did not bear any recognizable likeness to what it was said to represent. In both cases, I suggest, the talk was seen as the dominant form which helped to clarify or supplement the meaning of the drawing, and in a sense, to override it. By contrast, rather than seeing the accompanying talk as overriding the meaning of the drawing, what is going on can be seen as an interplay of the different ways of making meaning. When a child is including, or excluding, features of the world in a drawing, and when they are encoding and decoding intentions in their drawings in a playful and on-going way, they are experimenting with the language of materials and marks and building concepts at the same time. From this perspective, drawing is a form of language, (see Goodman 1976), which carries meanings in ways which are semiotically specific to it. Through their drawing, children are identifying and capturing those elements of their experience that will help them to classify and order it, creating structure and pattern in their thinking. In effect they are constructing the criteria, providing visual markers for them, which will enable them to conceptualize their experience. Similarly, they are experimenting with verbal language, using sounds and words as another symbolic form of representation. My observations showed that, rather than filling in what was missing from a drawing, talk and drawing interact with each other as parallel and mutually transformative processes. Sometimes the talk feeds into the drawing with the verbalized intention being transformed into drawing. Sometimes the drawing feeds into talk: the drawing intention is transformed into talk. Sometimes these processes are apparently concurrent.

It is interesting that Cox explains talk in relation to drawing in terms of what it tells us about children's accidental discoveries. They 'see things' in their pictures. She also suggests that children change their minds frequently about the meaning of a drawing because they 'may not

be able to hang on to the idea of what they want to draw' (Cox 1997: 7). These interpretations seem to imply that children are not in control of the drawing process. On the contrary, I would suggest that the child is in control: these so-called accidental discoveries and changes of mind are central to what the child is quite intentionally engaged in when drawing – the process of decoding and encoding mark and meaning.

This concurs with the analyses of both Kress (1997) and Matthews (1999). They both see drawing as part of the broader meaning-making activity of young children. Kress discusses the 'multi-modality' of children's representational activity; the 'multiplicity of ways in which children make meaning, and the multiplicity of modes, means and materials which they employ in doing so'. He uses the term 'mode' 'to indicate that we make signs from lots of different stuff'. Drawing offers one range of possibilities, amongst others. When children are making their drawings they are constructing signs – 'a combination of meaning and form' (Kress 1997: 6) – exploring how different forms can be made to carry meaning. All the drawing processes I have described show the children playing with this process of 'signing'. Children's recognition that marks can be made to stand in for objects and experiences in the world was powerfully demonstrated when I was observing Kylie. She drew a figure and declared: 'That's my mummy. I don't want to lose her'. Matthews' view of drawing as meaning making arises from his extensive observations of the different kinds of information that children encode in their drawings from a very early age. He shows that from the beginning, children's so-called 'scribbles' are meaningful, and that what children are trying to draw, rather than 'the shapes of the object as perceived from an actual or notional station point, as some kind of picture', is a record of 'the event of their own processes of perception and thinking about the object in relation to the medium. Very young children, in their use of visual media, are not drawing objects per se, but drawing their own processes of attention' (Matthews 1999: 93).

Drawing thus becomes a constructive process of thinking in action, rather than a developing ability to make visual reference to objects in the world. In being integrally related to the development of thinking, drawing activity is integrally related to communication (see, also, Pahl 1999a, 1999b). In the same way that drawing activity is not isolated from other modes of sign-making, it is not an isolated behaviour but a socially meaningful activity. The shift in emphasis in the interpretation of 'representation' away from lifelike resemblance of the drawing to the object in the world, towards the child's own purposes, allows us to focus on the way the drawing represents in the socio-cultural world. Light (1985) argues that we should explain children's drawings in terms of what information they are trying to convey, rather than what they contain – and this is a social act. Meanings are constructed and negotiated in a social context. As was evident in the observations I've referred to above, the children responded to the sign-making going on around them (both verbally and through the drawings themselves). As well as exploring sign-making to develop thinking, in playfully experimenting with the communicative practice of drawing the children were exploring a range of communicative possibilities. I have already mentioned making jokes. Further examples included the use of drawing to record and create narratives; to plan their model making; and, in the case of 4-year-old Holly, to persuade.

When her father came to collect her from the nursery she held up her drawing of a girl in a pink dress saying, 'I've always wanted a pink dress.'

Seeing drawing as an aspect of the interactive, communicative context in which children's thinking develops clearly places the study of children's drawing in a Vygotskyan perspective (Vygotsky 1978). As Wales argues, the Vygotskian tradition, in contrast to that of stage theory,

> sees the focus as that of interpreting what children are doing in the interactive context in which their behaviour is typically rooted. This involves trying to construe children's behaviour, not in isolation, but in terms of their ability to interpret the contexts in which they occur as an integral part of their performance with these tasks. (Wales 1990: 144)

For Stetsenko, the originality of the Vygotskyian approach to children's drawings is that 'his cultural-historical approach focuses on the meaning of the child's achievements in the domain of drawing for his or her life in a real world, in a given socio-cultural context, as a member of a human community' (Stetsenko 1995). This shift reflects the recognition that the idea of a 'real' world that is somehow accessible perceptually in a way that is distinct from our representations of it is highly questionable. The role that children's drawing plays is a constructive one. Through it, children purposefully bring shape and order to their experience, and in so doing, their drawing activity is actively defining reality, rather than passively reflecting a 'given' reality.

References

Arnheim, R. (1954) *Art and Visual Perception: A Psychology of the Creative Eye*, Berkeley: University of California Press.

Athey, C. (1990) *Extending Thought in Young Children: A Parent Teacher Partnership*, London: Paul Chapman.

Burgin, V. (1986) *The End of Art Theory: Criticism and Post-Modernity*, Basingstoke: Macmillan Education.

Costall, A. (1985) 'How Meaning Covers the Traces', in N. H. Freeman and M.V. Cox (eds.) *Visual Order*, Cambridge: Cambridge University Press.

Costall, A. (1995) 'The Myth of the Sensory Core: The Traditional Versus the Ecological Approach to Children's Drawings', in C. Lange-Kuttner, and G.V. Thomas, (eds.) *Drawing and Looking*, New York: Harvester Wheatsheaf.

Cox, M. (1997) *Drawings of People by the Under-5s*. London: Falmer Press.

Davey, N. (1999) The Hermeneutics of Seeing, in I. Heywood and B. Sandywell (eds.) *Interpreting Visual Culture: Explorations in the Hermeneutics of the Visual,* London: Routledge.

Freeman, N. H. and Cox, M. V. (eds.) (1985) *Visual Order*, Cambridge: Cambridge University Press.

Gardner, H. (1980) *Artful Scribbles: The Significance of Children's Drawings*, New York: Basic Books.

Gibson, J. J. (1973) 'On the Concept of 'Formless Invariants' in Visual Perception', *Leonardo*, Vol 6, pp. 43–5.

Golomb, C. (1974) *Young Children's Sculpture and Drawing*, Cambridge, MA: Harvard University Press.

Gombrich, E. (1960) *Art and Illusion*, London: Phaidon Press.

Goodman, N. (1976) *Languages of Art*, Indianapolis: Hackett.

Kellogg, R. (1969) *Analysing Children's Art*, Palo Alto: National Press Books.

Kress, G. (1997) *Before Writing: Re-thinking the Paths to Literacy*, London: Routledge.

Lange-Kuttner, C. and Reith, E. (1995) 'The Transformation of Figurative Thought: Implications of Piaget and Inhelder's Developmental Theory for Children's Drawings', in C. Lange-Kuttner, and G.V. Thomas, (eds.) *Drawing and Looking*, New York: Harvester Wheatsheaf.

Light, P. (1985) The Development of View Specific Representation Considered from a Socio-Cognitive Standpoint, in N. H. Freeman and M.V. Cox (eds.) *Visual Order*, Cambridge: Cambridge University Press.

Luquet, G. H. ([1927]1977) *Les Dessins enfantin*, Lausanne and Paris: Delachaux and Niestlé.

Matthews, J. (1999) *The Art of Childhood and Adolescence: The Construction of Meaning*, London and Philadelphia: Falmer Press.

Matthews, J. (2003) *Drawing and Painting: Children and Visual Representation*, London: Paul Chapman.

Pahl, K. (1999a) *Transformations: Meaning Making in Nursery Education*, Stoke on Trent: Trentham Books.

Pahl, K. (1999b) 'Making Models as a Communicative Practice: Observing Meaning-Making in a Nursery', *Reading*, November 33(3) pp. 114–119.

Piaget, J. and Inhelder, B. ([1948]1956) *The Child's Conception of Space*, London: Routledge and Kegan Paul.

Stetsenko, A. (1995) 'The Psychological Function of Children's Drawing: a Vygotskian Perspective', in C. Lange-Kuttner, and G.V. Thomas, (eds.) *Drawing and Looking*, New York: Harvester Wheatsheaf.

Thomas G. V. (1995) 'The Role of Drawing Strategies and Skills', in C. Lange-Kuttner, and G.V. Thomas, (eds.) *Drawing and Looking*, New York: Harvester Wheatsheaf.

Vygotsky, L. (1978) *Mind in Society*, Cambridge, MA: Harvard University Press.

Wales, R. (1990) 'Children's Pictures', in R. Grieve, and M. Hughes (eds.) *Understanding Children: Essays in Honour of Margaret Donaldson*. Oxford: Blackwell.

13

ORIGINALITY AND ORIGINALS, COPIES AND REPRODUCTIONS: REFLECTIONS ON A PRIMARY SCHOOL PROJECT

Anthony Dyson

Vol 3, No 2, 1984

As a newly qualified teacher (then working in a secondary school), I was vaguely aware of a dilemma. But because of prevailing beliefs about the function of art education in schools, I could at that time scarcely analyse my difficulty; now I think I see what it was. The central purpose of art education was, I felt, the fostering of pupils' imaginative powers; but it was a process which could not be set in motion, I thought, without the provision of examples and demonstrations. These, ironically, would inhibit the very inventiveness I was seeking to provoke (or, perhaps, to release!). I tried in various unsatisfactory, untidy ways to resolve this conflict. For example, to make my introduction of a practical project more effective, I would make sketches and diagrams on the blackboard, but even whilst engaged in this I felt guilty, and was therefore furtive about it. The instant my explanations were finished, I would erase the heretical evidence from the board. Then, the creative powers (with which the pupils were all thought to be naturally endowed) would be given full rein, primed – though not conditioned, I fondly imagined – by my fleeting manifestations!

This feeling of guilt was a strange thing. I had myself received five years' instruction in a school of art before proceeding to a course of teaching training. At my school of art, I had been urged to *study* my subject and to become familiar with its fundamental principles; I was not merely left alone to engage in 'self-expression'. And yet I had somehow (perhaps during the teacher-training course, but probably in less easily locatable ways) absorbed the idea that

Figure 1: Samantha, aged 7, at work with three portrait reproductions: *Hampton Hill Primary School, London, England.*

the *study* of art, with all that the term implies, was inappropriate to the needs, interests and capabilities of young children. In his book *Ideals and Idols* (1979), E. H. Gombrich reproduces an interesting exchange of correspondence with Quentin Bell, who was then Professor of Fine Art at the University of Sussex. In one letter, Gombrich remarked that a teacher he knew had argued that art is 'creativity' and that, this being so, it could not be taught. Bell replied that he had once worked in a primary school, where he had shocked another member of staff by inviting his pupils to make copies of reproductions of Raphael's paintings. Stimulated by these reproductions, the children had made extremely beautiful drawings. Predictably, they had not imitated – probably not even perceived – Raphael's characteristically subtle rendering of volume: their interpretations had more of the flatness of a Simone Martini. The scandalized colleague reacted as though the children's artistic virginity had been violated by this requirement to copy from reproductions. Bell's retort was that his pupils' supposed visual innocence had already been lost many times over since infancy, through constant exposure to influences beneficial and otherwise. The Raphael exercise at least concentrated their attention on exemplars of high quality. It was an exercise demanding hand and eye co-ordination, and it was for the pupils an early experience of the study of art – an experience that could with similar teaching profitably be built upon during their subsequent years of schooling. Alas, for most pupils it is an experience that is all too seldom encouraged.

Figure 2: Children, aged 7–8, classifying portrait reproductions: *Hampton Primary School.*

Part of the problem is that children's art has for the last few decades been a subject of study by psychologists rather than by artists, and by art educators whose interests are psychological rather than aesthetic. Psychologists (Rudolf Arnheim (1974), for example) have produced much influential writing which, whilst it is of course excellent in its own way, has in a sense been inhibiting for teachers of young children. During their training, most teachers in this category will have studied a considerable volume of psychological material referring to children's art but, unless specialists in the subject, will scarcely have studied art itself. It is little wonder, then, that many teachers feel their duty is fulfilled if they simply provide picture-making materials and perhaps a title or two (and what a relief it is when Guy Fawkes or Christmas festivities automatically provide subjects!) , urge their pupils to 'use their imaginations', and stand back – even if only metaphorically – and await the pictorial outcome. This, at least if the children are young enough, will infallibly be charming; and this charm seems to confirm still more strongly the conviction that young children's art activity is 'not to be interfered with'.

It is not appropriate at this point to become too embroiled in those difficult and elusive concepts signalled by the words 'originality', 'imagination' and 'creativity'; writers such as R. F. Dearden (1968) have dealt admirably and concisely with such issues. It will be enough for the moment to suggest that there still persists an idea that, if given opportunities and facilities and, above

all, a freedom from 'inhibiting instruction', pupils will be more likely to give form to 'original ideas', will be allowed greater scope for the exercise of the imagination, and will give fuller expression to an 'innate' creativity. Those holding such views will accordingly shrink from the idea of copying, ignoring its usefulness as a means of helping pupils to study and come more fully to understand the work of others more accomplished than themselves. There is, of course, room in a child's experience for art as expression; it will be salutary, too, to make room for art as investigation. Artists have, by and large, always been avid students of the work of their colleagues, as a glance at the letters of Van Gogh or the journal of Delacroix will show. Even artists like Kandinsky or Klee, who might often be seen as the very embodiments of the cult of artistic self-sufficiency, clearly developed their craft on the basis of such study. (The word 'craft' is not, incidentally, used casually here. One of the arguments of this chapter is precisely that the element of craftsmanship, of sheer know-how, is in urgent need of reinstatement in art education – in spite of the fact that it was admittedly given unduly feverish attention in even the best of nineteenth-century art education).

Let us look squarely at the business of copying. It is often thought to be damaging – but why? Is it possible that this has become one of those mysterious taboos – like drawing with a ruler, or using a rubber – that is strictly observed for no analysable reason? The argument

Figure 3: Children aged 7–8: a discussion of a series of mediaeval depictions of the months of the year: *Hampton Hill Primary School.*

seems to be that copying militates against a pupil's own inventiveness – or, at least, that time spent copying would be far better spent 'expressing' personal ideas. The attitude is perhaps descended from that of the founders of the Royal Academy, who for a hundred years refused to grant full membership to those professional copyists, the reproductive engravers, on the grounds that invention was the prerogative of the true artist, whilst engravers were merely a 'set of ingenious mechanics'

Dearden (1968) has pointed out that unless children are given opportunities to come to know, for example, the poetry of others generally acknowledged to be competent in their craft, they are hardly likely to develop any concept of *what a poem is*. I suggest that one of the most effective ways of coming to know works of visual art is to engage in that most salutary form of note-taking: copying (and the word is here given its full range of meanings – replicating, emulating, reproducing, interpreting). Although the European Romantic tradition (other cultures see not to share this particular difficulty), insofar as it has embodied the cult of the individual, has tended to obscure the fact that most artists have always learned from each other in this way. There exist, for example, 'copies' of Persian miniatures by Rembrandt, 'copies' of Rembrandt by Van Gogh, 'copies' of Van Gogh by Francis Bacon... If this were not the case, there could hardly be such a thing as 'the history of art'. If there were no such influences, and corresponding emulations, all would be the work of idiosyncratic individuals constantly re-inventing art, and the broad patterns on which the writer of history depends would be absent.

There seems to be a vital distinction between the kind of drawing that comes about as naturally as speech, and that which is (but not at all in a derogatory sense) contrived; between that form of drawing which is the descendent of instinctive infant scribble, engaged in by all children, regardless of whether or not orthodox art materials are available, and that form of drawing which embodies consciously adopted conventions; between that which comes about whether tutored or not, and that which is nurtured by the deliberate acquisition of taught skills. Adherents of what has come to be known as 'child-centred' education seem to have been mesmerized by the former, and to frown on the latter as being against the natural inclination of children. Art, it is frequently forgotten, is a matter of the employment of convention, and, as such, there is very little about it that is 'natural'. Art is, in a very important sense, artificial. John Constable (who, ironically, is popularly renowned for his naturalness) knew this better than most: 'the Art pleases by *reminding*, not by deceiving', he pointed out. No artist mastered more fully that sleight of hand which transforms flicks of paint into a reminiscence of things seen in nature; no artist was more completely aware of the need for conscientious study as a means of attaining that mastery; no artist showed us more clearly the fallacy of the idea that visual experience can, given sufficient skill, be represented in pictorial facsimile.

These two forms of drawing – 'natural' and 'contrived' – are, though distinguishable, related. In fact, the 'natural' and the 'contrived' coexist in the drawings of most mature artists. Insofar as the 'natural' is less consciously controlled, it is to a large extent this element in a drawing (or painting, or sculpture) that determines what we call style – the artist's 'handwriting'. Children who are ultimately identified as having facility in drawing begin to make a transition from the

'natural', less conscious form of drawing, to the 'contrived', more consciously controlled form quite early – often around the age of seven or eight. The shift of emphasis is frequently assisted by copying. And the images that are copied are, naturally, those that come most readily to hand: comic caricatures, advertising graphics, and so on. Our reluctance to involve children in copying (Quentin Bell's sin against the innocence of child draughtsmanship!) comes about through an exaggerated respect for 'natural' drawing. Inevitably, sooner or later, children will seek to emulate the drawings of others, and we should welcome this rather than discourage it. It provides a golden opportunity to engage pupils in the serious study of art. 'Natural' drawing has its place in the infant school and well beyond; but I should here like to propose that our scruples about interfering with the innocence of 'natural' childish drawing is at the root of our failure to include in the art education of almost all pupils up to the age of sixteen an adequate element of appraisal. It is at the root of the traditional separation in education of what the Gulbenkian Report (Robinson 1982) refers to as 'experience' and 'appreciation'; the separation of practical art from the history, criticism and appreciation of art.

The writer's recent experimental work with two classes of primary school children (ages seven to eight and nine to ten) was based on the premise that the fusion of experience and appreciation should begin at least by the time a child is seven. It was based on the principle of *studying* art. In setting up the experiment, it seemed important that the work be undertaken in circumstances as realistic as possible. Accordingly, a school catering for children from a variety of social and cultural backgrounds was chosen:[1] full classes of about thirty children were taught; the normal school timetable was adhered to; and no special materials or equipment (not even a slide projector) were used. The chief source of visual stimulus was a large collection of postcard reproductions of drawings, engravings, paintings, sculpture, architecture, furniture, musical instruments and other artifacts.[2] This was supplemented by a few examples of 'the real thing': an oil painting, an engraved wood-block, and an etched metal plate with corresponding print, for example. Besides relative inexpensiveness, the collection of postcard reproductions had certain very important advantages over books and slides, and complemented the appraisal of original art objects in valuable ways. The most prominent advantage was that the reproductions could be grouped and classified and compared in endless ways. This flexibility provided an ideal basis for discussion with individuals, between the members of small groups of pupils, and with the class as a whole. The paintings, plates, blocks and prints made it possible to begin to develop pupils' insights into the relationship between the real thing and reproductions of it; made it possible to discuss the distinction between photographic reproduction and, say, engraved reproduction; and, with appropriate reproductions, provided an effective introduction to the gallery visit which was to be a culmination of the experiment.[3]

Many pupils in both classes were capable of a high level of discussion of the relationship between things seen in nature, original representations of these visual experiences, and reproductions of the originals. When the 7–8 year-olds were shown a small oil painting of a boat on a beach and were asked simply 'What is this?', the reply 'It's a boat' was very promptly contradicted by the protest 'No, it's a *picture* of a boat!'. It was then but a small step to the notion of 'a photograph of a picture of a boat', fortified by a comparison of the texture of an

original and the texturelessness of a photographic reproduction. When the children were given a magnifying glass and asked 'How was this picture made?', there was no doubt that their careful scrutiny (and fingering) of the object reinforced their notion of an artefact – an artefact not dissimilar to their own paintings; no doubt that it was at least a first step towards their sense

Figure 4: Linocuts by children, aged 9–10: *Hampton Hill Primary School* (The cuts were based on postcard reproductions of paintings the children were eventually to see at the National Portrait Gallery).

of community with artists and craftsmen. The discussion of originals and reproductions led to the matter of relative scale. One 7-year-old discovered two reproductions of the same painting by George Stubbs. The reproductions were different in size, one being printed on a leaf of a large calendar, the other being a postcard version. On the back of the postcard were printed the dimensions of the original painting in the National Gallery. With this information, a rectangle the exact size of the original was drawn on the blackboard, and the two reproductions were placed like postage stamps in its corners.

Throughout the discussions with children, careful attention was given to the matter of accurate terminology. For example, a clear distinction was made between the word 'copying' (in the sense of making a single re-presentation) and the word 'reproducing' (in the sense of making something capable of identical repetition). There are, of course, subtle overlaps of meaning that young children can hardly be expected to grasp; but if, with Jerome Bruner (1962), we believe that the essence of an idea introduced to young children can be 'revisited' with increasing degrees of sophistication throughout their subsequent schooling, there seems no good reason for delay. Pupils were helped to make such distinctions as this by making 'one-off' copies in a variety of media, and by making their own printed reproductions (in the tradition of the eighteenth- and nineteenth-century engravers) of postcard images from linoleum blocks (see Figure 4).

As the work progressed, it became increasingly evident that there was a pronounced interdependence of experiences: an interdependence of one practical enterprise with another; of practical experience with discussion, appraisal and response; of one concept with another. This was particularly clear in one project involving the 7–8 year-olds. Each child was given three portrait reproductions: one 'modern' (incorporating the usual liberties with colour, handling etc.); one 'traditional' (highly illusionistic); and one schematic (with very clear, emphasized line). In the first place, the children were asked to arrange the reproductions chronologically: the oldest on the left, the newest on the right. What ensued was a salutary reminder of the importance of the teacher's awareness of his own need for vigilance in the use of language. For example, Samantha considered a twentieth-century painting by Walter Sickert to be 'older' than a portrait of Elizabeth I. It transpired during discussion that the child had interpreted the words 'old' and 'new' not in the chronological sense intended by the teacher, but in the sense of 'used' and 'pristine'! And there was certainly a drabness about the Sickert and a brilliance of colour in the Tudor painting that made the little girl's decision eminently logical (see Figure 1).

One aim of the project was, however, to see if these young children could detect any evidence for chronological placing. Accuracy of dating was, of course, neither expected nor sought; chronological sequence was considered enough. This was a particularly fascinating exercise, because it revealed so much that (to invoke Bruner again) was a potential foundation for subsequent learning. The children were all quite confident that the portrait of Anne Boleyn was painted 'long ago'; their estimates of just how long ago ranged from 10 to 1,000 years. One boy suggested the almost correct figure of 500 years, and when asked why, he answered after some pondering that he had based his estimate on his seven years' experience of the world,

and had multiplied this to what he considered a feasible extent. One might well be tempted to smile condescendingly at all this – but it was a valuable beginning. Another example: Benjamin did not doubt that the portrait of Shakespeare was earlier than that of Churchill. Shakespeare, he noticed, wore 'old-fashioned' clothes; and his comment that the Churchill portrait 'looks like it's just been painted' seemed to denote an acute perception of the artist's vigorous brushwork. There were other salutary reminders to the teacher of the need for care in selecting resources: one pupil decided that a portrait of Gaudier-Brzeska (twentieth century) reproduced in monochrome, was older than the sixteenth-century portrait of Henry Howard because 'in the olden days they used to use black and white'!

Another preconception dismantled by the children was this: I had long argued for a comparative approach to the study of art objects, and had suggested that it made good sense to present younger children with sharply contrasting images whose differences they could readily spot – pictures by Picasso and by Leonardo da Vinci, for example. However, Christopher (aged nine) selected from a number of reproductions of flower paintings, in a wide range of styles, two very similar Dutch seventeenth-century pictures, and spent a whole hour carefully comparing them and listing the differences and similarities.

It is vital that children have frequent opportunities of working from direct experience, of making drawings and paintings from objects they can handle, and of environments in which they can

Figure 5: A 9-year-old from Hampton Hill Primary School working in the National Portrait Gallery.

move. These are extremely important ways of coming to appreciate such properties as texture, structure, space, and volume. But the message of this chapter is simply this: that studying art objects and images is an effective vehicle of learning for young children; that such study can be more sharply focused through that activity deprecatingly called copying; and that working in this way may assist inventiveness. It certainly will not inhibit it.

Notes

1. I must here record my appreciation of the kindness and cooperativeness of Mrs. Olive Alderson and her colleagues at Hampton Hill Primary School, during the Spring Term, 1983.
2. Generously donated by: the Courtauld Institute Galleries; the Geffrye Museum; Hampton Court Palace; the Horniman Museum; the Iveagh Bequest, Kenwood; the National Gallery; the National Portrait Gallery; the Tate Gallery; the Victoria and Albert Museum; the William Morris Gallery, Walthamstow; Windsor Castle; and the British Museum.
3. I must here acknowledge the interest and energetic collaboration of Liz Rideal, Education Officer at the National Portrait Gallery.

References

Arnheim, R. (1974) Art & Visual Perception, Berkeley and Los Angeles: University of California Press.

Bruner, J. (1962) The Process of Education, Cambridge Mass: Harvard University Press.

Dearden, R.F. (1968) The Philosophy of Primary Education, London: Routledge and Kegan Paul.

Gombrich, E.H (1979) Ideals and Idols, Oxford: Phaidon.

Robinson, K. (ed.) (1982) The Arts in Schools, London: Calouste Gulbenkian Foundation.

14

Art Learning in Developmental Perspective

Norman H. Freeman

Vol 15, No 2, 1996

Art education has several interests to protect. It is vital, for instance, that children be given studio experience and produce as interesting artworks as they can. Yet it is not the primary function of studio sessions to add to the national corpus of pictures. The purpose is to provide the children, and their peers, with public evidence of their engagement with art. My job as a psychologist is to try to puzzle out what kind of reasoning is in children's minds when they engage with art. For that purpose it is sometimes necessary to get children out of the studio, and to try to detect what *general internal resources* children have that they can call on. I do not intend to belittle the role of the teacher as an external resource, or what the teacher and the child can develop in common. However, an external resource will only have an effect if there is uptake by the child; and the concern is to say something about the resources that make the uptake possible. At this stage, it does not matter much what one calls those internal resources. Certainly a full account of them would have to appeal to concepts of imagination and art discipline. Some of the research can be found discussed in Freeman (1994, 1995) and in Freeman and Sanger (1993), and one of the full data-sets is reported by Freeman and Sanger (1995). This chapter focuses on the nature of the approach more than on the data-analyses.

A psychologist is supposed to do a little more than 'diagnose' the internal resources that children bring to a situation, they are also supposed to describe the situation and classify it into those aspects that are difficult for children to understand, and those aspects that are easy to understand. For example, when you look at a picture, do you know what your feelings are? It

is often difficult to use reflective awareness to understand your own feelings when looking at a picture. It may be similarly difficult for children of any given age, or it may be that the children at that age are under the illusion that feelings are transparent to the person who is experiencing them. It is important to know which of those is the case when discussing pictures with any age group. There is a fine text by Harris (1989) on the slow dawning of comprehension of emotions in general. Again, do you know how you personally go about interpreting a picture? Sometimes, it is true, one is acutely aware of the knowledge base on which one draws during interpretation, but it is difficult to explain the operation of interpretative processes. If it were easy to explain interpretative processes, psychological research would be a good deal easier than it is. If explanation is difficult for us as adults, it is more difficult for us as children. We have, in Bristol University, been working on what resources the children have, what they find easy and difficult about pictures, and what they *know* about what is easy and difficult about pictures. As far as I am concerned, such judgmental awareness, no matter how rudimentary it may be in a young child, entitles one to say that that child is operating in the mode of an art critic (see also Golomb 1992). Some of these children, when they grow up, will become very skilled amateur art critics in their spare time.

In sum, the paper is not about picture-production, nor is it about children's responses in the presence of particular pictures. The focus is not on the child in the role of artist or in the role of beholder, but on children's *general ideas* on what pictures are. One way of putting the matter is to say that children acquire a *theory* of pictures. If some of the aims of art education are to help children develop a love of art, an understanding of art, and a sympathy for the efforts of artists, we need to know how to talk children through the issues. One way to address children's concerns is to address their theory. So here we are going to begin to diagnose what is in a child's theory of pictures. The important word is 'begin'; for children have very rich and complex minds, and we cannot give a full account. One false step in diagnosing the basics would have a snowball effect and research would get further and further from reality.

Let us begin at the beginning by imagining that we simply know nothing at all of what a picture is. That presumption of ignorance is a traditional game that some researchers play at the start of a series of studies. One could simply ask primary-school children of various ages, 'What is a picture?' (see Gardner, Winner and Kircher, 1975) It is no surprise that one gets fragmentary and rather superficial answers. But that does not matter, for the initial aim is not to diagnose children but to diagnose what properties are in these mysterious objects called 'pictures'. Remember, at this stage we are pretending that we know nothing about picture properties and that the children are the sole experts. To cut a long story short, if one collects up the fragments of answers, it is easy to see that a few basic ideas tend to come up repeatedly. First, children in primary school mention that you can see what a picture is of or *about*. That suggests that there is something beyond a picture of which perhaps a picture triggers a recognition. Not all pictures do this, but some certainly do. Secondly, children tend to use the language of action, conveying the idea that someone making a picture is something that someone does, so some notion of human agency is lurking there somewhere. Thirdly, children often say that pictures can be nice to look at, so some notion of a beholder's enjoyment emerges. Finally, children may try

to convey some idea that pictures can be interesting and special in some way. Even from such a limited sort of survey one gets the idea of traditional concerns lying behind what children may say, concerns about truth and fact, artefact, beauty, and significance. Despite the efforts of post-modernism, these traditional concerns seem to be alive and well.

Selecting the notion of a beholder's enjoyment, let us start with the topic of 'beauty'. Remember that we still officially know nothing about pictures beyond the fact that some children have raised the notion that some pictures can be beautiful. There may seem to be little to say about pictorial beauty in general; but in fact we are not at all interested in trying to get extended disquisitions from children, but to get small comments that can be classified. There are actually rather few possibilities in a classification scheme for beauty. First, we want to know whether the children think that beauty is an objective property of some pictures in perhaps the same way that paint is an objective property. Secondly, if they do not think that, perhaps they think that beauty comes from whatever it is that a picture relates to in the world; perhaps to them a picture is rather like a mirror, reflecting the beauty of the world to which it is 'pointed' (see Parsons 1987). Thirdly, maybe children think that the agent, the artist, beautifies a picture somehow, regardless of what is depicted. Fourthly, maybe children think that beauty is in the eye of the beholder, and only in the eye of the beholder. It does not matter whether all such ideas are largely correct or grossly mistaken. What matters is whether such ideas enter into the way in which children *reason* about pictures. If one or more of the above ideas were to hold a powerful place in a child's pictorial reasoning, it would be useful for an educator to know that fact in order to stage-manage a meeting of minds around art.

Now let us pause for a moment. We have, so far, staked out two claims. The first claim is that it is possible and desirable to draw out a sort of map within which children's pictorial reasoning may be exercised. This map can take the form of a net in which notions about a picture are caught by virtue of the place of a Picture in a net of relations between World, Artist and Beholder. The proper term for such a net is an 'intentional' net. The term 'intentional' has the technical sense of a relation between two things in which one thing is *about* or *of* the other. (see Searle 1983) Thus a belief held by a Beholder has to be a belief about something; and the object of belief has to be particular in some way (you cannot just say 'I believe frogs,' you have to 'believe something *about* frogs.') There is something similar in the case of fears and desires. Pictures are objects or instruments of belief-desire reasoning. A picture is an intentional object in that it might be designed to be about a state of affairs or the possibility of something, and so on. The artist may or may not be an authority on the significance of any individual picture she has produced: false beliefs, rationalizations and wishful thinking afflict artists just as much as they afflict the rest of us, including us as children.

The second claim staked out was that we should start at the beginning and treat children as experts, asking children about what pictures are like. Now, of course, we can use the net as a guide, as was done above for the example of 'where does beauty come from?' Here is a brief note on what can happen when one starts such research.

If you ask children whether they can tell if a picture is beautiful or not, they either think it is a trick question, or they answer that all you have to do is to look at a picture and you can directly see if it is beautiful. Accordingly, we devised a question that removed the World from the intentional net: we casually asked 'How could you tell whether a picture of a unicorn is beautiful if you've never seen a real unicorn?' An easy reply would be 'just look at the picture and see.' However, we have found that such a question often blocks such a simple 'all you have to do is to act as a beholder' reply.

The following small piece of data is from little study run with Melanie King on urban children of 11 years of age. Only five children gave a prompt reply about pictorial qualities (how the picture was drawn, what the configuration was). Those answers were standard and reasonable answers that came from the children's acquisition of knowledge about how to justify a judgement on a picture in terms of the depicting surface. Five children said they did not know how one could tell, and one more child said that 'it's a bit hard'. Why should it be hard to see if a picture is beautiful? An answer might be detected from the remaining five children who focused on whether unicorns were beautiful rather than on pictures of unicorns. I suggest that even these sophisticated children regressed to transporting a property across a relation: if a picture is to be judged and you know what the picture is about yet cannot see the referent (i.e. no visual Beholder-World relation is possible), what you can do is to imagine how the World would look if it could be seen, i. e., transport the property from World to Picture and thence from Picture to Beholder. That may seem laboured and formalistic; but one of the 7-year-olds we also studied in fact came near to articulating just such a chain of reasoning. The transcript is worth reading slowly to mimic the laboured way in which the child puzzled the matter out. She said she would judge the beauty of the picture:

> By the way I usually sort of think – like you could say a princess is beautiful, or like, if you want, you could say a tramp is ugly, then you could say a unicorn is sort of more beautiful than a tramp – and it's an animal, so it's sort of as beautiful as a princess.

Here we have a clear case of pictorial reasoning, along with a resolute justification, in which all the labour is put into puzzling out how something you can never see can be a suitable case for depiction. Once the child has puzzled that out, she then seems to take it completely for granted that the depictable quality, here 'beauty' or 'ugliness,' will then automatically appear in the picture. That is very reminiscent of one of the sorts of judgement discussed in Parsons (1987).

Now, let me summarize for the moment. We have situated a picture in the centre of an intentional net, and are trying to discuss pictorial problems with children in order to see how they can run short chains of argument over the net. One approach is to set them 'dilemmas' as in the unicorn example. An unappealing aspect of the unicorn problem is that it verges on being a trick question. However, there are many pictorial dilemmas that are perfectly prosaic. Thus, 'You've got a dog you're very fond of; you love this dog, you think it's great and it falls sick and you're afraid it's going to die, so you call in an artist to paint it. What should the artist do?' Here, the child is invited to take the stance of a patron who will judge the picture by acting

as a beholder (and, in this case, not bothering with considerations of value for money, or size of canvas). The dilemma is, if the artist paints the dog sick and dying, as is the current state of the world to which the artist is related, maybe that is not what the child wants as a memorial painting. If the artist paints the dog not sick and dying, then the artist would have to know what the dog looked like before it fell sick. If the artist does not have access to that prior knowledge, then the depiction would be a sort of fiction. Is the child willing to settle for a picture as a sort of fiction acting as a memento?

Are there age-related changes in children's criteria for that sort of pictorial function? In a small study with Jo Bowden we found that 31 out of 36 children aged between 7 and 11 years resolutely opted for the healthy dog memorial, as against current reality. That near consensus may seem obvious. However, we are not much concerned with whether results look obvious or not, for the main point of interest lies in cross-comparing opinions that change with age against opinions that are acquired early and remain in place for a long time. It is not difficult to generate many kinds of dilemma. One can do the same thing for a shop that a child loves, and has deteriorated and become dusty and dirty: one can degrade anything or one can improve anything by suitable repair, rearrangement or patched-in makeup. I have, so far, been able to find little in the literature that provides a solid body of evidence on children's developing knowledge of pictorial dilemmas. What I find interesting is that most teachers I talk to have accumulated a vast store of insight, yet somehow the art education literature seems to have missed out on a systematization of the knowledge.

Let us return to the intentional net and ask a simpler question about beauty. Remember, what we are after initially is whether children of different ages believe that beauty is objectively inside a picture, gets directly transported from World to Picture, gets created by the Artist by virtue of the relations of production, or is simply in the eye of the Beholder. One way to start is, 'If you've got something really ugly in the world, can you get a pretty picture of it?' Or, 'If something is really pretty, could you get an ugly picture of it?' The technique here is to attribute one property (here a property of the World), and then to negate it (here in the Picture), and ask children about the link. I personally prefer to avoid direct negation since it might sound like a trick question: it seems better to generalize one of the terms to a broad merit term as in, 'If something was really ugly could you get a good picture of it?'

We first worked with rural children in a Caribbean island. For these very rural children, considering whether an ugly thing would make a worse picture than a pretty thing, ten out of twelve 11-year-olds automatically said, 'Yes!' We enquired why that should be so. In the main, the children's reasoning can be represented as 'Because if something's ugly, it would be an ugly picture, and an ugly picture is a bad picture, so it would be worse.' That is a very neat and very simple argument: beauty/ugliness is in the world, it becomes transferred onto a picture plane, and then you just map that property onto the terms 'good' and 'bad', so if something is ugly then it must be a bad picture. The majority of the 11-year-olds were absolutely clear about this, absolutely clear about their reasons. As far as we could ascertain, the children were not just casting about: they knew what they thought. Turning now to the 14-year-olds, nine out of

twelve of them said, 'No, of course not.' And we asked, 'Why not, how come, if something is really ugly it wouldn't make a worse picture?' They conveyed that the outcome depends on the artist – on skills and enthusiasm. Now that is rather a nice age-related shift, because what the children were doing was shifting from just focusing on Picture and World to spontaneously invoking an entity, the picture producer, in a corner of the intentional net. That is one way in which one detects when a generative theory is developing in the mind of a child, when she takes a straight question and gives an answer in terms that had not been explicitly mentioned.

In replication runs in England, exactly the same shift occurred. This time, the shift that we are getting at where you move away from 'pictures are of something,' to the fact that it is an artefact that determines its properties, with an artist actually doing it, tended to occur between the ages of seven and eleven. I do not think that the three-year lag is of great interest in itself. The point of interest lies in whether children from another culture undertake the same shift in reasoning. We had twelve 7-year-olds and twelve 11-year-olds from London. All the younger children except one said 'Yes, an ugly thing must make an ugly picture, and that would be bad', and all the 11-year-olds except one said 'No, of course not, pictures don't work that way.' We did it again with variations that do not matter here, with Jo Bowden, with 7, 9 and 11-year-olds, and got the same results basically (a couple more exceptions but the same shift). This conceptual shift seems to be occurring in a small English city; the run-down British capital; and a small Caribbean island, and it occurs in the same sort of way, just, perhaps, on a different timescale. Maybe in urban children who have art classes and a lot of magazines, round about age nine is the time at which they pick up this generative theory.

The interesting thing is not a single child ever appealed to the Beholder. That surprised us only a little. True, it is always open to someone to claim that beauty is in the eye of the beholder, however, it is difficult for children to conceive of looking as a really generative process. In their theory, it seems to be mainly Picture, World, Artist; and the Beholder is just the passive person who comes along and glances at the picture. In the children's theory, it is as though people like us who go to an art gallery leave our minds at home. Perhaps that is exaggerated, but here is a small piece of evidence that shows up the asymmetry between Artist and Beholder in children's reasoning.

All bar one of the children in the metropolitan study agreed that an artist can shape a picture to make a beholder happy. Pictures have power to give pleasure or pain, and the intentional relation between Artist and Picture orients an artist towards exercising that power. The question is whether the children regard beholders as being passive recipients of whatever the artist has symbolically invested in the picture. Only two out of twelve of the 7-year-olds broke away from such a view. When asked if the way you are feeling affects the way you look at a picture, ten out of twelve of the 7-year-olds said that a beholder's prior feelings were irrelevant, since what mattered was what was 'in' the picture. In contrast, nine out of twelve of the 11-year-olds explained that how you felt was very important in the way you looked at a picture. Again, the shift to an interpretative theory of intentional relations was significantly evident.

We also asked whether an artist's feelings would affect how good the picture was. Here ten out of twelve of the 7-year-olds said that the artist's feelings were indeed relevant; and that judgement contrasts with their view of the beholder's feelings noted above. Does that indicate that the children were in some way reasoning in a more sophisticated fashion about the artist? Alas, it was noticeable that the children regarded happiness as *directly* transferred to the picture: a happy artist would make a 'happy picture' and a sad artist would make a 'sad picture.' As one would expect, only one out of two of the 11-year-olds held to such a view: the rest explained that the artist's skill determined the picture quality. Again then, an early reasoning-pattern based on absolute qualities-to-be transferred gave way to appropriate reasoning about intentional relations.

Let us take a closer look at the question of mood and picture. We said, 'Well, look, you're passing a shop window and it's a picture shop, an art shop, and it's got these pictures in, and one day you're just feeling sad, you look at the window, you see a picture there, and another day you're feeling really happy as you walk past, so you look at the picture. Do you think you would look at it differently?' The 7-year-olds, with only a couple of exceptions, were patient with us: if a picture is interesting, that is what you see, so it does not matter how you feel. The relevant facts about beholders are not yet *integrated* into their intentional net. Some of the 11-year-olds had a sophisticated story, a sort of projective theory. Some of them had a less sophisticated theory, and one of them just said, rather endearingly, 'Well, if you were really sad, you wouldn't want to look at pictures, would you? And if you did, you wouldn't appreciate them, would you?' Turning now to the artist, to keep the equation matched, we asked whether if an artist is happy or sad affects the picture the artist is going to produce. 7-year-olds, again with just two exceptions, were very clear about that. The answer was, 'Yes, of course.' 'If you are happy, you'll make a happy picture, and a happy picture is pretty and good to look at, and that will be better. If you are sad, you might choose all dark colours in producing your picture and it won't be a good picture, will it?' Apparently then, feelings do not affect beholders but they certainly affect artists, in a *pictorially-relevant* way. Children are building up a theory of a picture as an artefact, in which the power lies in the hand of the artist, but at this age the Artist has not got the power to override the World, no matter what her relationship is with it. If something is ugly, it will be a bad picture, if the artist is in good shape it will be a good picture, but the ideas are not yet integrated where they can balance one against the other. Again, the 11-year-olds were very clear. An artist might be feeling really sad, but then if she has got a lot of skill she might produce a good picture. And, as one 11-year-old explained, 'I'd rather have a really good artist who was feeling sad, than a rotten artist who was feeling really pleased with herself.'

Next, I should like to focus on a central fact about depiction, using a comment by one 7-year-old child as a stalking horse. We established that a fictitious character, 'Sarah doesn't like snakes.' That is a proposition about a person's relation to the real world. We then cast the person in the role of Beholder by asking, 'Could you have a picture of a snake that would make Sarah like snakes?' That question seemed to polarize 7-year-olds, whereby eight children said that it was possible for a picture to alter a relation to the real world in such a case, and seven children

said that it was impossible. What is of interest is the remaining child who said, 'Not exactly, because that's only a picture, that's someone's mind being put on paper.' What is important is that the child has got what Wollheim (1993) said, correctly, was a central fact about pictures. In Wollheim's formulation, 'The central fact about art is that it is an intentional manifestation of mind.' This 7-year-old, in thinking about snakes, had seized a corner of that central fact: a picture is someone's mind being put on paper. It will now take the child some years to get her inferential apparatus working so that she will come out with really better conclusions. All that I am suggesting in this chapter is that it is not too difficult to make sense of the journey the child is going on once we start to use the intentional net as a map. The child will go round and round the net, progressively integrating judgements on the relations within the net.

To conclude, the present approach is based on a thought experiment whereby one regards a picture as initially devoid of all properties but with the potential to acquire properties. One then asks children whence a property could come if a picture is actually to acquire that property. If we knew what properties to enquire into, we could build up an account of how children gradually enrich their aesthetic judgements by drawing finer distinctions between properties and distinguishing between the Artist, Beholder, and World as sources of these properties. At some point one would expect children to be able to segregate judgements, to be able to say that a picture can simultaneously be ugly yet be a good picture, or that the topic in the world may be ugly (e.g. War) yet Guernica is not a bad picture. Such reasoning is what makes folk aesthetics possible. Accordingly, we can categorize what we are after as exposure of conceptual change within the child's theory of pictures. Early pictorial reasoning is what makes it possible for people to develop art criticism; the aim is to study the emergence of art criticism in the child. The price to be paid for a method of research that detaches the child from first-hand involvement is a degree of pallidness. It is a price that scientists are accustomed to pay. The study of the child's theory of biology says nothing about how children will interact with pets and pests, but does inform us about how children categorize the animal kingdom. The study of critical pictorial reasoning has just the same status, affording insight into what pictorial inferences and causal arguments children of different ages regard as legitimate. Once that is known, children can be engaged in more informed debate about pictures.

This chapter is an edited version of a presentation given at Art and Fact: International Conference on Learning Effects in Art Education. [LOKV] Rotterdam 27–28 March 1995

References

Freeman, N. H. (1994) 'The Emergence of a Framework theory of Pictorial reasoning', in C. Lange-Kuttner and G.V. Thomas, (eds.), Drawing and Looking, London and New York: Harvester Wheatsheaf.

Freeman, N. H. (1995) 'The Emergence of Pictorial Talents', in J. Freeman, P. Span and H. Wagner, (eds.) Actualising Talent, London: Cassell.

Freeman, N. H. and Sanger, D. (1993) 'Language and Relief in Critical Thinking: Emerging Explanations of Pictures', Exceptionality Education Canada, 3. pp. 43–58.

Freeman, N. H. and Sanger, D. (1995) 'The Commonsense Aesthetics of Rural Cildren', Visual Arts Research, 21, pp. 1–10.

Gardner, H., Winner, E., and Kircher, M. (1975) 'Children's conception of the Arts', *Journal of Aesthetic Education*. 9. pp. 60–77.

Golomb, C. (1992) *The Child's Creation of a Pictorial World*, Berkeley, CA: University of California Press.

Harris, P.L. (1989) *Children and Emotion*, Oxford: Blackwell.

Parsons, M. J. (1987) *How We Understand Art*, Cambridge: Cambridge University Press.

Searle, J. K. (1983) *Intentionality*, Cambridge: Cambridge University Press.

Wollheim, R. (1993) *The Mind and its Depths*, Cambridge, Ma: Harvard University Press.

Postscript: A look back at 'Art learning in developmental perspective'

Norman Freeman, University of Bristol, 2008

A look back at a paper after more than a decade gives one the chance to see if there is a sensible and fresh answer to three questions about whether the paper was worth writing.

First, what was going on at the time that explains why the ideas in the paper were expounded as they were? There's a near-universal delusion that grips authors: the delusion that the authors knows what they're doing at the time of doing it. They sort of do know, but hindsight gives clarity over why they did it in the way that they did it. In the present case it turns out that there is something worthwhile in putting matters into perspective.

Second, did anything come of the ideas in the paper? There's a near-universal anxiety amongst experimentalists lest their ideas vanish away in a fog of fine distinctions and their findings get shovelled away into a spoil heap of incompatible data. In the present case it turns out that those haven't happened. Yet.

Third, is there any conception, perhaps only implicit or vaguely present in the paper that is newly promising nowadays? A fresh direction in explanation is on the agenda.

What was at issue
There has long been an interest in trying to characterize children's general concept of the pictorial realm (or the peculiarities of children's pictorial reasoning, their folk aesthetics or their intuitive theory of pictures, conceive of it how you will). The paper asked what do children find it easy and difficult to work out about pictures and picture-making. The commonest preoccupation amongst those who work with children is, reasonably enough, keeping an eye on child development. Childhood is not a steady state: that instability is, in part, what gives educators an opportunity to intervene in one way or another, and psychologists to put to the test their explanatory models. A developmental emphasis had marked the magisterial text of Michael Parsons (1987), in which was propounded an aesthetically-sophisticated account of pictorial development. A decade or so later, although the first page or so of the 1996 paper naturally fell into that forward-looking perspective, the emphasis fell increasingly on the breadth and complexity of art-reasoning at whatever phase of development a child happened to be. The question naturally arose whether the two views were essentially rivals in the research recipes that they offered. To what extent is

a choice forced on us if we want to make best progress in understanding what children are up against in trying to grasp the pictorial realm?

A seminar on the development of conceptions of art was set up at the 1996 Convention of the American Psychological Association in Toronto. The session was chaired by John Kennedy who had established his pioneering credentials via work with blind people drawing with pens that raise a welt on the page. So he was unquestionably well-placed to act as referee or adjudicator or debate-shaper on the issue of progress and discovery. Would there be academic blood and teeth on the carpet? Well, it so happened that Mike Parsons and I had been writing to each other anyway, and at dinner the night before the seminar we had worked out that the only way we could really make sense of current ideas was to drop the overly-tidy stage-development conception in the Parsons book and then treat our two perspectives as complementary. So that was what we did at the seminar. In fact, to help us keep our minds on the point, we swapped name-badges beforehand; and with the amused support of John in the chair, all was sweetness and light. Up to a point. The compact was sealed in a joint piece (Freeman and Parsons 2001) and that's how matters rest (Trautner 2008): two perspectives (amongst others, of course), characterized by respect for the sheer complexity of the task facing the child.

What research managed to unearth
How does the child of any age undertake (a) the task of co-coordinating insights about artist, viewer, scene and picture-surface, whilst (b) grappling with the three great pictorial functions of representation, expressivity and attractiveness? Did that perspective get anyone anywhere in the next decade or so? The proposal is that such a view of aesthetic judgement and reasoning holds good for experimental psychology and for art education. We are gradually coming to fill in the details of what it takes to reason aesthetically within the framework of the 1996 paper (and its 2001 revision with Mike Parsons). A statement on the art-education implications became needed for the first ever handbook of art-education research and policy sponsored by the National Art Education Association of the USA, that appeared in 2004 edited by Elliott Eisner and Michael Day. Here are a couple of examples since 1996 that were reviewed in the handbook chapter (Freeman 2004).

What makes a picture worth framing and putting on display? Adolescents in structured interview reckoned that such a means of commemorating artists' achievements allow any viewer thereby to infer something of the tastes of the person who had chosen the picture for display (Maridaki-Kassotaki and Freeman 2000). The crucial point is that in the course of replying to an innocuous question about a picture, respondents spontaneously invoked the mentality of (a) someone making a pictorial choice (a patron? a curator? a householder?), and (b) someone who reflects on the nature of the pictorial choice (a casual witness? an art critic? the viewing public?). The mere fact of getting such a broad stance revealed from a narrow-focus question seems to validate the emphasis on breadth of pictorial thinking in the 1996 paper.

Near the start of assuming a pictorial stance, do preschoolers allow the artist to determine the meaning of a picture? If an artist says she is drawing a balloon, are we bound to attach the caption 'A balloon' to the picture or do we have the choice of relabelling it 'A lollipop'? Bloom and Markson (1998) reported that 4-year-olds unduly respect the artist's avowed intention. That's particularly interesting because over-respect for intention is still taught as being one of the classical philosophical-aesthetic fallacies. Too bad:

if you are working with preschoolers, it is useful to treat the intentional stance as a virtue. It is to the child's credit that she answers an innocuous 'what is it?' question by invoking the mind of the artist. Or so the current story runs. There is a great deal of behind-the-scenes discussion of so-far in-progress work that reveals preschoolers to be more flexible than that bald account implies. Flexibility within an intentional stance would be even more to the child's credit. However that research turns out, the focus is perfectly placed to illuminate questions about child psychology and about art education. There is a formidable list of basic questions about any educator's stance on artist intention that are worth answering when trying to engage students in critical and aesthetic debate and reflection (see Barrett 2004).

A fresh move
Finally, will a fresh look be worth taking on the main aim of the chapter, which had been to explain why it is necessarily the case that children's pictorial reasoning is both complicated and untidy. As far as explanations are concerned, this millennium is already marked by the use of evolutionary considerations in most areas of psychology in one way or another. Is there any chance that a small dose of evolutionary theory will help us here? In the field of cognitive development, a lead discussion-point is the extent to which it makes sense to divide domains of representation and reasoning into core domains and non-core domains. A core domain is one for which there is reason to think that evolution has shaped us so that we each and every one of us start life pre-programmed. The other domains arise piggyback on core domains, and appear late in our human record. At present, there is agreement that we each are innately impelled into building sets of beliefs about the domains of biology, physics, number, language and psychology (the latter rather oddly called 'theory of mind'). Pictures arise late in our history, and there is no reason to think that picture-making is absolutely essential to survival. But that does not entail that art is just a luxury: it is a powerful tool for human development. In the absence of a crystal ball all one can do is make an educated guess that in another ten years or so, developmental psychologists will be explaining the peculiar complexity and untidiness of pictorial reasoning by how the pictorial domain has piggybacked its way into our life. It is not so implausible a notion. After all, a child who appeals to an artist's intention is drawing on some theory of mind, some notion that mental states cause events. A first stab at rewriting the 1996 account informed by domain conceptions is in Freeman (2008).

References

Barrett, T. (2004) 'Investigating art criticism in education', in E. W. Eisner and M. D. Day (eds.) *Handbook of research and policy in art education*, Mahwah, NJ: Erlbaum. National Art Education Association (USA) pp. 725–750.

Bloom, P. and Markson, L. (1998) 'Intention and analogy in children's naming of pictorial representation', *Psychological Science*, 9, pp. 200–204.

Freeman, N.H. (1996) 'Art learning in developmental perspective', *International journal of Art & Design Education,* 15, pp. 125–131.

Freeman, N.H. (2004) 'Aesthetic judgement and reasoning', In E. W. Eisner and M. D. Day (eds.) *Handbook of research and policy in art education*, Mahwah, NJ: Erlbaum. National Art Education Association (USA) pp. 359–378.

Freeman, N.H. (2008) 'Pictorial competence generated from crosstalk between domains', in C. Milbrath and A. Trauttner (eds.) *Children's understanding and production of pictures, drawing and art: theoretical and empirical approaches* Cambridge, MA: Hogrefe pp. 33–52.

Freeman, N.H. and Parsons, M.J. (2001) 'Children's intuitive understanding of pictures', in B. Torff and R. J. Sternberg (eds.) *Understanding and teaching the intuitive mind: Student and teacher learning,* London: Erlbaum pp. 73–91.

Maridaki-Kassotaki, K. and Freeman, N. H. (2000) 'Concepts of pictures on display', Empirical *Studies of the Arts,* 18, pp. 151–158.

Parsons, M.J. (1987) How *we understand art: A cognitive developmental account of aesthetic experience,* Cambridge: Cambridge University Press.

Trautner, H.M. (2008) 'Children's developing understanding and evaluation of aesthetic properties of drawings and art work', in C. Milbrath and A. Trauttner (eds.) *Children's understanding and production of pictures, drawing and art: theoretical and empirical approaches,* Hogrefe pp. 237–260.

15

Teaching Now with the Living: A Dialogue with Teachers Investigating Contemporary Art Practices

Tara Page, Steve Herne, Paul Dash, Helen Charman, Dennis Atkinson and Jeff Adams

With:

Rebecca Benjamins, Carole Dickens, Carol Gigg, Hannah Hutchins, Andy Law, Juliet Morris, Mary Jo Ovington, Peter Sanders, Elaine Thompson, Henry Ward and Lesley Whelan

Vol 25, No 2, 2006

Introduction

Contemporary art practices have the potential to make a significant contribution to the art curriculum, students' learning, social inclusion and the development of cultural identity. However, according to Downing and Watson's authoritative, government-funded research report, *School Art: What's in It?* (2004), only a minority of schools are including such practices in their art and design curriculum. Although some schools are developing innovative art practice, there is

little research into how this may affect teaching and learning. As a consequence of this, Goldsmiths College, Tate Modern and eleven 'partnership' teachers investigated how teachers and learners engage with contemporary art practices in school and explore the ways in which appropriate teaching, learning and communication methods can be developed. Their experiences form the substance of this chapter.

This research developed from existing links between Goldsmiths College Art in Education and Tate Modern Education, such as shared MA teaching, conference papers, joint gallery workshops and school partnerships. Tate Modern's Education and Interpretation department, internationally renowned for its innovations in the educational application of contemporary art, has strong ties with Goldsmiths Art in Education, who have been pursuing research within this field over a number of years. Many schools have been part of previous successful Goldsmiths and Tate research projects, such as the 'Art Now in the Classroom' partnership project between Tate Modern and Goldsmiths (2000 and annually since then), which worked with KS2 and KS5 pupils using Tate Modern as a Primary resource. Thus this research took advantage of this existing productive relationship with the two institutions and 'partnership' primary and secondary schools.

'Partnership' schools are those that work with Goldsmiths and Tate Modern to educate and train pre-service teachers. Mentors/SBTs (School Based Tutors)/partnership teachers work closely with staff to enable students from Goldsmiths to complete the three-year Bachelor of Education and/or the one-year Postgraduate Certificate of Education. These beginning teachers have also fostered contemporary art projects systematically through assignments that have been implemented through close ties with teacher/mentors and it is from these well-established relationships that the sample group of eleven partnership teachers was selected.

Our research occurs at a time of sustained interest and growth in contemporary arts practices in the UK. This boom has been signalled by the international success of Young British Artists in the 1990s, the controversial and internationally acclaimed Turner Prize, the government's linking of wealth generation to the creative industries and a renewed cultural infrastructure of high-profile galleries including Tate Modern, Modern Art Oxford, Saatchi, Baltic and Ikon. Directly related to this phenomenon is the growth of a plural social context, globalization and the need to develop social policies of inclusion in which cultural variety and difference are acknowledged and celebrated. In addition to the Downing and Watson report (2004), a number of research and policy initiatives inform this project[1] and have pointed to the pedagogic potential of engaging with contemporary art in the gallery or classroom. These initiatives have encouraged teachers to develop their contemporary practice as artists alongside their professional work as teachers, but they have also revealed that many teachers are uncertain of their subject knowledge in this field (Hyde 2004). The teachers we worked with were determined to address both of these crucial issues, which are further explored below.

The government commissioned a report into creativity, culture and education, *All Our Futures* (NACCCE 1999). It recommended that emphasis should be placed upon developing and

teaching creative practices at all levels of education and across all subjects. Reports such as these coincide with the rapid expansion of social theory, which continues to increase our understanding of socio-cultural identities (Dash 1999). Similarly, the UK's government statutory curriculum and training agencies require that teachers provide a curriculum that meets the needs of all learners from whatever social and cultural background. However, tackling challenging social issues through productive, creative and imaginative learning strategies can be problematic. The difficulties of these new learning strategies have been extensively explored in critical writing on art education in recent years (such as, among others, Addison and Burgess 2000; Atkinson 2002; Dalton 2001; Efland et al. 1996; Hughes 1998; and Steers 2003). For these writers, a common theme is the need to challenge entrenched and expedient approaches, to encourage more extensive learning and communication methods, and the need to countenance social and cultural dynamics as an integral, if unresolved, component of the curriculum. The eleven partnership teachers agreed with these views and have found that engagement with contemporary practice has evolved learning strategies that comprise methods and frameworks associated with questioning, autonomous learning, and an awareness of the contingent, and sometimes conflicting character of subjectivity.

Contemporary artists like Sonia Boyce frequently explore sociocultural issues and media that are relevant to students' lives. Their work challenges the traditional ideas of knowledge and skill acquisition that currently inform school curricula. These methods of communication and issues of cultural identity are significant as they often arise from the community the artist inhabits, and draw on the experience of that society. For instance, the work of Chris Ofili uses the emblems of daily life to analyse and display the experience of being Black, a British community participant, and the resulting social tensions. Ofili also explores the ambiguities and contradictions of popular signifying systems, and how these result in the construction of identity.

Identity formation is inseparable from the processes and structures of learning, whether it be in school or beyond in the wider community, and is crucial to our understanding of learning, the acquisition of knowledge, and communication. The contemporary artists that inform the work of our teachers, including Sonia Boyce, Jenny Holzer, Steve McQueen, Keith Piper and Gillian Wearing, all comment on issues that are central to the lives of school learners, such as identity, ritual, gender, sexuality, race and the assimilation and impact of technology.

Significantly, these methods of art production also require spectators to engage with artworks in new and different ways. Young learners' engagement with art production in the school curriculum, like those of contemporary artists, is already affected by their acquaintance with globalizing technologies such as the Internet, foreign travel and the media. Our classroom practitioners suggest that if this is to be a meaningful engagement, new learning strategies must address questions that challenge social, cultural and political norms, and explore notions of inclusion and the development of critical thinking skills. In our teachers' schools, these issues and practices are already having profound effects upon the content, structure and methods of teaching and learning.

Explorations with teachers: grounding contemporary practice

Defining contemporary art was the point at which we began our discussions with the partnership teachers. Although we had anticipated that this may have been an impossible task, we believed that it was necessary to gather ideas in order to establish the ground upon which much of the subsequent discussion would be based. Unsurprisingly, given that the location of the schools are all in the London area and in striking distance of a large range of galleries and museums, many of the teachers hinged their definitions around institutions with high public profiles, such as Tate Modern and the Whitechapel Gallery, although some argued that contemporary art was less likely to be found in mainstream galleries, but rather in smaller commercial galleries. The 'contemporary' aspect of contemporary art as 'new' or 'current', as well as 'innovative' was also evident in their discussions:

> To me contemporary art is very alive. It pertains to our life at the moment and our society or other societies … it's art dealing with problems of 'now' by artists who are living.

Several teachers made the point that contemporary art is also associated with new media or methods of presentation such as installation:

> … artists use traditional media in non-traditional ways – experimentation is a key feature … work that could involve different skills rather than traditional methods of painting … or maybe stretching those traditional methods, doing something else with them.

Most of the teachers associated the content of contemporary art with cultural and social issues, and this comment was typical:

> I think it's to do with culture, people and the person that does it, and it doesn't necessarily have to just be a kind of visual art.

A key point that emerged from this was that contemporary art demands questioning and thinking:

> Whereas with other art forms you can get by with showing and telling, with contemporary art you have to question ideas.

> It's art that has ideas and thinking at its centre … it's about the thought process as well as the actual visual look of what's produced.

> It's about what's gone into it – the thought process that's gone into it to make it.

> When I think about working with children contemporary art is something that asks questions and demands answers – it doesn't necessarily 'look good'.

Finally, all agreed that it was very perplexing and difficult to define or explain. Many of the teachers' responses appear to be rationales for conferring the high value of contemporary

art practices in schools. Dominant amongst them is the concept of expanding pupils' critical horizons as contemporary art often isn't what pupils would traditionally expect art to be, it immediately places the pupil in a questioning situation, extending what they understand 'art' to mean. The 'current', 'new' and 'contemporary' nature of this art was conceived as intrinsically valuable to pupils:

I think for them knowing that the art is being produced at the moment is of value – knowing that they can go and see it and it's fresh and part of our culture…I think that means something to them.

The relationship between contemporary art and identity, for both teachers and pupils, was frequently cited as one of the less obvious values of teaching and learning through these practices. Contemporary art was thought to enable pupils to see that their identity as a practitioner goes beyond the school context and the idea of teachers and pupils both being practitioners gave a sense of shared experience. The teachers also referred to the concept of the artist-teacher, where they became models for creative behaviour. This was seen as having the additional benefit of the process of 'reverse influence', where teaching and the pupils' creativity can affect the teachers' own art:

The work I do in school is bound up with the work I do as an artist, the materials I use: I will try them out with different classes. Sometimes, not necessarily thinking about it, I look at it afterwards and realise that it's come through my own work. I have a studio space and I'm producing work, it's a balance, I would like to do it full time I suppose. But I do really enjoy teaching…we bounce [ideas] off each other, I suppose.

Issues such as race and gender were often seen as taking a more prominent part in the content of contemporary art. This was seen as of particular value and sometimes cited as being a key reason for working with these practices:

I like to use contemporary art for gender balance because there's so much more going on with women…maybe there was before but we don't know about it.

Similarly with race, teachers saw in contemporary art practices the possibilities for rethinking the status quo of the art curriculum by extending or reshaping it:

We should be looking for Black and Asian artists…Chris Ofili features quite highly, partly because of his politics, which are quite pertinent really – particularly in my school which has a lot of race problems. It's good to look at his work and see what statements he's trying to make.

…to reflect the community of the school, because it is a multicultural school and we have very few white children, but it makes me so angry all the examples of artists' work in the QCA (Qualifications and Curriculum Agency work) are virtually all dead white men… there are one or two units that are actually okay to work with as they are, but the majority

of them … it's just scary to think that lots of teachers would be picking up these units and thinking, 'we need this, I must go and get the resources for their delivery'. As I'm sure lots of people must.

Some thought that contemporary art has crosscurricular value at primary level and that this value could lie in issues-based work because of its relevance across a range of subject areas. Most of the primary teachers taught across the curriculum through art and both primary and secondary teachers commented that pupils were given more control over a project, both its direction and its aesthetic management, when working with contemporary practice. This was evident in the increasing confidence and decision-making apparent in the production of the work:

Contemporary art gives pupils permission to value their work.

It improves their language, it improves their looking, it improves their listening … it touches so many areas of the curriculum other than art.

Explorations with teachers: learning methods

All of the teachers were interested in the new ways of working that contemporary art demands. For many the final product was not the most important part of the learning processes:

… sometimes the end product isn't what matters. What matters is what you've learned in the doing of it, although I think the end product does matter to children … I think they do have to have a sense of liking what they've produced but it doesn't have to be visually beautiful. Art teaching is actually talking to children, asking them why they're doing things. So, yes, there has to be input, they've got to be given information in the structure, but within that structure, then you can allow them freedom.

It also affects learning styles:

Contemporary art addresses preferred learning styles and children do not all respond to learning in the same way … so when [the artist] Michael Brennan-Wood came in, some of the kids said 'I want to work alone', even though it was a group project …

Working with conceptual art demands innovative ways of working. All teachers noticed that once exposed to this kind of work and these processes, over a period of time, the pupils were able to take it in their stride. They avoided the derisive comments often made in response to conceptual art. A key indicator of success was a mutual respect for work that might otherwise have been considered 'beyond the pale', where pupils were willing to discuss and analyse work rather than reject it:

I think they become more involved with it if they feel that it belongs to them or they can take something from it, and that's why I think it's important for the children. Plus, I think

it shows them that they could do something like that if they have seen something that represents them in it or they perhaps think that the artist is very similar to them in whatever they're expressing...

This experience led the teachers to take on work with children that they might formerly have rejected as too difficult. Some noted a positive correlation between the children who were involved in projects that included a reference to contemporary art with those who later opted for art at more senior level.

The teachers thought that the wide range of possibilities inherent in contemporary art, both in terms of style and content, meant that pupils often needed to justify why they had made their work. They were also encouraged to have an attitude of questioning and criticality as artists themselves and consequently debate and discussion had prominent roles in the learning process:

> That doesn't mean that you necessarily, as a group, arrive at the 'right' meaning, more that you can reach a collective agreement about the group's ideas about the meaning of the work.

> ...as they develop through the school and as they're exposed to these kinds of approaches, they begin to develop independently and start to really – I'd argue – become artists and actually have an independent, different way of looking at the world... So often they'll say, 'Why is that art?' and my kind of catchphrase response is, 'Let's take art out of your question, ask the question again, and say "Why is that?" Right, let's have a discussion about it. Now how much more interesting is that?' And they say, 'But why does somebody do it?' I'd say, 'Well, why not?'... it gives them the idea of looking and thinking and trying to make a decision about what something is.

Some commented on the way that more traditional projects could be revivified by contemporary art, such as a portrait project that began with Sonia Boyce's painting:

> They were very interested because she was actually quite local... and they obviously could relate to the Barbados they know. So they were very enthusiastic, very keen – they had lots of questions. I remember they asked me why she painted herself with blue hair. That was one of the questions that came up regularly, actually. They are fascinated by her having blue hair. And [also] talking about her holding her family up, which the children don't have any difficulty interpreting...

This process of integration of traditional modes of learning with projects that focused on contemporary practice interested many teachers:

> It's great to use as a doorway to older art, because it means something to pupils' own lives – there are references which they 'get'.

Sometimes teachers adopted the reverse process, teaching a sense of the contemporary through older art forms:

> We did a project called 'inside the body'. We started with Leonardo da Vinci, looking at the Renaissance artists and how they used dissection techniques. Then we carried it through and looked at loads of different people, like Francis Bacon, and its natural conclusion was to bring it to the modern day. We ended up looking at Helen Chadwick and Kiki Smith. It gives them the a sense that artists continually look at what's gone on before and produce their own interpretation of it.

Working with contemporary art in galleries, experiencing it at first hand, was seen as crucial to most of the teachers:

> We use lots of galleries. They're a valuable resource and education programmes are usually good and accessible. When we visited the Journey exhibition at the Serpentine we went on the bus. In the exhibition the kids saw artists responding in unusual ways, so on the way back they did the same … 'What kind of things are on top of bus shelters', etc … It was easy for them to 'see' what the artists were up to.

The teachers often pointed out that once the children had been involved in contemporary art projects, they subsequently found places like Tate Modern more accessible, making the artwork seem less remote. They noted that this made them less judgemental and more willing to accept the differences between works. They viewed work less hierarchically and were more willing to incorporate their own work within the realm of contemporary art:

> It gets them out into the world, it teaches them that people like art, that people look at art, that maybe they could be artists.

All of the teachers found that the demands of teaching and learning in the field of contemporary art often required rigorous planning. One teacher gave the example of preparing a project with an artist-in-residence, where they would plan lessons in 'infinite detail'. All the participants thought that the pupils' responses to ideas was much better if there was more time devoted to planning and research. Many also thought that working with contemporary art was harder because it demanded more preparation on the part of the teacher. However, this also led to unexpected freedoms, for example the 'tailoring' of projects to a particular topic or purpose. The indicators of success for many were the transformations in the pupils' way of seeing the world, especially where the teacher perceived that this gave them a renewed view of their own cultural identity.

Explorations with teachers: developing conditions for learning and assessing

This was a key area of contention for many of the teachers. Some felt that assessment can be difficult, and perhaps unnecessary as an outcome for projects:

The pupils' abilities – their imagination and expression – far exceed any assessment criteria.

Some teachers commented that assessment isn't necessarily a problem and that through careful interpretation of assessment criteria it can be managed. Others felt that formal examinations at 16 were difficult because the intellectual capability to successfully analyse contemporary art can be more demanding than other forms and that assessment at this stage tends to prevent collaborative work. All secondary teachers felt that formal assessment made these issues more critical:

I don't think the [14–16] curriculum allows for working in a very contemporary way because it's very prescribed ... Recently a moderator came in and you just knew she was coming from a very traditional viewpoint and didn't like the fact that if they were drawing a face they hadn't done umpteen studies ... You have to play a bit on the safe side and make sure all you cover all these points.

Assessment can be become a series of obstacles because the skills involved do not sit easily within the current criteria:

I think the pitfall is possibly about the whole skill thing ... because I think that there are perhaps problems with the kind of traditions of assessing art that are about being 'good at drawing ... And I think that there are huge problems with judging and assessing art full stop, and massive problems with putting a grade on it. I think that it comes down to criteria, and making sure that the students are fully aware of the criteria on which they're going to be judged prior to making a piece of work.

Others were concerned about the way that assessment affects and prescribes the content of the curriculum:

Some areas of contemporary art are taboo – Manga cartoons and Sci-Fi and aspects of animation. I don't know if they have worked out how to value or assess this work yet.

However, assessment was viewed as having potentially positive aspects:

In terms of assessment of skills and techniques we looked at how a child worked, how a child cooperated with others, the choices a child made and, really importantly, at how quickly they responded to the idea, and their confidence and flexibility in responding, I think it gives opportunities for assessment rather than taking them away.

Significant barriers to teaching and learning through contemporary art were identified by the teachers. Lack of resources, equipment, time, limited space and digital facilities are constraining factors. Even well-funded schools considered themselves to be struggling to support ambitious

projects such as video documentary. Subject knowledge limitations and a lack of understanding of contemporary art were also cited:

> When it comes to working on projects in school often the main problems that arise are with other members of staff who are less keen on, less familiar with or less interested in contemporary art. I think that so many people think like that because of the SATS [statutory tests] and the Government's recommendations...

One of the most difficult issues to deal with is sex and sexuality. On some gallery visits teachers have been forced to request work be concealed from the pupils. Obscene language presents a similar problem and interviewees thought that this was a more difficult issue with younger children.

> One constraint is the explicit nature of some contemporary art exhibitions, so we don't go when these are on.

> ...Marlene Dumas – a lot of her work is quite explicit. We keep that book in the office. I suppose you censor it to a certain extent. At the Saatchi gallery there's a lot of nudity and it's harder to talk about when it's 'in your face'. However, some would be prepared to use work about sexuality – Tracy Emin's video work for instance – but only after much an extended period of time to 'prepare the ground' with the pupils, otherwise it was thought to be problematic. Sometimes parental views were seen as limiting, especially with regard to work that may appear to be sexually explicit. Strategies have been developed to deal with this however, parents appeared to have been more willing to accept contemporary art when their child has been involved in successful projects.

A crucial ingredient in the teaching through these practices is appropriate and continuing professional development (CPD). Art courses were seen to be helpful, but often inadequate for the requirements of a specific project. As far as CPD is concerned, research into contemporary art was vital:

> I'd like the time to research contemporary artists and their practices built into the curriculum as opposed to pushed into spare time.

Collectively, the primary teachers agreed that it was a feature of their projects that the acquisition of specialist expertise was essential. This may be a requirement of engaging with contemporary art practice in many primary schools. Some found that the best professional development had come from working alongside an artist on location, with workshops developed specifically for staff at evenings and weekends. However, events like these were dependent on staff goodwill and had to be in the teachers' own time. In-service training days can only be used according to the school development plan and art only features periodically. Additionally, the successful engagement with contemporary art practice by primary schools is dependent upon the willingness of school management to support projects.

Conclusion

It is over two decades since the last major paradigm shift in thinking about visual art education, represented by the critical and contextual movement in the UK and DBAE (Discipline Based Art Education) in the USA (Taylor 1986; Dobbs 1992). This led to the broader inclusion of critical and contextual studies, gallery and museum visits, artists in schools and a global perspective to art education policies, and, to an extent, classroom practices in most Anglophone countries. Many of these influential developments have been criticized for not going far enough in reflecting contemporary cultural and social theory. For instance, one of the findings of Downing and Watson's work (2004) is that the range of artists and types of work studied in schools is limited in terms of chronology, cultural context, ethnicity and gender, comprising predominantly early twentieth-century Western painting and sculpture. As we have seen from the explorations above, our teachers are determined to expand these curriculum horizons and venture into the uncharted territories of the new and the contemporary. In doing so they have offered concrete realizations of new pedagogies.

Not surprisingly, these innovations are fundamentally grounded in the imperfect conditions that prevail in our schools. The teacher participants' ideas have often been curtailed, altered and adapted, yet their progress has also been impressive, as has the responses of their pupil – as they have candidly discussed. There is much that we can learn from their experience, whether in terms of the conditions necessary for the successful engagement in contemporary practice or the learning strategies that they employ. The underlying social critique and interrogation of identity associated with contemporary art practices, when employed within contexts of learning and teaching, introduces a radical view of our understanding of the learner, the teacher, the process and the product. This obligates a social responsibility to conceive learner and teacher identities in ways that transcend older, dormant or traditional understandings that are embedded within current school art education practices. Teachers and pupils are already rapidly developing diverse and innovative strategies and learning environments. These may have a prominent role to play both in the future of art education and in the school curriculum as a whole.

Note

1. For example: the DCMS funded 'En-quire' project is administrated through Engage, the National Association for Gallery Education which brings consortia of galleries together to work with schools to explore contemporary art in visual arts education; the Arts Council England (ACE) with NSEAD (National Society for Education in Art and Design) sponsor the successful Artist-Teacher Scheme.

References

Addison, N. and Burgess, L. (2000) 'Contemporary Art in Schools: Why Bother?' in R. Rickman (ed.) Art Education 11–18: Meaning Purpose and Direction, London and New York: Continuum.

Atkinson, D. (2002) Art in Education: Identity and Practice, Dordrecht: Kluwer.

Atkinson, D. and Dash, P. (eds.) (2005) Social and Critical Practices in Art Education, Stoke on Trent: Trentham.

Dalton, P. (2001) The Gendering of Art Education: Modernism, Identity and Critical Feminism, Buckingham and Philadelphia: Open University Press.

Dash, P. (1999) 'Thoughts on a Relevant Art Curriculum for the 21st Century', *Journal of Art and Design Education*, Vol. 18, No. 1.

Dobb, S. (1992) *The DBAE Handbook,* Los Angeles: J.P. Getty Trust.

Downing, D. and Watson, R. (2004) *School Art: What's in It? Exploring Visual Arts in Secondary Schools,* London: National Foundation for Educational Research/Arts Council for England/Tate.

Efland, A., Freedman, K. and Stuhr, P. (1996) *Postmodern Art Education: An Approach to Curriculum,* Reston, Virginia: The National Art Education Association.

Hollands, H. (2000) 'Ways of Not Seeing: Education, Art and Visual Culture', in R. Hickman (ed.) *Art Education 11–18: Meaning Purpose and Direction,* London and New York: Continuum, pp. 55–68.

Hughes, A. (1998) 'Re-Conceptualising the Art Curriculum', *Journal of Art and Design Education*, Vol. 17, No. 1, pp. 41–9.

Hyde, W. (2004) The Impact of the Artist Teacher Scheme on the Teaching of Art and on the Continuing Professional Development of Art and Design Teachers. DES Best Practice website. Available from URL www.teachernet. gov.uk/professionaldevelopment/opportunities/ bprs.

National Advisory Committee on Creative and Cultural Education (NACCCE) (1999) *All Our Futures: Culture, Creativity and Education,* Sudbury: DfEE.

Steers, J. (2003) 'Art and Design Education in the UK: The Theory Gap', in N. Addison, and L. Burgess (eds.) *Issues in Art and Design Teaching,* London and New York: Routledge Falmer, pp. 19–30.

Taylor, R. (1986) *Educating for Art,* Harlow: Longman.

16

5 x 5 x 5 = Creativity in the Early Years

Mary Fawcett and Penny Hay

Vol 23, No 3, 2004

Context of the project

Over the last four years, the Arts Education Development Officer for Bath and North East Somerset has been researching the needs and wishes of schools with regard to creative educational arts activities. The 5 x 5 x 5 project model was developed – five artists, five schools and five galleries working together – and proved highly successful. The 2001 research project, Making Art Work,[1] recommended that the early years should be a future focus. A serendipitous encounter between the Arts Education Development Officer and an organizer (a lecturer in Early Childhood Studies) of the Hundred Languages of Children Exhibition, (see below) provided the impetus for 5 x 5 x 5 = Creativity in the Early Years, which was launched in 2002.

The time was opportune to explore the ways in which early years' settings of all kinds (reception classes, nursery schools and classes, preschools, private nurseries and early excellence centres) were working within the framework of the *Curriculum Guidance for the Foundation Stage* (QCA and DfEE 2000), especially in the area of early learning, defined as 'creative learning and development'. This Curriculum Guidance (now obligatory) recommends 'providing children with well-planned opportunities to work with artists, musicians, dancers and other creative people'. While there is a long tradition of artist residencies, practice is not always satisfactory; 5 x 5 x 5 sought a continuous collaborative relationship between artist and educator rather than 'one off' events with no legacy. In designing this project, the educational practice in the northern Italian city of Reggio Emilia of employing an artist in every preschool as a full-time member of staff suggested a desirable goal. However, importing ideas from other cultural contexts can be dangerous and far from the wishes of the Reggio Emilia educators. Careful consideration of the principles and practice in relation to the educational context in the UK was necessary.

Research focus

The project's qualitative research questions were, first, to examine the impact on the children's creativity, second, to enquire into the nature and potential of the partnership between the educators, artists and colleagues from cultural centres and third, to explore the kind of evolution and sustainability of changes to practice within the early years' settings as a consequence of the year-long intervention.

'Creativity' in the curriculum

The word 'creativity' is often used loosely and with varying meaning. In order to clarify our thoughts we examined the concept particularly in relation to young children (Fawcett 2002). The definition from the *All our Futures* report (NACCCE 1999), 'imaginative activity fashioned so as to produce outcomes that are both original and of value', may not be very helpful without also including the four features of creativity: 'using imagination, pursuing purposes, being original and judging value'.

Recently Craft has suggested another perspective that portrays creativity as a broad 'life-wide' capacity, not solely connected with the arts. She has called this 'little c creativity' as 'the capacity to use imagination, intelligence and self-expression'. 'It is the capacity to route-find across the breadth of life's contexts...' (Craft 2000).

Another definition, with regard to young children, states that '[c]reativity is about connecting the previously unconnected in ways that are meaningful for the individual' (Duffy 1998). We favoured thinking of creativity as a way of understanding in all children, not the preserve of a few talented individuals, and that it is at the heart of young children's early learning. According to Malaguzzi, 'Creativity should not be considered a separate mental faculty but a characteristic of our way of thinking, knowing and making choices' (Malaguzzi 1998: 75).

The Reggio Emilia approach

In the UK, a new consciousness of the capacities and creativity of young children has been stimulated by recent tours of the Hundred Languages of Children Exhibition (Reggio Children 1996 – an exhibition of children's work accompanied by text explaining the underpinning philosophy) and also by Study Visits to Reggio Emilia. The internationally acclaimed work of these preschools (for children from 3 to 6 years) is significantly supported by an artist (*atelierista*) as a permanent full-time member of staff in every preschool. The collaborative relationship between the artist and educators is probably the key to the high quality, imaginative, thought-provoking work of the children. However the philosophy and practice of the Reggio Emilia preschools more broadly demonstrates that with imagination, professionalism, dedication and respect for the rights of young children the impact can be enormous (Edwards et al. 1998).

Their principles are founded on an image of children as creative, capable learners from the moment of birth. With regard to creativity, Loris Malaguzzi (founder and director of the Reggio Emilia preschools) wrote: 'Once children are helped to perceive themselves as authors or inventors, once they are helped to discover the pleasures of inquiry, their motivation and interest

Figure 1

Figure 2

explode.' But he adds a warning that '[t]o disappoint the children deprives them of possibilities that no exhortation can arouse in later years' (Malaguzzi 1998).

The hundred languages of children

This phrase, taken from a poem by Malaguzzi, is an imaginative evocation of the many ways in which all kinds of ideas can be represented and communicated. It is also the title of the famous exhibition, constantly touring the world. Children are perceived as communicators from birth and as they develop in their early years, they discover many ways of representing their feelings, theories and imaginative ideas. Their communications can be expressed as words, drawing, 3D constructions, movement, music – indeed, through any symbolic form. In their early years children do not confine their expressions to one form; they move naturally and easily between, for example, drawing, speaking, singing and moving.

In Reggio, the artists and educators aim to give children the opportunity to use as many different 'languages' as possible. These various forms of representation strengthen the development of mental schemas and allow every child a voice. This concept of diverse modes of thinking and representation is comparable with Howard Gardner's well-known theory of multiple intelligences (Gardner 1983).

The achievements of the Reggio Emilia preschools are unique; they do not constitute a recipe to be copied. Their philosophy and practice are the result of more than 40 years' work and continuing evolution. However, they offer a powerful example of the way in which adults can work creatively together, drawing strength from clearly defined principles based on a deep respect and a spirit of enquiry into the understandings of children.

The 5 x 5 x 5 = Creativity in the Early Years Project

This innovative project brought together five early years' settings, five artists and five cultural centres to work together for a year in the local authority area of Bath and North East Somerset.

The selected settings were all of high quality, they were well-equipped and staff had thought carefully about the curriculum. However, the most striking element of the practice in the settings, prior to the project, was the high level of structure in their timetables and the subdivision of activities into the curriculum areas laid down in the Foundation Stage Guidance (QCA and DfEE 2000).

The artists

The artists' brief drew on the Creative Foundation project[2] which is based on the approach in Reggio Emilia:

> The atelierista is a studio worker, an artisan, a lender of tools, a partner in a quest or journey. In this way you are a maker, but maybe more richly you are an enabler, someone who will attend to others in their creation, their development and their communication of knowledge. (Duckett)[3]

Figure 3

Figure 4

The artists worked collaboratively with the educators, not only when engaged directly with the children, but also in planning and reflection sessions. While utilizing their own personal media skills they also developed awareness of the dispositions amongst the children and considered the multiple intelligences and the 'hundred languages' of children. They also participated in the various levels of professional development (see below).

The cultural centres

All the centres (except one) had previously taken part in 5x5x5 projects and were interested in supporting initiatives that involved the wider community. The representatives of the invited cultural centres were individuals with their own expertise in education, communication, curation and management. Each cultural centre brought a different creative potential to the project and essentially provided a rich physical or virtual space in which to construct meaning and to contribute to the 'creative learning community'.

The processes

In this research project, the comparative element of the five groupings – which we called triangles – gave us a unique opportunity to examine the impact of the experience on the creativity of very young children and the involved adults. This was not a series of separate residencies but everyone together forming a community 'researching children researching the world.' The project has been strongly supported and guided by the experience of SightLines Initiative.[4] Their 'Young Children Thinking in Action' project and currently the 'Creative Foundation' project (see note 2) explore comparable territory using a similar philosophical base to 5x5x5.

Principles of 5x5x5

From the start a set of principles, inspired by the Reggio approach, were adopted. They are founded on an image of 'a child who is strong, powerful, rich in resources, right from the moment of birth' (Rinaldi 1998).

1. Artists and educators are seen as enablers 'who will attend to others (the children) in their creation, their development and their communication of knowledge' (Vea Vecchi in Edwards et al. 1998).
2. A 'reflective and creative cycle' underpins the work. This starts with observations of and listening to the children, followed by a reconnoitring of the possibilities, experimenting and evaluation of the outcomes. The themes for work with the children are developed from the children's interests and motivations.
3. The whole process of children's explorations, thinking, representation and discussions is the focus, not the final product.
4. The 'hundred languages of children' inspires the use of many forms of expression.
5. Documentation – involving the gathering, interpretation and presentation of the children's learning experiences – is an essential element and forms the basis of an exhibition and report.
6. Professional development for all the participants, artists, early years' educators and colleagues from the cultural centres, is an integral part of the project.

Designing the learning contexts

In Reggio Emilia, the word *progettazione* is used to describe the flexible planning which allows the child to make choices. The *progettazione* is a way of describing an approach which develops the contexts of explorations, observations, collecting, researching points of interest/ curiosity, investigations, problematizing, collaborating, supporting the children's thinking. Through these creative interventions, adults focused on extending opportunities and making connections – making meaning (Edwards et al.1998). This approach is in opposition to a 'programme' implying pre-defined curricula and stages.

A global, flexible approach was developed as the work progressed. The learning context was defined by the relationship between the learning group and the documentation – 'that which happened at the intersection of the two'. Observation of points of fascination, struggle, exchange and listening provided tools for flexible analysis. The creative/reflective cycle involved identifying key elements/thinking, hypotheses, analysis and future possibilities with individuals or groups. The stages for each triangle involved identification, investigation, expansion, expression, re-viewing and re-cognizing.

In practice this meant that the themes and interests of the children were identified through observations by both artists and educators, these were then supported by the enabling adults (artists and educators working together) over an extended period. This process may also be defined as an 'emergent curriculum'.

Documentation (observations, photography, actual objects) provided material for reflection, which in most cases took place immediately after every session. As evidence of children's actual ideas, problem-solving and representations, the documentation also provided interest and insight for parents, demonstrated the value of their activities to the children themselves and created a legacy for the future.

Professional development

Professional development was seen as a continuous, reflective, collegial process. We were all learning together about the children's explorations, hypotheses, representations and understandings and about our roles as facilitating enablers.

The starting-point was the initial professional development led by colleagues, including an artist and educators, from SightLines Initiative. Four intensive sessions took place in the term before work with the children began (Fawcett and Hay 2003). These initial sessions were followed by ongoing review sessions at monthly intervals and regular mentor support. Each triangle also engaged in constant dialogue to enable continuous reflection and evaluation, as did all the mentors, coordinator and evaluator.

The role of senior management within the settings supporting the projects was crucial and we also identified the need for professional development for the whole staff team in order to invest in change. In some cases parents and governors also participated in the professional development sessions.

Artists and educators offered children provocations and challenges to create interventions that playfully expanded and added dimension to the focus of interest. The emphasis was on children initiating ideas with artist/educator provocations/creative interventions. This approach developed observant systems that prioritized children's engagement, curiosity, communication, theories, exchanges and learning dispositions.

From the outset we defined a philosophy of freedom within a structure, having a framework and working with the 'spaces in-between'. Certain principles underpinned the project but there was no prescription for approaches or outcomes.

The findings: the effect on the children

Our research into the impact on the children was based on observations, review meetings, semi-structured interviews and reports involving all the educators, artists, representatives of the cultural centres, several parents, mentors, coordinator and evaluator. The intention was to involve all the participants in formative evaluation. Every triangle was very different and each had their own rich story to tell.

All the adults (over twenty individuals) reported enthusiastically on the benefits to the children. Without exception it was deep involvement of the children that struck the artists and educators: 'engagement 100 per cent' (artist). 'We have been very conscious of the children's energy and excitement, their thirst for new experiences' (educator). The evaluator observed all settings and was struck by the intense concentration in every case. An example from a community-run preschool will give the flavour:

> The room was darkened and the eighteen children (3–4 year-olds) were constructing boats and houses from large cardboard boxes with torches as their light source. All manner of other decorative materials were available such as cardboard tubes, pipe-cleaner wires, feathers and beads. The children remained totally engaged for almost two hours. They were supported by several adults: the artist, a colleague from the cultural centre taking video and photographs, the educator and a parent both documenting the children's conversations.

This level of absorbed activity can be attributed to the ethos created by the project. 'The children really enjoyed other people respecting their ideas, giving them freedom and space to explore' (artist). 'They know what they want to do and have their own ideas.' 'The children became less dependent on adults, much more independent' (educator). Since children were encouraged to take initiatives, it followed that they demonstrated their increasing confidence to do things on their own.

Children were also observed by all their educators and the artists to have become more investigative and imaginative. They created fantastic stories in all kinds of situations: through movement, where they went to an 'underwater supermarket'; with projected light, where characters called 'buzz-fingles' were the protagonists; in role play where the story of Beauty and the Beast evolved into 'the four beasts and the father and no child'.

The rich use of language arising from artist/educator provocations and the children's inventions was also noted in their increasing asking of questions. One educator commented: 'the children have become so keen to ask questions – we can't stop them. They want to know, discover.'

All the children enjoyed the construction such as making sculptures with the withies, using overhead projectors and other light sources, shadow puppetry. They learned many new techniques such as using florists' wire, making charcoal.

Even though the children often worked individually, they were part of something larger. 'There's been a lot more cooperation' (educator). 'The children taught each other' (artist). 'They argue and share and solve issues without immediate adult intervention.' 'From a tangle children can sort themselves out – given space – and then through that they develop friendships. They seem to have a lot of respect for one another' (artist). Their negotiating skills and strategies developed over the project and this was noticeable in other parts of their nursery programme. 'They looked to each other more for problem solving, rather than to the adult – talked to each other more' (educator).

As a consequence of their involvement in the project confidence and self-esteem grew – especially among shyer children. This was noted in most settings.

Children came to be seen by others, and themselves, as experts. For example, one child 'became the theatre producer. He was like a conduit for the storytelling. He created an imaginative environment' (artist).

There was initial anxiety that an open-ended emergent curriculum might not achieve the requirements laid down in the Foundation Stage Guidance and in the local educational authority checklists. The contrary proved to be the case and indeed, 'these children have gone a lot further than previous years' (educator). In preparation for an OfSTED inspection, another setting reviewed the project documentation they had gathered and 'realised how much more the children were actually doing, seeing, expressing, playing and thinking about' (mentor). The OfSTED inspector was full of praise after sitting in for a complete session.

In the setting where parents took an active part in the running of the preschool there were glowing reports about the consequences they were observing at home: 'Theo begged to make things and to paint from the moment he wakes up – so I now keep paints and paper ready. After his session on Friday he wanted to and did spend two hours quietly cutting, sticking and painting' (parent).

Obviously at this stage in children's development we are not seeking talented individuals but rather recognizing that all children have the capacity for creative investigation, construction, imagination. We can easily misjudge children's capacities. One artist noted that '[s]everal children were not originally thought of as creative before the project by the teachers or parents, but they proved to be so.'

Creativity seems to emerge from multiple experiences, coupled with a well-supported development of personal resources, including a sense of freedom to venture beyond the known. Creativity seems to express itself though cognitive, affective and imaginative processes. (Malaguzzi 1998)

Among the few concerns which emerged were those associated with the selection of children for the work with the artist: some parents were disappointed that their child was not part of the group. It was essential to focus on a manageable fairly small group for the project's research. However, the approach soon began to permeate the settings and to benefit many more children (see below).

Some artists' perspectives

For all it was a very different experience from anything they had done before – none had previously had the chance for such a long-term project with young children, nor been involved in such an open-ended process. Often, artists feel that they are there to 'make the school look good'. 'As an artist you are usually expected to pull hats out of bags and to have something which is "wow". This was different.'

The 5x5x5 philosophy was in tune with the personal values of all the artists. One said that she was 'overwhelmed, completely empowered and inspired about it – because it is based around freedom, lack of expectation, it's not about me it's about them (the children)'. She was also 'completely convinced that this philosophy should be applied in every context, at home and in early years' settings'.

Several others felt they had learned a great deal about the children and intended in future to work in longer projects where there is a chance to really build relationships. This project had broadened their understanding of this age range: 'I'm now consciously thinking about development and play (when is it play and not play?).' Another commented that a '...creative framework enabled me to think creatively again. I loved the joy of working with the younger children.'

Several recognized the subtlety of the balance between providing provocations and standing back observing and listening. 'The project has given me confidence to work like this. You need to listen as much as talk' (artist). Another said she had learned how to be sensitive about intervention and when to hold back. It was challenging to work in the 5x5x5 way. The contrast between adult-directed 'art work' (e.g. making cards which were all the adults' ideas) and the freedom of the 5x5x5 approach 'really made me think, I became so aware' (artist).

One artist spoke of her experience 'Over the years in many Primary and Secondary Schools the teacher disappears and when they come back they have no idea what has happened. They don't carry on activities when the artist is not there – when they could have.'

Artist–educator collaborations

Everyone appreciated the collegiality of the experience and the varied contributions. 'The artists brought openness, the quality of questioning, their ways of responding to the children'

(educators). As might be expected, the artists brought in all kinds of interesting resources, such as a big box of artists' tools, a bundle of withies, 'treasure trove' items, unusual fabrics, light sources and large boxes. Additionally, the way these were presented was 'aesthetically interesting, the artist used interesting bowls and boxes' (educator). The artists' knowledge of the potential of materials, for example florists' wire and how to make things – actually making charcoal with sticks and a fire – were exciting new possibilities. The drama and movement artists contributed their own special perspectives and ways of thinking. An educator commented 'I benefited from watching another person's ideas as a truly creative person (not just concerned with 3–4 year-olds' art).'

Among the benefits were the different ways of thinking, provoking and asking questions. 'There's been a merging, picking up skills from each other' (educator). 'Our dialogues were a way of reflecting, they were easy and useful' (educator and artist together).

The power of the reflective and dynamic debates between the artists and the educators has been so rewarding that all intend to continue the approach.

Collaboration with the cultural centre
There was also the third arm of the triangle: collaboration with the cultural centre. This was a unique element and each triangle was completely different. The cultural centres included Theatre Royal, Royal Photographic Society, Michael Tippett Centre, University of Bath Creative Arts Department and the Hotbath Gallery. There were no prescribed requirements from these centres – the project was open-ended; each became involved and contributed what they were able to. Much depended on the pressures within the workplace and the opportunity for flexibility of the staff there. With older children, such centres might well be used as a site for learning, but with the long-term creative development of 3–6-year-olds and their everyday early years' settings as our goal, the contributions were of a different kind. Two brief case studies will demonstrate the possibilities of such collaborations.

Hotbath Gallery with Acorns
Staff from the Hotbath Gallery were able to take part every week in the session. They took video film and digital images throughout the morning (guided by nods and gestures from the artist and the educator). 'The more eyes and ears the better!' (gallery staff). They also stayed on for the reflection period – at least another hour. This very tangible support from the gallery was especially important for this triangle – for both the artist and the educator. 'We couldn't have done it without them' (artist).

For all the adults there was delight in the fascination of the children's developing creativity – 'the children blossomed', and 'quiet children became leaders' (gallery staff). The setting took up the offer of a visit to the gallery in the sixth week. During the visit the children had the opportunity to experience the exhibition – hands on. Then they had their own workshop and their creations were put on display alongside the rest of the exhibition. This visit was 'an eye-opener' (gallery staff). 'It opened up possibilities and ideas of what we could offer in this space.' Additionally,

technicians made a shadow screen and equipment, such as an overhead projector, was made available to the educational setting.

University of Bath Creative Arts and the Kinder Garden

The contribution of Creative Arts Department at the University of Bath was also generous and interesting. The visual arts coordinator became a strong member of the triangle. He made possible the use of the Walcot Chapel exhibition space for a separate exhibition, and working towards this was a learning opportunity. His interest in how one can represent process and involvement in discussions to that end were very helpful, both practically and philosophically. His 'fresh eye' and his role as a supportive and critical friend helped the staff improve their skills in 'making learning visible'. The setting very much valued the opportunity to present children's enquiries and work in a professional exhibition setting which was respectful and not presenting the material as 'cute art'. 'The professional level of the exhibition gives weight to the importance of the children's learning and experience' (educator).

The impact on the educators and the settings

In four settings, the impact of 5 x 5 x 5 was profound and significant changes affecting the whole school and nursery are being embedded. The most important element was the use of time: understanding of the value of unbroken stretches deepened, rather than the fragmented apportioning of 30 minutes for this and 10 minutes for that. Timetables were revised. The selection and use of materials also changed, with priority being given to raw materials (large cardboard boxes, sticks, large sheets of paper, different mark-making tools) rather than commercial plastic toys. Some were able to rethink their use of space, creating less-structured, open and flexible possibilities.

There was a change in the adults' priorities. They observed much more, listening carefully, thinking deeply and critically about if, when, and how to intervene. Much of the detailed planning (which in practice might never happen) was replaced by an emergent curriculum.

Many of the adults read and studied literature (especially from Reggio Children) in ways that they had not done before. Their confidence was increased by their well-informed practice and understanding. In one setting, the focus on a new building was an important element, but we also discovered the importance of the full involvement of all members of staff (not just one) and the need for designated times for reflection and evaluation.

At the time of writing it seems clear that the long-term sustainability of this approach is safe. In four settings, the artists have embarked on fellowships that allow their work to continue for two more years. The two schools are planning professional development and re-organizing play provision and timetables. The two nurseries are ensuring that all children are encountering the ethos and that all staff are learning about the values and principles.

Further details of the findings will be found in the Report (Fawcett and Hay 2003).

Conclusions

Over the last year, while 5x5x5 has been taking place, we have experienced the intense absorption, concentration, delight and creative representations of the young children. The depth of engagement and increasing understanding of all the adults, too, has been remarkable. The project has the potential to build foundations for the future and change both children's and adults' behaviours. We know that our approach to learning develops all the participants' knowledge, self-esteem, communication skills and emotional health. The project is about investing in artists and educators – the impact of the professional development will have far-reaching effects on artists and educators for the future of children's learning.

All the adults, through their experimental practice, their close scrutiny of the children's exploration, representation, imagination, and their discussions at all levels, have become a 'creative learning community'. This represents a dynamic, powerful support system and helps sustain commitment and progress.

Nevertheless, the approach has been challenging and several issues at the heart of the project should be addressed in any future projects:

- Professional development permeates the project and should be attended by all the participants. This is not 'training' in a didactic style, but closer to the 'pedagogy of listening' (Rinaldi in Giudici et al. 2001). All the participants are seen as reflective researchers, documenting and evaluating their own practice. On a practical level this has implications for staffing arrangements in educational settings. Time, and supply cover, are necessary to ensure that all the members are 'in tune' with the philosophy and principles. Without this there may be tensions and problems.
- Documentation is at the heart of this approach. It enables educators and artists to focus on children's thinking, it informs the children and their parents; it guides planning and enables assessment. Documentation is time-consuming and requires practice to develop the necessary skills; however, with support it does become manageable.
- Mentors, who supported each other through regular contact, were found to be essential. This role will be examined in greater depth in the second year.
- The educator working with the project must have clear support from senior management.
- In preparing for the project, settings need to work out designated time and space.
- A weekly session (a half-day) for a term seemed to be a good length and frequency for the involvement of an artist.
- A focus group of children needs to be selected (or allowed to evolve), but numbers must be limited – the impact will spread across the rest of the group.

The future

We now wish to develop our research further and move to a heightened research level that will involve our current 'team', as well as others, in deepening, connecting and exchanging their learning in a wider context. The emphasis will continue to be on creative and reflective practice with professional collaboration between artists, educators and cultural centres. The project has

proved to be an excellent model of practice that places the child at the heart of the creative learning process. The underpinning philosophy of 5 x 5 x 5 is an extremely important element in the project: it is about respecting children's ideas, making learning visible and harnessing the curiosity, creativity and energy of adults and children.

In particular, as the project evolves, artists and educators will explore various lines of enquiry, among them the practical aspects of documentation, a core element; children's developing schemas; the role of the mentor; and the concept of learning dispositions.

SightLines Initiative will continue to act as adviser to the project, providing support, ideas and resources. The establishment of the Bath/Bristol ReFocus group – a satellite learning group affiliated to the national network of ReFocus groups coordinated by SightLines Initiative – will lead to closer collaboration with other similar research projects across the UK.

Our aims for the future are:
- To develop reflective, creative early years' work locally, and encourage it regionally, building a 'critical mass' of artists and educators involved in a 5 x 5 x 5 ReFocus group.
- To establish effective models for professional development and advocacy.
- To document, evaluate and disseminate this research and actively contribute to a growing body of practice.

Our vision is that all participants in this 'creative learning community' will share principles and values based on the philosophy of children as competent and creative learners, articulated so well by the approach in Reggio Emilia. We hope that the process of this research will challenge and inspire participants to provide high standards of creative education for their children.

Acknowledgements
The project, based in Bath and North East Somerset, was managed by the Arts Development Team, supported by the Early Years Development and Childcare Partnership, and made possible through substantial funding from NESTA (National Foundation for Science, Technology and the Arts) and additionally from Bath and North East Somerset Council and Arts Council England (South West).

Notes
1. Making Art Work (2000–1) was an action research project initiated by Bath and North East Somerset Arts Development Team in collaboration with Bath Area Network for Artists (BANA). The project aimed to establish the nature of support needed for schools to assist them in improving the quality and quantity of their arts education work. In this context, arts education refers to the use by schools of professional artists and arts organizations to help deliver the whole curriculum. The project examined the interface between artists, arts organizations and schools. The project aimed to reinvigorate arts education in Bath and North East Somerset by renewing teachers' interest, skills and confidence in the arts. For the Report and further information contact Bath and North East Arts Development, 16A Broad Street, Bath BA1 5LJ; Tel: 01225 396425;

2. Creative Foundation is a three-year practice and research group set up in 2001 by SightLines Initiative. It involves eight early years' settings working with collaboratively with artists and with each other forming 'an observable community of creative, reflective, early childhood work'. Further information from Robin Duckett, SightLines Initiative, 20 Great North Road, Newcastle upon Tyne NE2 4PS; Tel: 0191 261 7666; e-mail: info@sightlines- initiative.com

3. Personal communication from Robin Duckett Director of Creative Foundation from his Guidance Notes for Artists. See http://www.sightlines-initiative.com for more details about the Creative Foundation project.

4. SightLines Initiative, founded in 1995 by Robin Duckett, is a charitable trust and is the UK reference point for the international Reggio Children network. Sightlines advocates and develops a creative approach to learning through the development of artist/educator projects which are responsive and reflective, encouraging children to think and act creatively within a supportive setting.

References

Fawcett, M. (2002) 'Creativity in the Early Years: Children as Authors and Inventors', *Early Education Journal,* No. 38.

Craft, A. (2003) 'Creative Thinking in the Early Years of Education', *Early Years,* Vol 23, No. 2, pp. 143–54.

Duffy, B. (1998) *Supporting Creativity and Imagination in the Early Years,* Buckingham: Open University Press.

Edwards, C., Gandini, L. and Forman, G. (eds.) (1998) *The Hundred Languages of Children: The Reggio Emilia Approach – Advanced Reflections,* Greenwich, Connecticut: Ablex Publishing Company

Fawcett, M. and Hay, P. (2003) *5x5x5 = Creativity in the Early Years,* Bath: Bath and North East Somerset Arts Development Unit.

Gardner, H. (1983) *Frames of Mind: The Theory of Multiple Intelligences,* New York: Basic Books.

C. Giudici, C. Rinaldi and M. Krechevsky (eds.) (2001) *Making Learning Visible: Children as Individual and Group Learners,* Cambridge MA, Harvard, Project Zero and Reggio Emilia: Reggio Children.

Malaguzzi, L. (1998) in C. Edwards, L. Gandini, and G. Forman (eds.) *The Hundred Languages of Children: The Reggio Emilia Approach – Advanced Reflections,* Greenwich, Connecticut: Ablex Publishing Company.

National Advisory Committee on Creativity and Cultural Education (NACCCE) (1999) *All Our Futures: Creativity, Culture and Education,* London: Department for Education and Employment and Department for Culture, Media and Sport.

Qualifications and Curriculum Authority (QCA) and Department for Education and Employment (DfEE) (2000) *Curriculum Guidance for the Foundation Stage.* London HMSO.

Reggio Children (1996) *The Hundred Languages of Children Exhibition Catalogue,* (available from SightLines Initiative).

Rinaldi, C. (1998) 'The Thought that Sustains Educational Action', *Rechild,* April. (See www.sightlines-initiative.com ReFocus collection of articles).

Postscript

Since the publication of this chapter **5x5x5=creativity** has evolved to become an independent charitable organization, supported in this process by the Esmée Fairbairn Foundation. The Board of

Directors supporting the project is representative of several universities, with the previous Director of Education in the chair and colleagues from arts organizations and national educational bodies. Our patrons include Richard Wentworth, Professor Anna Craft, Sir Christopher Frayling and Professor Iram Siraj-Blatchford.

The ongoing research has gained a national reputation for quality and innovation, evident in the increasing number of citations in government policy documents and related research. Over eight years, $5 \times 5 \times 5$ = creativity has worked with 70 educational settings in six local authorities, engaging thousands of children and many parents. Although our work has close connections with the principles of the new *Early Years Foundation Stage*, our name has changed from $5 \times 5 \times 5$ = creativity in the early years to $5 \times 5 \times 5$ = creativity, since the research work has broadened its reach across primary schools.

The cross disciplinary artist's team has formed AND (Artists Network Development) leading integrated professional development as a vital part of the research. Every year an evaluation report has been published together with an exhibition of learning stories (all available from www.5x5x5creativity.org.uk). In 2006 we published a DVD, *A Hundred Voices*, which won a national award in 2007 – the TACTYC (Training, Advancement, and Co-operation in Teaching Young Children) Award for a Creative learning Journey. In 2008 a substantial book, edited by Bancroft, S., Fawcett, M and Hay, P; *Researching Children Researching the World: $5 \times 5 \times 5$ = creativity* was published by Trentham Books.

Our learning journey over the past decade has been full of amazing moments, beyond our expectations. $5 \times 5 \times 5$ has been an open-ended adventure, maintaining great respect for the infinite capacity of children's imagination and creativity. The research team revisits and reviews particular recurring themes and questions, theories and fascinations to understand learning more profoundly and offer new possibilities to others.

$5 \times 5 \times 5$ = creativity is a visionary, ground-breaking project which demonstrates the depth of learning fostered through exquisitely sensitive creative partnership. Children and adults involved in $5 \times 5 \times 5$ are sowing seeds of systemic change in our education system, well beyond early years and primary, into secondary, further and higher education phases. (Dame Tamsyn Imison, education strategist)

$5 \times 5 \times 5$ is a research process designed to deepen thinking, challenge perception and stimulate change. $5 \times 5 \times 5$ is exploring exciting ways in which the creative and cultural community can be involved in meaningful learning with children and their families.

Looking to the future, the hope is to ensure that children and young people who have been involved with $5 \times 5 \times 5$ = creativity will be more confident and creative thinkers; they will be more successful in their individual achievements in all aspects of their lives.

Penny Hay 2008

Reference

Bancroft, S., Fawcett, M and Hay, P; *Researching Children Researching the World: $5 \times 5 \times 5$ = creativity*, Stirling, VA: Trentham Books.

17

Tuition or Intuition? Making Sketchbooks with a Group of Ten-Year-Old Children

Gillian Robinson

Vol 12, No 1, 1993

> Teaching art...the words sound wrong somehow, like 'baking ices', 'polishing mud', or 'sliced lemonade'...(Roger Fry 1919: 887)

Introduction

This chapter addresses the aesthetic theories of Roger Fry and investigates their significance for art education in the primary school (Robinson 1989). Roger Fry was, at the turn of the nineteenth century, established as an authority on classical Renaissance art. In 1910 he risked his reputation as a prominent art critic by championing the Post-Impressionist painters in his controversial exhibition of their work at the Grafton Gallery. The thinking which accompanied this change of emphasis had repercussions in the field of art education, and continues to have great significance, particularly now in view of the constraints placed upon art educators by the requirements of the National Curriculum.

Fry's recognition of the significance of 'primitive' art, which gave rise to his theories of modern art, in turn influenced his views concerning the value of children's *art* and consequently his beliefs regarding the teaching of art. Of these ideas, perhaps the most pertinent was his belief in the quality of children's personal vision. In recognizing the importance of a child's personal vision, one is brought to consider, as was Fry (1910), whether or not art education impedes certain aspects of the development of children's drawing, whether there is a causal relationship

between art teaching and the dwindling powers of originality, and subsequently to question whether drawing can be taught.

Fry came to the conclusion that the more 'art teachers', the less 'art'. His reasons for making such an uncompromising statement were that he believed the essence of art was 'the discovery by the would-be artist of something that never existed before in the whole history of the world', an 'unknown quantity'. Therefore, he argued, if it is cardinal that art derives from the mind of the artist and fundamentally concerns the 'personal vision' of the artist, then it cannot be taught. This 'unknown thing', Fry maintains, cannot be handed over, for it is 'the reaction of the individual with all his emotional and sensual idiosyncrasies of vision' (Fry 1919). In fact, Fry adds, not only is it impossible to teach art but the act of teaching it can be distinctly antagonistic to the genesis of art by creating a situation in which it is difficult for the artist (here Fry is referring to the child) to be himself, to retain 'under immense compulsion of his surroundings the conviction of the value and importance of his own personal reaction'.

Fry argues that since art education is about 'the full development of sensibility which is peculiar to each individual', and therefore since its whole value depends on that 'unique individual quality', it consequently seems rather futile to teach a child to draw, on consideration of the fact that 'it alone of all created beings can draw' (Fry 1917–1919).

Fry, critical of the art practices of his day,[1] offered an alternative theory of art teaching; a theory of personal vision. One may justifiably question the validity of Fry's suggestion of an alternative method of art education when he had already stated his belief that art cannot be taught, but his proposition was an art education in which children could be encouraged to sustain and celebrate their individuality. Malcolm Ross endorsed this when he wrote that in education we look, above all, for the presence and power of a personal vision (Ross 1984).

As it is my contention that Fry was speaking ahead of his time, the purpose throughout my research has been to adapt Fry's theories and offer them to children in practical activities, and through discussion and questionnaires. Here, I intend to focus on the part of my research in which a group of sixteen 10-year-old children were invited to 'sustain and celebrate their individuality' by making and using sketchbooks.

Session 1: Introducing and making sketchbooks

As a sketchbook is used by artists, often as a means of recording ideas relating to personal vision, I discussed with the children the possibility of making and using a sketchbook of their own. This proposal generated much excitement, and some disbelief at the suggestion that in a sketchbook one was able to draw anything you liked, when you liked. They found it difficult to believe that sketchbooks could be kept in their possession, carried around, taken home, and brought back to school. They were also amazed that I would not demand to see what was drawn in them, but that they would be welcome to show me if they wished. The sketchbooks were for their own ideas, their personal vision. These enthusiastic reactions were pleasing but at the same time they were a sad indication of the extent to which we as teachers structure and

Figure 1: Various materials were provided.

restrict children's art-making activities and, immediately they are finished, claim the results for the wall. Various materials were provided (Fig. 1); some chose to marble paper for the cover, others preferred to use plain paper and design it later. They could not wait to get started – it was almost as if they had been given a present (Fig. 2).

Figure 2: They could not wait to get started.

Session 2: Early responses and results

In the next session the children returned with their sketchbooks and were offered (1) the opportunity to appreciate each other's sketchbooks and show them to me if they wanted to (they were keen to do both); and (2) time and space in which to work in their sketchbooks or design their cover if it was not already completed.

Children regularly visited the classroom in order to show me their latest additions. Some of the children in the group filled their sketchbooks quite quickly, with seemingly no shortage of ideas. They asked to be allowed time and materials to make another. As time went on, themes began to emerge – a salutary reminder that we rather frequently aim for a single session performance, with no development or continuity, whereas the sketchbooks enabled the children to follow through themes of their own choosing.

Cartoon-like drawings were popular, but even these showed evidence of individual approaches. For example, although William and Steven were both interested in cartoons, each had a very different *modus operandi*. Steven drew a single item to fill each page, often a head, using a thick pencil (Fig. 3), whereas William, after four crayoned drawings, developed an expressive broken line using ink (Fig. 4). He was so excited that he was able to draw what interested him, and was so pleased with the success of his sketchbook, that his confidence in his own ability increased. As a result, his attitude and approach to his school work generally showed a marked improvement.

Louise began her sketchbook with a drawing of a face, some lettering and miscellaneous small images in crayon. Suddenly she decided to use watercolour, and in a short space of time she produced nine abstract and colourful paintings (of which Fig. 5 is an example), which both pleased and surprised her.

Figure 3: Steven drew a single item to fill each page, using a thin pencil.

Figure 4: William developed an expressive broken line using ink.

An individual and personal approach was most evident in Bianca's sketchbook. Bianca made four drawings in her first sketchbook: two in pencil (a mouse and a horse's head), one in felt tip pen (an ice cream), and one in wax crayon (a rainbow), within the space of three days. She then drew an imaginative underwater picture in pencil, followed by two double page drawings using a similar linear style and corresponding theme. Both were drawn on the same day. Two more drawings followed two days later. A week later she made five further drawings, all in the same day, and four the following day. Five days later she drew two pictures with the same directness, using recurring dragon-like images (Figs 6 and 7).

A page of animals broke into the sequence, less linear, and shaded, followed by a self-portrait. Then she reverted to the original fantasy image for one page. The next page was a complete departure from the theme which she had developed, being what appeared to be a drawing of an artist (possibly herself) and model, with an abstract drawing in progress on the easel and four more finished works on the floor of the studio. This picture is, in my opinion, remarkable in its subject matter, complexity, quality of line and confident execution (Fig. 8). On the facing

Figure 5: Louise produced a series of nine abstract and colourful watercolour drawings.

Figure 6: Using recurring dragon-like images.

Figure 7: Using recurring dragon-like images.

page, incongruously placed, were two eyes of dissimilar size, one below the other, and a mouth adjacent to a profile without a chin – a collection of disjointed images which nevertheless combine to make a cogent composition (Fig. 9).

Three figures, part mermaid, part figurehead, completed the sketchbook in a flurry of flowing tails and hair (Fig. 10). Bianca then asked to be allowed to make a second sketchbook and left drawings on my desk as gifts or for my comment. Her mind was full of images and she was impatient to release them (Fig. 11). For Bianca a sketchbook was like an open door to another world.

Figure 8: A drawing of an artist (possibly herself) and model.

Figure 9: Disjointed images which nevertheless combined to make a cogent composition.

Figure 10: Three figures, part mermaid, part figurehead, completed the sketchbook in a flurry of flowing tails and hair.

Figure 11: Her mind was full of images and she was impatient to release them.

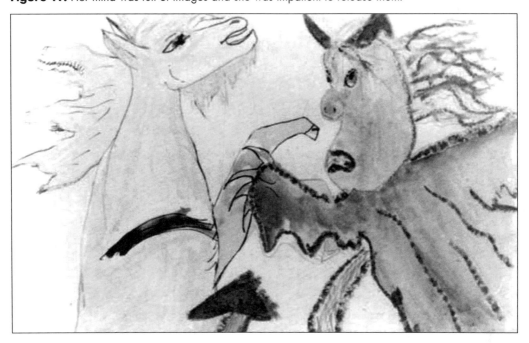

Session 3: Looking at artists' sketchbooks

The objective of this session was to extend the notions of sketchbooks by looking at, and discussing, the work of some artists. Sketchbooks by Paul Klee, Cezanne, Henry Moore, Pablo Picasso and Turner were all available in facsimile editions.

We also looked at an original sketchbook dated 1907 which had belonged to an art student. We discussed individual styles and themes in the sketchbooks and then the children took them to look at individually or in a group. Through this activity the children became aware that artists have a very compelling personal vision which is manifest in their work.

Session 4: Evaluation

It seemed an appropriate moment to give the children in the group an opportunity to indicate their opinions about having a sketchbook. On a sheet of paper they were given two questions. The first was:

1. Someone said of Turner's sketchbook 'In his sketchbook he is completely himself'. Is this true of your sketchbook?

Responding to this, four children from within the group of sixteen replied that in their opinion they were not completely themselves when they were drawing in their sketchbooks because they used other people's ideas or copied other people's art, 'because most or my drawings are copies', 'because I copy other artists' work sometimes to get ideas'. Seven of the group considered that much of their work was spontaneously their own, although they 'sometimes look at other people's work to get an idea' or take the idea 'but using my different idea as well, putting in my own style and details'.

Louise, who had suddenly become aware that she had images in her own mind which she could use to produce the abstract watercolours in her sketchbook, commented:

> I quite enjoy copying other people's work or getting ideas from other people's work although now I am using more of my ideas.

Six members of the group, however, were sure that in their sketchbook they were able to be themselves: to 'make up' other pictures, 'imagine things' and get on with their own ideas.

Two gave more detailed reasons. Bianca cited the dragon image, which she drew repeatedly, as being the result of a freedom to be herself in her sketchbook. Joanne, who obviously understood both herself and the question, replied succinctly that she was completely herself in her sketchbook because most of her drawings were

> ... soft and gentle with an occasional touch of madness.

In reply to the second question concerning sketchbooks, which was simply:

2. Have you enjoyed having a sketchbook?

All sixteen replied in the affirmative. Various reasons were given. Half the group gave as their reason the availability of the sketchbook, enabling them to draw in it whenever they liked:

> ...because I absolutely adore sketching and I do get bored at playtime during school, so it's nice to have a small sketchbook handy.

William said:

> It is good fun and you can get things from your mind out on to the paper.

Others in the group appreciated the personal and individual aspects of a sketchbook:

> ...because you can get all your ideas out on paper. I quite like drawing abstract drawings.

> It's good fun to draw in your own personal book. When you draw on paper everyone can get to see it.

> Because I like drawing to express some of my deepest feelings.

Two children mentioned specifically their own personal recurrent image or style, which they had discovered and developed through their sketchbook. For example, Louise wrote of her discovering enjoyment in abstract drawings, while Claire enjoyed having a sketchbook simply because it meant that she had got a record of her drawings. The sketchbooks were a very good indication of children's impulse to draw and an effective way of nurturing a child's personal vision.

Session 5: Discussion and questionnaire

The questionnaire was based on Fry's theories concerning the teaching of art. A lively discussion preceded written responses. The first question referred to the belief which Fry expressed when he wrote in the *Burlington Magazine* (August 1917): 'I cannot doubt that if children were stimulated to create instead of being inhibited by instruction we should no longer need to complain as we do today of the want of creative imagination.'

From this the children were asked which of the following best stimulated them to paint or draw:

1. Seeing another artist's work;
2. Discussion prior to starting a picture;
3. Being left alone, closing one's eyes and picturing in your mind;
4. Any other inspiration for drawing which they liked to one's mind; or suggest as being effective.

In their initial discussion, and then in their written replies, the children's priority was solitude. Seventeen out of the nineteen replies included 'being left alone'. In discussion Lee said:

> I like being left alone. It's always quiet and there's no noise so you can think properly.

Bianca and several others also thought that 'closing your eyes and getting a picture in your mind like those imagination pictures (mind pictures)', creates the embryo of a drawing. In a classroom full of children where it is difficult to be alone, encouraging children to become detached by closing their eyes and mind picturing[2] allows them space to evoke their personal vision. One child described the situation thus:

> I like being left alone because then I can think about lots of things but sometimes I can just shut myself off and everybody around me is making lots of noise and I take no notice.

For most of the children the only stimulus to create that was needed was the opportunity to focus on their own ideas, described as

> being left alone and then closing my eyes and picturing something in my mind and then drawing it.

I asked Bianca in discussion why she preferred a combination of being taught skills and techniques, and being left alone on her own. She replied:

> Because, say like you're drawing, and you don't know exactly how to do this, you go up to your teacher and the teacher explains it and you go away and continue.

Kirsty said:

> I don't think it's a good idea to be told what to do, because when I start to draw I have a faint idea of what I'm drawing but then I just start building it up.

So even, in this situation, where inspiration might not be immediately apparent, children prefer freedom of ideas to instruction. Another question pertinent to this chapter, was: Do you have a personal vision of your own art?

In discussion some children gave their ideas concerning their personal vision in respect of what they preferred to draw: 'cartoons', 'actual things instead of just blobs all over the place', 'dragons and animals and horses'. In the written replies, their personal vision still involved the subject matter of the picture but described in more detail. For example:

> Yes, my own 'personal vision' is to really get into the art of figure drawing, especially in movement...

But in addition other ideas began to emerge, such as the way in which they drew:

> I like doing pencil drawing because you can get all kinds of different shades.

Each comment indicated an individual and personal approach. The following two remarks concerning the value of individual ideas, both to the artist (in this case the child) and to the viewer, were unexpected:

> I see my art as something I will be proud of. In my mind's eye I think that my art is good, even though other people don't think so.

That comment could appropriately have been made by Fry as he watched people's reactions to his first Post-Impressionist exhibition. It is just one of the problems faced by people with personal vision. If I had ever doubted children's artistic impulse or their ability to recognize it and express it, my doubts now foundered on the rock of their conviction for, reaffirming Fry's belief that children do have a personal vision, they wrote their sincere testimonies:

> My art is an imaginative art, forming on to the paper before me … My drawings are bright reds, oranges and bright colours. I like drawing mind pictures. I can switch off and be in my own world and draw things from that world in my mind. The existence of shape, movement and dreams of action is there to please only me! Though first seen in my mind, in flames of colour, now seen to eye in black and white. My art seems to flow from me, like waves on the shore, like a waterfall in the desert.

The teacher's dilemma is: cultivation or inhibition? With Bianca's urgent cry ringing in our ears, we return to Fry's proposed alternative approach to art education, the leitmotif of this chapter. We cannot deny that, as Fry suggested, the teacher has a very prominent, yet sensitive, role to play in the stimulation of creative powers in art education. It is a role which demands insight and energy. There is indeed a need for a relaxed and controlled atmosphere in which children are free to evoke their inner vision. Appropriate information, reference, visual stimulus and materials should be available so that the children are stimulated to create in response to their inner vision and can thus fulfil their impulse to draw. Above all, each child's distinctive response should be respected and their individuality celebrated, for, in the words of Marion Richardson: ' … these mental images may die, like empty day-dreams, or live as joyful expression' (1948).

This paper was first presented at the NSEAD conference 'Drawing Art and Development: British Museum, July 1989.

Notes

1. For a description of art education at the turn of the nineteenth century see S. Macdonald (1970) *The History and Philosophy of Art Education*, London, LUP. See also A. Dyson, (ed.) (1989) *Looking, Making and Learning*, Bedford Way Series, Institute of Education, University of London; Chapter 2.

2. The children in the group had, earlier in the research, been invited to paint 'mind pictures' based on the practices of Marion Richardson. That children have personal vision was a belief shared by both Fry and Richardson (see Robinson 1989).

References

Dyson, A. (ed.) (1989) *Looking, Making and Learning,* Bedford Way Series, Institute of Education, University of London.

Fry, R. (1910) *Manet and the Post Impressionists,* Catalogue Essay for Exhibition at the Grafton Gallery November 1910.

Fry, R. (1917–1919) 'Children's drawings', Fry Papers, Kings College Library, Cambridge, FP 4/1.

Fry, R. (1919) 'Teaching Art', *The Athenaeum,* 12 September, p. 887.

Macdonald, S. (1970) *The History and Philosophy of Art Education,* London: LUP.

Richardson, M. (1948) *Art and the Child,* London: LUP.

Robinson, G. (1989) The Aesthetic Theories of Roger Fry: Their Significance for Art Education in the Primary School., Unpublished PhD.

Ross, M. (1984) *The Aesthetic Impulse,* Oxford: Pergamon Press.

Postscript

Although this chapter was written some time ago the key issue of the perceived polarity between the nurturing of the individual 'artist' and the 'teaching' of art, is on-going. The purpose and effectiveness of sketchbooks in the primary classroom in relation to the above is also a continuing relevant topic for discussion.

Roger Fry argued that every child is an artist with his own 'vision', described by Fry as the 'unknown thing' which cannot be taught and can also be easily destroyed. I would stand by the conclusion which is arrived at in this chapter, that, if it is cardinal that art derives from the mind of the artist and fundamentally concerns the 'personal vision' of the artist, it cannot be taught and should be nurtured. However, the nurturing process involves more than standing back and marvelling; it includes providing a rich learning environment in which there is much to discover. The two paradigms are not necessarily mutually exclusive. They can be reconciled.

Using sketchbooks in the classroom is one way of achieving this reconciliation as their use can develop a 'sketchbook attitude' which enables children to think and see for themselves. It fosters what Fry described as 'the reaction of the individual with all his emotional and sensual idiosyncrasies of vision', but with informed understanding

Since the advent of the Art National Curriculum in England in 1992, sketchbooks have become established in many primary schools. Where the process has been understood by the teacher, sketchbooks are used as a place to explore and reflect, offering an arena for generating ideas. Children can arrive at creative solutions through knowledge of the work of others whilst still retaining their own voice. The use of sketchbooks can play a vital role in nurturing informed creative minds in possession of what Fry described as a 'full development of sensibility which is peculiar to each individual'. Working in this way intuition can continue to play an important role alongside tuition.

Gillian Robinson, 2008

18

An Art Enrichment Project for Eight to Ten-Year-Olds in the Ordinary Classroom

Angela Martin

Vol 17, No 2, 1998

Background to the research

The original research took the form of three separate action research art projects in an ordinary primary school in November 1995. I had a strong interest in the visual arts, having completed several years of full-time art training, as well as qualifying as a primary teacher. I knew from looking at the results of short-timed art lessons that there was a lot of talent bubbling below the surface that was not being given the chance to develop. In normal art lessons teachers generally complained that by the time the children had started a piece of work it was almost time to clear away. The short curriculum time-bites did not help the emergence of artistic talent. Children tended to fall back on stereotyped images because they were always aware of the ever-pressing time limit and wanted to finish their work. I was sure that, given the right workshop atmosphere, exciting media and enough time to develop ideas and a creative response, they would surprise everyone. I wanted to provide the venue for talent to surface and at the same time provide known talented children with opportunities to analyse, evaluate and go on improving their work. I spent two days at a time working through an intensive art-enrichment programme alongside three class teachers in their own classes. I was fortunate in having a capable final year teaching student to take my own class when I needed to be released for this.

Figure 1: Colouring sheets for warm-up activity.

This is the story of just one of these projects in detail – a design project for 8–10 year-olds. However, I will refer to the results from the data for all three projects in order to give the reader a fuller picture of the impact of art enrichment on a school. The design project was planned for a mixed-age class of thirty children where half were studying the Egyptians in History. The art work provided opportunities to use Egyptian and modern design while designing and painting large decorative pots. The specific art enrichment activities provided opportunities for children to analyse and change their work through a series of paintings and three dimensional work.

Purpose of the research

The research was set up to benefit teachers, children and the school community as a whole. Teachers were encouraged to look at art teaching afresh, unaccompanied by feelings of inadequacy and the idea that there was only one correct way to teach art. Recent OfSTED findings (1996) confirm that much of the poor confidence teachers suffer teaching art can be traced back to lack of expert advice. In the project, teachers were able to see their own children succeeding with and enjoying the tasks. Guskey (1986) noted that teachers' own interest in a particular teaching method was triggered by seeing their pupils improve their performance. Children benefited because they were able to develop individual work and meet challenges in a supportive, secure environment where teaching was targeted to individual need. Seefeldt (1995), looking at the astounding quality of children's work in Reggio Emilia in Italy, noted the importance of carefully-planned teaching intervention in an atmosphere of motivation and security. The time available allowed teachers to help children evaluate their own and others' work and develop creative ideas through having the time to complete a creative process. Parents benefited from seeing their children's creative products displayed around the school for the school community to appreciate. Cullingford (1985) reporting on a survey in 1983, found that parents expected their children's talents to emerge in school and thought that school would make a crucial difference. More specifically, the research was set up to find out whether art enrichment could meet the needs of the artistically gifted, uncover new talent and ultimately affect all children's learning. The research also needed to prove that working alongside teachers helped fulfil a training need and that action research as a methodology provided a means to initiate positive change.

Research design and methodology

The content of the programme was planned, with teachers linking the art work to elements of the history national curriculum. This was done in order to avoid a bolt-on effect and root the art teaching firmly in other areas of study. The planning was never entirely fixed because creative teaching involved keeping an open mind and risk-taking. This mirrored the creative process itself, where ideas had time to 'incubate' and change. The planning involved two levels of art provision. The enrichment activities were designed around an exciting range of media in order to improve drawing, painting and problem-solving ability. These were large decorative pots painted on paper with a mixture of paint, wax crayons, pastels and felt tips. An element of this design was then isolated using a card window and then enlarged into a new design and transferred onto a white hardboard surface and painted. This was later varnished. Enlargements of parts of the original design were also made into three-dimensional pictures using corks and card. The corks lifted up parts of the design to give it a different focus and appearance. For those not doing the enrichment activities, general art activities were also available, using varied media. These included a warm-up activity where colouring sheets of modern and Egyptian pots were available to colour. Small pots were painted or made into collages using feathers, ribbon, pasta shells, sequins and gold paint. Three-dimensional viewing tunnels were made, using a card stand, sheets of card and decorated with pastels.

The teaching involved preparing examples of large pots that I painted beforehand showing Egyptian and modern designs, and mounting them on the walls together with a wheel showing the Egyptian colour system. This created an environment that was different from the children's 'normal' classroom. Abstract paintings, including works of Mondrian and Klee, and pictures of modern glassware, were used to emphasize modern design. I demonstrated ways of designing within a pot outline using a range of media paint, charcoal, felt tips and wax crayons. I did this in front of the whole class group in order to model how to produce patterns that were alive and unexpected. It was necessary to demonstrate the combination and potential of these materials because using them together was outside all the children's everyday experience. When children

Figure 2: Collages.

Figure 3: The viewing tunnel.

were enlarging and developing their original paintings into three-dimensional pictures, I demonstrated techniques and problem-solving strategies; 'thinking aloud' in front of the class. Children were encouraged to work through breaktimes, and take breaks when they needed to by looking through art magazines and books or taking part in a less demanding art activity. This freedom was important in developing commitment to their work and allowing ideas to develop, and supported the four stages of the creative process (Wallas 1926). These stages are preparation, incubation, illumination and verification. Preparation is the stage where materials and initial ideas are gathered together; incubation is when these ideas re-arrange at a subconscious level; illumination is when a solution is seen; and verification is the working through of that solution in a practical way.

Rigid time schedules tend to be incompatible with originality; a poem, sculpture, woodcut or story require unpredictable periods of work often with time out intervals interspersed

Figure 4: Use of the card window.

with periods of intense involvement. Thus the traditional art period or craft hour tend to inhibit the testing dreaming and planning phases essential to unique and creative output. (Hauck and Freehill, 1972: 133)

Although the research design provided for all children to attempt the enrichment activities if they felt drawn to them, some children were initially chosen to form an enrichment group. These were individuals who in the opinion of their teachers showed one or more characteristics taken from Renzulli's three-ring conception of giftedness, (Renzulli et al.1981) which include above average ability, task-commitment and creativity. These children were encouraged to take up the challenges that the enrichment tasks presented and worked alongside other less able children providing an important model for their work. Research by Holt (1983) and Leonard and Thompson (1994) suggests that peer modelling can be a factor in children building up a conceptual model for their own drawings. Other important elements of the research design included displaying work throughout the school as soon as it had been completed, in order to confirm that criteria for the production of creative products had been met in some of the work. Data, in the form of interviews and impromptu taped comments from eight teachers, thirty children, the headteacher, students, secretarial staff and ten parents, were collated to provide an overall picture of the impact of all three projects. Questions for each group are listed below.

Teachers' questions covered these points:

1. Evidence of on-task behaviour and self-motivation.
2. Reactions to the time element and intensity of experience.
3. Observations on the emergence of new talent and creativity.
4. Exposure to risks for children and teachers.
5. The impact of high teacher expectation.
6. Does art enrichment extend and support artistically gifted pupils?
7. Does enrichment provide high quality art opportunities for all children?
8. Were there any surprises – which children, and why?

Children's questions covered these points:

1. Their reaction to art experience over two days.
2. Their reactions to having two teachers.
3. Which activity was enjoyed most, and why?
4. Reactions to extending the two day limit.
5. Self-image as an artist. The reactions of the child to work done.
6. What was said to significant adults.
7. What could be improved in the work?
8. Reactions to teaching and explanations given.

Parents' questions covered these points:

1. Reaction of child to two days' enrichment.
2. Reaction of parent to work produced.

I took on the role of a teacher and action researcher simultaneously as I had to take a full part in the teaching and then stand back to make objective conclusions and recommendations and conduct the taped interviews.

Rationale for research design

The art activities were chosen with the characteristics of artistically able children in mind plus the elements of successful American art enrichment programmes described by Madeja (1983). Lally and Brant (1951) found that the ability of artistically-gifted children to persevere over time on long-term projects at a young age was an important feature of their talent. Others, including Winner (1993) and Hanson (1983), comment on the need gifted children have to draw, and their willingness to try out new materials and techniques and take risks with line, form and colour. They also highlight the interest of these children in art work generally. The American programmes highlight the importance of a stimulating climate where drawing and painting is the foundation for a lot of the work. Also emphasized is the importance of 'hands on' experience as well as expert examples of artists' work. Other elements within these programmes are consistently high teacher expectations and a teaching balance between instruction and freedom. Critical thinking strategies to evaluate their own and others' work are developed with careful teaching. With the design of this project I tried to incorporate these elements into the planning and teaching cycles. Drawing and painting formed the basis of the enrichment activities. Art books and magazines were freely available and examples of specific art work were shown to illustrate specific design techniques. Evaluation was used as a teaching tool, individually and in groups, and children were encouraged to pin up their work and look at it from a distance.

Results from the data

Results from the interview data were surprising. Teaching styles and high teacher expectation played a significant role in the artwork produced. All the teachers who took part in the projects commented on the high standards set. A review of OfSTED findings in art reflects the results from the data. Where high standards were regularly achieved, constructive criticism and high expectations were essential in helping pupils to assess and improve their work (OfSTED 1996: 12). The time factor made a significant difference to standards achieved. All the children interviewed enjoyed working over two days. All children would have gone on longer and 75 per cent felt a sense of anti-climax, admitting to feeling bored when it was over. The extended time factor allowed children to build up motivation and commitment. All the children who were talked to informally midway through the design project knew exactly what they were going to do next, and how they were going to do it. There is evidence from the interview data that enrichment provided for teacher training needs. All the teachers who had worked on a project were enthusiastic and said it was a valuable InSET experience. Joyce and Showers (1983) found that only 5 per cent of teachers they studied were able to incorporate a new strategy without assistance. The range of media on offer was crucial in providing children with the means to express and stimulate ideas. All children interviewed said that the range was exciting and all enjoyed

Figure 5: One child's development.

working on different surfaces, especially hardboard. The results strongly suggest that art enrichment met all children's learning needs including, surprisingly, children with learning difficulties. Teachers mentioned the fact that this group were as motivated and interested as the others and unexpectedly 'disappeared' and worked hard. The data also indicates a widespread emergence of new talent.

There have been instances of pupils who previously may not have been viewed as having artistic talent coming through, and through concentration and their obvious

Figure 6: Another child's development.

enthusiasm for what's presented to them they have produced work of a very high calibre indeed. (Head teacher's comments at the end of the project).

Children's interviews suggest that at least 10 per cent of the children's image of themselves as artists were changed by the experience. All children interviewed said they had improved their techniques and 90 per cent said they were proud of their work. Interviews showed that enrichment did not reinforce peer-stereotyping because gifted children met with a new set of teacher expectations and had to work as hard as other children. They could not rely on their reputations as the 'artists' in the class. The data shows however that individuals rose to challenges and gave an honest account of the learning process.

Yes I've enjoyed it very much. I liked it when you had to smash a can and then draw it. I had to do it a couple of times until I got it better. Then I got it better and I went onto my board and it came out good. (Bobby)

All children appreciated having two teachers working as a team as it cut down queues and gave them two viewpoints on their work. The photographic and display material provided proof that some criteria for the production of creative products had been met in some of the work. Bessemer and Treffinger (1981) devised a matrix which analysed creative products using the interrelated dimensions of novelty, resolution and synthesis. They defined novelty as the degree of originality shown, resolution as a mark of successful problem-solving and synthesis as complex ideas refined into a creative solution. Some of these elements were apparent in the work. Although the interview-time available did not allow thorough questioning on these points, all the teachers, staff, and students interviewed attributed the work to secondary aged children and commented on the unusual and powerful quality of the designs.

Conclusions and recommendations from the research

Drawing conclusions from the art teaching itself, I felt even better results could have been obtained by making the timescale longer. The children were just beginning to develop their own ideas on the second day and needed more time. Also the typical doldrum period experienced on the afternoon of the first day – where children absorbed the demands made on them and gathered energy for work – would not have been worrying if teachers had known the time-scale was longer. The way children took advantage of the opportunities depended largely on what art experience they had had to date. I think the design project was successful because the group of children involved had, two years earlier, been involved in a similar project one afternoon a week, over half a term. They seemed to start naturally where they had left off before; they had less difficulty with the tasks than other groups and the doldrums period was much shorter. Tentative conclusions could be made here, supported by Marjoram and Eyre (1990), that enrichment is an experience that is powerful enough to last over time, and that children need time and tranquility to digest new concepts.

Another conclusion pinpoints the importance of a school climate that is sympathetic and alert to providing high quality learning opportunities for all children so that 'gifted behaviours' can emerge:

Figure 7: Display of some finished work.

> Research tells us that gifted behaviour is both topical and temporal in nature. That is, such behaviour emerges in relation to a sincere area of interest and it operates during maximum efficiency during given periods of time. (Renzulli et al. 1981: 8)

Also highlighted is the central issue of seeing art as a serious cognitive activity which needs sound planning and progressive skills acquisition and is not side-lined in importance by Science and Technology:

> Visual education is treated as if it is quite unimportant but it's of vast importance because things we see around us affect us all our lives. Art training sharpens the visual sense and if people's visual sense is sharp you get beautiful things around you. If it's not they don't care about their surroundings. It makes a vast difference to a city, to a country. (Hockney, 1976: 29)

The importance of a school climate that values adults and children as individuals and where teachers' talents can be used and developed for the good of a school community is seen as important. Action research is acknowledged to be a useful way to initiate the first wave of change. However, it is also recognized that for art enrichment to benefit children in the long term it must be adopted as a regular working practice which requires a whole school commitment.

References
Bessemer, S.P. and Treffinger, D.J. (1981) 'Analysis of Creative Products: Review and Synthesis', *Journal of Creative Behaviors*, 15 pp. 159–79.

Cullingford, C. (1985) (ed.) *Parents Teachers and Schools*, London: Robert Royce.

Guskey, T. R. (1986) 'Staff Development and the Process of Teacher Change', *Educational Researcher*. 15. pp. 5–12.

Hanson, L. (1983) 'Options for the artistically talented', in S. Madeja, (ed.) *Gifted and Talented in Art Education*, Reston,VA: National Art in Education Association, pp. 32–8.

Hauk, B. B. and Freehill, M. F. (1972) *The Gifted Case Studies*, WMC Brown Co.

Hockney, D. (1976) *David Hockney on David Hockney*, London: Thames & Hudson.

Holt, J. (1983) *How Children Learn*, New York: Dell.

Joyce, B. and Showers, B. (1983) *Power in Staff Development through Research in Training*. Alexandria VA: Association for Supervision and Curriculum Development.

Lally, A., and LaBrant, L. (1951) 'Experiences with children talented in the arts', in P. Witty, (ed.), *The gifted child*, NYC: D. C. Heath, 1951, pp. 243–256.

Leonard, L.L. and Thompson, S. (1994) 'Copy? – Real Artists Don't Copy But Maybe Children Should', *Art Education*, November pp. 46–51.

Madeja, S. (ed.) (1983) *Gifted and Talented in Art Education*. National Art Education Association.

Marjoram, T. and Eyre, D. (1990) *Enriching and Extending the National Curriculum*. London: Routledge and Kegan Paul.

OfSTED (1996) 'Issues For School Development Arising From OfSTED Inspection Findings 1994–1995, Key Stages 1 and 2', London: HMSO.

Renzulli, J.S., Reiss, S.M. and Smith, L. (1981) *The Revolving Door Identification Model*, Mansfield Centre, Connecticut: Creative Learning Press.

Seefeldt, C. (1995) 'Art a Serious Work in Young Children', *Art Education*, March pp. 39–45.

Wallas, G. (1926) *The Art Of Thought*, London: Jonathan Cape.

Winner, E. (1993) 'Exceptional Artistic Development – The Role of Visual Thinking', *Journal of Aesthetic Education*, Vol 27, no 4 Winter.

19

Electronic Paint: Understanding Children's Representation through their Interactions with Digital Paint

John Matthews and Peter Seow

Vol 26, No 3, 2007

Introduction

This chapter considers the development of cognition in relation to very young children's use of a stylus-driven, electronic painting, drawing and writing tablet as compared with their use of other mark-making media, such as pencil and paper and physical paints. The chapter also compares children's use of this stylus-operated drawing and painting device with their use of mouse-driven computer painting programs. An overall intention is to extend knowledge about how young children develop early understandings and skills in symbol and sign formation, especially in drawing, painting, emergent writing and mathematical logic. The authors wanted to find out how the introduction of electronic, digital, interactive devices impact upon children's development in semiotic understanding. Are there universals in the development of understandings and skills in symbolization which are independent of specific medium demands? Or is development in semiotic understandings and skills highly medium-specific and tied to the possibilities of specific media, whether these be physical, pencil and paper technologies, or 'virtual' worlds created in a silicon-chip universe?

Traditionally, early years' educators have placed great importance on the child having a rich background of experience in a sensorial, physical world if she is to gain a full and complete understanding of formal, abstract world of semiotic systems. The idea behind this is that children's emergent concepts are initially 'embedded' in their actions (Donaldson 1978). Since

Piaget, we have known that if the young child is forced to abandon this embedded knowledge and prematurely inducted into abstract, symbolic systems, she will flounder.

Given that the child's environment and playground nowadays includes doorways to electronic, virtual worlds (in the form of television, digital still and video cameras, playstations, mobile phone cameras and computers) it is important to assess how these electronic media impact upon children's development. Put in its simplest way, do children still need sand, water, wooden blocks, paint and paper, and the other traditional staples of the nursery world? Or are we already witnessing the formation of very different developmental pathways as children grow up with electronic, digital, interactive devices?

Prior studies (Matthews 1999, 2003, 2004) strongly support the hypothesis that children's spontaneous use of writing and drawing media is crucial in the development of their understanding and use of semiotic systems, including language, mathematics and other forms of symbolic and pictorial representation and expression. Part of this earlier project included the beginnings of an enquiry into children's use of electronic and digital media (for example, the video camera and mouse-driven computer paintbox). However, the main focus of these earlier studies was on children's use of physical media, including readymade objects, junk materials and especially physical pigment and physical writing and drawing materials – pencils, pens and paper and so on.

These studies, along with the work of other authors (see Smith 1983; Wolf 1983; Athey 1990; Stetsenko 1995; Golomb 2004; Kindler 1997) show that children's spontaneous, self-driven, self-directed use of mark-making materials, on a two-dimensional writing or drawing surface (for, example, a sheet of paper) plays a crucial part in the their acquisition of symbolic skills. Anna Stetsenko (1995) suggests that this may be because, more than in any other medium, the act of drawing immediately suggests to the child the dual nature of symbols and signs. The child quickly perceives that the marks and shapes she makes on, say, a sheet of paper, are, at one and the same time, two-dimensional marks and yet simultaneously refer to events and objects beyond the picture surface. These events and objects may form a part of the real world or they may exist in a wholly imaginary world. Because the child spontaneously initiates and drives a constant procession of expressive and representational possibilities, and gains great pleasure from doing so, the acts of mark-making, more than any other precursor symbolic activity, lead the child naturally into a world of symbols and signs.

Now, with the advent of electronic information technology, electronic digital interactive devices have been added to the child's tools and playthings. It is essential that we have some understanding of how these new drawing, painting and other image-making surfaces or 'screens' interact with the development of children's understanding of symbols and signs. At present, although there is much rhetoric about the so-called 'digital generation', there is little actual empirical evidence about how these new electronic media impact upon the development of understanding of the semiotic systems in which children will be immersed in today's world.

Studies in early symbolization show that children bring to mark making media patterns of action and systems of thought which are the precursors of their understanding and use of the symbol systems they will encounter in school and in the outside world. The evidence so far suggests that children transfer these understandings across media domains. For example, emergent representation and expression formed with pencil and paper technologies is carried over to electronic and digital media.

An earlier study was conducted by John Jessel and John Matthews in 1993, in which very young children were introduced to microcomputer paintbox programs. The intention was to compare the children's use of electronic paint with their use of physical pigment. We introduced a small sample of children, aged between 2 and 6 to a microcomputer paintbox program. We found that certain features or principles of development were transferred across media domains, despite the difference between electronic materials and physical ones. We also found that there were noteworthy variations made in the development of symbolic thought, which were the product of the new possibilities (and constraints) of this new electronic painting, drawing and writing device.

In this 1993 study (Matthews and Jessel 1993), the device used by the children was a mouse-driven microcomputer, so there were many differences between use of this device for painting, drawing and writing compared with pencil and paper media. When one draws with a pencil, on a piece of paper, the causal relationship between the actions made and the resultant effect – a mark, a trace or a shape – is direct and immediate. This is what gives the act of drawing with physical materials a fast developmental route to semiotic systems. When one draws with the mouse-driven personal computer, however, the causal relationship between action and visual trace is neither direct nor immediate. The drawing surface is separate but adjacent to the visual-display surface as well as being at right angles to it. In addition to accommodating to this disparity, the children also had to learn to operate the mouse in order to make a mark appear on the screen. They had to coordinate at least three different motor-schemes. They had to simultaneously press the button on the mouse, whilst moving the mouse, whilst watching the screen. There were other important differences too. In pencil and paper media, the relationship between drawing actions and the physical and visual positions of the resultant marks is absolute. The marks correspond (of course) spatially and visually to the marking actions made. On the computer screen, however, the relationships between action and trace are relative, not absolute. For example, 3-year-old Robert makes a complete ellipse with the mouse on the table surface, but sees only a segment of his elliptical trace appearing on the screen. Also, in the software John Jessel and I used at the time, colours did not mix on the screen. Nor was the mouse pressure-sensitive. When using a pencil, brush or crayon, emotional changes in the draughtsperson cause changes in the pressure applied to the marking instrument, which are in turn translated into variations in the quality and intensity of the mark or trace. Variations in pressure applied to the mouse, on the other hand, caused no variations to occur on the drawing surface – or rather, on the visual display surface or monitor.

For these and other reasons, the experience of drawing and painting with the mouse-driven computer paintbox program is different in important respects to that of drawing or painting

with physical pigments. Even nowadays, children's experience of drawing, writing or painting on a computer is commonly mediated by the use of the mouse. Indeed, one of the present authors, Peter Seow, recently found that some children's expectations regarding the drawing and painting possibilities of the computer were based upon their experience of mouse-operated computers – 'You can't draw well on a computer', offered one child. Now, with the availability of pressure-sensitive, stylus-driven drawing and painting programs, which also allow colour-mixing on screen with a pressure-sensitive tool, many of these constraints and limitations no longer exist. Peter Seow and I introduced children to such a device, in which drawing actions could be performed directly onto a virtual drawing surface: the screen of a tablet personal computer. The software we used was called 'Artrage'. When the children drew on this tablet, the direct causal link between actions performed and resultant visual effect was not broken because marks and traces could be seen to be the direct consequence of actions made. At least, this is true when the computer is behaving properly. When it does not, and delays and dissonances occur between drawing actions and the appearance of marks or traces, this has important consequences for the child's understanding and development. At such moments, the child's experience parts company with her usual experience of causal relationships within self-initiated events in a physical world. We will return to this point later.

Video-recorded naturalistic observations of a sample of twelve children between the ages of two and eleven were made. Initially, naturalistic observations were made of eight children producing drawings, paintings, writings, and mathematical signs in both electronic paint and in pencil and paper. However, this sample was perhaps atypical in that they were the children of educational professionals working within the National Institute of Education, Nanyang Technological University, Singapore, and had some acquaintance with electronic and computerized machines. Subsequently, the authors extended the research sample to include children across the socioeconomic class groups and also those who lacked experience of working or playing with computers, and had no experiences with digital drawing and writing media.

We introduced a total of twelve children, between the ages of two and eleven, to the tablet PC. The children were permitted to draw anything they wished. Each child was allowed to spend up to an hour with the computer, although they could stop whenever they wanted. They all produced paintings and drawings which were saved in the computer. For some of the children, we were able to make hard-copy prints of their paintings. The results of the investigation of children's use of this electronic painting and drawing device are discussed below.

From this initial study of children's spontaneous drawing, painting and writing in electronic paint, the authors then extended the scope of the research to include children's use of simple interactive programming devices. There was seen to be an important link between children's experience of spontaneous mark-making, drawing, painting and writing and their use of simple interactive programming devices. The children's use of this programming software and its relationship to their prior experience with electronic paint will also be described and discussed below.

Very young children use electronic paint

In the first sessions, each child was accompanied by parent or parents and introduced to the stylus-operated tablet personal computer in a studio of the National Institute of Education. Our later sessions took place in a local nursery and kindergarten and only the two investigators were present with each child. In three sessions the child was accompanied by siblings, who were also given an opportunity to use the computer, one at a time. The computer was switched on, placed on a table and opened up so that its screen faced the child who sat before it. The child had a clear and close view of the screen, on which a new 'page' was on display, along with a full spectrum of colours, arranged in an arc at the bottom right-hand corner, and a set of tools (depicted by 'icons'), on the bottom left-hand side. Next to the palette of colours was a sliding scale with a virtual 'button' which could be operated, by use of the stylus, to vary the tonality from full luminance ('white') to complete darkness ('black'). The child would have his or her parent sitting alongside. The parent, sometimes with the assistance of one of the investigators, would introduce the child to the device.

Typically, one of the adult companions, either the investigator or the parent, would say to the child something like: 'This is a special drawing and painting device. You can draw on this screen with this pen or stylus', and here the adult would direct the child's attention to the stylus located

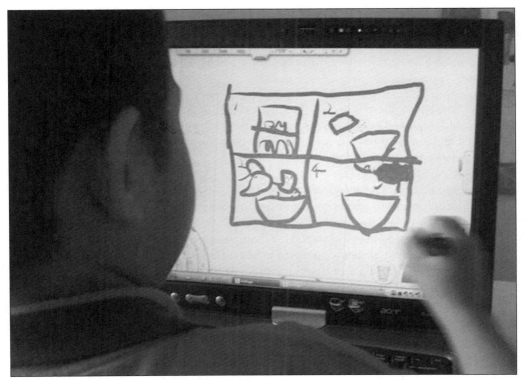

Figure 1: Child using the Tablet PC with stylus.

at the top left of the screen, withdraw it from the aperture in which it was inserted and show it to the child, 'rather like you would draw with a pencil on a piece of paper. You may try it.'

It was hoped that the child would, at this point, make exploratory marking actions on the screen on her own initiative. With two exceptions, however, the adult would feel obliged to demonstrate that the stylus did indeed leave a visual trace when pressed and trailed against the screen. Fifteen years ago, John Jessel and I sometimes felt the same need to demonstrate to some of the subjects that the mouse could be manipulated so as to leave a visual trace. In the present study, one 4-year-old child, Glen, expressed disbelief that such a pen (which resembles a ball-point pen) was capable of drawing on what was, surely, a glass screen! This is an interesting example of a child's expectations of a new medium based upon prior experiences in the world. Glen was one of our subjects who had no experience of computers, but he did know that ball-point pens do not draw on glass!

In retrospect, it might have been the case that the adults intervened prematurely and that, given ample time, the children would discover the affordances of stylus and screen by themselves. Valuable information on how the child discovers the trace-making potential of the device might be gained from future studies in which the child is allowed any amount of time to make this discovery.

However, there seems to be required a careful balance between the child's solo exploration and the adult companion's assistance, if the child is to maintain interest and engagement. The role of the adult companion here is a subtle but crucial one, and more will be written about this later.

However, the investigators restricted their own demonstration of the use of the stylus to a minimum and requested parents do the same, so as not to unduly affect the child's drawing. It was found that just a stroke or a squiggle would be sufficient to start off the child's own, self-guided, self-initiated drawing and painting.

As in the earlier study (Matthews and Jessel 1993), it was found that the children seemed to move through a similar sequence of drawing actions as they do with traditional, physical drawing tools. Earlier studies by Matthews (1999, 2003, 2004) revealed that children move through successive generations of drawing actions, commencing with those which reflect the natural oscillations of the skeletal and muscular frame (Smith 1983), to evermore differentiated structures which involve simple structural principles or drawing rules (Matthews 1999, 2003, 2004; Willats 2005). These structural principles include the continuity or discontinuity of line, the principle of closure, the demarcation of beginnings and ends of lines, linear attachments, junctions and direction changes. These structural principles are reiterative and can be varied virtually infinitely. From the principle of continuity of line, the child starts to think in terms of linear journeys and the flow of time. Discontinuity, expressed in the making of discrete clusters or 'lines' of dots, leads the child to understandings of discrete displacements in time and space and to the idea of counting and number. From the principle of closure, the child develops an

interest in the closed shape and its representational possibilities, including the encoding of inside and outside relations. From the demarcation of the beginnings and ends of lines, the child discovers visual narrative, with its linguistic and mathematical implications. Superimposition of one layer of colour over another was also a principle which was explored with both physical and electronic paint.

As John Jessel and I noted (Matthews and Jessel 1993) when introduced to the mouse-driven computer paintbox, children seem to move through these structures in the same sequence as they do with physical pigments. There were, however, some interesting variations prompted by the nature of this new medium. The very youngest children start off with the first generation of marking actions, those which issue from the natural swayings, pushings, pullings and stabbings of the drawing arm, in conjunction with other movements of the body. These consist of three general categories of movement. One is the *horizontal arc*, which is a side-to-side fanning action of the drawing arm, the action mainly issuing from the shoulder, but quickly varied by inflections of wrist and elbow. The second is the *vertical arc*, which is a repeated, downward stabbing of the marking instrument against the surface. The third is a *push-pulling* movement, in which the marking instrument is repeatedly and alternately pushed away and pulled toward the draughtsperson's body.

Even at this level of drawing, however, the investigators detected significant changes in these early marking strategies, caused by the unique properties of the digital electronic drawing and painting device. In the study of the children's use of the mouse-driven computer paintbox program, it was found that although horizontal arcing and push-pulling movements left traces of their passing, in the case of the vertical arc, although the computer registered some effects, it did not have the same expressive power as this action has when performed upon physical pigment with a handheld tool. This is because, since the mouse depends on electronic rather than tactile contact, actions within the third dimension had little effect on the character of the marks made. As we mentioned, this is not to say that no effect at all was achieved by banging the mouse against the surface of the table. The children found various ways in which the mouse could be dashed against the surface and leave a record of its impact (and still without breaking the mouse!). However, it remains true to write that there was a clear tendency for the children in this initial study soon to abandon this use of the mouse. Like all of us who use a mouse-driven computer, it was quickly learnt that movement of the mouse through the air, without contact with any physical surface, served other, more salient, purposes, notably the relocation of the mouse for further drawing without affecting the writing or drawing already achieved.

However, this situation was all changed with the use of the stylus-operated tablet. Here, the impact of the stylus against the screen did result in expressive variation and quality in terms of dashes, dots, blobs and spots. The other marking actions, too, were altered and enhanced by the stylus. Unlike the mouse-driven paintbox, the stylus is pressure-sensitive, so that fluctuations in emotional temperature of the drawing actions resulted in expressive variations in the quality of the mark. Other general variations from physical pigment should be noted. When using physical pigment, one is painting with reflected light, but with electronic paint one is painting

Figure 2: Child's mark making on the computer using a stylus.

Figure 3: Child's exploration of colors using the stylus and paint software.

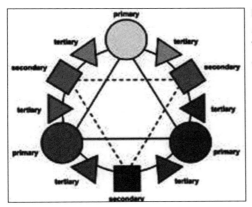

Figure 4: Colour Wheel. Source: Walker Arts Centre, Minneapolis Institute of Arts, Image from The Artist's Toolkit: Visual Elements and Principles, http:// www.artsconnected. org/toolkit/encyc_colorwheel.html

with light itself. The colours are intensely luminous and, whether driven by a mouse or a stylus, never run out. Nor does the paint become muddy. It never dries because it was never wet in the first place. We are dealing with a medium which to some extent emulates the physical world, but it is not physical. Yet, paradoxically, whilst it is not physical, it does have its own sensuality. This seems especially marked with the stylus-driven paintbox. Although all our other studies strongly suggest the need for young children to experience the sticky, viscous, dripping nature of real paint, the authors found that it was untrue to assume that electronic paint lacked any kind of sensuality. The contrary seemed to be true. All the children seemed to enjoy the frictionless skidding and gliding sensation of the stylus across the glass screen. Later, we must consider the pros and cons of the different kinds of sensory experience offered to children by electronic paint and physical paint.

Colour

Other major differences, suspected in the Jessel and Matthews study, were confirmed in the present study. One important difference is the child's use of colour. It has often been suggested that very young children have difficulty handling a large range of colours. Sometimes, it is even ventured that the very young may only be able to handle one, perhaps two, or, at the most, three colours. Such ideas become enshrined in dubious developmental 'stage' theories of children's art and have strong repercussions on educational planning and provision.

The notion that very young children are incapable of using more than one or two colours was flatly contradicted when the children were offered an electronic palette. With the electronic paintbox, a full spectrum of colours is available and accessible even to the youngest of our subjects. Even 2 and 3 year-olds seem able to choose from an essentially limitless palette and use these colours.

The explanation for this lies partly in the nature of the medium and partly in a conceptual muddle that has arisen about colour and pigment. The practical and logistical problems of arranging a huge array of physical pigments for children accounts for some of the problems

children encounter when using physical paint. (Imagine the task for the adults to provide for a complete spectrum of physical paints for each member of even a small group of children.)

But the practical problems are also compounded by (and, in fact, probably originate from) conceptual problems. There is no convincing reason why physical paint cannot be arranged in a logical, scientific way – a point we should bear in mind in any comparison of electronic and physical pigment. Colour is often poorly taught to children, usually reflecting the teacher's own confusion. Sometimes, 'colour-wheel' theory, or one of its variants, is invoked, often in a highly formal, abstract way, with diagrams on a whiteboard or in a slide show which formularize the colour spectrum in a way which is both artificial and potentially misleading. In this system, a central circle is divided into three quadrants labelled Red, Blue and Yellow. These are referred to as the 'Primary Colours'. A second, concentric circle, surrounding the first is made and also divided into three sections to explain the existence of what are referred to as the Secondary Colours. One section of this outer circle overlaps half the red and half the blue quadrant of the first circle and is labelled 'Purple'; next to this is another band, which spans half the Blue quadrant and half the Yellow quadrant, and so is labelled 'Green', and the final section of this outer band overlaps half the Red and half the Yellow and so is labelled 'Orange'. Sometimes, a third concentric ring is added, in which, using the same formula, the so-called Tertiary colours are explained (a version of this model is illustrated in Figure 4).[1]

Sometimes this theory is explained with no actual colours used at all – just a diagram of the 'colourwheel' with its word annotations drawn on the whiteboard! On other occasions this is demonstrated with a slide-show and, with any luck, at least the colour-mixes appear natural, possible and logical. The real trouble starts when the children are asked to use this highly schematized theoretical framework and mix colours themselves. Sometimes, the children do not even get to see or use pure colours. This quickly makes a nonsense of the colour-wheel theory. This is because, in order to mix a true Purple, Orange or Green, one needs at least to start off with a pure Red, Yellow and Blue.

Children often struggle to achieve colour mixes from supposed 'primary colours' which are rarely true reds, blues and yellows to start with! When this happens, they are often compelled to ignore their own perception of the false colour mixes, and even be obliged to memorize and recite this formula, persisting in calling secondary colours, 'Purple', 'Orange' and 'Green', even if, optically, they are muddy mixes which bear no relation to their word labels! It is easy to see how such a conceptualization (and its variants), compounded by use of impure pigments, quickly leads to total confusion in the children's minds.

It is against this confused conceptual background that the mythology of very young children's supposed deficiencies in their understanding and use of colour has been conjured. Research into children's use of colour is, at present, rather limited as compared with their use of line and shape. Part of this paucity of knowledge has come about from medium-specific constraints. If the child is required to choose from a range of coloured pigments (whether presented in tubes or jars and so on, or already arranged on a palette), it is difficult to discern the degree of

arbitrariness involved in the child's selection and use. Also, while children may seem to display a preference for certain colours, this may reflect their favouring of other properties of the pigment, properties which might have nothing to do with the hue of the pigment. For example, a child might select, say, a purple pigment, not for its hue but for its texture, or its level of viscosity or fluidity. The same holds true for the child's choice of coloured markers. What seems to be a favourite colour may turn out to be the child's understandable preference for a pen with which it is satisfying to draw, perhaps because of its fluidity (or even resistance) against the surface of the paper. It is possible that the electronic palette, with its easily accessible range of pure, spectral colours, which can be mixed directly on the screen, which never muddy, which are textureless and never run out, offers an opportunity to conduct some useful research on children's use of colour.

With the mouse-driven computer, John Jessel and I began to suspect that children were quite capable of selecting and using dozens of colours. Now, using a stylus-driven painting tablet, Peter Seow and I confirmed this. In fact, it is true to state that very young children are capable of selecting, using and even mixing an infinite range from spectral colours if – and only if – these are presented to the child in a logical, scientific way and accompanied by informed adult advice.

Tonal variation

A related mythology concerning very young children's understanding and use of tonal gradation was similarly exposed in our study. Again, it is often assumed that very young children have great difficulty understanding tonal variation and its relationship to hue. Again, this apparent difficulty seems to be the result of poor adult conceptualization and explanation. Teachers often compound any conceptual problems the children might have with poor instruction.

It may come as a surprise to some readers that we found that even the youngest of our subjects had little or no such problems with adjusting tone and mixing hue and tone together. The principle of the use of tone and hue, although made heavy weather of by certain kinds of instruction is, in fact, very easy and even (one might argue) 'natural' to very young children. The simplest way to express the relationship is this: the colour spectrum consists of a continuum of colours which have been roughly divided into seven categories (at least, in contemporary technological societies). These are: Violet, Indigo, Blue, Green, Yellow, Orange and Red. All the colours along this spectral continuum may be darkened or lightened by the use of black and white respectively. In a well-designed electronic paint program, this can be understood readily because all the colours can be seen directly and any chosen colour may be darkened or lightened as the result of actions that emulate actions made in the physical world.

On the screen of our tablet PC, pure spectrum colours are arranged in an unbroken continuum, in the correct sequence. The continuum of tonal gradation, from darkest to lightest, can be experienced with a minimum of difficulty by 'sliding' the virtual button up and down a sliding scale. The colour one has selected from the palette darkens or lightens according to the direction, up or down, the button is 'dragged' by the stylus. We concede that there occurred

Figure 5: Child drawing on the Tablet PC with the stylus and electronic paint software.

a little 'difficulty'. This seemed to us to be a minor, software design issue. The button on this software was very small, and to locate it with the point of the stylus was sometimes problematical for us adults.

However, with some experience, all the children mastered this, and could see quite clearly the continuum of dark to light or vice versa. This meant that, in contrast to the folklore of children's development in art, we found even the youngest child (3-year-old Grace) was able to precisely select hue and tone of any colour she wanted. Indeed, Grace spent almost an hour in the most studious mixing and refining of colour, in a series of coloured patches on the screen. This seems to dispose of Steven Pinker's (1994) assertion, that 3-year-olds have no competence in the visual arts whatsoever. This type of strident claim is part of the rhetoric of the dominant Chomskian view of language, which sees development in language as distinctly different from development in all other modes of representation and expression. Such a view has had enormous effects on our understanding of the development of representational and symbolic

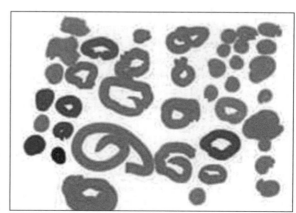

Figure 6: Exploration of colors and sizes.

Figure 7: Child's drawing connecting different geometric shapes.

thought, yet, in the light of careful investigations of how young children detect and exploit the expressive and representational possibilities of a range of media, perhaps some of the core claims of the Chomskian project should be scrutinized very carefully.

Line and shape

As with children's use and understanding of colour and tone, we found that the children were intrinsically motivated to explore line and shape very thoroughly. As in their use of pencil and paper technologies, they found the infrastructural investigation of visual structure absorbing in itself. Given the high range of variety that the children bring to their exploration of shape, some of the ways in which the teaching of shape is conceived in education is very tedious and restrictive. Typically, shape is conceived by the teacher or educational planner in terms of a simplistic and watered-down form of Euclidean geometry. In our studies of drawing and painting with both physical and electronic paint, children's spontaneous, self-driven exploration of investigation of shape is far more complex and interesting than the prescribed package of knowledge offered in much early years' education. Given the right tools and the right level of adult, intellectual companionship, children form emergent understandings which comprise an interweave of topological, Euclidean, projective understandings and dynamic knowledge – and this from near the outset of mark making.

The capability of even young children to operate and hold together simultaneous causal chains of thought is due to the non-sequential nature of the computer. Many complex, interlocking processes (like mixing hue and tone together) only become complicated and impenetrable when they are fragmented into compositional language. Well-designed visual displays offer the child the opportunity to bypass linear description and see, if not at a glance, then very readily, quite complex total systems. This is why computer games are so successful with the young. These allow holistic engagement with complex systems because of clarity of visual and dynamic display. When we introduced children to simple programming devices, we found the same held true. The design of these visual and dynamic environments allowed the child to

manipulate several streams of cause and effect simultaneously. More research is, of course, required to ascertain how deep, lasting and transferable is this new kind of knowledge.

We also found that, as with pencil and paper drawing, the paintbox tablet also encouraged an easy flow between concerns which may be classified as mathematical, logical and linguistic. We have not the space in this chapter to go into detail, but it is important to note that most of our subjects free-flowed from aesthetic concerns to mathematical logic (essentially set-theory), numerical partitioning and the sorting-out of cardinal and ordinal numbers. The children used the medium of electronic paint to form mathematical descriptions very like those described by Worthington and Carruthers (2006) and which they term 'mathematical graphics'. 4-year-old Glen's diagram describing the 'planting of seeds' was such a mathematical graphic.

Additionally, the children would also associate linguistic, written (and sometimes spoken) narrative with the unfolding of a pictorial representation. Because the study took place in Singapore, we also had examples of Chinese characters, or 'shu fa', amongst emergent Roman alphabets. Contrary to expectations, these characters seemed to us equally beautiful as those created by the traditional Chinese brush ('Zhong Guo maobi). It is a mistake, we feel, to assume that a machine will, of necessity, produce sterile art. 4-year-old Glen selected a fine electronic brush (albeit of Western design) to write elegant characters to tell a story about Chinese superheroes.

Because we could sense that the children were using the device to consider a bundle of processes ranging from the aesthetic, the expressive, to the mathematical and the linguistic, we decided to extend the study by introducing the children to simple programming software.

Very young children perform simple programming

The software we used is called 'Scratch' and was developed by Mitchell Resnick and his team at the Media Lab (Resnick et al. 1998).This provides children a platform to create animations, games and interactive art. It is based on the educational philosophy of Constructivism where

Figure 8: A drawing depicting the steps to plant a seed.

Figure 9: Chinese language writing using the stylus and paint software.

children learn through the process of creating artefacts, reflecting on their creations and sharing the created artefacts with others. 'Scratch' lets a child create or import digital artefacts such as a drawing and add actions to those artefacts through program steps. For example, the child can specify that the artefact move forward 10 steps and turn 90 degrees or change its colour. Children are able to program each artefact with a series of logical actions as specified by the program steps and coordinate actions between different digital artefacts.

Resnick reported that children learn best in the process of designing and creating artefacts which are meaningful to them (Resnick et al. 1998). Peter Seow and I also found this. We helped 4-year-old Glen import a stereotypical 'clip-art' cat, but he was not impressed by this creature, preferring to draw his own, bright green cat which he then programmed to rotate in a circle.

We found that the children's experience of spontaneous mark-making in electronic paint seemed to assist the transfer to the use of this programming device. The children could now not only draw or paint subjects on the screen, they could also animate these. Knowing what we do about very young children's interest in representing both the shape and movement of objects, that children have available the technology to animate their drawings seems a logical next step. Prior research (Athey 1990; Matthews 1984, 1999, 2003) has already established that,

Figure 10: Child's programming and drawing in Scratch MIT.

in their pencil and paper drawings, children are considering the dynamic aspect of events, as well as the shape and form of objects.

We have not the space here to give a full description of the children's use of the 'Scratch' program. Suffice it to say that it does seem very likely that the experience of free drawing, painting and writing with electronic paint, and being able to handle many dimensions of the painting experience, including those which are mathematical, logical and linguistic, set the background for the children's engagement with simple programming. (Perhaps further experiments using a control group might confirm or disconfirm this).

Conclusion

The importance of the role of the adult companion cannot be overemphasised. As with studies of children's development in digital movie making (Matthews 2006), it was found that the adult investigator introduced the child to the computer using metaphoric language. Indeed, the user-friendly nature of well-designed computers is dependent on this metaphoric dimension. We talk of 'going into', of 'dragging' 'windows' around; of 'dropping' something into something else. We talk about the computer 'doing something', that it is ' thinking' about something, and even that it gets 'sick', like us, and does not always 'work' properly. The children also seemed to appreciate to some extent what was meant by the computer 'remembering' something, or 'saving' something. The visual displays seem to work best when they are based upon elemental ideas about location, visual shape and movement.

The investigators used this metaphorical language to help the children navigate their way 'into' and 'through' this digital landscape. After only a couple of sessions, the majority of the children, even the youngest, were able to 'open up' the program and retrieve art works 'stored' in the computer's 'brain.' This was true of Glen, who had never used a computer before, after only his second session with a tablet PC. The use of language between adult companion and child, engaged in working on the tablet PC, is worthy of a study in itself. The collaboration we observed between siblings and classmates would seem to be another valuable research avenue.

As mentioned above, if there occur any gaps or delays between actions performed by the child on the computer and resultant effects on the screen, this will hinder the flow of the child's thought. It is vital therefore that the computer and software are reliable. The child needs to establish a trustworthy causal relationship between his or her actions and events on the screen. This is especially so for the very young child, because, as we have noted, their thinking is embedded in actions in the physical world. A very young child expects to see a direct result from the action they have performed on the computer. If delays do occur between action and effect, the adult companion must try to bridge this gap with explanation, but, of course, the internal actions of the computer are invisible and the child's thinking depends on constant sensory feedback to establish a sure relationship between action and effect. The same applies to adult computer users too, but this is especially so for the smaller memory capacity of the very young child, who will have difficulty internalizing explanations (however ingenious) by adults about what is happening inside the computer.

Although the computer emulates behaviours in the real world, this is not to say that the software we used was a poor copy of real experience. We would argue that it is essential that children have access to real paint, real surfaces, and to all the sensual and physical aspects of the art process. The question that we raised in the introduction – can this digital interactive environment bypass and become a substitute for real experiences in a sensory world? – can be answered with a resounding 'No!' Nothing can replace the experience of real paint on real surfaces, and the multitude of possible worlds painting and drawing open up. It would be a tragedy if computer painting was simply used to replace the rich, chaotic world of physical pigments as a cleaner, less messy way of making artworks.

The other important, related question we asked in the introduction is whether development has universal aspects or whether it is tied to the demands of specific media. The answer seems to be that development has universal biases which cause it go in certain directions rather than others. It can be shown that, at a deep level of description, there is a universal dimension to development. However, the child's interaction with new media reveals that the principles which drive development are deeper and more abstract than has generally been thought. The insertion of different media into developmental trajectories favours and encourages certain avenues of development rather than others. A recent example is a study which suggests that children's development in video movie-making follows developmental principles we have seen in representational and expressive development in other, traditional media, but that the video camera teases out certain threads rather than others in the interweave of development (Mattews 2006). For instance, the video camera seems to encourage the child to consider line-of-sight and point-of-view. These are essentially projective understandings, which may not show up so clearly in, say, the child's interaction with pencil and paper technologies.

Similarly, electronic paint has qualities of its own, which we have described above, in terms of painting with light itself, in terms of colour, shape and movement. These unique qualities cause important new twists and turns in developmental trajectories. We cited the example of the child's understanding of tonal variation and hue. We also felt that the children enjoyed a kind of sensuality unique to this microchip universe. Although it is essential that children explore the messy gooeyness and splatteriness of real pigment, the smooth glide of electronic paint across a luminous glass screen is also a sensuous and enjoyable experience.

Indeed, the authors feel that electronic paint, if used well by teachers, may clarify the conceptual muddle which is typical of many of today's 'art lessons'. The revisiting of the logic of the artist's palette is a very good instance of how computerized painting might rejuvenate, rather than replace, the act of painting.

Acknowledgments

We thank the NTUC childcare group for their support of the research project that was conducted at their premises and the wonderful children we worked with over the many weeks. We thank many parents at NIE who so readily allowed their 263 children to participate in our studies.

Note

1. See artsconnected.org/toolkit/encyc_colorwheel.html, Accessed 13th April 2009.

References

Athey, C. (1990). *Extending Thought in Young Children: A Parent–Teacher Partnership*, London: Paul Chapman.

Donaldson, M. (1978) *Children's Minds*, Glasgow: Fontana.

Golomb, C. (2004) *The Child's Creation of a Pictorial World*, Hillsdale, NJ and London: Lawrence Erlbaum Associates.

Kindler, A. (1997) Paper prepared for presentation at the INSEA International Conference: Our Futures in Design, Glasgow, 10–15 July.

Matthews, J. (1984) 'Children Drawing: Are Young Children Really Scribbling?' *Early Child Development and Care*, Vol. 18, pp. 1–39.

Matthews, J. (1999) *The Art of Childhood and Adolescence: The Construction of Meaning*, London: Falmer Press.

Matthews, J. (2003) *Drawing and Painting: Children and Visual Representation*. 0–8 Series, Tina Bruce Series Ed., London: Paul Chapman.

Matthews, J. (2004) 'The Art of Infancy', in E. Eisner, and M. Day, (eds.) *Handbook of Research and Policy in Art Education*, Hillsdale, NJ and London: Lawrence Erlbaum Associates, pp. 253–98.

Matthews, J. (2006) 'Very Young Children's Development in Moviemaking', *Mind, Culture and Activity*, Vol. 13, No. 2, pp. 129–55.

Matthews, J. and Jessel, J. (1993) 'Very Young Children Use Electronic Paint: A Study of the Beginnings of Drawing with Traditional Media and Computer Paintbox' (original version), *Visual Arts Research*, University of Illinois, Vol. 19, No. 1, Issue 37, pp. 47–62.

Pinker, S. (1994) *The Language Instinct*, London: Penguin.

Resnick, M., Rush, N. and Cooke, S. (1998) 'The Computer Clubhouse: Technological Fluency in the Inner City', in D. Schon, B. Sanyal, and W. Mitchell, (eds.) *High Technology and Low Income Communities*, Cambridge, MA: MIT Press, pp. 266–86.

Smith, N. R. (1983) *Experience and Art: Teaching Children to Paint*, New York: Teachers College Press.

Stetsenko, A. (1995) 'The Psychological Function of Children's Drawing: a Vygotskian Perspective', in C. Lange-Kuttner and G.V. Thomas, (eds.) *Drawing and Looking: Theoretical Approaches to Pictorial Representation in Children*, London and New York: Harvester Wheatsheaf, pp. 147–58.

Willats, J. (2005) *Making Sense of Children's Drawings*, Hillsdale, NJ and London: Lawrence Erlbaum Associates.

Wolf, D. (1983) 'The Origins of Distinct Symbolic Domains: The Waves of Early Symbolization. The Example of Event Structuring', Paper presented at the Annual Meeting of the Eastern Psychological Association, Philadelphia, April 1983, Harvard Project Zero, Longfellow Hall, HGSE Cambridge, MA 02138.

Worthington, M. and Carruthers, E. (2006) *Children's Mathematics: Making Marks, Making Meaning*. London: Paul Chapman.

20

Attitudes to Making Art in the Primary School

Robert Watts

Vol 24, No 3, 2005

Introduction

The origins of this research lie in a visit to an exhibition of student work at the Royal College of Art. With me, sat on the gallery floor and working in their sketchbooks, were twenty pupils from a West London primary school. I remember watching them draw with a confidence and spontaneity lacking in the work around them, and with a conviction I believed only young children possessed. I assumed that many shared an ambition: 'When I grow up I want to be an artist.'

But when I questioned the children about their intentions and ambitions, art and design was a subject that featured peripherally, if at all: 'When I grow up I want to be a footballer.' 'When I grow up I want to be a vet.' 'When I grow up I want to be a scientist.' I was unsettled to find that few – and only the younger ones – were sufficiently enthusiastic about art to imagine pursuing the subject into adulthood. It was, it seemed, something to be enjoyed today but to be discarded at a later date. I questioned the pupils further: Why do children make art? Why do adults make art? How is art important? The range and the quality of the responses I received convinced me that further research was required into children's attitudes towards making art.

The status of art and design in the primary school

Recent research in this area (Herne 2000; Rogers 1998; Downing et al. 2003) has focused, firstly, on the causes of changes in the status of art and design in the primary school and, secondly, on teachers' attitudes towards teaching the subject. A key influence on young

children's attitudes to art and design is the importance allocated to the subject in primary schools. Herne (2000) suggests that the recent renewed emphasis on raising attainment in literacy and numeracy has led to a marked decrease in the time allocated to teaching the foundation subjects.[1] The introduction of extra funding for 'booster' lessons in core subjects for struggling pupils has led to many receiving fewer lessons in foundation subjects such as art and design. Herne also highlights the reduction in both the quantity of in-service training provided for primary teachers during this period, and of resources allocated towards the subject.

While it was predictable that the pressure of raising attainment in national tests would restrict the time available for art and design in upper Key Stage 2 classes, it is disturbing to find evidence of a 'trickle-down effect' in primary schools towards younger classes: 'The only art I saw being made in my Year 1 class,' reported a trainee teacher in an infant school in 2003, 'was when the children were allowed to draw illustrations to their writing'. A second student, placed in the foundation stage, saw even less: 'I was amazed,' she reports, 'for the seven weeks I was in school there was no art made in their Reception class'[2]

Those tempted to blame teachers for allowing art and design to become marginalized in the primary curriculum should be aware that the status of the subject is inevitably determined at a higher level. Herne (2000: 218) cites the 1998 revisions to the primary curriculum as the catalyst for a reduction in the amount of time schools devoted to art and design; Rogers (1998) observes that, since 1998, students in initial teacher training are no longer required to study all areas of the curriculum, whilst Downing (Downing et al. 2003) highlights the roles played by the Department for Education and Science, local education authorities and the Office for Standards in Education, acknowledging that 'the pressure ... from the DfES, LEAs and OfSTED to downgrade the importance of the arts [has led to] ... a concentration on the core curriculum'. A 2001 survey calculated that the average amount spent in primary schools each year on art and design materials was around £1.25 per pupil (Rogers et al. 2001). Given these restrictions, it is arguable that recent moves to place creativity at the core of the curriculum (NACCE 1999) are destined to have a limited effect. It is certainly difficult to dispute that during the past ten years the gap in status between the core subjects and art and design has widened in primary schools.

Teachers' attitudes towards art and design in the primary school

Issues surrounding the status of art and design in primary schools are interwoven with those concerning its purpose. Aside from brief modules on initial teacher education courses, only a minority of primary school teachers have received an art education that extended beyond the age of sixteen. For the majority, opportunities for reflection on the complex range of reasons why art is taught are likely to be rare.

Recent research into student teachers' perception of arts provision in secondary education in England (Harland et al. 2000) identified the 'urgent need for research into arts provision in the primary sector', whilst recent research carried out in Cyprus (Pavlou 2004) has explored the ways in which teachers' approaches to teaching art impact upon their pupils' attitudes to the subject.

Figure 1: Drawing at the Royal College of Art.

Downing subsequently surveyed the attitudes and experiences of head teachers and class teachers in the UK towards teaching the arts in primary schools and concluded that:

> The most highly endorsed purposes...were to develop creative and thinking skills and... communication and expressive skills. These were followed by purposes associated specifically with learning in the arts, which were ahead of purposes associated with personal development...Many head teachers viewed the arts as central to raising standards in schools; also noted were the arts' impact on motivation, behaviour, attendance and self-esteem. (Downing et al. 2003: 13)

The report presents a picture in which the aims of well-meaning teachers are frustrated by the constraints of an unsympathetic system. The suggestion is, that given sufficient time and resources, a clear improvement in the provision for art and design in primary schools would take place:

> While not revealed in any performance tables or end of key stage tests, head teachers and class teachers were convinced of the value of the arts in education and seemed determined to ensure their continued contribution to the education of the whole child and the welfare of schools. (ibid.)

Downing's research raises several questions. Firstly, it is arguable that the 54 per cent of head teachers and 43 per cent of class teachers that responded to the survey would be more likely than not to demonstrate positive approaches towards teaching art and design. Those teachers that held the subject in low regard would be less likely to reflect upon their attitudes towards it for sufficient time to complete a questionnaire. Similarly, those who were positive about art and design, yet believed that they were making insufficient provision for their pupils, may have been disinclined to respond to the survey. Secondly, the survey does not explore the extent to which teachers' attitudes and opinions toward art and design affect their pupils' perception of the subject. Were those teachers who demonstrated a positive attitude towards art and design communicating this enthusiasm to their pupils?

The research design

Prompted by the findings of the Downing report (Downing et al. 2003) and by my initial enquiries into children's attitudes towards art and design, I carried out a pilot study with a group of 20 Key Stage 2 pupils. The questions I asked were those prompted by the discussion with pupils following their gallery visit: 'Why do children make art?' 'Why do adults make art?' 'Do you think that you will make art when you are an adult?' 'How is art important?' The results of the pilot study were presented to groups of trainee teachers for discussion, and students were subsequently invited to carry out similar surveys within Key Stage 2 classes during their school placements. 316 individual responses were received from 15 trainee teachers.[3]

Pupils were not offered a list of optional responses. Whilst such a list would have ensured that the process of categorizing responses would have been less subjective and more reliable, the range of responses would inevitably have been less broad (the question 'Why do children make art?' for example, prompted 42 different responses; the breadth of the range of responses proved to be a key factor in the research, an issue discussed below). Consequently, pupil responses were categorized. For example, responses to the question 'Why do children make art?' were categorized as 'to communicate/for self-expression'; responses categorized within this heading include: 'To show how they are feeling', 'To express what they are thinking' and 'If you don't speak English you can draw your feelings.' Some responses could arguably have been categorized differently; however, all individual responses were retained and several are discussed below.

Several Key Stage 1 classes were also surveyed but data was not collated. The process of gathering responses from pupils too young to complete the questionnaire independently proved to be unreliable, with high levels of repetition within responses from some classes. However, some individual responses are referred to in the discussion below in order to illustrate specific points. Finally, it is arguable that the contrasting responses to the questions 'Why do children make art?' and 'Why do adults make art?' may in part be due to the fact that young children are often told that you cannot make the same response to two different questions!

The research data

Why do children make art?
The majority of pupils (57 per cent) suggested that the main reason why children make art is because it is fun. This response was highly typical of 7-year-olds (2 per cent), less so of 11-year-olds (49 per cent). Reasons that related to personal development were also relatively frequent, with 20 per cent of pupils suggesting that children make art 'because they want to be artists', 'to be good at art' or 'to learn'.

A wide range of ideas surfaced in the responses made by older pupils: 11 per cent of 10-year-olds and 16 per cent of 11-year-olds, for example, suggested that children made art to communicate or to express themselves:

> If a child knows what they want to say but they don't know how to say it they can draw a picture to show what they mean (Natasha, 10).

> Art is a good way to express your feelings and the painting asks the viewer, 'What is this trying to say?' (Ellie, 10).

Relatively few suggested that the main reason for making art was the aesthetic value of the product itself:

> You can decorate the house (Zahira, 9).

> To put it on the wall if it is perfect (Paul, 11).

> So the world is not dull (Anton, 8).

Similarly, only a small proportion of pupils, but one that remained consistent in size across the age range, cited reasons that concerned children's talent, ability and creativity:

> We make art because we have lots of ideas and we can bring them together in art (Immanuella, 7).

> I think children make art because they have more imagination than adults do. Then they draw it (Georgie, 9).

Responses referring to the therapeutic value of art were concentrated in one particular class, suggesting that this was a theme that the class teacher may have explored with the pupils.

> They do art because when they get angry they can't find the words to explain what they feel so they draw a picture to relate to it (Tamara, 10).

Table 1: Why do children make art?

	7	8	9	10	Age 11	Total%
For fun	62	53	57	56	49	57
Personal development	27	27	18	19	13	20
Communication / audience / evidence	6	3	8	11	16	9
Aesthetics / product	0	7	8	3	10	6
Demonstrate ability / talent / creativity	3	3	6	5	0	3
Therapy	0	0	0	5	5	2
Physicality	2	0	0	1	7	2
Don't know	0	7	3	0	0	2
	100	100	100	100	100	100

If you get angry you can do some art and you can make yourself calm (Mizan, 10).

The physicality of art and design materials was referred to by only a small percentage of pupils:

It is very messy and children like to be messy (Farshad, 10).

Whilst only a minority identified the value of art as a practical alternative to more academic subjects:

It's easier than English and Maths (Arran, 7).

There's no numbers and words in it and I can do it (Daniel, 7).

Specific art and design processes were mentioned by only a very small number of pupils.

Table 2: Why do adults make art?

	7	8	9	10	Age 11	Total%
Money	15	17	17	22	46	23
Fun	20	13	28	23	10	19
Personal development	24	20	8	19	13	17
Fame	6	13	18	13	5	11
Communication	12	3	12	9	10	9
To encourage others	17	10	5	8	7	9
Aesthetics / product	0	17	9	3	1	6
Therapy	2	0	3	3	7	3
Don't know	5	7	0	0	1	3
	100	100	100	100	100	100

Why do adults make art?

Pupils' responses to this question were spread more evenly across a wider range of themes than the first. 23 per cent of pupils thought adults made art 'for money', 19 per cent 'for fun', 17 per cent for reasons relating to personal development and 11 per cent for fame. Within these figures there are variations according to the age of the pupils: only 15 per cent of 7-year-olds thought that money was the main reason adults make art, whereas 46 per cent of 11-year-olds thought this to be the case; 20 per cent of 7-year-olds thought that fun and enjoyment was the factor that motivated adults, compared with only 10 per cent of 11-year-olds. Younger pupils were more likely to perceive a stronger continuity between reasons provided by children and those by adults, whereas older pupils were more likely to believe that the reasons why adults make art were different to the reasons why children made art.

Older pupils suggested a range of further reasons why adults make art and were more likely to understand that people make art for a variety of reasons:

> Adults make art because they can make money out of it. Also because you can express your feelings when you draw. If they do make a good drawing they can sell it to a gallery and people can see what that person can do (Tamara, 10).

Younger pupils were more likely to link the idea of fame with money, whilst some older pupils were beginning to betray signs of suspicion of artists' motives:

> To make money and to be famous (Stacy, 7).

> Not many painters do it for fun and enjoyment. They do it for money and fame, but not all painters do that, thankfully (Ellie, 10).

Ideas about communicating ideas and feelings through art transcended age groups:

> Art is another way to express what they are thinking (Leon, 10).

> Adults make art to remember things (Hannah, 7).

Younger children were more likely to believe that adults make art for altruistic reasons:

> Because they want to show the children how to make things, so they can make them when they are older (Daniel, 7).

> So children will read books (Sabrina, 7).

Relatively few responses referred to the aesthetic value of the work itself, and the majority of these came from pupils in the same class:

They might like all the different patterns (Zahirah, 10).

Because it's beautiful (Nathan, 10).

The belief that making art can be a therapeutic process was referred to by a small number of children in each age group:

Adults make art because they find it enjoyable after a stressful day (Joshua, 11).

To cheer themselves up (Michael, 7).

Other reasons included:

To communicate with people who don't speak the same language (Georgia, 8).

They didn't have a chance when they were a child (Hannah, 7).

To experiment (Daryl, 9).

They are inspired (Kevin, 10).

Table 3: How is art important?

					Age	
	7	8	9	10	11	Total%
Communication	15	13	26	31	33	23
Personal development	26	43	15	25	16	25
Aesthetics / product	21	17	30	16	21	21
Fun	12	3	8	6	0	6
Money	5	6	9	5	8	7
Therapy	5	0	1	5	8	4
Physicality	0	0	1	0	0	0
There's no right or wrong	0	0	2	3	3	2
Don't Know	17	17	8	9	10	12

Table 4: Do you think you will make art when you are an adult?

					Age	
	7	8	9	10	11	Total%
Yes [fun, interested]	29	40	29	27	21	29
Yes [talent, progression, career]	32	23	28	19	13	23
Yes [useful in other areas]	5	0	5	0	0	2
Maybe	0	7	2	3	15	5
No [other interests]	12	10	20	14	18	15
No [not interested / talented]	22	20	17	38	33	26
	100	100	100	100	100	100

These responses, although only made by only small numbers of pupils, are significant in that they demonstrate a capacity for absorbing a wide range of ideas, and are discussed below.

How is art important?
The perceptions of art as being something that is fun for children, in contrast to being lucrative for adults, was referred to only rarely in responses to this question, which were dominated by themes of communication, aesthetics and personal development. 69 per cent of pupils made responses relating to these themes, whereas only 7 per cent suggested art was important because adults can make money from it and 6 per cent because it is fun. Older pupils most frequently identified communication as being the most important function of art, whilst younger pupils regarded personal development as the key issue. Several responses raised new issues, whilst others develop earlier ideas. This question prompted the widest range of responses, with pupils suggesting a total of nearly 60 reasons why art is important, responses that are discussed below.

Do you think you will make art when you are an adult?
Older pupils were less likely to visualize themselves as making art as adults. 66 per cent of 7-year-olds said that they intended to make art when they grew up, compared to 34 per cent of 11-year-olds. Pupils were deliberately not asked whether they thought they would be artists when they grew up, but whether they would make art: this is, however, a distinction that may not have been entirely clear to younger respondents:

> Yes I will make art when I grow up because I love art. In fact after singing it is my favourite (Hannah, 7).

> Yes I think I will make art because I have a big imagination, but I wouldn't do it as a job (Nathan, 10).

Around half of the 7-year-olds who expected to make art when they were older said 'Yes' because they thought it was fun or because they were interested in the subject; others referred either to their talent for art, to making progress with their skills or to the possibility of a career in art. Those who did not expect to make art when they were older explained that this was either because they had other, stronger interests or, more often, that they were neither interested nor talented enough to continue:

> I won't make art when I grow up because there are much more better things to do like be a fireman (Jordan, 7).

> I don't want to be an artist, I want to be a scientist (Jasmine, 7).

Finally, 11-year-olds who thought that they would make art as adults were more likely to explain that this was because it was something that they enjoyed doing rather than because they had a talent for the subject or because they saw it as a career option. There is also evidence that

older pupils were developing clearer ideas about their future careers and more likely to view art as a pastime:

> I plan to be a doctor so all day I'll be busy with other people's problems. It would be nice to unwind with art (Nancy, 10).

> I think I will make art but not for money. Nor fame. For my own enjoyment. A pastime, or a hobby (Ellie, 10).

Discussion

That younger pupils would demonstrate more positive attitudes towards making art than older pupils is an outcome of this research that may reasonably have been anticipated. Less easy to predict was the range of the responses made by many pupils, responses that provide persuasive evidence of young children's capacity to absorb relatively complex ideas. The reflective nature of many of these responses has, I believe, implications for teachers' expectations of their pupils.

The Downing report (Downing et al. 2003) concludes that the majority of teachers believe that the purpose of teaching art and design is to develop skills associated with creativity, communication and expression. However, the outcomes of this research suggest that teachers fail to communicate these learning outcomes with the majority of pupils. Whilst many children suggested that they make art because they enjoy it, and adults because they want to earn money, children viewed neither of these reasons as *important* compared to issues of creativity, communication and expression.

The findings of this research indicate the majority of children assume that the concerns of adult artists are far removed from their own; that adults make art for fame and money whilst children make art for fun. The belief that adults make art primarily for money is one that, though widely held amongst the pupils, is largely untrue. However, the minority of artists – dead or alive – who attract acclaim, admiration or notoriety are also those whose work is sold for substantial sums, and those whom children are likely to learn about. Consequently, it is understandable that children associate adult artists with fame and wealth rather than obscurity and poverty. It is to be expected, perhaps, that younger pupils regard the main reason for making art as to have fun. It may be unwise to discourage pupils from perceiving art as a 'fun' subject, as fun is, arguably, an increasingly rare and precious commodity in the primary school curriculum. What makes the subject 'fun' is, in itself, another question. Had it been possible to challenge pupils making this response, more may have been learned about their attitudes to, for example, particular materials or processes. It may be that children regard art as a subject that is enjoyable *in comparison* with other subjects; perhaps because, as suggested by a small number of older pupils, *'there's no right or wrong'* – a point raised by Eisner:

> The arts teach children that problems can have more than one solution and that questions can have more than one answer. The arts celebrate diversity. While the teacher of spelling

is not particularly interested in ingenuity of response from students, the arts teacher seeks it. The arts celebrate multiple conceptions of virtue. They teach that there are many ways to see and interpret the world and that people can look through more than one window. Furthermore, this lesson is seldom taught in schools. (Eisner 2003: 17)

When asked 'Why do adults make art?' a response from one pupil was 'for the same reasons as children'. Few other professions demonstrate such strong, tangible and practical links between the practice of young children and that of adults: the processes children experience in the classroom are often identical or closely related to those employed by artists. There is a visibility, a physicality and a continuity to an artist's practice that children recognize: 'I may not be able to draw as well as her,' a child could argue, 'but that's because I'm not big enough yet.' Whilst many pupils said that children make art mainly because they enjoy it, and adults primarily for money, they think that art is *important* for other reasons. Almost three-quarters of responses to the question 'How is art important?' raised themes of communication, aesthetics and personal development, whilst only a minority referred to either money or enjoyment. The suggestion here is that many children are content to ascribe to adults a rationale for making art to which they themselves feel they are not entitled. Perhaps, in anticipation of not being taken seriously by adults, they do not take themselves seriously. Essentially, the children are saying that art is important because it communicates ideas and feelings; because it provides opportunities to develop practical skills; because it changes our lives; because it is beautiful – but the reason why *I* make art is because I enjoy it.

Implications for teachers

Teachers surveyed by Downing (2003) provided thoughtful reasons why art and design is important and provided a convincing rationale for the subject's place in the curriculum; however, on the evidence of this survey these learning outcomes are not being efficiently communicated to pupils. Should children's reasons for studying art and design not correspond more closely with their teachers' reasons for teaching it? Less than one third of pupils identified the development of creative, thinking, communication or expressive skills as reasons why they made art, compared with 60 per cent of teachers. This raises the question of how effectively teachers share their reasons for teaching art with pupils. If the majority of teachers believe that the most important reason for making art is to develop creative and thinking skills, then more pupils should be aware of this.

It is hard not to be impressed by the range of pupil responses to this survey. The richness and variety of children's ideas are a clear indication of the level of reflective thinking of which they are capable, with many of the responses forming a coherent rationale for the subject:

We make art to remember things especially when something good or bad has happened (Sam, 10).

Adults make art to communicate with people who don't speak the same language (George, 8).

Art sometimes shows things from the other way (Immanuella, 7).

These responses are proof that young children are able to think reflectively about the value of art and suggest that teachers should have high expectations of their pupils' capacity for generating and sharing challenging concepts. Those pupils that are taught a range of practical art and design processes will be more likely to discover ways of engaging with the subject; similarly, those prompted to consider a wide range of reasons why artists make art may be more inclined to reflect on the value of the subject and on their own attitude towards it.

Finally, the research suggests that teachers should encourage children to recognize connections between their own and artists' work. In his famous assertion that he spent his life trying to draw like a child, Picasso demonstrated his understanding of the bond between children's work and adults' work, as well as of the value of art shared across generations. One 8-year-old pupil surveyed was also observed during a drawing lesson. He was heard to declare at the start, unprompted, that he intended 'to do a Picasso', and proceeded to make a distorted yet recognizable portrait of a classmate. Providing pupils with opportunities to make connections between their own and artists' work may prompt them to reflect more carefully on their reasons for making art.

Conclusions

The research raises further questions. Many pupils made positive, creative and articulate responses to the questions in the survey. Is this the result of specific experiences of learning in art and design in school, or evidence of a broader capacity for assimilating and evaluating a range of arguments? Are these pupils offered a broad and balanced art curriculum, opportunities to engage directly with artists' work, to discuss creativity, motivation or communication? Are teachers identifying specific learning outcomes for art and design and sharing them with pupils?

While the results of this survey suggest that, as they get older, some pupils lose interest in art and design, individual responses are evidence of a capacity for a mature and powerful engagement with the subject. The interesting and important aspects of this research lie in the margins of the data: the wide range of responses from pupils suggests that young children are fully capable of developing an awareness of the breadth of valid reasons why art is taught.

'Learning in the arts', suggests Eisner (2003: 10), 'is not a monologue but a conversation.' The conversations that take place between children and their teachers help to shape and define children's approaches to learning, and the reasons for making art offered to children by teachers may have a significant impact upon their attitudes to the subject. Do we want all children to believe that they will make art when they are adults? No, but we do want schools to encourage children to develop, extend and retain their curiosity in the visual world. And even though almost all of the children in the survey may eventually stop making art, the early years of an art education can provide for them valuable lessons, both practical and philosophical, that other subjects cannot provide. Of the many reasons for making art provided by these

children, none is simpler yet more challenging than that provided by Gloria, aged eleven: 'Art is important because you're never wrong.'

Notes

1. In UK schools the Foundation subjects are those outside of the core subjects of English (Literacy), Mathematics and Science. The Foundation *Stage* is the curriculum followed by 3–5 year-olds; subsequently they progress through Key Stages 1 (5–7), 2 (7–11), 3 (11–14) and 4 (14–16) of the National Curriculum.
2. Interview with a PGCE student, Roehampton University, 2003.
3. The rate of returns was not considered to be an important issue as students were regarded as 'messengers' of data rather than respondents themselves. It could be argued that, as with the Downing report, those students with a particular interest in art and design would be more likely to carry out the survey; however, these students would have had very limited time in which to influence their pupils towards demonstrating positive approaches towards the subject.

References

Downing, D., Johnson, F. and Kaur, S. (2003) *Saving a Place for the Arts? A Survey of the Arts in Primary Schools In England*, Slough: National Foundation for Educational Research.

Eisner, E. (2003) 'What Do the Arts Teach?' *International Journal of Arts Education*, Taiwan, Vol 1, No. 1, pp. 7–17.

Harland, J., Kinder, K. and Paola, R. (2000) *Arts Education in Secondary Schools: Effects and Effectiveness*, Slough: National Foundation for Educational Research.

Herne, S. (2000) 'Breadth and Balance? The Impact of the National Literacy and Numeracy Strategies on Art in the Primary School', *The International Journal of Art & Design Education*, Vol 19, No. 2, pp. 217–23.

National Advisory Committee on Creative and Cultural Education (NACCE) (1999) *All Our Futures: Creativity, Culture and Education*, Sudbury: DfEE.

Pavlou, V. (2004) 'Profiling Primary School Teachers in Relation to Art Teaching', *The International Journal of Art and Design Education*, Vol 23, No. 1 pp. 35–47.

Rogers, R. (1998) *The Disappearing Arts? The Current State of the Arts in Initial Teacher Training and Professional Development*, London: Royal Society for the Encouragement of Arts, Manufactures and Commerce.

Rogers, R. et al. (2001) *Artworks Survey of Art and Design Resources in Primary and Secondary Schools*. Corsham: NSEAD.

21

ROOM 13: ONE ARTIST, 11 YEARS, ONE SCHOOL

Anna Harding

From: Magic Moments, collaboration between artists and young people, 2005, London: Black Dog Publishing

Room 13 started life at Caol Primary School in Fort William in the Scottish Highlands, where it was set up by local artist Rob Fairley. It provides a blend of pupil autonomy, artistic and intellectual freedom, and curriculum enhancement that is not usually found in schools, giving pupils the intellectual skills they need to fulfill their potential in years to come. Attendance is voluntary; older pupils can go at any time during the day to work in the studio as long as they are up to speed with their class work. Pupils take responsibility for their own learning and for the running of their arts studio.

Mr Fairley says:

> I give them critical feedback every step of the way, asking them difficult questions to make them think analytically about what they are doing. I treat the work here like any other piece and give it the analysis that I would of *Guernica*. It is the integrity of the work that I am looking for.

Due to the success of the project, which is constantly evolving, a network of Room 13s has now been developed, each with their own identity, in schools in Britain and even in an orphanage in Katmandu. For this book, Room 13 at Caol Primary was asked to contribute artwork in response to the theme of *Magic Moments*.

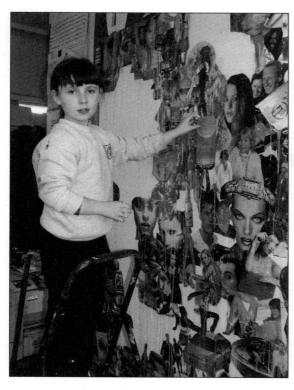

Figure 1: Artist at work in the studio.

AH: What is Room 13?

Pupils: Good question...you would really need to visit one to see! Nobody really understands unless they visit. They are art studios run as a business by the students who use them. The business side helps with all areas of normal school work, the art side lets us talk about stuff which we would not otherwise get a chance to do.

AH: How does it operate?

Pupils: They work by each studio having a management team who raise all the money for stocking the studio by running a business...we, here in Caol, take photographs and sell them, make T-shirts, Christmas cards, postcards, design brochures, mouse mats...all sorts of things. The studio operates like any professional studio...maybe busier? The whole project is run by a small group here in Caol, supported by all the studio MDs.

AH: How do you describe Room 13 in terms of your overall activity?

Pupils: Fun

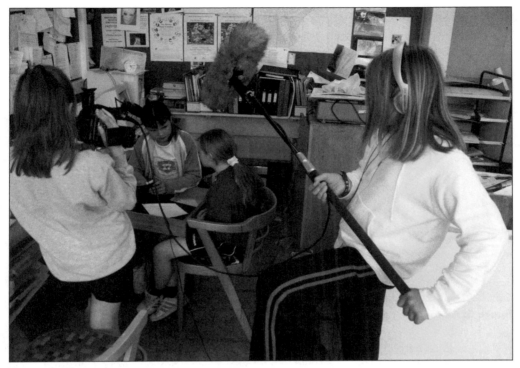

Figure 2: Film production.

AH: Where does the work take place—what type of school?

Pupils: It can take place anywhere. We are organizing a piece which will be made from clouds which we are going to gather on Ben Nevis...but the work will be made in the studio (probably). All the studios in the UK are in normal state schools.

AH: What's unique, special about this context?

Pupils: Nothing really...though when Danni and Eileen were at a conference in Orissa in India they came back saying that it WAS unusual for such a long running student led project to exist in a state school. Actually somebody has just pointed out that it is pretty unusual for 12-year-olds to go to conferences in India!

AH: Room 13 seems to be unique in being long-term as opposed to a short intervention like most art projects in schools. Can you say something about the long-term nature of the project?

Pupils: Room 13 has been going in Caol for 11 years and is run by us. It started just in Caol but now we have studios in Lochyside Primary and Lochaber High School

Figure 3: Artwork.

(also here in Fort William), Sacred Heart Primary in Glasgow, Hareclive Primary in Bristol, The Helpless Children's Mother Centre orphanage in Kathmandu, and Arasavanangkadu School in Tamil Nadu in India, and Hayley and Nikki are going out to Johannesburg at Easter to open one there. We are also going to start our own art college here in Fort William. The long time it has been running is good because everyone understands how it works and it means that long ideas can be done … some works we plan could take years and years to make.

AH: It's perhaps not a coincidence that the project was set up in Scotland. Do you think this fact is significant?

Pupils: Have to ask Mr Fairley because we don't know!

Mr Fairley: It probably is. It was Plato in his Republic (Book VII) who suggests that art should be the basis for all education and also wrote that a teacher should 'avoid compulsion … and let your children's lessons take the form of play. This will also help you to see what they are naturally fitted for'. George Davie in his classic account of the generalist tradition of Scottish University education *The Democratic Intellect*, writing about university education 150 years ago, says:

The importance of [the] system was that it afforded a method of instruction well suited to enliven and bring home to the students the cultural and general content

of the courses. The practice in fact was to supplement the lecture hours, in which the [teacher] had the class at his mercy, with examination hours in which, without detriment to his authority, he met the students more on a level, and, in the course of questioning them round the class on the subjects of the lecture, might himself become involved in argument...[1]

This is precisely what Primary Seven [the final year of Scots Primary school] in Caol and Room 13 are doing. Room 13's headline-making successes have all been in the visual arts but even here we cannot claim to be particularly innovative, but are putting into practice tried and proven thinking. In 1931 the Scottish artist William Johnstone was appointed as full-time assistant art teacher at Lyulph Stanley and Haverstock School for Boys:

The effect on the children some initially difficult and disinterested (sic), was impressively swift, for his teaching was unlike anything they had come across before. More importantly it was unlike the accepted form of art education in elementary, secondary and grammar schools at the time... He would win their confidence, and keep his own work alive, by teaching them not as a teacher but as an artist, as though in his studio inviting them to paint, as artists, with him and on art of their own time and their own making.[2]

Room 13 differs not one jot! So, yes... you can say that Room 13 is basically Scots in philosophy... but it works worldwide.

AH: What opportunities and constraints does the context present — e.g. time, space, and expertise?

Mr Fairley: Time is easy – there is never enough. Our P7 class can use the studio whenever they want as long as we keep our class work up to date — which means answering emails like this is not a problem... we just come and do it. When Rosi and Ami made their Channel 4 TV film last year they were hardly EVER in class but still kept up. Space depends on the studio... Lochyside is probably the best space out of the UK studios... it is bigger with lots and lots of sinks and good light. Caol is getting cluttered with all the canvasses we use. Expertise? Each of the studios is really good at something different. We are good at painting, digital imaging, video and film making, Lochyside are good at sculpture and our web site was made there, Lochaber High School's Room 13 is a multi media studio and Hareclive is mostly a painting studio. Sacred Heart in Glasgow is a music studio and they have a composer in residence! We can always swap artists/composers in residence when we want. We are thinking of putting an actor in residence into one of our next Room 13s!

The opportunities Room 13 offers are huge because everything we do is for real. Nothing is done because a teacher thinks it is a good idea or a good lesson... if

Figure 4: Artwork.

we make a film it is aimed for being on TV (Rosie and Ami's was short listed for a Grierson Award so it must have been okay), when we write articles then they are meant to be published and when we make artwork the pieces we make are meant to be shown in galleries and have to mean something to us. It also allows us to travel, which is good…from Easter to Easter some of us will have been to Kathmandu, London, Glasgow, Delhi, Bhubeneswar, Calcutta, Varanasi, Agra, Inverness and Johannesburg. Money is the biggest constraint and until we can set up the project to be self funding it always will be.

AH: Is there a key idea?

Pupils: No…other than it is a studio that we run by ourselves.

Mr Fairley: It also does not patronise and operates at a high intellectual level (certainly undergraduate level).

AH: Whose idea was it?

Pupils: Nobody's … it just slowly grew.

AH: How and why did it start and develop?

Pupils: Two P6 girls eleven years ago started it when they asked Mr Fairley to come in and work with them. He said he wouldn't unless they paid him … so they did.

AH: How did it change from the first idea?

Pupils: It hasn't really changed, just got bigger and it is pretty cool to be able to have a network of Room 13 artists from all over the world to work with.

AH: How long has it been going on for?

Pupils: 11 or 12 years.

AH: Has Room 13 had to adapt or develop?

Pupils: Yes. Room 13 in the high school is different … each primary school studio is different, and the ones in other countries are very different, but the main idea is the same.

AH: What do you feel Room 13 offers young people – e.g. permission, ways of thinking, being?

Pupils: We have had a big discussion about this. We think it offers different things to different people. Some people want to just run the business side and others just want to make artworks. Some people just come into the room for peace and quiet to read a book and others come to listen to music and to talk about stuff. It certainly encourages everybody to think in different ways and to look at things in new ways. It is good for allowing us to control our lives in school rather than always just having to do what we are told with no explanation of why.

Mr Fairley: It gives us freedom.

AH: What are the dynamics which make this project succeed?

Pupils: O gosh I don't know. Don't know what dynamics is! Have looked it up so … one of the things which upsets adults but we think is fun is that the criticism in the studio is really, really fierce. The artists in residence are quite likely to tell you that your work is rubbish unless you can say why you made it that way but that means you can ask them the same things … so we are always discussing and arguing. Also respect, the adults totally well respect us and we respect them. We are all equal really, as they say they learn from us as much as we learn from them.

Figure 5: Film production.

AH: What does the work do to/for young people/adult artists?

Pupils: In Room 13 there is no difference between adult and young artists. We are all just artists.

AH: What do you think is the value of Room 13 for you?

Pupils: We will ask everybody in the room...Rachel, in the film, said it was like a home to her, so it will be interesting to see what everybody thinks

Anne: An interesting place where your brain can run riot.

Katelyn: A peaceful room and a good place to sit and think.

Eilidh: A place where you can be yourself.

James: It can be annoying because of the noise but mostly it is quite fun.

Chloe: It is nice and relaxed.

Nicole: It's fun AND relaxing.

Lucy: (this years MD) It's better than class because you can do your own work your own way, and I got the chance to visit Tate Modern in London, and I really like taking photographs.

Rebecca: It's a fun and creative place to be. We can learn about philosophy and do all sorts of interesting things.

Mark: You can paint in it and you find you don't mess about as much as in class—you sort of concentrate better.

Mrs Innes: (parent and classroom assistant) It keeps my children out of the house and at school!

Codie: Don't know ... fun, good place to paint.

Hayley: I have got the chance to go to South Africa and I find it good even after school.

Amy: I got the chance to go to Tate Modern in London and you learn all sorts of different things.

Jamie: Because it's a place where you can paint and you are allowed to make a mess!

Laura: Because you can do what you want.

Alan: I like it because you can have a lot of fun and paint big big pictures.

Mrs Smith: (P7 teacher) Freedom.

AH: When do things work well/ less well and how can they be best supported?

Pupils: We think the more we can run things the more easily it works. People are always saying we don't want to learn but actually what we want to learn is not always what we are taught, Room 13 allows us to learn all the stuff we do in class but in a different way. The project can be best supported by trusting us.

Mr Fairley: Money is the way we can be supported best!! We always need more and the more money we can put together the more Room 13s we can open.

AH: What do you consider the key success (or otherwise) of Room 13?

Pupils: We have been arguing over that one for ten minutes. Don't think there is a key success. Depends what you mean. The thing that made people notice us was winning the Barbie Prize...but that was just work from that year and we had been running the studio for years before that. Rosie and Ami's film being shortlisted for the Grierson Award was even bigger because the Barbie was just against other schools while the Grierson was against all other arts documentaries on TV. Winning three Artworks awards was important too (Young Artists of the Year awards scheme is run annually by the Clore Duffield Foundation) The key success to the whole project hasn't happened yet...it will be when people really REALLY start to take us seriously.

AH: What is its value for artists/young people?

Pupils: It lets us be ourselves.

Mr Fairley: It allows us to be more creative than would otherwise be possible and gives us the chance to make new forms of artwork.

AH: How do you measure the success?

Pupils: Jamie suggests we use a successometer! Or you could measure success with a ruler but its size would depend on what font you printed it out on. Seriously we don't know. Miss Cattanach (our head teacher) has said she can see the difference in the whole school but we are not sure how she means. We think that the constant attention from other schools wanting to join the Room 13 group is a sign of success. Room 13 teaches us that we have to take responsibility for our own actions.

AH: Has the project changed?

Pupils: Only very slowly...but each MD has a different way of doing things and of course each studio is different.

Room 13s go from strength to strength, their recent notoriety making their team members celebrity figures in the art world, with residencies at the Irish Museum of Modern Art, Dublin and conference presentations at Tate Modern.

Note

1. George Davie, *The Democratic Intellect*, EUP 1961, p. 14.
2. Ian Tregarthen Jenkin, '*William Johnstone: His Contribution to Art Education*' Arts Council of Great Britain's Hayward Gallery exhibition catalogue of Johnstone's work. 1981, pp. 15–18.

Notes on Contributors

Jeff Adams

Jeff Adams is a Reader in the Department of Education at Edge Hill University, Lancashire. Prior to joining Edge Hill he worked at Goldsmiths, University of London, researching into art education and leading the MA Artist Teachers and Contemporary Practices Programme in collaboration with Tate Modern and the National Artist Teachers' Scheme. Before joining Goldsmiths, he lectured at Liverpool John Moores University, coordinating the PGCE Art and Design course, and tutored in contemporary art history for the Open University. Jeff's earlier career was spent teaching in secondary comprehensive schools in Yorkshire and Cumbria.

Angela Anning

Angela Anning is Emeritus Professor of Early Childhood Education at the School of Education, University of Leeds. Her First Degree was in Fine Art and English. Her teaching career in art has spanned nursery, primary, secondary and Further and Higher Education. For fifteen years she has taught art and design to Leeds Primary PGCE students. Her research interests are art and design education, family intervention programmes and professional knowledge. What binds these disparate research interests together is an abiding interest in how intelligence/knowledge is expressed in action.

Dennis Atkinson

Dennis Atkinson is Professor of Art and Design Education at Goldsmiths, University of London. He is Head of the Department of Educational Studies and Director of the Research Centre for the Arts and Learning in the Department of Educational Studies. He taught for 17 years in secondary school and was Head of Art for 12 years. He gained his PhD from the University of Southampton in 1988. He was the course leader for the PGCE Art and Design Secondary Course at Goldsmiths for ten years and still contributes to this programme. He is MA tutor for modules in Visual Culture and Education; Culture, Pedagogy and Curriculum; and Contemporary Art, Identity and Education, which is taught in association with Tate Modern in London. He is currently Principal Editor of the International Journal of Art & Design Education and has published regularly in academic journals since 1991.

Helen Charman

Helen Charman worked at Tate Modern, joining in 1999, where her role involved setting up the Schools Programme. Prior professional roles include Education Coordinator at the October Gallery (London); Arts Development Officer at the London Borough of Harrow; and Education Coordinator for Cultural Cooperation (London). She taught at primary level for four years and studied for her MA Art History at Birkbeck College, University of London, and her Diploma in Arts Administration at Roehampton Institute, University of Surrey. She is currently a doctoral student at the Institute of Education, researching professionalism in art museum learning.

Grant Cooke

Grant Cooke devised the process of 'Negotiated Drawing' with the help of Deirdre Griffin when they were both advisory teachers with the Brycbox Arts in Education Team in the Outer London borough of Kingston.

Maureen Cox

Maureen Cox was Senior Lecturer and is now Emeritus Reader in Psychology at the University of York, specializing in children's cognitive development. Her main area of research is children's pictorial representation; she has written many journal articles and books, and her book *Children's Drawings*, published by Penguin, was awarded second prize by the Standing Conference of Studies in Education for best book on education published in 1992.

Sue Cox

Sue Cox is a Senior Lecturer at the University of East Anglia and currently teaches on the Masters level PGCE (Primary), with responsibility for Art and Design and General Professional Studies. She is also course director of the MA in Advanced Educational Practice. In her previous post at Nottingham Trent University she taught and held leadership roles on BA (Education) and B.Ed. courses (Art and Design and Education Studies) and MA courses. She has undertaken a number of funded research projects in art and design education and children's participation. Her research interests centre on art and design in the primary phase; the primary curriculum and pedagogy; children's participation and decision making; children as researchers; and action research. Her background in philosophy of education informs her work in art and design education. Prior to entering higher education she taught for 12 years in primary schools in the UK and in Hong Kong.

Paul Dash

Paul Dash is a Lecturer in Education and MA module Coordinator in the Educational Studies Department at Goldsmiths, University of London. He currently leads the MA in Artist Teachers & Contemporary Practices. He is a member of the Bilingualism and Culture Research Group and the Centre for Arts and Learning. He taught in London schools for 22 years and three years at Institute of Education. In 2002 He received the Peake Award for Innovation and Excellence in University Teaching, and in 2003 he received the Windrush Award for Contributions to Education.

Frank Dobson

At the time of the original publication of his paper, Frank Dobson lectured in the Education Department of Loughborough University of Technology, England. Educated at Scarborough High School and St Catharine's College, Cambridge, he taught English in schools before moving to Loughborough College of Education, teaching educational psychology to student teachers and then, when the college became part of Loughborough University, to MA students taking Design Education. His chief interests are visual perception, cognitive psychology and creative behaviour.

Mary Fawcett

Mary Fawcett has had a career spanning 50 years in the field of early years' education. After teaching in nursery and infant schools, parenting, and community development work with the playgroup movement, she was a lecturer in education at the University of East Anglia. Subsequently, at the University of Bristol, she initiated and directed the BSc in Early Childhood Studies. Her handbook Learning Through Child Observation published in 1996 (Jessica Kingsley Publishers) is still widely used. With colleagues she wrote Focus on Early Childhood: Principles and Realities published in 2000 (Blackwell Science). In 2002 her article, 'Creativity in the Early Years: Children as Authors and Inventors', was published in the Early Education Journal (No. 38). Now retired, she is an educational consultant, principally for Bath & North East Somerset Council's $5 \times 5 \times 5$ = Creativity in the Early Years project.

Gillian Figg

At the time of the original publication of her paper, Gillian Figg was a primary school teacher on secondment for two years to West Glamorgan Institute of Higher Education where she lectured to BEd students. Her research centred on the design and evaluation of a painting programme for the primary school. She was involved in the NSEAD/Berol Primary Education Art, Craft, and Design Research Project, and the commencement of a project, initiated by the West Glamorgan Education Authority, which investigated ways to encourage children in aesthetic appraisal of the natural environment, following on from strategies developed by the School Council's Art and the Built Environment working parties. In 1980, while teaching at the Cwmrhydyceirw Primary School, Swansea, Gillian Figg was awarded the National Society for Art Education /Berol Bursary.

Deirdre Griffin

Deirdre Griffin devised the process of 'Negotiated Drawing' with Grant Cooke when she led the Brycbox Arts in Education Team in the outer London borough of Kingston. She went on to become a Drama lecturer in the Department of Educational Studies at Goldsmiths, University of London.

Mani Das Gupta

Mani Das Gupta is a Senior Lecturer in Developmental Psychology at Staffordshire University. Her research interests centre on child development in general with a particular focus on the development of children's reasoning, teaching and learning, and the relationships between early attachment and later cognitive and social development.

Jenny Hallam

Dr Jenny Hallam is a Lecturer at the University of Derby. Her PhD thesis 'A Critical Analysis of Art Education in English Primary Schools' used ethnographic methods informed by social constructionism to explore the educational contexts which shape children's artistic development. Her current interests centre on exploring children's experiences of art in the classroom and how children would like to see art taught and designing, implementing and evaluating art interventions designed to enable primary teachers to teach art more effectively.

Anna Harding

Anna is Chief Executive of SPACE studios, London. She founded the MA Creative Curating course at Goldsmiths, University of London, and has been a curator and writer since 1984. Her books include *Magic Moments: Collaboration between Artists and Young People*. She curates The Contemporary Art Museum and Beyond. Her essays include 'Open space: Art in the Public Realm in London'; 'The Art of Negotiation'; 'The art of the unseen city'; 'Participatory Art and the Gallery' in Out of Here (IKON).

Penny Hay

Penny Hay is an artist and educator. She is currently working part-time with the Arts Development Team for Bath and North East Somerset as the Arts Education Development Officer and coordinates two major research projects: $5 \times 5 \times 5$ = Creativity in the Early Years, and CEDES (Creative Education for Disaffected and Excluded Students). Previously she was a teacher and lecturer in arts education at Goldsmiths; the Institute of Education, University of London; Roehampton Institute; Bath Spa University College; and the University of the West of England. Penny has worked extensively in gallery education across the UK and coordinated the professional development programme for the National Society for Education in Art and Design.

Steve Herne

Steve Herne is a Lecturer in Art in Education at Goldsmiths, University of London where he was formally responsible for the general, specialist and studio practice art courses within the Primary BA(Ed) programme. He currently coordinates and teaches the Creativity and Learning, Visual Arts, and Studio Practice courses on the Education, Culture and Society (ECS) BA(Hons) programme. He also contributes to the MA Artist Teachers and Contemporary Practices. He served as an Education Advisor to the London Arts Board, was advisor for Visual Arts in Tower Hamlets and is a Co-Editor of *The International Journal of Art & Design Education* (iJADE). His research interests include curriculum studies, situated learning, communities of practice, museum and gallery education, artists in schools and arts education evaluation.

Bruce Holdsworth

At the time of the original publication of his paper, Bruce Holdsworth was Senior Lecturer in Art at De La Salle College of Higher Education, a constituent college of the University of Manchester. He was a regular contributor to JADE and a member of its Editorial Board. A practising painter and potter, he now runs Bruce Holdsworth Books, an on-line bookselling site which specializes in books on Art and Design and related subjects.

David Jackson

At the time of the original publication of his paper, David Jackson was research assistant in the Department of Education of Trent Polytechnic, Nottingham, England. A professional painter and printmaker, he worked under Dr Michael Bassey on the Primary Schools Research Project, which was funded by the Manpower Services Commission in the UK.

Helen Lee

Helen Lee is a Senior Lecturer in Critical Psychology at Staffordshire University. Her research interests centre on the construction of knowledge, with a particular focus on the use of discourse and rhetoric; the role of psychology in addressing inequalities; the use of critical qualitative methods; spirituality, embodiment and resistance.

John Matthews

John Matthews is an artist and educator. His research, conducted in London and Singapore, has been concerned with the origin and development of expression, representation and symbolization in infancy and childhood. He is the author of many papers, chapters and three books, including *The Art of Childhood and Adolescence: The Construction of Meaning* (Falmer Press, 1999) and *Drawing and Painting: Children and Visual Representation* (Paul Chapman, 2003). His latest work is on the precursors of expression, representation and symbolization in non-human primates: *Starting from Scratch: The Origin of Expression, Representation and Symbolization in Human and Non-Human Primates* (Taylor & Francis, forthcoming 2009). John Matthews is at present Professor of Art Education and Head of Visual Arts in the National Institute of Education, Nanyang Technological University, Singapore.

Tara Page

Tara Page is a Lecturer in Art and Design in Education, joining the Educational Studies Department at Goldsmiths in 2004. Previously she taught in the UK, Australia and Canada in the areas of Art and Design and Special Educational Needs. She has recently been involved in a research project with Tate Modern investigating the uses of, and strategies to teach, contemporary art. Her research interests include the cultural context and constructions of identity, the use of photography within qualitative research and rural and isolated education.

Sheila Paine

At the time of the original publication of her paper, Sheila Paine was a Lecturer in Art Education at London University's Institute of Education. A past-President of the National Society for Art Education, and Assistant Editor of JADE, she was also editor of the book *Six Children Draw* (Academic Press, 1981) and the author of Artists Emerging: Sustaining Expression through Drawing (Ashgate, 2000). An illustrator and painter, she also conducted further research into the development in drawing of individuals. She established a national reputation through her energetic promotion of many vital activities in art and design education, and the foundation of the Journal of Art and Design Education owes much to her contribution. Sheila Paine died in 2003.

Margaret Payne

At the time of the original publication of her paper, Margaret Payne was Senior Lecturer in Art Education at Roehampton Institute of Higher Education, London. A professional painter and printmaker and a Fellow of the Royal Society of Printmakers, after gaining the NDD (Harrow School of Art) and ATC (Goldsmiths College) she taught in various secondary and junior schools. Further part-time study at London University led to a BA (Hons) in History of Art (1981), an MA in Education (1983) and the Certificate in Early Childhood Education (1989). Her research interests concerned the place and role of History of Art and Art Appreciation in the curriculum of nursery, infant and junior schools.

Gillian Robinson

Gillian Robinson is Director of Research Degrees at Anglia Ruskin University. She received her MA and PhD from the University of London Institute of Education. Her PhD research has led to articles in journals, conference contributions and electronic media. She contributed to a book on quality in art in the primary school and wrote a book on children learning through sketchbooks. As a practising artist she has been collaborating with a poet and an international conductor and composer. She convenes a Special Interest Group at Anglia Ruskin in Art, Design and Sketchbooks.

Peter Seow

Peter Seow is a research associate with the Learning Sciences Lab in the National Institute of Education, Nanyang Technological University, Singapore. Prior to joining the lab, he was in the software industry, with 10 years' experience in leading projects, consulting, and systems development. He has worked with primary schools to design and implement learning environments, integrating the use of mobile technologies. His research interests are the design of mobile environments and understanding learning through the use of media-rich authoring environments like Squeak and Scratch in the programming arts.

Geoffrey W Southworth

At the time of the original publication of his paper, Geoffrey W Southworth was head of Leyland Seven Stars County Junior School, Preston, Lancashire, England. During his years in primary education he was concerned with art education, and gave lectures in several colleges. For his MEd degree, taken at Liverpool University, he submitted a dissertation on 'The curriculum process model and its implications for art education in the primary sector'. Publications include 'The Teaching of Drawing in the Primary School' in *Education* 3–13 (1981). His paper arose from his work as a member of Lancashire County's curriculum project Art in the Primary School, 7–11. He is a practising painter and exhibited work includes a one-man show at the Vernon Gallery, Preston.

Robert Watts

Robert Watts is a Senior Lecturer in Art and Design Education and Programme Convener for the MA Art, Craft and Design Education at Roehampton University, London. Having trained, worked and exhibited as a painter, he became a primary teacher in 1991 and taught in inner-city schools for ten years. His research interests include children's drawings and the use of artists' work in primary education. He has recently begun work on research for a PhD in Art Education investigating children's concepts of visual beauty.

INDEX